First published 2008 by

Liverpool University Press, 4 Cambridge Street,
Liverpool L69 7ZU

and

FACT
(Foundation for Art and Creative Technology)
88 Wood Street, Liverpool L1 4DQ

British Library Cataloguing-in-Publication data
A British Library CIP record is available

ISBN 978-1-84631-181-9

Printed and bound by Gutenberg Press, Malta

Designed by www.burneverything.co.uk
Burneverything would like to thank Eleanor Suggett

HUMAN FUTURES:
ART IN AN AGE OF UNCERTAINTY

EDITED BY ANDY MIAH

103008 /WORDS

Encounters with the future occur via a series of provocations in artistic endeavour, design interactions and cultural imaginations, which seek to consider the social impact of technology for humanity. The manifestation of these visions, as technological artefacts and social processes, infuses and reconstitutes our minds, bodies and world.

This book brings together diverse voices to articulate the various areas of inquiry that orbit this futurological landscape. It portrays how the visual and textual culture of technological innovation is made and remade through bioculturally diverse forms of consumption. This is achieved by presenting innovative works from internationally renowned artists, writers and designers to stimulate new forms of interaction with the future, in ways that transcend the borders between the physical, virtual, biological and digital.

The book addresses such issues as:

- the convergence of the NBIC (nano-, bio-, info-, cogno-) sciences;
- the ethics and aesthetics of human enhancement
- the future of biological migration and transgressions
- the emergence of systems and synthetic biology;
- the prospect of emotional and networked intelligence; ecosystem responsibility.

This book is essential reading for scholars interested in the range of perspectives that inform inquiries into the future of humanity. It consists of scholarly essays, images, interviews, design products, artistic artefacts, original quotations and creative writing.

These symbiotic nodes are interwoven with and stimulated by material from the Human Futures programme at the Foundation for Art and Creative Technology, which took place during Liverpool's year as 2008 European Capital of Culture. Together, they interrogate the expectations and actualities of human futures, as they emerge within the social sphere.

Dr Andy Miah, FRSA, is Reader in New Media and Bioethics at the School of Media, Language and Music, University of the West of Scotland, a Fellow at the Foundation for Art and Creative Technology (FACT), and a Fellow of the Institute for Ethics and Emerging Technologies (IEET).

TABLE OF CONTENTS

FOREWORD

SIR DRUMMOND BONE

152 Words /0.1 Introductions /Human Futures

When we talk about the need for radical interdisciplinary thinking in order to understand an environment which paradoxically is increasingly created by our own activities, we rarely think radically enough. We cannot constrain ourselves to biology with electronics, or even to bioethics with government policy. We have to think policy, electronics, biology, ethics, all art forms, urban planning, psychology et al. in as near an integrated network as possible. This is the aim of this book.

As the lines between art and technology and indeed the human and the technological become ever more overtly indefinite (on close observation they were probably always interpenetrative), and as the sheer pressure of human numbers and their mobility require new structures to cope – and more than to cope, to ensure value in our lives – we need to be as generous in our speculations as these essays encourage us to be.

ADAPTIVE SYSTEMS

IS TECHNOLOGY DESKILLING
OR ENHANCING THE MIND?

engaging with landscape

de-skilled? or enhanced?

restrictive Willian Lathem

SAT NAV

"I'm very happy that there
will be new HCs after i die"

Harold Cohen evolutionary art

incremental mutation

unrestrictive Karl Sims

where does the creativity lie in general art?

change vs. predicition? IS TECHNOLOGY CHANGING THE WAY WE THINK?

WHAT IS CREATIVITY?
- art
- culture
- could a computer tell a joke?

HOW CAN ARTISTS CONTRIBUTE TO THE POSITIVE DEVELOPMENT OF THE FUTURE OF THE MIND?
- are artists' works morally neutral? — should they be?
- how do we democratize shaping the future of the mind?

VIRTUAL REALITY & SELF FICTIONS — are they the same?

INTUITION — i.e. we don't know how we do it

FUTURE OF THE MIND

LEARNING — e.g. checkers playing machine from 1950s

COMPUTER COMPANIONS
- computer diaries for the elderly
- de-humanizing
- are computer companions cynical deceptions?

NO ONE HAS SENSED IN THE PAST. NO ONE HAS SENSED IN THE FUTURE. PRESENT IS

ALL ONE CAN SENSE FOR AS LONG AS THE SURFACE STIMULATION CONTINUES.[1]

LIFE IN THE 21ST CENTURY: PRACTICE-BASED RESEARCH AND THE APPLICATION OF ART

MIKE STUBBS AND LAURA SILLARS

2397 Words /0.2 Introductions /Human Futures

As children are faced with learning how to do up their own buttons or cross the road for the first time or to understand what loneliness feels like, the human race has repeatedly had to re-adapt to an ever-changing environment. From finding new food sources or fuel to keep warm, or coping with the effects of war on a mass scale, it remains a daily reality that, for a large percentage of the global population, human futures means affording food to ensure survival. The context of the issues and discoveries explored in this book emerge from FACT's *Human Futures* programme, which developed throughout Liverpool's European Capital of Culture year in 2008. Bringing together artists, scientists, philosophers, technologists and ethicists into face-to-face dialogue with the public, who have an equal investment in the future, we created a programme that was broad enough to engage people from a wide range of disciplines and which had multiple entry points for non-specialists. De-mystification of technical languages, artistic intervention and debate are central to creating more meaningful opportunities to consider how inquiries into the future impact on daily life.

The complexity of the legal, ethical and scientific debates that help us navigate around ideas about the future is vast, and intersection and cross-pollination is problematic. While our society today seems to offer infinite access to knowledge and while our interconnectedness invites the consideration of everything simultaneously, knowing everything nevertheless remains outside our grasp. On futurology, Bruce Sterling writes that, *'Tomorrow Now* is a book about nearly everything. But you can't simply write a book about every aspect of the future because it's like writing a book about every aspect of the present.' So, if it is in the present that we find our future, the problem of the vastness of everything and the elusiveness of understanding remains. This causes anxiety. And while we can try to predict some of the causes and effects of tomorrow from what we know about today, it is predominantly unexpected external influences that determine individual and group behaviour and that lead to significant change. Change is difficult and can be painful, and fear of pain can be worse than pain itself. How we deal with pain and change is not only governed by external forces. Our power to imagine, re-narrate and innovate can give us comfort in changing circumstances. Most powerfully, our ability to imagine things differently can actually enact change itself.

(UN)AUDIENCES

trusting artists

what are the controversies?

ARTISTS MAKE
INTERESTING THINGS

do we really want to make a social work
using artists in a pedagogical way?

create a space for
incubation and curation can art be programmed?

HEALTHY BUILDINGS

GHETTOIZATION OF NEW MEDIA ART

NEW TERMINOLOGY

UPSTREAM ENGAGEMENT

WHAT IS TECHNOLOGICAL
PROGRESS?

genetic agriculture - who owns what?

law

climate change

LACK OF COMFORT

RADICAL PROGRAMMERS

FUTURE OF THE BODY

cultural capital

body as a community

learning from
audiences

WHAT DOES COLLABORATION
MEAN?

relationship with scientists?
whose bioethics?

FUTURE OF NETWORKS

who is the artist?

body as a network

Art is not a panacea for society. Neither is it a crystal ball into which we can gaze and see what lies ahead. It does not necessarily even provide us with any answers. With a self-reflexive sense of our own institutional agency, FACT's *Human Futures* programme has attempted to navigate a set of concerns about life that we face collectively at the end of the first decade of the 21st century. From the birth of cinema, through collage in film, to media artists' manipulation of individual frames and sub-frames, artists and technologists have explored non-linearity. Stories do not have to be told with a beginning and an end. In a digital environment where editing and special effects blur seamlessly into primary production, the concept of the original is no longer so relevant, as all content can be manipulated. Truth and deception overlap.

Artwork and art process has the power to encapsulate some of the most complex debates of our times and, through offering a visceral experience, can traverse intellectual distances at light speed. Artists have synthesized worlds into which the possibility of representation is infinite. They have found new forms of expression and have animated new architectures. They have often attempted this outside the realm of pragmatism, the political, and the plausible. In this way, they sustain a crucial feedback loop into the dominant ideologies of our times by questioning from the left field and insisting that there are different ways of looking at a problem. Producing a programme with the lofty ambitions of engaging theoretically and creatively to comment on the future of humanity raises a set of challenges. Applying this overarching title to a series of works that, like all good art, defy categorization would have been glib over-simplification and reductionism had we not accepted from the outset that *Human Futures* was a mode of inquiry, as opposed to a didactic descriptive framework into which a whole body of work would sit comfortably.

Throughout this book there are images and fragments from the art we commissioned, the artists we worked with, and the people who took part in the debates we held. However, there is no satisfactory way to portray these works through the medium of text. To paraphrase one of our artists, **Pipilotti Rist**, if it could have been said, it would have been written. Instead, we utilize this introduction to engage with the role of artistic practice in the broader context of knowledge and research development. Artistic practice is a process that, however focused in its questioning, rarely works in a linear fashion. The artists we have worked with have not taken the question 'what is the future of the human?' and tried to answer it literally. Pipilotti Rist's practice over the last two decades has drawn on the fragility and complexity of the human condition, exploring how mass media relates to individual identity and how overarching systems such as religion can affect and structure the way we relate to the world.

The media systems we live and work within, their velocity and insidious power, has been central to the work of **AL and AL** over the last ten years as they have woven alternative universes out of computer-generated imagery and blue screen technology. Simultaneously critiquing and celebrating the speed with which a global cultural village consumes and worships fame and power and the digital culture that reproduces and endlessly copies these persona icons across the planet, AL and AL's work was developed for the *Human Futures* programme from an 18-month residency at Metal in Kensington, a ward just outside Liverpool city centre. Of its time and of its place, Eternal Youth superimposes the aesthetic of the sci-fi film onto the collective psyche of lost boys in a city that is struggling to find its way into the 21st century. The artists who contributed

to curator Jens Hauser's **sk-interfaces** exhibition – from well-established artists such as Orlan, the Arts Catalyst group and Stelarc to younger artists such as Zane Berzina and Julia Reodica – all produced work that focused the audience's attention on the big questions of life via the physical details of life itself: an ear growing on an arm, a cell being killed in a Petri dish, a pretty jewellery box containing what seems to be a tattooed piece of flesh that is in fact a designer hymen. Through capturing a fragment of life and turning it on its side to look at it from a different angle, these artists not only create potent artworks, they also model new ways of looking at the world.

Art can bring the complexity of life alive. Zbigniew Oksiuta's experiments in creating environments that can operate outside gravity seem fantastical and the workings of a sci-fi enthusiast with too much time on his hands. For instance, in one piece, the artist creates the conditions that would be needed to send a capsule of plant seeds into space to enable life to exist outside Earth's atmosphere. However, on closer inspection, his work engages with the scientific proposition that the survival of the human race will, in time, require leaving the planet. Oksiuta's work is highly formal and beautiful and points to the fragility of the conditions needed to sustain life. His art does not lecture us, nor does it represent scientific facts. Instead, it creates a space where we come face-to-face with the material reality of our existence; it makes the intangible and grandiose tangible and small.

Alternatively, Swiss artist Yann Marussich's moving performance complicates our sense of biological separateness and visualizes the shared system of intake and output that enables human life – breathing in and breathing out and the sharing of oxygen. His contribution to *Human Futures* sees the artist locked in a plexi-glass pressure-controlled tank after having ingested methylene blue. As the pressure rises, blue liquid starts to drip from the pores of his body; first from under his arms and from his mouth and then eventually the whole surface of his body releases the blue – even dripping from his eyes. Revealing the workings of a body that almost always remain invisible and showing how much we seep into the world around us, Marrusich's work raises concerns that are directly articulated by artist Oron Catts. Catts' work in laboratories has been driven by a concern that the ethical frameworks that exist within scientific contexts are not rigorous enough and do not consider the implications of what they mean for humanity at large.

We cannot separate art from the cultural conditions of its production and, more widely, its role within the public sphere. While thinking about the future in the public domain is a gesture towards a form of civic participation that, it can be argued, only the arts can access, this work does not mask the harder realities of life. It does not cushion the blow, or get every participant a job, but it aims to carve out freer spaces for debate and discourse, where difficult conversations are allowed and, indeed, encouraged. The by-products of this process are often raised self-esteem and awareness, confidence and a sense of self-worth that can, in turn, lead to hard social outputs. By holding human futures at the heart of the matter the ephemeral character of socio-political agendas that could dominate our field of vision are held at bay. This has enabled us to look further than our immediate social concerns.

LEFT: PIPILOTTI RIST 'YOUR SPACE CAPSULE' (2006/2008, FACT)
(PHOTOGRAPHY BY BRIAN SLATER, COURTESY HAUSER & WIRTH, ZURICH & LONDON)
MIDDLE: PIPILOTTI RIST 'OPEN MY GLADE' INSTALLATION VIEW AT TIMES SQUARE, NEW YORK (2000)
(PHOTOGRAPHY BY PUBLIC ART FUND, COURTESY HAUSER & WIRTH, ZURICH & LONDON)
RIGHT: PIPILOTTI RIST 'APPLE TREE INNOCENT ON DIAMOND HILL' (2003/2008, FACT)
(PHOTOGRAPHY BY BRIAN SLATER, COURTESY HAUSER & WIRTH, ZURICH & LONDON)

Debates led by FACT's community internet TV channel tenantspin have ranged from the real-time reality of Tesco-led regeneration to the fact that one of the most profound challenges of the 21st century and the future of the human is our increased redundancy in an expanding post-industrial society. A post-industrial, post-climate-change society was the backdrop for the apocalyptic vision of young people who developed films with FACT's education programme exploring their concerns for the future. Their bleak depictions of life, where the chasm between rich and poor had become even more impenetrable, sickness more virulent and humanity no more emotionally robust than today, provokes a conversation around what we need to learn today to have the tools we will need to survive tomorrow.

Our histories of art, science and media have run parallel to the rise and demise of increasingly global processes of industrialization. Collective philosophical and empirical understandings of the world are imbued into the realm of art. In turn, art's economic framework is part of the globalized carbon-fuel-based system that we live in today. Art is implicated in the structures it critiques. And yet, as the binaries of synthetic and natural, constructed and real, have become less and less meaningful, it is our curiosity to investigate the relationships between things that leads to the development of new knowledge. Art helps us search again for those ideas that are often overlooked or taken for granted but which, if we could think about them differently, could significantly alter our experience. As Michel Serres (1995) has commented: 'the error condemned today will sooner or later find itself in the treasure houses of discovery'.

By asking the question 'what is the future of the human?' FACT has aimed to provide a safe space for cross-disciplinary debate, art and practice-based research. Through actively encouraging experimentation, provocation and interference, we acknowledge that it is artists who have repeatedly provided early warnings to the cultural, economic and political ramifications of new technologies through a variety of mediums, tactics and gestures. Many of the following texts and images in this volume demonstrate how performative acts and resistance to accepting the status quo explode the terms of engagement and insist that we address big questions differently.

In a post-human, digital age where we can easily imagine ourselves beyond the physical confines of our own mind, body and world, art can offer the tools we need to think differently about ourselves. Obfuscating our collective, critical faculties at a time when we must think laterally and not literally would be folly. In this task, the role of art agencies – such as FACT – is to protect the complex practice of making art and to pioneer its inclusion in the social domain on its own terms. *Human Futures* has been a vital learning process to help FACT articulate what we value about art, what the public is most concerned about for their futures, and what our institutional responsibility is to the practice that is at our artistic core. The exchange of ideas around these themes between practitioners and commentators across disciplines is essential in moving beyond image, surface and appearance. Humanity's obsession with status, wealth and control has, in the technology-rich 21st century, thrown an age-old quest for the extension of life into an increasingly possible socio-economic framework. The ramifications of this need intelligent and challenging discussion. Neither the hand of God, nor science and technology is going to fix things for us. That time is over. False expectation and reliance on other people to resolve things never was an answer. In imagining human futures we accept our own agency. We invent the society we want to be.

ART'S TASK IS TO
CONTRIBUTE TO
EVOLUTION, TO
ENCOURAGE THE MIND,
TO GUARANTEE A
DETACHED VIEW OF
SOCIAL CHANGES, TO
CONJURE UP POSITIVE

ENERGIES, TO CREATE
SENSUOUSNESS, TO
RECONCILE REASON
AND INSTINCT,
TO RESEARCH
POSSIBILITIES AND TO
DESTROY CLICHES AND
PREJUDICES.

(PIPILOTTI RIST, 2008: 208)

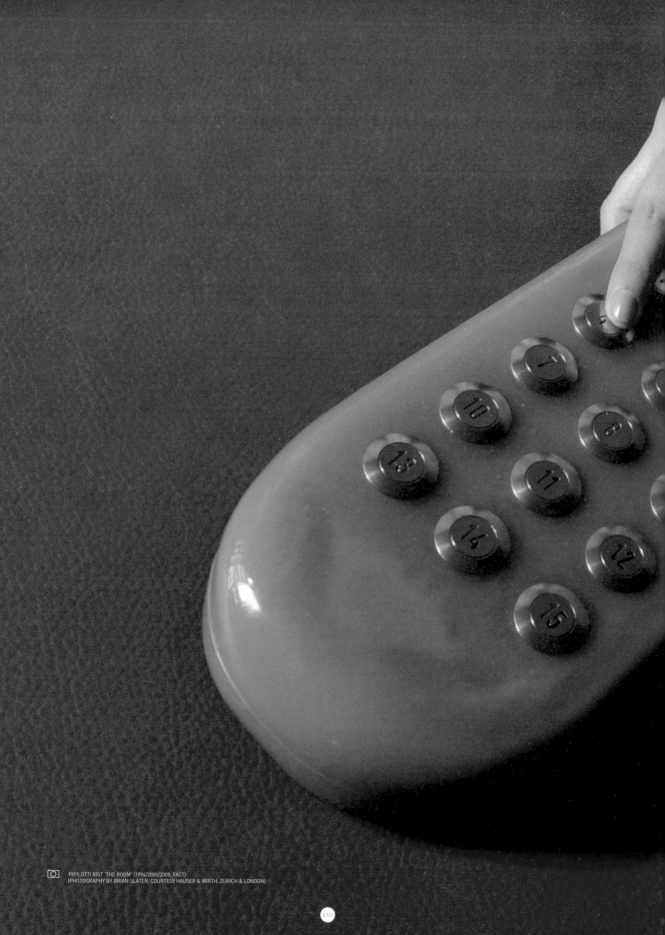

REFERENCES

Rist, P. (2008). 'Pipilotti Rist Questionnaire'.
Frieze Magazine, September 2008, 117 p. 208.
Also available online at
http://www.frieze.com/issue/article/pipilotti_rist_que
stionnaire/ [accessed: August 2008].
Serres, Michael (1995). *Conversations on Science,
Culture, and Time*. Ann Arbor: University of Michigan
Press

(Endnotes)
[1] From Mike Stubbs (2001). ZERO.
Celebrating the 40th anniversary of Yuri
Gagarin's first manned trip to space, in
an age when space tourism has become a
reality what does the future hold for
our new born? A first shaft of light, a
splinter of an image, first movements
and a sense of independence. Zero is a
lyrical view playing on the metaphor of
weightlessness, mobility, existentialism
and consciousness. At what point are we
aware of our own bodies, what is private
and where does the external world begin?
Text from writings by Net Robot Netochka
Nezvanova.

INTRODUCTION

ANDY MIAH

3656 Words /0.3 Introductions /Human Futures

In recent years, the long-term future of humanity has become of particular concern to various governmental and scholarly institutions. This is due to the many aesthetic, legal and ethical biological transgressions that have begun to occur through emerging technologies, such as genetic modification, cloning, stem cell research and much more. These transgressions call into question the foundations of social order, thus creating a complex, multifaceted imperative for humanity as a whole to foresee.

During this period, new communities of academic inquiry have emerged, including the Future of Humanity Institute at Oxford University, the Centre for Responsible Nanotechnology, the Institute for Ethics and Emerging Technology, the Methuselah Foundation programme, and the Singularity Summit. Their explorations are accompanied by well-funded research programmes, which have investigated such issues as human enhancement and life extension. Equally, there has been remarkable and varied expansion in studies of the links between art and science, some of which investigate the challenges these technologies provoke. Yet the collaborative spaces within which various disciplines can explore future visions of humanity remain sparse and individual disciplinary perspectives have been disempowered by their isolation.

This book establishes a new environment of interrogation to inform our understanding of humanity's future. The authors present work that situates discussions about human futures within the social and political sphere. Moreover, many of their contributions consist of works that extend their expertise to new terrain. This demonstrates the distinctiveness of the contributors and their commitment to speak across disciplines in order to initiate debates among wider publics. For instance, nanotechnology expert Richard Jones is also a blogger and uses a WordPress platform to discuss emerging issues in the public dissemination of nanotechnology. Alternatively, William Sims Bainbridge (aka Catullus) advisor for the USA National Science Foundation and author of various influential science and technology governance reports is, as his essay reveals, an expert online gamer. We also connect the design work of Anthony Dunne and Fiona Raby with the ongoing discussions in bioethics and biolaw about genetic selection and testing. These examples speak to our intention to broaden the range of imaginations that are brought to discussions about the future. Additionally, the artists and designers presented here undertake their work in a time when fundamental parameters of human existence are in question, due to the prospect of commercialized space exploration or the creation of synthetic biological life forms, for instance. Our uncertainty about the merit of such pursuits is mirrored in the work of new media artists and designers, whose explorations with biological matter re-constitute the terms through which our uncertain future is imagined.

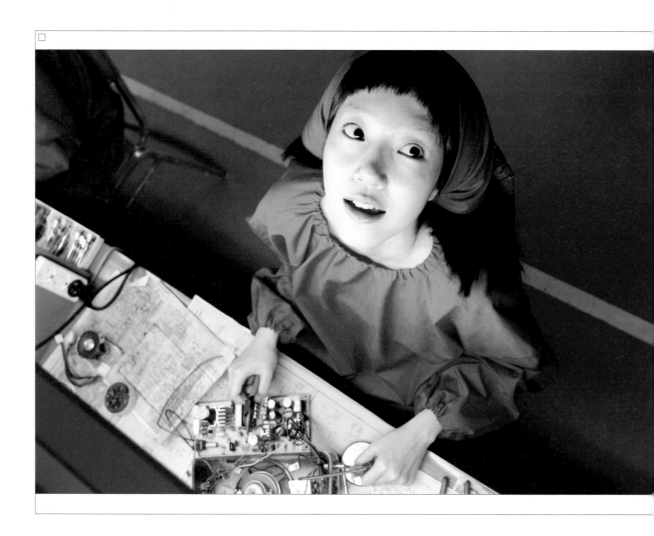

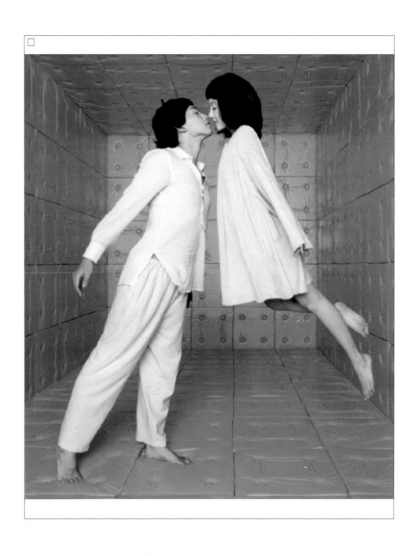

The contributions should be seen in the context of the last 20 years of research into public engagement with science, during which time a broad biopolitical commitment towards creating a democratized future has emerged. Human Futures empowers various voices to actively shape conversations about the future – artists, scientists, philosophers, designers, sociologists and science fiction writers. In this sense, it engages with the imperative of inter-disciplinarity and recognizes that various knowledge economies operate around discussions on the future, some of which are more able than others to shape the agenda of social concern. In response, Human Futures re-negotiates this economy.

The futures conceived here are not constructed as wholly utopian or dystopian environments. Their composition resists such polarization – as either technoprogressive or bioconservative – to allow the playful exploration of other possibilities. Moreover, the version of humanity's future they present is constituted by the dual processes of the mundane integration of technology within society and the omnipresence of radical transgressions that are implied by these interactions. As such, this volume re-tells future scenarios, connecting the inquiries of artistic and design endeavours with various textual forms. The impossibility of arriving at the future, and our perpetual uncertainty over the present, governs these various contributions.

At the forefront of our concerns – and FACT's *Human Futures* programme more broadly – has been the aim to reconcile the role of artists and designers in dealing with the social and political challenges that are an integral part of these collective imaginations, but also to interrogate the concept of the artist. A central part of this analysis involves questioning what we understand by authorship, either as an individual or collective act, where each presumes a certain level of attributive responsibility and culpability. Ineed, many of our essays and images speak to the collaborative nature of future imaginations.

Despite our aspirations, we recognize that explorations of the future take a number of risks. The first is the passing of time, which wreaks havoc on speculative gestures. The second is complacency, or failing to take into account the complexity of the past and the present in order to satisfactorily inform visions of the future. The third risk is of failing to find the right balance between conviction and uncertainty. It is the last of these that concerns us most here. It is also the reason why scholarly research is sceptical of futuristic inquiries. The age of uncertainty portrayed within our subtitle articulates the moral, political and social uncertainty that surrounds the development of science and technology. It acknowledges that discussions about radical transhuman enhancements will take place alongside conversations about how to improve the conditions of fundamental human needs; the management of pain, mobility in later life, and so on. This duality is central to our Human Futures and it governs each of the sections.

The first section, *Visions*, stages various perspectives on the future. **Steve Fuller** explains the historical development of human interference with biology, from the development of the scientific process to its contemporary transgressions. His recognition of the broader history of how people have been 'Playing God' re-constitutes the field of concern that is often presumed to exist in a

post-Genomic era. His contribution shows how humans have played God long before this period and he argues that our engagement with the concerns arising from new technologies must first reconcile this entrenched human predisposition to affect nature. Proposing an alternative to how science has developed, **Jennifer Willet** explains BIOplay, an inquiry into the conditions that shape the modern scientific laboratory. Willet's proposition to re-constitute the lab provides the possibility of its becoming a different kind of social space, one where 'external ecologies' have the possibility of opening up science to wider public scrutiny.

In light of Fuller's critical history, **Russell Blackford** argues on behalf of a genuinely liberal approach to human enhancements. His main concern is that, among the jockeying of views between technoprogressive and bioconservative perspectives on emerging technologies, there has been no clear systematic exposition of this view within debates about biological transgressions arising from genetics, nanotechnology or biogerontology, for example. **Ruud ter Meulen** is less certain about the value of such a commitment to enhancement and interrogates what it would mean to create a better future for humanity. While not directly confrontational to Blackford, Meulen asks humanity to consider what would constitute improvement, noting that pursuits of enhancement do not always lead to better individual or collective circumstances. **Richard Jones** extends Meulen's concerns, though he further challenges Blackford's optimism for a future that embraces technology without caution. Jones explains how nanotechnology and synthetic biology present new challenges to the disruption of human identity. He also re-contextualizes familiar topics, such as environmental concern, by considering the use of power by such information technology giants as Google.

Meulen's and Jones' uncertainty is made manifest in the contribution from **Anthony Dunne, Fiona Raby** and **Andy Miah**, who contextualize the prospective merit of genetic testing as a mechanism for making better lifestyle decisions, specifically dating. Utilizing their *Evidence Dolls*, Dunne and Raby asked young women to consider whether genetic tests of former lovers would have led to their making different decisions about their life and love. The dolls function as the manifestation of such decisions and the mixed responses obtained by their participants speak to the uncertainty described in the book's title. In various ways, Dunne and Raby provide evidence of what would occur if such choices were available to people, which resonates with the first signs of such possibilities.

Section II, *Contested Bodies*, takes us into the complex biopolitics of freedoms and restraints that are implicit to Section I. **Sandra Kemp** personalizes discussions about the future by attending to modifications of the face, as a critical construct in how we reconcile the proposition from biotechnology to alter biology. Thus, interrogating the face as site of biological transgressions opens up lines of debate about how identity is problematized by body modification. Kemp's contribution also provides an overview of how various artists have worked with the new medium of creative biology to enliven debates about the future of humanity. The personalization of this biopolitics is nowhere more prominent than in the contribution from **George J. Annas,** who reprises two US cases where scholarly inquiries into biological transgressions have led to criminal accusations, specifically of bioterrorism. Focusing on

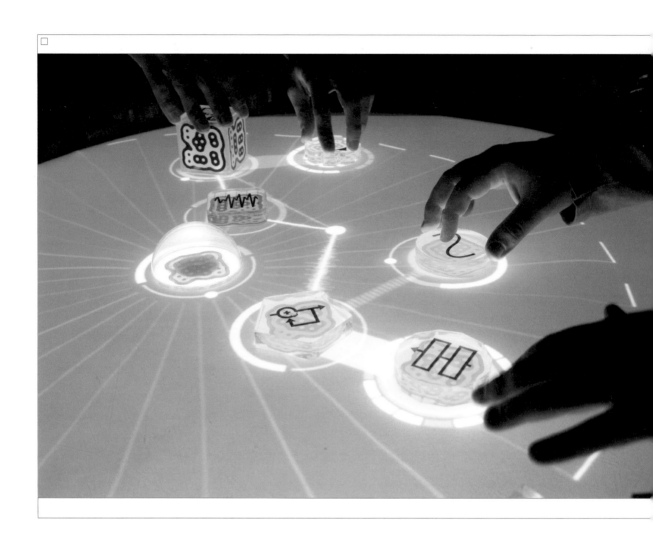

The reactable is a collaborative electronic music instrument with a tabletop tangible multi-touch interface. Several simultaneous performers share complete control over the instrument by moving and rotating physical objects on a luminous round table surface. By moving and relating these objects, representing components of a classic modular synthesizer, users can create complex and dynamic sonic topologies, with generators, filters and modulators, in a kind of tangible modular synthesizer or graspable flow-controlled programming language.

Thomas Butler and Steve Kurtz, Annas outlines that the possible risks of creating novel biocultures are often far less than the social harms of their being policed. Kurtz's recent success in overturning the criminal charges against him has particular resonance to this text, as his work has inspired a number of artists who contribute to this book.

Gregor Wolbring articulates the constraints placed upon ranges of abilities in the context of one of the most celebrated and tightly governed competitive environments in the world: the Olympic Games. He focuses on recent discussions about the South African sprinter Oscar Pistorius, a double below-the-knee amputee, who campaigned successfully for the right to qualify for the Beijing 2008 Olympics and Paralympics, rather than just the latter. Wolbring explores how various kinds of abilities might be governed in the future, in the context of emerging biotechnological modifications. **Marilène Oliver** further extends Kemp's recognition of the convergence between physical and virtual environments. As an artist working to articulate this convergence, Oliver begins with the contested body of the Visible Human Project, a criminal subject who was documented by various critical theorists as the first immortal, due to his being digitally reproduced after death. By invoking the concept of medical surveillance, Oliver explores the subjective space of medical imaging technology. Her inquiry speaks to broader fascinations with human–machine interaction, the possibility of artificial intelligence and, to return to Kemp, what identity might mean in 'a digitally mediated world'. Concluding this section, **Simone Osthoff** and Eduardo Kac reflect on the process of creating hybridity in art works. Their interaction restates the biopolitics of new media art works that draw on biological matter. Also, Kac's work on telepresence and transgenics further situates this section's engagement with the contested bodies of information and matter.

Identity politics form a central part of broader political economies that surround debates about the future. Section III, *Political Economy of the Future*, articulates some of these parameters focusing on a range of topics from governance to public engagement. **Kate O'Riordan** begins by considering 'creative cloning'. Her essay reinforces concerns that are apparent within earlier papers, notably Fuller. However, it elaborates on the range of interests that converge around the development of such science to develop 'consenting consumers' of biotechnological products. O'Riordan also emphasizes the connection between ethics, politics and culture, which broadly reflects the contents of this book, as an attempt to provide a wide encounter with visions of the future. **Nigel Cameron** provides written evidence that was presented to the House of Representatives in the United States government in June 2008. His contribution signifies the process of expert engagement, which assists in shaping policy on the governance of emerging technologies. Cameron's essay also engages with the broader concerns that are invoked by nanotechnology and genetics, such as their application to warfare.

Duncan Dallas re-situates the role of experts in conversations about the future. His work as the founder of the *Café Scientifique UK* has been a central contribution to debates about public engagement with science. Here, he reflects on the last ten years of the café, asking what we must do next to most effectively situate science within society, rather than simply pay lip service to

such aspirations. As Dallas outlines, one of the risks of public engagement work is that it becomes instrumentalized, as a process for authenticating decisions taken by those empowered to ensure that science progresses without resistance. Dallas is followed by contributions from the *Material Beliefs* project, one of the leading public engagement with science initiatives taking place today. **Pramod K. Nayar** considers politics in a somewhat different sense, returning to the concerns of previous authors who focus on radical human enhancements. Nayar considers what rights such posthuman people should enjoy and whether we have some basis from which to know these claims in advance. His contribution appeals to the idea that evidence of such claims exists within literary narratives and resonates with the earlier essay by Dunne, Raby and Miah. It also reflects the interest to find common ground between ethics and social science, which has become a critical area of concern in the last ten years.

David Bennett takes us towards Section IV with an essay about what can be learned from science fiction to inform the emerging debates about nanotechnology. His essay focuses on how science fiction narratives have become part of mainstream debates in science policy, which in turn have affected its development. Bennett's essay encompasses a plethora of scientific developments and related social activism, from Greenpeace's protests against nuclear testing in the 1970s, to the latest accounts of nanotechnology. His essay reinforces the internationalism of the volume, speaking to the various US and EU responses to genetically modified organisms along with the broader global responses to environmental concerns, which raise manifold complexities of delivering social justice.

The essays in Section IV, *Creative F(r)ictions*, are a culmination of the works presented throughout the volume. They demonstrate the importance of bringing a range of perspectives to debates about the future of humanity, rather than just the usual kinds of expertise that govern such conversations. Our first essay from **George Annas** provides an unnerving indication of how debates about human experimentation might proceed in a world of human enhancement. Its location is purposely juxtaposed with the prior section on political economy to reinforce the links between governance and literary narrative. Annas's essay consists of the minutes of a meeting that took place some years ago, as part of a secret programme to exploit individual rights to benefit the development of science and governmental priorities. The cases reveal instances of dubious experimental science, whereby individual autonomy is repeatedly undermined or manipulated to pursue undisclosed ambitions.

Heather Bradshaw takes us further into the lives of people who face difficult choices as a result of developments in genetic science. Her story tells of a future where our ability to control early embryonic life is much greater. Offering helpful parallels to Dunne, Raby and Miah in Section I, *Sorrel* is an emotive piece about the feelings of responsibility and guilt people face when confronted with difficult procreative choices. The two sets of parents described have discovered they are responsible for the fate of embryos carrying a fictional incurable disease, which brings pain, impairment and a short life of between 10 and 40 years. One couple comes from a culture that encompasses great extremes of suffering but also great power and freedom. The other

couple belong to a softly utilitarian culture, which emphasizes pleasure and the avoidance of the risk of pain. Each culture deals differently with the unusual, imperfect, situation of illness that cannot be wiped away by technology in an otherwise perfectible society. The tale articulates a contrast between the human and the humane, but which best represents the more desirable future of humanity?

William Sims Bainbridge (aka Catullus, the Blood Elf Priest) locates us within another non-real world, that of *World of Warcraft*, where Catullus was conceived and where he lives out a complex life of quests and brutal combat. One of the themes throughout this volume has been how to reconcile the virtual and the physical worlds that we now inhabit in various ways. Catullus is aware of these challenges and offers sage advice for those who doubt that virtual worlds carry the same moral weight as their physical counterparts. As he tells it, it is those who occupy the physical world that should doubt their existence, particularly the inevitability of their mortality, something that does not operate by the same principles in his land. **Jane Grant, John Matthias** and **Nick Ryan** tackle the duality of virtuality and physicality head-on in the award-winning *Fragmented Orchestra*. Their invitation to experience a distributed, 'vast musical brain' reconstitutes the cultural practice of composition. Their work, along with visuals from Matt Wade, provides an auditory presence to consciousness, offering connections to ideas about the Internet as a hive mind and the prospect of a self-aware, artificial intelligence.

Together, the contributions from **Ann Whitehurst** and **Norman Klein** draw to a close the pursuit of speculating on *Human Futures*. Almost none of our essays enters the realm of futurology, instead offering grounded critiques of future gazing. Whitehurst and Klein are no exception and, in some sense, their contributions are the most critical about the future, as a subject of concern. Whitehurst alludes to the masculinized nature of future making. She notes that technology has typically marginalized and persecuted the freedoms of women and, in so doing, has diminished both men and women. Her poetic encounter with the obstacles arising from being asked to concretize the future verbalizes her anxiety about the present where, still, the most basic needs of many people are not only unmet, but increasingly violated. Klein's re-encounter with the last thirty years functions as a prologue to forthcoming works that wrestle with understanding the recent past, in order to advise our future. His thoughtful, and often ironic, staging of the past beautifully resists one of the core temptations of future gazing – the act of polarizing competing visions of the future. Noting his 'hope' for the future amidst multiple cases where technology has been co-opted for capitalist, exclusionary ends, Klein values technology's contribution to society and is willing to embrace opportunity for humanity to get it right.

Oron Catts and **Laura Sillars** bring us back to the start of the *Human Futures* programme, which launched with the *Sk-interfaces* exhibition at FACT in 2008. Their conversation offers a provocative reflection on the capacity of Catts' work to re-establish the rules by which science is utilized to better understand what it means to be human. We conclude with a contribution from the **etoy.CORPORATION,** which, appropriately, engages us with the theme of life after death. In an era where scientists are beginning to find ways of prolonging life, the prospect of immortality comes under greater scrutiny. What does it mean to remember people, things, events? The

etoy.CORPORATION invite our consideration of this question and, in so doing, resist the idea that questions of immortality reside solely in the sciences of cloning, life-extension and so on. Their immortality is personal, collaborative and intimate. It also speaks to the relationship between biology and computing, an enduring theme throughout the book.

This linear explanation of the book does not do justice to the extensive inter-connections that are present across the essays and sections, some of which will be obscure while others transparent. For instance, Norman M. Klein was also an integral part of AL and AL's *Eternal Youth* exhibition at FACT in early 2008. The visual components of this text amplify and extend the work of the essays in various ways and various decisions have led to their being included. It is hoped that further research of the authors, artists and their works will make these links clearer.

Principally, the images have inspired the selection of essays, based on the work of FACT's *Human Futures* programme, which provided a context of concerns. They also relate directly to the work of contributors from artists to this volume, such as that of Marilène Oliver, a practising artist who inquires into what we understand by bodily integrity in a fragmented, digital era. Other features that are dispersed throughout the text serve to juxtapose visions of utopia and dystopia that are the subject of our essays. For instance the *Double Happiness Jeans* feature neutralizes (or perhaps reinforces) the immorality of sweat-shops, by locating them within a virtual world. The film screen shots are also critical components of the text. They further describe what our immediate community of publics experienced while they were being asked to think about the future of humanity. As part of the *Human Futures* programme, these movies expand the, often narrow, pool of narratives that shape discussion about the future, a good example being Lynn Hershmann Leeson's *Strange Culture* (2007) or Park Chan-Wook's *I'm a Cyborg, But That's Ok* (2007). The book also represents the people who have participated within FACT's *Human Futures* events, and dispersed around the book are quotes from people within our community who took part. These engaged publics are our audience, our peers, and they have been central to the form of this final artefact.

ACKNOWLEDGEMENTS

I would like to offer some personal acknowledgements. First, thanks to Mike Stubbs and Laura Sillars for the opportunity to work with *Human Futures* and for sticking with the book project throughout times of uncertainty. Our dialogue speaks to the heart of what this book aims to achieve and I think it is all the richer for it. Also, thanks to new friends at FACT, for their commitment over these months. Thanks to people at Liverpool University Press, who have responded to our aspiration to produce a text that is academically critical, while being visually beautiful, engaging and innovative. Thanks to the design team at BURN for their unwavering creative commitment, which I have enjoyed seeing flourish. Their belief in the project has been integral to my enthusiasm to undertake this work. Special thanks also to Bettina Hörmann, for considerable editorial assistance in the final, crucial stages of delivery. Finally, thanks to our contributors - authors, artists, and designers - whose generosity made this book possible.

SW:

For cosmetic surgery enhancing the way we look, I feel it is for the individual to decide what they are unhappy about. If something is affecting their lives whether it is lines or wrinkles on their face, or whether their breasts are too small or they have too much fat and need liposuction. Every time they look in the mirror they are drawn to whatever it is that they don't like about themselves and there are procedures available where they can change these things and feel so much better about themselves afterwards, it should be up to them to decide.

TITANIUM TENANTS

These quotations are from the tenantspin Debate titled Titanium Tenants (2008, 20 February), which involved Dr Anthony Mark Cutter, Dr John Hunt, Sharon Waldron, John McGurik, Laura Yates, Patrick Fox, Steve Graham, Vera Cook. The main topics of conversation were cosmetic surgery, stem cell research, prosthetic enhancements and transplantation.

AMC:

Even when it may seem frivolous to some people, the desire for cosmetic surgery for some people can be a very deep, psychological need and there is a serious benefit to having your look adjusted. This is something very much to think about, the decision-making process that people go through.

AMC:

One of the things I talk about when I talk about any technology, whether it's... tissue engineering... or a Botox injection, is that it is very important not only to think about the different ethical and legal position which I might have, but also the kind of cultural background in which that particular technology or medical procedure is actually taking place.

LY:

I would just like to read out a quote from Aldous Huxley's *Brave New World*: "Not to mention the right to grow old and ugly and impotent, the right to have syphilis and cancer, the right to have too little to eat, the right to be lousy, the right to live in constant apprehension of what may happen tomorrow, the right to catch typhoid, the right to be tortured by unspeakable pains of every kind. There was a long silence. 'I claim them all,' said the savage at last. Mustafa Mond shrugged his shoulders 'You're welcome,' he said"

SW:

Cosmetic surgery is expensive, but it's a lot more accessible now to everyday people... Most definitely non-surgical procedures are a lot more accessible to people. Injecting Botox and dermal fillers in your local hairdressers and places, they are not covered by the Health Care Service but because they are doing it a lot cheaper people will go there and have it done, if they are not covered by the local health care commission they are not sticking to stringent guidelines on how the Botox has got to be kept under controlled conditions. People do it because they want to look good and I do think that celebrity culture has affected this – young girls look in magazines and see flawless complexions on stars but the majority of them all are airbrushed, they are not like that when you see them on the street. 9 times out of 10 they will not look like that when they are going to get their coffee at Starbucks.

PF:

A recent poll by SAGA shows that a quarter of women over 50, and 1 in 10 men aged over 50, have had, or would be willing to have, some kind of cosmetic surgery.

AUDIENCE:

I have dermal implants, which you can see in my forehead and in my stomach as well, which are titanium. They are purely for aesthetic reasons. It is done in the same way as piercing, they put a large needle into a part of your body be it your neck or arm and make a pocket in your skin and implant it in. It doesn't always take. I don't see any problem in that — I have known a lot of people who have had implants. It can be very aesthetically pleasing to certain people — not everyone likes it — it's just a matter of choice.

JMC:

When I was a child in the dark ages — and I'm only 42! — I was told that animals had a medical reason for licking their own wounds. Your gran used to tell you to let the cat lick your sores.

JH:

We would like to extend the life of hip joints beyond 22 years but 22 years for an artificial hip joint is fantastic.

JH:

It's controversial and so you read the headline and think 'what exactly is controversial about it?' Which bits of these are controversial? Are the public being told it's controversial? Or have the public decided it's controversial? I am a member of the public and there are some bits of it that overstep my boundaries, but that doesn't make it controversial for me. It is creating issues that I would like discussed because I don't see what the issues are in some respects.

JMC:

We can only go by what we read in the press but no doubt there are things going on in laboratories every day that we are unaware of — it's like manufacturing, they hold things back until they are ready to let things go onto the market. Since the invention of heart transplants we have had a man have a hand stitched on from a person who has just been killed, we have had a full-face transplant in France for a woman who was disfigured in a car crash, there is a lady in America who has spent over 200 thousand pounds because her aim in life is to look like the Barbie doll. It's all taking place, we don't know where it will end and ultimately it is up to yourself, if you have the where-with-all and the money, and you want to enhance your features, do it.

VISIONS

VISIONS

THE FUTURE IS DIVINE: A HISTORY OF HUMAN GOD-PLAYING

STEVE FULLER

WHAT IS IT
ABOUT THAT UPRIGHT APE
HOMO SAPIENS THAT
DESERVES A FUTURE
AS 'HUMANITY'?

4925 Words /1.1 Visions /Human Futures

This question originally defined a theological concern that, over the centuries, has been handed over to philosophers, scientists and science fiction writers. It is fundamentally theological because it alludes to an, as yet, unrealized yet knowable human potential that reflects our past connection with a higher order of being from which we have subsequently become separated. The Genesis story of the Fall is the most obvious precedent, but the idea is also present in Plato's identification of knowledge with memory (anamnesis), such that we come to know something by literally 're-membering' it, that is, reacquainting ourselves with lost parts of a pre-existent whole.

Even before Lamarck and Darwin argued that we are beings 'always already' in transition, it was clear that there was more to the human condition than the statistically average member of *Homo sapiens*. If nothing else is certain, the species to which our distant descendants will belong is bound to be different. However, our concern is whether our change in character amounts to an improvement. Lamarck and Darwin diverged on whether such a question even makes sense. Here, Lamarck is our guide – as I imagine he will remain, as human futures are considered in the 21st century. Unlike Darwin, Lamarck regarded so-called lower organisms as God's successive drafts for designing a perfect world, to which our own efforts contribute in an increasingly self-conscious way. Lamarck has been frequently derided for his notorious belief in genetic self-improvement – that offspring can acquire more easily the physical and psychic traits that originally took the hard-earned efforts of their parents. However, our increasing adeptness at switching genes on and off, not to mention amplifying and diminishing their expression, may give renewed credibility to Lamarck's views.

This chapter tracks the history of the aspect of Lamarckian evolution that distinguishes it most clearly from the scientifically dominant Darwinian variety. It consists of an aspiration that I call *theomimesis*, literally 'God-playing', a neologism whose ambiguity explores the semantic space between our assuming the lead role in a play scripted by God and our scripting a play in which we assume the role of God: from monotheism to humanism. Since so much of what passes as modern history has been portrayed as the conflict between these two senses

of *theomimesis*, with the latter gradually overtaking the former, it has often overlooked the vast overlap of agreement on fundamental principles – not least the primacy accorded to humanity, regardless of its ultimate subordination to some higher-order deity (Gray 2002).

This contrasts with a view of nature, common to the great non-Abrahamic religions of the East, as well as certain hedonistic and sceptical strands in Western thought, which identify the divine with the natural and accord no special metaphysical privilege to humans among other life forms.[1] In this context, countenancing the prospect of 'becoming fully human' is a non-starter; something else simply – and inevitably – replaces us. Those attracted by such a meaningless sense of the human condition will have a hard time taking seriously what follows.

HUMAN FUTURES AS THEY USED TO BE

My PhD is in a field that once took the process of becoming human as its distinctive subject matter. It is called 'history and philosophy of science' or 'HPS'. Nowadays the 'H' and the 'P' live a 'separate but equal' existence in HPS, both in more-or-less respectful distance from the 'S'. But it wasn't always like that. For most of the 19th and 20th centuries, HPS was the field whose wisdom would be sought to plot something worthy of the title 'human futures'. It took seriously Lord Bolingbroke's (1752) definition of history as philosophy teaching by examples, but specifically in the cause of providing direction to science as the vehicle by which that upright

ape, *Homo sapiens*, might become fully 'human'. The exact meaning of 'human' in the various formulations of HPS varied but all were designed to do things: on the one hand, to create maximum distance between us and the other apes (without entirely denying our animal nature) and, on the other, to portray our own creative potential as approximating that of the biblical deity (but without triggering charges of blasphemy). Words like 'rational', 'self-conscious', and even 'meaningful' were invoked as the *sine qua non* of humanity.

In the 19th century, HPS threw up three possible normative horizons within which the task of 'becoming human' might be achieved, each associated with a national tradition: English, German and French. I shall review each briefly because remnants of them survive today.

The English tradition stems from the polymathic natural philosopher and theologian William Whewell, Master of Trinity College Cambridge and founder of the British Association for the Advancement of Science. Whewell saw the advancement of science as the literal extension of humanity's biblical entitlement. As beings created in the image and likeness of God, we are destined to fathom the intelligent design of the universe. Indeed, science as a lifelong pursuit – in Whewell's original coinage, the vocation of the 'scientist' – would not make sense if we did not presume reality to be 'intelligible', that is, tractable of our modes of understanding (Fuller 2007b: chaps 1–2; Fuller 2008a: chap. 2). And why would such an assumption bear so much insight and benefit, if it did not reflect a genuine relationship between the structure of our own →

GOD
EXISTS
BECAUSE
WE DO

WE EXIST BECAUSE GOD DOES

mind and that of the divine creator? However one ultimately judges it as a defence of God's existence, we shall see that it remains a potent background argument in attempts to justify our capacity for *theomimesis*.

However, in keeping with his clerical office, Whewell interpreted our biblical entitlement to know in rather deferential terms, the secular descendant of which is Thomas Kuhn's idea of 'normal science', the workaday puzzle-solving that characterizes most actual scientific work, which presupposes a dominant paradigm that provides an overarching explanatory theory and methods of investigation that have already provided exemplary solutions to standing problems. The paradigm provides scientists with their sense of discipline, not unlike monastic training, from which they rarely if ever deviate in the course of their careers. Whereas Kuhn held that every true science was governed by a single paradigm at a given time, Whewell believed that science itself had only one paradigm, whose founder was Isaac Newton. Newton unified the disparate claims and evidence concerning physical phenomena, both on earth and in the heavens, into a universal theory of matter and motion. For Whewell, everyone who heeds the calling of the scientist follows in Newton's footsteps, filling in the gaps of his mechanical world-view, the completion of which will enable us to comprehend the divine plan. It would not be far-fetched to liken this vision of Newton's significance to the second coming of Jesus, in terms of science providing greater specification and power to the original Christian message.

Not surprisingly, Whewell opposed those who promoted science outside

an explicitly Christian context, ranging from secular humanists such as John Stuart Mill to more explicitly anti-theistic thinkers such as Herbert Spencer and Charles Darwin. This perhaps makes Whewell irreconcilable to today's intellectual sensibilities. He thought of science without the benefit of religious guidance in much the same way as the Church thought about magic and alchemy, both of which involved arrogating to oneself powers that only God could bestow, typically with the help of his licensed clerical mediators. While it is easy to dismiss Whewell's overall perspective as warmed-over salvationism, most of it has survived without the theological overlay. For Whewell himself, it provided the basis for advocating – much against the wishes of his equally religious colleagues in the liberal arts – the centrality of the natural sciences to the university's concerns. He was also responsible for the presentation of 'the scientific method' in both philosophical and popular texts as a generalization of the method of Newtonian mechanics. Indeed, as science has become seen as having a diverse nature, and Newton's exemplary status has declined, the idea of science as the crowning achievement of humanity has also faded.

The German tradition departs from the English with a shift in emphasis in the interpretation of *theomimesis*: from '*theo-*' to '*-mimesis*'. In Whewell's place, we have the great Prussian education minister and founder of the modern university, Wilhelm von Humboldt, whose exemplary human was not the formidably technical Newton but the broadly accomplished Goethe, who made significant contributions to poetry and optics, while advising heads of state. The difference

also reflects a shift in Christian sensibility from 'Catholic' to 'Protestant'. Thus, the future of humanity is less about trying to complete a mission started by superior beings than acquiring for ourselves their superior qualities. On this view, we do not merely follow in Christ's footsteps but we come to live Christ's life. The appeal of this option rests on an implicit understanding that, by virtue of his material character, Jesus is an enhanced, not diminished, version of the divine creator. The alchemical magician roundly condemned by the medieval church is resurrected and tentatively embraced as Faust. Goethe stands out here for his explicit challenge to Newton's singularity as a theorist of unified science. He claimed to have recovered the experiential dimension of nature that Newton simply discarded merely because it failed to fit his framework.

At stake here was a fundamental disagreement over the appropriate sense of the divine to which humans should benchmark their progress. Newtonian mechanics strikingly postulated counter-intuitive laws bolstered by abstract mathematics, as the basis for predicting and controlling nature. It left the impression that we would come closer to God by creating distance from our subjective experience so as to acquire, in Thomas Nagel's (1986) memorable phrase, 'the view from nowhere'. It was precisely that which Goethe denied. He treated the experiences that Newton discarded as signs of our hidden potential still waiting to be exploited. In this spirit, the German tradition equated the unification of science with human self-realization itself. Thus, we draw upon all the branches of organized learning

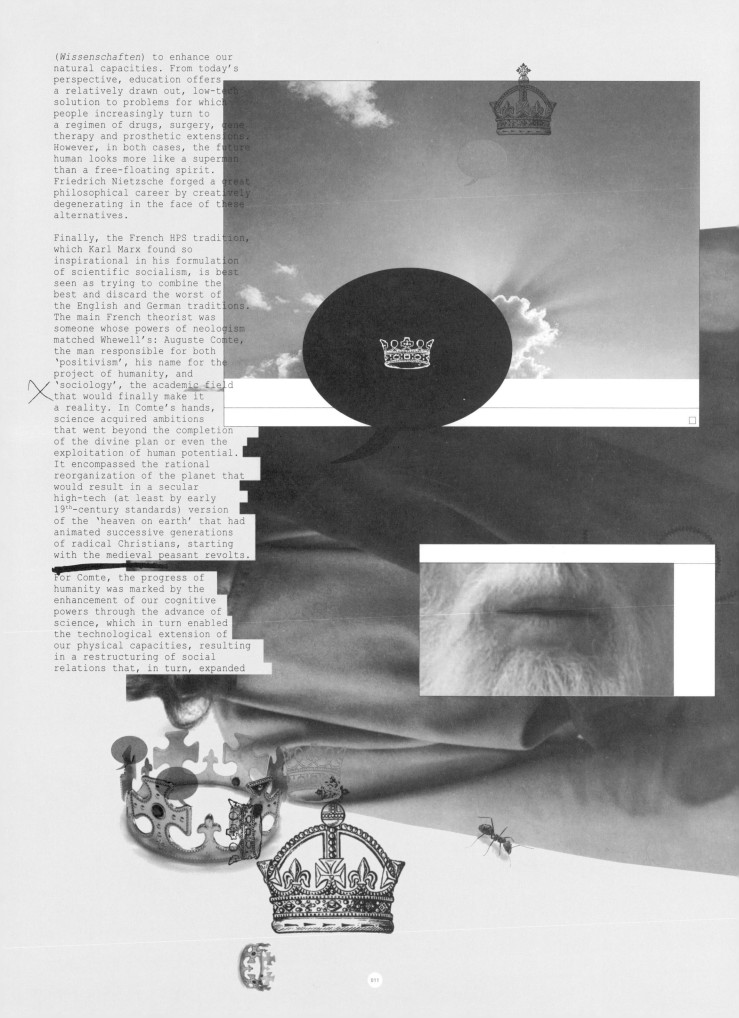

(*Wissenschaften*) to enhance our natural capacities. From today's perspective, education offers a relatively drawn out, low-tech solution to problems for which people increasingly turn to a regimen of drugs, surgery, gene therapy and prosthetic extensions. However, in both cases, the future human looks more like a superman than a free-floating spirit. Friedrich Nietzsche forged a great philosophical career by creatively degenerating in the face of these alternatives.

Finally, the French HPS tradition, which Karl Marx found so inspirational in his formulation of scientific socialism, is best seen as trying to combine the best and discard the worst of the English and German traditions. The main French theorist was someone whose powers of neologism matched Whewell's: Auguste Comte, the man responsible for both 'positivism', his name for the project of humanity, and 'sociology', the academic field that would finally make it a reality. In Comte's hands, science acquired ambitions that went beyond the completion of the divine plan or even the exploitation of human potential. It encompassed the rational reorganization of the planet that would result in a secular high-tech (at least by early 19th-century standards) version of the 'heaven on earth' that had animated successive generations of radical Christians, starting with the medieval peasant revolts.

For Comte, the progress of humanity was marked by the enhancement of our cognitive powers through the advance of science, which in turn enabled the technological extension of our physical capacities, resulting in a restructuring of social relations that, in turn, expanded

our horizons to achieve still more. The policy precedent for Comte's positivism was an 1814 work of his mentor Henri de Saint-Simon, *The Reorganization of European Society*. This pamphlet is eerily prescient of the recent European Union interest in 'shaping the future of human societies' through the regulated introduction of 'converging technologies' (Nordmann 2004). Saint-Simon had argued that Napoleon, prior to his ignominious personal end, had succeeded in consolidating Europe as a political idea that could now be taken forward as one grand corporate entity, a true *universitas*, to be managed by a scientifically trained cadre modelled on the civil engineers at the *Ecole Polytéchnique*.[2]

The shift from Newton and Goethe to Napoleon as the exemplary human – the first proper European – highlighted his ability to rise above lowly parochial origins to give purpose to a higher-order entity with an indefinite life expectancy. The focus on Napoleon, a resolute man of action, underscored the physicalistic construal of this sense of purposefulness. Comte and Saint-Simon deplored slavery in pre-scientific societies only because, as we would say today, it under-utilized human capital. The slave owners lacked the knowledge and the imagination to get the most out of their slaves' bodies. Under the circumstances, emancipation marginally improved productivity by opening labour to a variety of disciplinary regimes. However, in a fully scientized society, each person's productivity would be of concern to everyone, with social engineers best placed to determine how any given individual's labour might be most productively engaged for the greater good of all. These public servants would literally give meaning to people's lives by telling them what they are good for – on the basis of tests for intelligence, for instance.

In the early 19th century, this general sensibility was associated with the organization of social life around specially constructed physical spaces, such as factories, hospitals, schools and prisons, each subject to their own forms of surveillance and accountancy that together shaped the body into an efficient piece of social machinery. While these spaces remain very much with us, they have been supplemented – and sometimes supplanted – by the re-engineering of what the great medical professor at the Sorbonne, Claude Bernard, called the *milieu intérieur*, his vivid expression for our physiology that stressed its ongoing struggle to maintain health in the face of multiple threats from the external environment.

It would be hard to overestimate the normative significance of Bernard's perspective for the conduct of medicine, which over the 19th century came to shift its research and practice from, on the one hand, preparing the patient to undergo a variety of natural processes eventuating in the body's complete re-absorption into nature through death to, on the other, the indefinite postponement, if not definitive overcoming, of disability and death. Indeed, as long as the French model of HPS has prevailed, and the social sciences were understood as the reflexive application of the natural sciences to the human condition, medicine competed on equal footing with economics and psychology for providing the foundations for social life. Indeed, their boundaries were often not clearly

distinguished. Thus, the discipline that Emile Durkheim re-christened in 1895 as 'sociology' staked its distinctiveness on the existence of society as a literal 'social organism' whose skin corresponded to national borders and whose health could be gauged by diagnosing 'deviant' behaviours, based on official statistics that functioned as vital indicators to which bureaucrats, as society's physicians, could then administer. Unsurprisingly Durkheim was politically aligned with the *solidaristes*, the advocates of a French welfare state (Fuller 2006: 82–83).

HUMAN FUTURES AS THEY CONTINUE TO BE

An interesting account has yet to be given of how the three strands of HPS came to lose their respective backstories about the advancement of science that originally legitimated the particular futures that they projected for humanity. In the 20th century, images of future humans as technical specialists (UK), enhanced supermen (Germany) or efficient functionaries (France) acquired lives of their own in popular culture, eventually erasing any trace of their specific philosophical, let alone theological, origins.

However, one last effort was made by the Belgian positivist George Sarton in the aftermath of the First World War to establish a 'new humanism' that would aim to confer a unified sense of purpose for humanity across the increasingly divergent sciences of his own day and, more interestingly, across different periods in the history of science. The former project was, of course,

taken up immediately and with gusto by the logical positivists in the Vienna Circle, who went on to establish the philosophy of science as a discipline in the English-speaking world. However, the latter project received only muted expression in *Isis*, the world's premier history of science journal, which Sarton had founded in 1912.

A presupposition of Sarton's (1924) new humanist historiography is worth recalling when evaluating human futures: If a proposed future is indeed meant to contribute to a *common* project of humanity, then denizens of the past whom we would count as our progenitors must be able to see us as their legitimate heirs.[3] Needless to say, no simple fact can settle this matter once and for all. Rather, we need to imagine ourselves in continual counterfactual negotiation, always trying to imagine how to persuade those in the past that our sense of a desirable future is one that they too would have found desirable, or at least a responsible extension of their legacy. This implies that, as we alter our sense of where want to go, we need also to alter our sense of where we have come from. One might think of this imaginative exercise in co-producing the past and the future as humanity's way of simulating God's 'timeless present'.

Perhaps the most challenging feature of this exercise is that we must start from the assumptions of our would-be ancestors and then show through a series of steps, each of which they would recognize as reasonable, that our envisioned future is one worthy of their approval (Fuller 2008b). Whatever obstacles we face along the way might hint at some fundamental

difference in orientation to reality. Could I persuade, say, Aristotle that avatars in Second Life pass his definition of humans as the 'political animal'? From a strict Darwinian standpoint, there is no reason to presume that the answer is yes. After all, both he and I are creatures adapted to our respective times and places – and to no other. I would probably struggle even to get Aristotle to admit women as fully human. In that case, we might be forced to conclude that our notions of species are, as Thomas Kuhn (1962) would say, 'incommensurable'.

Of course, the difficulties I faced in my counterfactual encounter with Aristotle would be compounded were I to try to persuade any of our ape ancestors that we partake of a common project to realize humanity – that, in some sense, these simians have been trying, or at least would like, to be one of us. The problem received iconic treatment in Stanley Kubrick's *2001: A Space Odyssey* and especially loomed large in the century prior to Darwin's *Origin of Species*, when scientifically informed thinkers, not least Lamarck, believed in a progressive sense of natural evolution in which all creatures were striving for the same, divinely inspired ends. Both apes and 'primitive' humans were seen as merely victims of arrested development, to which the morally and cognitively appropriate response was not tolerance and care but outright remediation. In this respect, the cultural symbolism attached to demonstrations of ape language was one with the early history of HPS in the trans-historical vindication of the human as the expression of God's creative *logos* (Corbey 2005; Radick 2007). Perhaps the most inspiring →

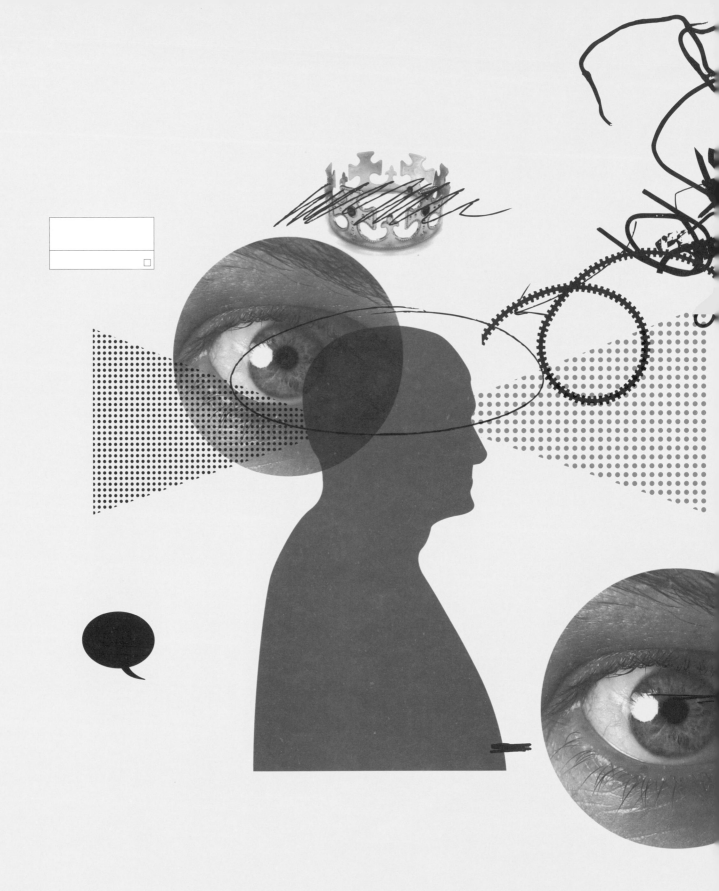

20th-century proponent of this perspective was the heretical Jesuit palaeontologist Pierre Teilhard de Chardin (1955), who was always on the lookout for 'missing links' between apes and humans, be they genuine (Peking Man) or fraudulent (Piltdown Man).

However, completing the project of humanity has become increasingly a process of redoing, if not undoing, much of what God had done. The French HPS tradition already displayed tendencies in this direction, traceable to the Gnostic strand of Christianity that inspired the French Revolution of 1789 – that is, the idea that the best way forward for humanity is to discard our prior collective history and begin again from scratch. Since all the biblical accounts of divine creation portray God as struggling to give form to matter, humans are needed to get the job done properly. The need for Jesus to be sent as the 'Son of God' to set a new horizon for humanity is the obvious precedent (Noble 1997). Thus, in introducing a dating system that started from year zero and a mode of address that flattened class differences (i.e. 'citizen', the precursor of the Communist 'comrade'), the First French Republic signified its desire to treat the human body and the physical environment as blank slates, in which we would legislate for ourselves in more exact terms what God had previously legislated only in gross terms.[4]

Perhaps the most popular representation of the Gnostic strand of *theomimesis* is its extreme version, namely, our abandonment of the carbon environment altogether as we upload consciousness to computers (Davis 1998). Other less extreme versions would still count as very

radical by 19th-century standards. For example, if other creatures are indeed divine rough drafts as Teilhard thought, then we might be entitled to incorporate the virtues exemplified by those creatures into our own life-worlds, if not our physical selves. In that sense, when we fly in a plane, we become cyborg-birds. Such projects are pursued by fields like 'bionics' and 'biomimetics', which exist at the interface of biology and engineering. It may mean that, in the end, humanity becomes identified with the organization of all of nature's virtues under a single intellectual regime. This was famously the aspiration of cybernetics, which in the middle third of the 20th century captured the Cold War imagination as the ultimate global survival strategy (Wiener 1950; Fuller 2007a: chap. 6).

However, the most influential strand of this second wave of *theomimesis* occurred once viable strings of nucleic acids replaced persuasive strings of words as the means of redoing God's handiwork. This transition has been recently cast with admirable frankness:

> The Watson/Crick revolution has shown us that DNA is all words. Genes are digitally coded text, in a sense too full to be dismissed as an analogy. Like human words they have the power to hurt, and that power is the greater because, given the right conditions, DNA words can dictate with stronger predictability than most human imperatives.

The author of this statement was *not* a radical theologian following in Faust's footsteps, believing that the correct enunciation of the divine *logos* would enable

things to come in and out of existence. Rather it was none other than the world's leading professional atheist, Richard Dawkins (1999: vi). Dawkins provides a glimpse into the appeal behind the idea that humanity might be re-engineered. It is largely the same as for participatory democracy, namely, that it might secure us greater and more flexible control over the stuff of life – by refusing to allow it to be settled once and for all by the arbitrary whim of some higher authority, be it an absolute monarch or some depersonalized conception of nature. Why Dawkins would then genuflect to Darwinian natural selection is a matter of speculation, given that Darwin himself thought that plant and animal husbandry would never match, let alone overcome, natural selection. But that story is for another day (Fuller 2008b: chap. 2).

Both utopian democratic and eugenic visions have been confronted with corresponding historical dystopias: ancient Athens, a liberal society that self-destructed once it removed restrictions on those qualified for political participation, and Nazi Germany, the world's leading scientific nation that both self-destructed and destroyed others once it removed political restrictions on human experimentation. It will be a measure of humanity's collective maturity in the 21st century to see beyond these very real disasters in order to reassert the ideals that they very imperfectly realized. It would involve, among other things, making human futures a normal topic of legislation, whereby elected representatives routinely debate on the sort of people they would like to see populating their societies.

Just as one might introduce or remove certain topics vis-à-vis a national curriculum, one might do likewise vis-à-vis various genetic-cum-environmental conditions. In both cases, the policies may turn out not to produce the desired outcomes. However, that simply means that the relevant decisions need to be revised on a regular basis, so as to correct and compensate for errors and, most importantly, to ensure a regular research stream devoted to enhancing our biological openness to the future.

If one needs a moment to mark this 'second coming' of *theomimesis*, it would be 1934, when Warren Weaver, the first director of the natural science division at the Rockefeller Foundation, launched a research programme after what he called the 'edge of uncertainty' (Noble 1997: 177–78). By this he meant the smallest unit of matter that retained its functional characteristics – that is to say, small enough that we could fundamentally rework the physical world to our advantage, but not so small that we would run afoul of indeterminacy at the quantum level of reality, as defined by Heisenberg's then-recently formulated Uncertainty Principle. Weaver called his version of *theomimesis* 'molecular biology'. The science bearing that name, which the Rockefeller Foundation seeded on both sides of the Atlantic, counts among its many achievements the discovery of DNA as the chemical basis of genetics.

Behind this second wave of *theomimesis* lies the most controversial of all science-religion relations – alchemy's quest for *minima materia*, access to which would purge nature of its impurities to enable humans to thrive in

perpetuity. A proper account of this endeavour that goes beyond stereotypes of mad magicians and captured the full scientific richness of this line of thought would reach back to the imprisoned 13th-century experimentalist Roger Bacon, taking in the 18th-century chemist Joseph Priestley's somewhat mistaken discovery of oxygen as the elixir of life and Gregor Mendel's better-grounded claim to have uncovered the mechanisms of plant and animal reproduction capable of revolutionizing food production (Fuller 2008a: 80–86). The account would culminate with Erwin Schrödinger (1967), a founder of quantum mechanics, who famously inspired a generation of physicists and chemists to move into Weaver's molecular biology labs with his 1943 Dublin lectures *What Is Life?*, in which he openly suggested that, by cracking the genetic code, we would finally be able to peer into God's mind and explore all the physically possible forms of life that the deity left uncreated.

In the end, molecular biology turned out to be much narrower in focus and less interventionist in spirit than Warren Weaver had hoped. At a time when Germany, the world's leader in the biomedical sciences, had just begun its period of Nazification, Weaver similarly aspired to 'breed superior men' through a regimen of vitamin consumption, hormone regulation and ultimately genetic manipulation (Morange 1998: 81). By today's standards, Weaver's interventionist rhetoric betrays a coarse Golem-like quality, not unlike the human futures featured in the early science fiction films of the period. Nevertheless, a refined version of Weaver's vision persists to this day among some influential policymakers at the US National Science Foundation

(Roco & Bainbridge 2002). They, too, hope to focus science's collective efforts on the 'edge of uncertainty', based on biotech interventions at the 'nano-level' – that is, the billionth-metre scale that allow for, say, strategically self-cleaning, self-repairing and otherwise self-correcting substances. Whether or not nanotechnology marks yet the third act in our God-playing, let us hope it avoids the mass violence that has often accompanied *theomimesis* in its previous incarnations.

[O] ANDREW NICCOL (DIR), 'GATTACA' (1997)

(Endnotes)
1 For more on this difference in religious world-views, see Fuller 2006: section 3.
2 For a famous trenchantly negative assessment of Comte and Saint-Simon, see Hayek 1952: chaps. 12–16.
3 This is not so different from a venerable interpretive principle in US constitutional law that would have judges ask themselves: 'What would the founding fathers have made of this case?'
4 Voegelin 1987 and Pinker 2002 criticize this tradition from, respectively, the political and the scientific side.

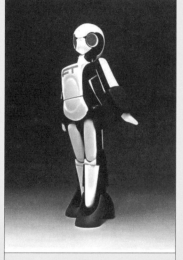

[O] TOMOTAKA TAKAHASHI, ROBO GARAGE, 'FEMALE TYPE' (2006, IMAGE COURTESY OF THE ROBO GARAGE)

REFERENCES

Bolingbroke, H. (1752). *Letters on the Study and Use of History.* London: A. Millar.

Corbey, R. (2005). *The Metaphysics of Apes*, Cambridge: Cambridge University Press.

Davis, E. (1998). *TechGnosis: Myth, Magic and Mysticism in the Age of Information.* New York: Crown.

Dawkins, R. (1999). 'Foreword' to Burley, J. (Ed.). *The Genetic Revolution and Human Rights.* Oxford: Oxford University Press.

Fuller, S. (2006). *The New Sociological Imagination.* London: Sage.

Fuller, S. (2007a). *New Frontiers in Science and Technology Studies.* Cambridge: Polity.

Fuller, S. (2007b). *Science vs Religion?* Cambridge: Polity.

Fuller, S. (2008a). *Dissent over Descent.* Cambridge: Icon.

Fuller, S. (2008b). The Normative Turn: Counterfactuals and the Philosophical Historiography of Science, *Isis*, 90, in press.

Gray, J. (2002). *Straw Dogs: Thoughts on Humans and Other Animals.* London: Granta.

Hayek, F. (1952). *The Counter-Revolution of Science.* New York: Free Press.

Kuhn, T. (1962). *The Structure of Scientific Revolutions.* Chicago: University of Chicago Press.

Morange, M. (1998). *A History of Molecular Biology.* Cambridge, MA: Harvard University Press.

Nagel, T. (1986). *The View From Nowhere.* Oxford: Oxford University Press.

Noble, D. F. (1997). *The Religion of Technology: The Divinity of Man and the Spirit of Invention.* Harmondsworth: Penguin.

Nordmann, A. (Ed.). (2004). *Converging Technologies - Shaping the Future of Human Societies.* Brussels: European Commission.

Pinker, S. (2002). *The Blank Slate: The Modern Denial of Human Nature.* New York :Viking.

Radick, G. (2007). *The Simian Tongue: The Long Debate about Animal Language.* Chicago: University of Chicago.

Roco, M. & Bainbridge, W. S. (Eds.). (2002). *Converging Technologies for Improving Human Performance: Nanotechnology, Biotechnology, Information Technology, and Cognitive Science.* NSF/DOC-sponsored report: Arlington VA.

Sarton, G. (1924). The New Humanism, *Isis*, 6, 9-24.

Schrödinger, E. (1967). *What is Life? With Mind and Matter and Autobiographical Sketches.* Cambridge: Cambridge University Press.

Teilhard de Chardin, P. (1955). *The Phenomenon of Man.* New York: Harper and Row.

Voegelin, E. (1987). *The New Science of Politics.* Chicago: University of Chicago Press.

Wiener, N. (1950). *The Human Use of Human Beings.* Boston: Houghton Mifflin.

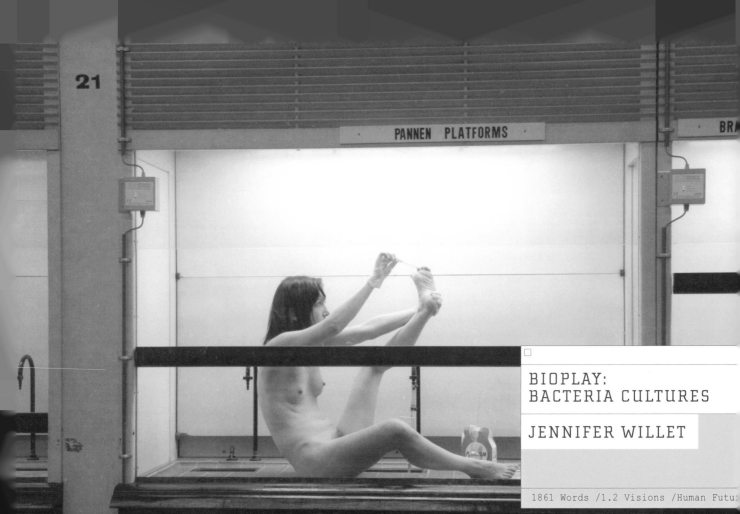

· PANNEN PLATFORMS ·

BR

BIOPLAY:
BACTERIA CULTURES

JENNIFER WILLET

1861 Words /1.2 Visions /Human Futu

Laboratories are actually very dirty.

I select which hood I am going to climb into based – on which one I perceive to be the 'cleanest'. I still spend an hour on my hands and knees, with Windex and paper towels, scrubbing all the surfaces inside the fume hood. Shards of broken glass are impossible – and I dare not tip my hands down into the deep sink well. What danger resides in the drains?

The soles of my feet are black.

This was originally an organic chemistry lab – retrofitted for teaching grade biological sciences. I am not as familiar with the chemistry field, and cannot predict what latent hazards present themselves to nervous bodies.

There is no need for so many fume hoods in biology – in fact just the opposite – with inverted air flow – sterile hoods pushing clean air in – rather then drawing toxic fumes out. Fume hoods are designed to protect the scientist from the specimen – where as with BSL1 biotechnology – the human body threatens contamination to the life forms made objects of manipulation and study.

The previous week I traced the surfaces of my body with a cotton swab – and traced/transferred micro -scopic bacterial life forms onto the gelatin nutrient agar plates. One week in the incubator – and the Petri dishes are teaming with fragrant stench - unruly colonies of bacteria. Each one is marked withits source location: big toe, belly

Harvested from my body - and cultivated in the lab. These bodies re-engage with me, if for only a short time, as I reproduce the procedure by which they were harvested for a small audience: myself - the photographer - and billions of single-cell organisms.

Biotechnology is arguably the most significant technological development of our time. Whereas in the past, humanity has harnessed the ability to produce and reproduce (in an industrial sense), and simulate (with computation), biotechnology allows us to breed and give birth to generational life forms. These new 'engines of creation' (Drexler 1986) serve as vital tools and subjects of science and industry - resulting in new techno-*ecologies*.

BIOTECHNOLOGY IS NOT SEPARATE FROM LIFE.

The ongoing processes and protocols in laboratory environments are part of a millennial continuum of human engagement in the manipulation of life - all the world's resources - an emergent property of ecology and culture. Biotechnology is not only defined by its processes and protocols - metaphors and specimens - but also by its tangled and interconnected relations with society, individuals, communities and ecologies. Biotechnology is also a reciprocal technology of the body - engaging in multifold instances of life - bacteria, proteins, cells, animals, scientists - as specimen, tool, procedure and purveyor. When we manipulate life in this manner, we are in turn manipulating ourselves.

BIOPLAY TOOK PLACE AT THE ART AND GENOMICS CENTRE, THE UNIVERSITY OF LEIDEN AND WAS FUNDED BY THE CANADA COUNCIL FOR THE ARTS, ALBERTA FOUNDATION FOR THE ARTS.

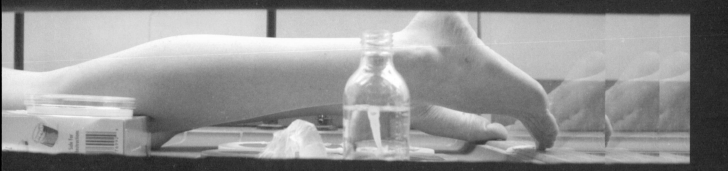

This process of life manipulation goes back thousands of years – where humans have been breeding, planting, culling and affecting life forms and ecological systems towards survival and aesthetic ends. Although it is easy – and reinforced by our anthropocentric view of this trajectory – to imagine this process as a one-way manipulation, where human beings are affecting the environment around them to suit their needs, this relationship is a reciprocal one. Humanity is a component of the ecology it intends to harness. In fact, this process of manipulating our ecology and ourselves is not restricted to the human race, though the pursuit of biotechnology is inherently a cultural act. If we abstract our analysis from the specificities of this particular incursion, then we can interpret biotechnology as an evolved relationship between species and environment – of ecology. Such an approach resonates with Richard Lewontin's (2000: 55) description of a cyclical ecology:

Every species, not only Homo Sapiens, is in the process of destroying its own environment by using resources that are in short supply and transforming them into a form that cannot be used again by the individuals of the species... But every act of consumption is also an act of production. That is, living systems are the transformers of materials, taking in matter and energy in one form and passing it out in another that will be a resource for consumption for another species.

In 2004 and 2006 I served as an Honorary Research Fellow producing artworks utilizing tissue culture and tissue engineering technologies at *SymbioticA*, the Art and Science Collaborative Research Laboratory at the University of Western Australia. While there, with this instance of interdisciplinary incursion, I conceived of the concept of a *laboratory ecology* – at the edge of life-altering, art denaturing instances of real hands-on knowledge of biotechnological protocols from a non-specialist perspective. At *SymbioticA*, I witnessed the mass instrumentalization of life as a scientific and technological tool, and simultaneously the object of scrutiny. I often look back at that time as an induction – or a disillusionment – as the moment when the biosciences became a real embodied knowledge set rather then a textual topic of study for myself. Though my research and production had centred on science, medicine and the body for a decade, it was at *SymbioticA* that my work as an artist came to *life*.

BIOplay is a more recent body of work conducted at the Art and Genomics Centre at the University of Leiden. It consists of a series of digital photographs, which document clandestine performances in laboratory environments where the artist removes her clothing and conducts biotechnological protocols in the nude. Often, the artist inserts herself directly into the controlled environments, built specifically for biotechnological specimens. In so doing, the artist inserts the human body literally and symbolically into the life-cycle of the lab.

The actions of the artist can only be performed for a very small audience because of the restrictions placed on what is acceptable behaviour in the

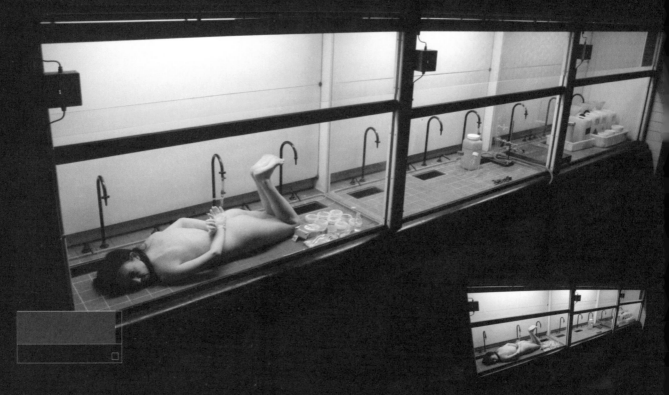

laboratory. Health and safety regulations insist that researchers wear lab coats and closed toe shoes. Additionally, community standards in the hard sciences insist on a certain level of decorum. Also, a strict professionalism of conduct is required, particularly in those facilities that house human remains. These rules articulate the bioethical commitment to respect, which are integral to such professional codes. An extended invitation to a large human audience - external organisms breeding contamination all over their bodies - is not possible in this specialized site. Though these types of regulations (and unspoken agreements) stem often from very real technical and procedural concerns, they also serve to prescribe a very particular separate and disinterested relationship between the scientist's body and the specimen's body.

With my most recent cycle of work I am interested in deploying new representations of the laboratory ecology, as I perceive it, the carefully balanced relationship between all organisms (and parts of organisms) inhabiting the lab - animal and human research subjects - cells, bacteria, enzymes, plants - the scientists themselves and even unwanted contaminants. What interests me about this ecology is our perception of the closed relationship, its purported isolation from external ecologies. Ideally within a lab, specimens and samples either originate in the laboratory vacuum, or enter from the external world (screened and sanitized) never to leave again. Additionally, elements of external ecologies, such as bacteria in the researcher's fingernails, hair and mouth, are prevented from infecting the

environment and organisms within the lab. I wish to produce a series of works that purposefully breaks with this convention - reconnecting the closed laboratory ecology with external ecologies - revealing the 'bodies in biotechnology' to viewers and participants as interconnected orders of life on this planet. These aspirations speak to the broader ethics of separating scientific inquiry from the world it inhabits. While these are assumed goods of scientific practice, I also see them as detrimental separations, where the messiness of biology within culture is made less authentic by such conditions.

Thus, I am interested in propagating alternative models of biotechnology towards a wider representation of possible practitioners (artists, mothers, accountants and swimmers) and a wider range of possible relations between the various orders of life that make up the laboratory ecology. If we apply these strategies, biotechnology does not only have to be understood from the perspective of rationality and scientific method, or from models established through business and industrialization. Rather, biotechnology could also be perceived as an art form, perhaps like cooking or poetry. It might also be treated as a process of cultivation, analogized to rearing a family, or as sexuality — as care for the self/other. If we avail ourselves to alternative non-specialist practitioners of biotechnology, along with alternative actions and alternative laboratory environments, then biotechnology will no longer only be understood as only an applied science but a life practice as well.

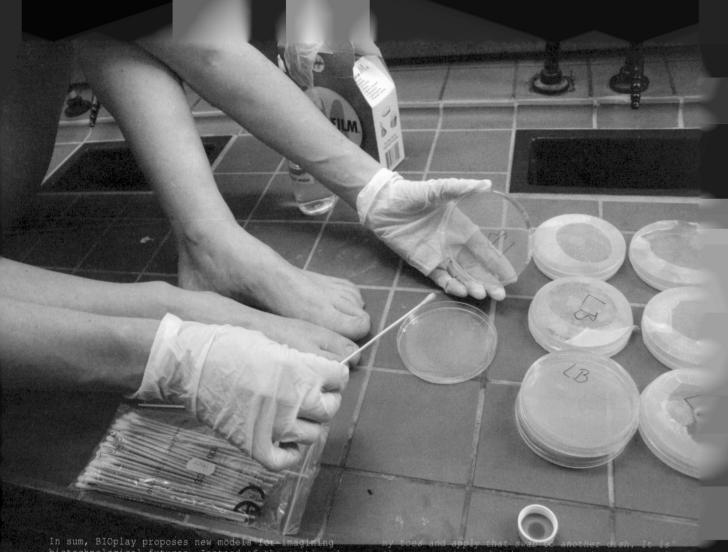

In sum, BIOplay proposes new models for imagining
biotechnological futures. Instead of the continued
proliferation of high-tech corporate models
for perpetuating biotechnology, it is interested
in imagining more democratic, low-tech,
community-driven, non-specialist models for
perpetuating the biotech future; imagining models
for biotechnology where the industrialized
instrumentalization of life is reduced to human scale
- bacterial scale - where we can share together with
other organisms in the sacrifices and rewards of
mutual life manipulation.

With BIOplay the resulting images serve in their
public dissemination to undermine established
top-down models for perceiving our own (human)
relations with the specimens in the lab - with
the *other* bodies in biotechnology. BIOplay is real,
but also symbolic. It is both an event and an initial
gesturing towards alternative practices. The next
body of work resulting from this concept is a suite
of collaborative images of UK-based artist Kira
O'Reilly and myself conducting tissue culture
protocols together - both neatly tucked inside the
sterile hood. But taken to its logical end, this body
of work will have to move out of the lab and into
the natural environment - forests, mountain tops,
arcades, skate parks, garages, bedrooms and kitchens.
BIOplay will have to imagine new ecologies all
together in which to engage with the bodies
in biotechnology.

*my toes and apply that swab to another dish. It is
the preparation, administrative permissions, and late
night coordination - that exhausts in allowing for a
few perfect seconds in the hood.*

I lay down, and rest - and let the bacteria rest.

*The tiles are cool beneath my back - and the glass
cabinet starts to collect perspiration and breath.
Warm and moist - and very, very cold at the same
time. I can hear the shutter of the camera clicking
again and again - and the hum of the fluorescent
lights - and the rumbling of the ventilation.*

*A sting in my lower back. A glass shard, missed
in the clean up - pierces my skin. Chemical or
biological contamination? The moment is over.*

*The bacteria dishes are relegated to biological waste
bins - and I get quickly to the shower.*

REFERENCES

Drexler, K. E. (1986). *Engines of Creation. The
Coming Era of Nanotechnology.* New York: Anchor
Lewontin, R. (2000). *The Triple Helix: Gene,
Organism, and Environment.* Cambridge, MA: Harvard
University Press

EMBRACING THE UNKNOWN FUTURE: IN DEFENCE OF NEW TECHNOLOGY

RUSSELL BLACKFORD

4599 Words /1.3 Visions /Human Futures

In February 1997, debates about human bioethics were transformed when a team of researchers at the Roslin Institute in Scotland announced that a female lamb had been conceived by somatic cell nuclear transfer (SCNT), then successfully brought to birth (Wilmut et al. 1997). The research team gave their new-born lamb the whimsical name 'Dolly' after the famous country and western singer Dolly Parton, for Dolly the sheep was cloned by a cell from the mammary gland and she was soon famous as the first mammal to be cloned from another that had already grown to adulthood.

The theoretical potential to clone human beings by SCNT immediately triggered a worldwide debate. Politicians and pundits thundered against the prospect. Innumerable government reports, essays, articles and books appeared, considering the moral problems that could arise should human cloning ever became practical. This included debates about whether such practices should be prohibited by law.

Within this ongoing debate, a distinction is frequently made between 'reproductive cloning' and 'therapeutic cloning'. The former refers to the postulated use of cloning technology to bring about the birth of a human child. By contrast, the expression 'therapeutic cloning' refers to the creation of a cloned human embryo for some other purpose, such as biomedical research or for harvesting cells or tissues to be used in therapy. However, therapeutic and reproductive cloning are not the only powerful technologies that became hot topics for moral and political debate in the post-Dolly social environment.

It is often hoped or feared that the technologies of the future may go far beyond therapeutic or even reproductive cloning, bringing about the transformation of human minds and bodies. The more dramatic prospects that are sometimes mentioned include extension of the maximum life-span, reconfiguration of the human body structure in an effort to obtain greater functional efficiency, and the use of technology to reshape psychological dispositions. Some enthusiasts may seek to enhance their own athletic, perceptual or cognitive capacities, or those of their children, to a point beyond any historical level of human functioning. Some may want to experiment with creating new types of ability, which we can describe in an abstract way, from the outside as it were, while having no concept of what the inner experience would be like (much as a person who is blind from birth could

not imagine the experience of seeing colours).

In this last respect, the creators of science fiction movies sometimes make an effort on our behalf, presenting the world as experienced by non-human beings or by humans with extraordinary perceptual powers. Whatever it might be like to be a bat (see Nagel 1974), Hollywood special effects can offer an impressionistic representation of what it might be like to have, say, a batlike echolocation sense - as in *Daredevil* (2003).

Some commentators discuss these possibilities in unapologetically apocalyptic tones. Edward O. Wilson expresses alarm that *Homo sapiens* might be superseded by a self-designing, self-directed, bafflingly varied form of life: *Homo proteus* (1998: 311). Lee M. Silver describes a scenario of future speciation into the Naturals and GenRich (or gene-enriched) (1999: 4-8). Mehlman and Botkin lament that unequal access to new genetic technologies could 'threaten the fundamental principles upon which Western democratic societies are based' (1998: 129). They conclude their book, *Access to the Genome*, with a note of warning: 'We are raftsmen approaching a social and evolutionary maelstrom. Whether we will emerge safely will depend on how well prepared we are, not to mention a great deal of luck' (130). Others fear a loss of meaning in our lives if they (and we) are dramatically changed by new technology. For example, Bill McKibben imagines situations in which the individuals concerned are genetically engineered so

thoroughly and successfully that - he suggests - life no longer poses them any meaningful challenges. Alternatively, he invites us to see them as having lost a sense of their own identity. Among his typical examples are the runner who feels no weariness from the strain and the genetically engineered rock climber who wonders, 'Is it really me doing this?' (McKibben 2003: 3, 53).

Against all this, it is *not* my intention to hype the possibilities or to suggest rhetorically that dramatic policy responses are needed to assert public control over rampant biomedical technology. On the contrary, a reality check may be useful: more than a decade after the cloning of Dolly there is still no immediate prospect of producing a human baby by reproductive cloning, not least because there have been significant practical difficulties in cloning primates more generally. Nonetheless, we are already confronted by controversial uses of genetic technology that demand a political response, such as the use of pre-implantation genetic diagnosis for the purpose of selecting the sex of an intended child. Moreover, we can be confident that many more such issues will confront us in the future. What, then, is the most appropriate policy, or mix of policies to implement, when a modern, secular, liberal society[1] confronts such technological possibilities?

I argue on behalf of a truly liberal response to new technologies: a policy response

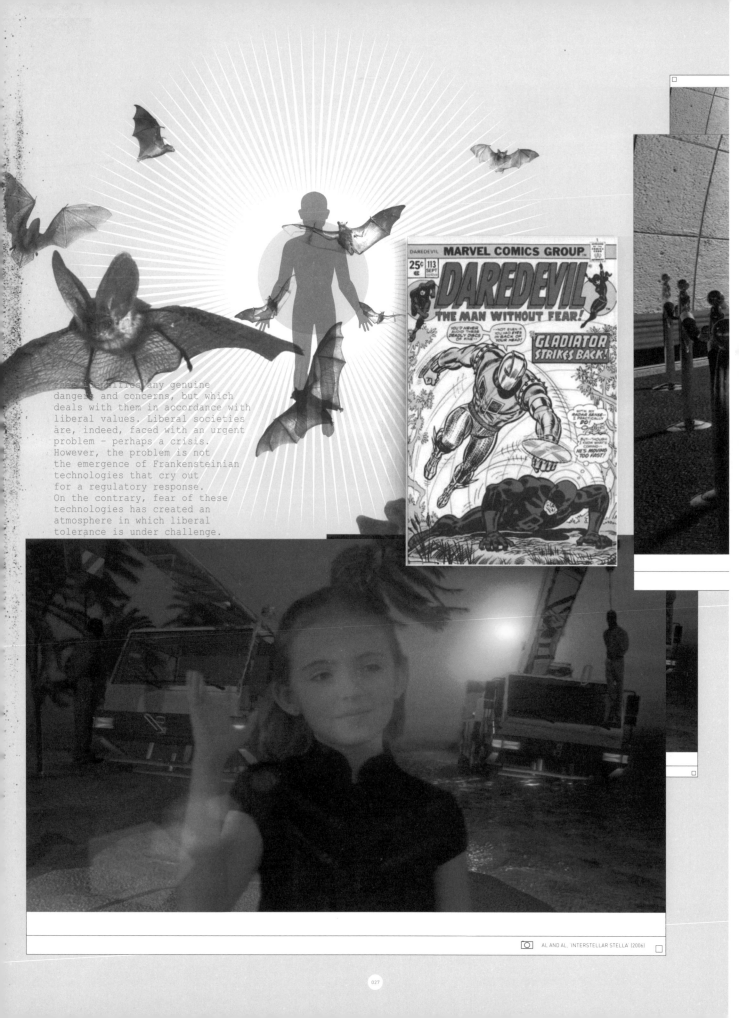

that identifies any genuine
dangers and concerns, but which
deals with them in accordance with
liberal values. Liberal societies
are, indeed, faced with an urgent
problem - perhaps a crisis.
However, the problem is not
the emergence of Frankensteinian
technologies that cry out
for a regulatory response.
On the contrary, fear of these
technologies has created an
atmosphere in which liberal
tolerance is under challenge.

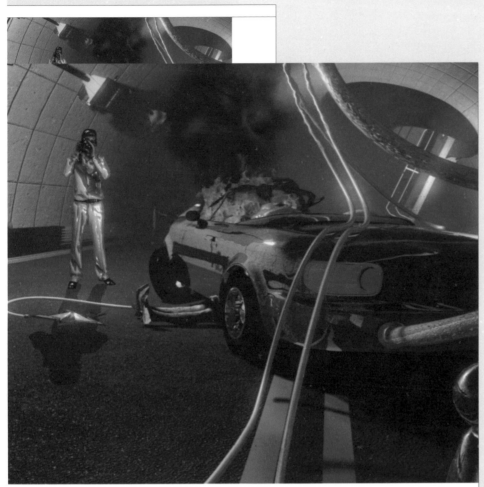

AL AND AL, 'INTERSTELLAR STELLA' (2006)

THE IDEA OF A LIBERAL SOCIETY

A liberal society embraces pluralism, in the sense that it does not seek to impose any one vision of what it means to be virtuous or to lead a good life. Within such a society, approval is commonly expressed for John Stuart Mill's view that 'experiments in living' should not be merely tolerated, but actually welcomed and celebrated (Mill 1974: 120).

As Max Charlesworth writes, 'In a liberal society personal autonomy, the right to choose one's own way of life for oneself, is the supreme value'. He adds that this includes an acceptance of what he calls ethical pluralism: members of the society are free to hold a wide range of moral, religious and non-religious positions, with no core values or public morality that it is the law's business to enforce (Charlesworth 1993: 1). Accordingly, a liberal society distinguishes between the sphere of personal moral views and that of the law; no one can use the law to impose their beliefs on others (16–20).

Admittedly, it is sometimes difficult to define the boundaries of liberal tolerance, and the broad idea has been formulated in different ways, even by its prominent defenders in the current debates about bioethics.
For example, John Harris writes of what he calls 'the democratic presumption', which he elaborates as the principle adopted in liberal democracies that the freedom of citizens should not be interfered with without good and

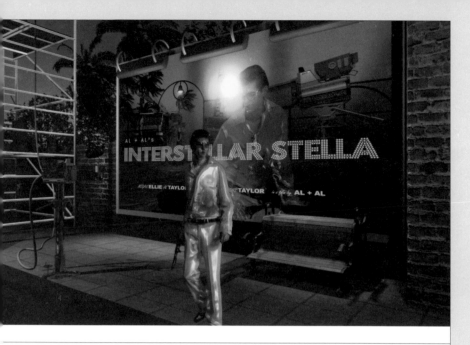

sufficient reasons. According to Harris, citizens should otherwise be at liberty to make their own choices, based on their own values; some serious real and present danger, whether to other citizens or to society, is required to rebut the presumption (Harris 2007: 72–73).

Similarly, Gregory E. Pence defends what he calls the 'classic liberal view', though he notes that the label is confusing. He explains that we should not try to dictate decisions about the good to others, instead leaving them alone as long as they leave us alone. For Pence, the justification for this approach is simply that all the alternatives have led to disaster (Pence 2000: 167).

In a recent defence of liberalism, Paul Starr offers a richer description of the liberal ideal. On Starr's account, liberalism has allowed people with different religious and moral commitments not just to live side by side, but to flourish together. A liberal state will not require everyone to worship in the same way, follow the same way of life, or profess an official ideology, but it expects citizens to show reasonableness and openness to ideas. It is not neutral about such values as disease and health, sloth and effort, deceit and integrity, cowardice and courage. There are, Starr suggests, excellences that it must promote to survive (Starr 2007: 176–77).

Nonetheless, he argues that a liberal state is neutral where divisions over the nature of the good life are deep and irreconcilable. Most crucially, the state apparatus of a liberal society allows a diversity of cultural and moral practices that cause no harm to others; this provides a framework for individuals' free development (2007: 22–23). On such an account, liberalism can welcome any worldview that is able to endorse such ideas as mutual tolerance and the free development of autonomous individuals.

As Starr points out, modern liberalism has also adapted to growing agglomerations of private power, the harsh collective and individual impacts of unregulated markets, social changes, economic crises and unprecedented scales of warfare (2007: 85–116). As a result of social and economic change, the apparatus of the state now exercises extensive powers for the purposes of social coordination and to ameliorate the harshness of economic outcomes that would arise under a system of unbridled capitalist competition (see Atiyah 1979: 571–779). However, these powers are explained in liberal thought as mechanisms to extend, rather than reduce, the practical autonomy of individual citizens (Lee 1986: 16–17; Raz 1986: 414–18).

Liberal societies give at least some support to Mill's harm principle: unless some kind of harm can be identified, a liberal society will be reluctant to restrict the liberty of individuals to act as they wish with the resources available to them. Under Mill's principle, even the idea of harm is restricted to direct, significant and wrongful harm to others. In particular, the harm described must be to secular interests, not to theological ones such as interests in personal salvation, holiness, purity from sin or conformity to the will of a deity. An early version of this idea can be found in John Locke's *A Letter Concerning Toleration*, in which Locke assigns to the civil magistrate protection of 'things belonging to this Life' but not 'the Salvation of Souls' (Locke 1983: 26).

In a liberal society, the coercive power of the state is brought to bear against individuals only with reluctance. Where individuals' personal lives and life plans are at stake, including their ability to express themselves freely, have consenting sexual relations and make reproductive decisions, the state will be particularly solicitous of freedom of choice, unless a compelling reason can be found to do otherwise. Prima facie, the infliction or threat of force by the state is considered objectionable, especially when deeply personal interests are at stake.

BIOETHICS AND THE CHALLENGE TO LIBERAL TOLERANCE

This somewhat idealized picture of a liberal society and its ethos of mutual tolerance might suggest that a forbearing, or even welcoming, attitude would be taken to new or postulated forms of biomedical technology. For example, reproductive cloning might be welcomed by a liberal society as an acceptable personal

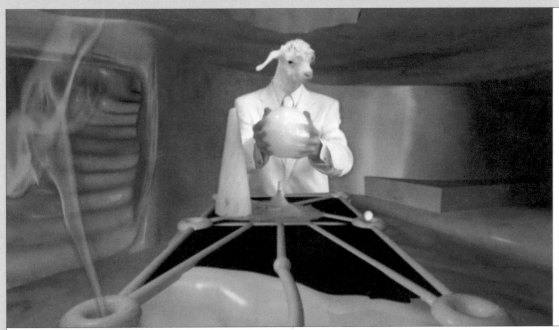

choice – particularly, but not solely, as a legitimate response to male infertility, but also as the preference of some lesbian couples.

Admittedly, reproductive cloning is not currently a safe method of reproduction, in the sense that it would involve a high risk of producing congenital disabilities. Even the most liberal society has good reason not to tolerate the use of a method of reproduction that is unsafe in that sense. Such *safety arguments*, as they might be called, could also apply to other technological interventions, such as the genetic engineering of human embryos.

However, the policy debate since the cloning of Dolly has been remarkable for the way that many participants have ignored, or even rejected, the liberal idea that experiments in living are to be welcomed. Prima facie, Mill's idea should apply to decisions about the full gamut of technological innovations (even though Mill himself could hardly have foreseen them). For example, in the absence of some argument based in liberal values, liberal societies should allow individuals to decide whether or not to bear and raise children created by the use of SCNT.

Arguments about safety, or even about the welfare of growing children, do not explain the character of the actual debate or the real-world policy responses. The debate appears to be motivated in large part by a wish to impose certain moral, or quasi-religious, ideals as social norms, and by a fear of the potentially strange

directions that societies might take as biomedical technology develops. Thus, reproductive cloning is frequently criticized not as a medical practice that is insufficiently developed for safe use, but as a violation of human dignity. As mentioned above, McKibben fears what he describes as a loss of meaning in a future society that utilizes new technologies to enhance human traits.

Margaret Somerville is one of many whose approach to bioethical questions is pervasively anti-liberal. The direction of her work is to argue against a wide range of innovations on the basis that they fail to respect life in the correct way, or that they are contrary to nature.[2] Such reasoning leads her to insist on legal prohibitions, even when our human sympathies might incline us the other way and no obvious harm is involved. Thus, she insists that the law should say 'No' to a couple who already have three boys and now want to have a girl,[3] even though she thinks that saying 'No' requires more 'courage' than saying 'Yes'. The illiberality is even more apparent when she adds that we must act because the value embodied in the law will become the societal value (Somerville 2007: 137–38).

This is both cruel and confused. For a start, the only reason why it might be thought to require more 'courage' to say 'No' is that it requires denying something to a couple whose deepest wishes will be set back by the refusal. It is not courageous in the sense of placing the nay-sayers at risk for a good cause, but only in the sense that there may be a kind of

courage in insisting on one's convictions, and imposing them upon others, even when to do so is actually cruel to them. That, I submit, is not the sort of courage that should be reflected in the laws of a liberal society.

Somerville's statement is not only cruel but also confused: it falsely assumes that merely *allowing* a practice, i.e. declining to prohibit it, entails endorsement by society as a whole. A liberal society should never accept that proposition. Liberal societies tolerate many practices that various individuals – sometimes enough of them to form an electoral majority – disapprove of for religious or moral reasons. Hence, a liberal society's mere failure to prohibit a practice can never entail that the practice is officially endorsed, along with whatever suspect value or values might underlie it. The value embodied in the law, by its silence in such cases, is simply the political value of liberal tolerance. Hence, Charlesworth is on strong ground when he observes that the decriminalization of suicide does not entail that the state morally endorses it. In a liberal society, all that is entailed is that the state categorizes suicide as a matter of personal morality that should not be proscribed by law (Charlesworth 1993: 39).

In the early 1990s, Charlesworth complained about a gap between liberal ideas and the widespread hostility, within liberal societies, to a range of practices in health and medicine. On Charlesworth's account, one would expect to see liberal societies

treating personal autonomy as central to ethical discussions about new reproductive technologies, and drawing a sharp line between the morality and legality of biomedical innovations. However, Charlesworth argues that many of the policy responses of the time were illiberal – often authoritarian or paternalistic (Charlesworth 1993: 1–2).

The years since – and particularly those since the cloning of Dolly – have only made the gap identified by Charlesworth more obvious. We have seen the emergence of widespread and politically influential opposition to many real or mooted technologies (e.g. embryonic sex selection, reproductive cloning, human genetic engineering and radical forms of life extension).

I submit that little of this can be justified on grounds that would be acceptable under the harm principle or any principled extension of it. More than ever, we should heed Charlesworth's contention: those engaged in bioethical discussion within liberal societies must take account of the fact that they are, indeed, living in liberal societies, and they should recall a liberal society's basic values (Charlesworth 1993: 27).

SHOULD WE FEAR THE FUTURE?

Against all this stands McKibben's claim that new technologies threaten us with a loss of experienced meaning in our lives.

Such fears, perhaps unarticulated, may explain a good deal of the illiberal rejection of new technology that has been characteristic of the debate. However, there is no justification for such a view. While it may appear, prior to the development of a new technology, that the sense of meaning in our lives is under threat, we adapt to the new circumstances and new social practices incorporate the new technology. As long as technological change does not proceed too quickly for adaptation, as with conquest by technologically superior enemies, arguments based on the loss of experienced meaning carry little weight for public policy.

Contrary to McKibben's claims, there is no prospect of a technology that will remove all challenges from life, thus rendering it meaningless – that would require omnipotence rather than the relatively puny means available to human science. If our powers of action were increased, either by direct changes to our bodies or by the availability of increasingly powerful tools, we would certainly be able to accomplish more than is currently possible. However, there would still be areas within which we would be challenged, neither sure of succeeding nor doomed to failure. Examples of a life without challenge are impressive only if we conflate a lack of *any* challenges with the ability to overcome some of our *current* ones.

Recall McKibben's example of a genetically engineered rock climber who wonders, 'Is it really me doing this?' (2003: 3, 53).

Here we have an example of the kind of incoherent thinking that so often sidetracks the debate. The question that McKibben attributes to the rock climber is not coherent. *None* of us are self-creators all the way down, any more than McKibben's rock climber. That is, none of us can distinguish a 'real me' from the empirical me that is, in the final analysis, a product of external causes.[4]

When McKibben's genetically engineered rock climber asks her question, it makes no more sense than when similar questions are asked by ordinary rock climbers (if they ever are). Both are in exactly the same situation: *both* are ultimately the products of forces outside themselves. Neither possesses the power of ultimate self-creation: no one ever does or could. The genetically engineered rock climber might be able to scale more difficult cliffs than others, but only if she has taken advantage of her genetic potential by adding hard training and the mastery of technique. The real 'her' is meeting the challenges, exactly as much as the ordinary rock climber's real 'her'.

McKibben is particularly troubled by the possibility that advanced genetic and other technologies will lead to immortal lives, though it is difficult to identify precisely what he finds so appalling about this. Why, in particular, is he convinced that immortals would find their lives lacking in joy and meaning? It is true, no doubt, that immortals would experience life *differently* from current people, who face the inevitable prospect of old age,

frailty and death. However, it does not follow that they would experience their lives as pointless, futile, joyless or worthless, or that they would live without finding personal significance and value in their activities and relationships.

In one passage, McKibben (2003: 160-61) offers a number of reasons for pessimism. He writes of a 'divorce' between immortals and the rest of creation, though this seems to involve no more than the fact that immortals would cease to be part of a system in which every living thing dies and gives up its nutrients to the land and to new living things. While McKibben may place a quasi-mystical value on this process, it does not follow that the immortals themselves would feel joyless because they were, in a peculiar sense, no longer a part of it. He writes, further, of a divorce of each human individual from every other, but again it is not clear what this really amounts to.

The complaint seems to be that immortals would not owe care to their juniors and attention to their elders, but let us consider this more deeply. There would still be love and friendship. There would still be children, though perhaps fewer of them, and they would still require nurturing and guidance. It is true that a society of immortals would not have elderly people suffering from frailty merely as result of old age, but that fact alone would not make life for immortals meaningless or joyless. Indeed, why would it not be an *improvement*? Might there not even be a special joy, in such a

society, in the interactions of parents and children while both are in the prime of their adult powers? The immortals might look back on many aspects of our own situation with pity.

To this extent, I see nothing in McKibben's analysis that articulates why the immortals should find their lives to be stale, meaningless or joyless. Of course, some aspects of current life would be lost, but they would be replaced by goods – experiences and relationships – of kinds that are not currently available to McKibben and the rest of us.

Of course, it is difficult to imagine what things would be experienced and valued in a future society that is very different from our own. What might give its inhabitants joy, a sense of connection with each other or other elements of their world? What might they experience as meaningful? Certainly, it is more difficult to imagine this than to list things that might be lost or, at least, be less commonly valued by our descendants. Compare an example offered by Nicholas Agar, that technology has transformed the significance of food and the means used to procure it. In the past, crops could fail and hunting certain animals required teamwork and a risk of death. In contrast, there is little opportunity for us to engage with the cultural practice of food production when we put a jar of pasta sauce in a supermarket trolley (Agar 2004: 62).

Yet this is not a persuasive example of meaning being taken away. Agar adds, correctly, that technology has displaced, rather

than destroyed, the significance of procuring and preparing food. We prepare beef Wellington for our guests, rather than informing them, 'I have meat'. We devote saved time from hunting and planting to reading novels, watching movies, reflecting on life's meaning, or going fishing which, as Agar observes, 'is usually more about spending time with nature than bringing it home for the cooking pot' (2004: 62–63). Indeed, these new opportunities to engage with nature seem far richer than the more instrumental conditions of our past.

Our distant ancestors were in no position to predict modern work arrangements, modern ideas of leisure, or modern cuisine. Unfortunately, we may not be much better off if we try to predict the future, or to imagine the thinking of hypothetical future people socialized in environments very different from our own. The future is not known to us and cannot be. It is not surprising if the attempts of science fiction writers and others, who try to imagine the unknown future, often seem crass, banal or unconvincing. However, it does not follow that the people of the future will live in a pitiable situation, or that their lives will be without the experience of meaning and joy.

CONCLUSION

In concluding, I must stress that the recent illiberal tendency in public policy cannot be confined to bioethical issues. Once the idea of liberal tolerance is

abandoned, many practices may be suppressed by the coercive power of the state, should they fail to gain acceptance within the political process.

Thus, just as it is possible to argue that human reproductive cloning should be suppressed because it is somehow 'interfering with nature' or 'playing God' or threatening our sense of life's meaning, arguments can be made for suppressing certain consensual sexual practices as 'unnatural', for suppressing certain speech as 'blasphemous' or 'offensive', or simply 'inappropriate' and so on. Again, much of our policy framework for dealing with recreational drugs seems to be driven by moralism, rather than a concern with liberty or even harm reduction. While the focus of this paper is on bioethical issues, it has implications that go far wider. A truly liberal society would be reluctant to interfere in many issues relating to sexuality, free speech and expression, family formation and other matters involving deep disagreement about values and the good life. Once a society goes down the path of allowing law-makers to impose their views (or those of an electoral majority), liberty is threatened across the board. Such an approach cannot be confined to one set of issues, such as bioethics.

We can expect the future to bring new political issues of many kinds. Some of them will provoke anger, fear and other strong emotions, as did the cloning of Dolly and the prospect of reproductive cloning for human beings. Next time such an issue

emerges and grants law-makers in supposedly liberal societies the opportunity to demonstrate their credentials as successors to Locke and Mill, they should not squander it. The future is not ours to see, but that is not a reason to fear it. Confident, liberal societies ought to embrace the unknown.

[1] I will henceforth use the expression 'liberal society' for short.
[2] See especially Somerville 2000: 55–88. Here, she mounts a sustained attack on both reproductive and therapeutic cloning, and calls for their prohibition.
[3] I.e. using a technological solution such as PGD.
[4] If we go back far enough to consider our genetic potentials and early childhood experiences.

REFERENCES

Agar, N. (2004). *Liberal Eugenics: In Defence of Human Enhancement*. Oxford: Blackwell

Atiyah, P. S. (1979). *The Rise and Fall of Freedom of Contract*. New York: Oxford University Press

Charlesworth, M. (1993). *Bioethics in a Liberal Society*. Cambridge: Cambridge University Press

Harris , J. (2007). *Enhancing Evolution: The Ethical Case for Making Better People*. Princeton: Princeton University Press

Lee, S. (1986). *Law and Morals: Warnock, Gillick and Beyond*. Oxford: Oxford University Press

Locke, J. (1983). *A Letter Concerning Toleration*. First published 1689. Indianapolis: Hackett Publishing

McKibben, B. (2003). *Enough: Genetic Engineering and the End of Human Nature*. London: Bloomsbury

Mehlman, M. J., and Botkin, J. R. (1998). *Access to the Genome: The Challenge to Equality*. Washington, DC: Georgetown University Press

Mill, J. S. (1974). *On Liberty*. First published 1859. London: Penguin

Nagel, T. (1974). 'What Is It Like to Be a Bat?' *Philosophical Review*, 83, 435-50

Pence, G. E. (2000). *Re-Creating Medicine: Ethical Issues on the Frontiers of Medicine*. Lanham, MD: Rowman & Littlefield

Raz, J. (1986). *The Morality of Freedom*. Oxford: Clarendon; New York: Oxford University Press

Silver, Lee M. (1999). *Remaking Eden: Cloning, Genetic Engineering and the Future of Humankind*. London: Phoenix-Orion

Somerville, M. (2000). *The Ethical Canary: Science, Society and the Human Spirit*. New York: Viking

Somerville, M. (2007). *The Ethical Imagination: Journeys of the Human Spirit*. Melbourne: Melbourne University Press

Starr, P. (2007). *Freedom's Power: The True Force of Liberalism*. New York: Basic Books

Wilmut, I., Schnieke, A. E., McWhir, J., Kind, A. J., and Campbell, K. H. S. (1997). 'Viable Offspring Derived from Fetal and Adult Mammalian Cells'. *Nature*, 385, 810-13

Wilson, E. O. (1998). *Consilience: The Unity of Knowledge*. London: Little, Brown

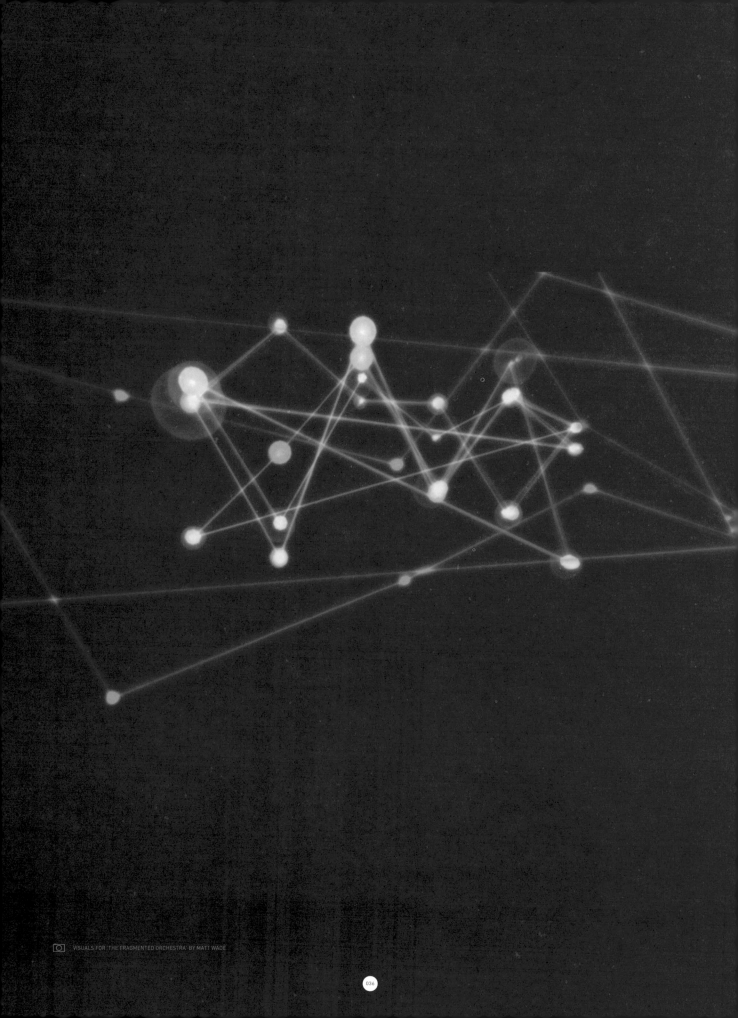

WILL HUMAN ENHANCEMENT MAKE US BETTER?

ETHICAL REFLECTIONS ON THE ENHANCEMENT OF HUMAN CAPACITIES BY MEANS OF BIOMEDICAL TECHNOLOGIES

RUUD TER MEULEN

3869 Words /1.4 Visions /Human Futures

'THE PROSPECT OF CREATING SUPERIOR OFFSPRING BECOMES WITHIN REACH...'

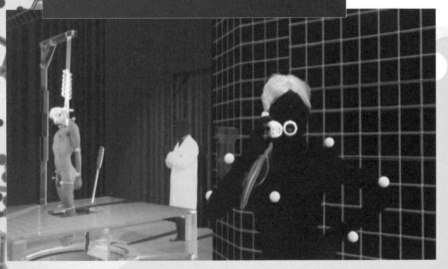

AL AND AL, 'PERPETUAL MOTION IN THE LAND OF MILK AND HONEY' (2004)

Most emerging biotechnologies are being developed in order to cure people of severe diseases. However, many of them also have the potential to function beyond the frame of therapy, namely for the enhancement of human capacities, be they body or mind. In practice we may see biotechnologies with such potential being used to make people think better, feel happier, or even as a way of improving their physical skills in sports, music, dance or to extend life-span. In the last five years, a number of governments around the world have spent considerable resources to consider these prospects, notably the United States President's Council on Bioethics (2003).

This potential of the collective NBIC sciences forces us to consider how the enhancement of human beings would alter our sense of self, our society and the goals of humanity in general. Will the augmentation of bodily skills, life-span, rationality or personal behaviour transform society and, in turn, confer that status of post-humanity upon us? Will enhancement of our individual capacities change our perception

of human nature in general, along with our relationship to other animals and even artificial life forms? In an era of enhancement, will we make different normative distinctions between 'normality' and 'disease' and, if so, how will this influence our society, either through our provision of health care or through the distribution of broader social goods?

Before we try to answer these fundamental questions it is important to establish that the enhancement of our capacities is indeed a good thing: do they really make us better? Do these technologies really lead to an improvement of our existence as human beings and do we even have a moral duty to enhance ourselves as argued by John Harris (2007)? Alternatively, are there too many potential harms that we will risk encountering as a result of such endeavours and should we better not try to enhance ourselves? This article presents some examples of enhancement technologies, followed by a number of ethical reflections.

EXAMPLES OF ENHANCING TECHNOLOGIES

There are two main categories of modification that we might discern: those that affect our *minds* and those which alter our *bodies*. Although this is a crude distinction, it will suffice for our purposes. To begin with the mind, in the field of psychopharmacology there is the example of Modafinil or Provigil, which is normally used to treat narcolepsy, a sleeping disorder. Modafinil can help to keep people awake. However, laboratory experiments have shown that a single dose of Modafinil can induce reliable improvements in short-term memory and planning abilities in healthy volunteers (Turner & Sahakian 2006). Other examples of such 'cognitive enhancers' are cholinesterase inhibitors that are meant to treat the cognitive decline of people with dementia. However, these can also be used to improve memory, particularly working memory. Dopamine and acetylcholine have a demonstrated, positive effect on working memory. Also, Modafinil has been shown to enhance working memory in healthy test subjects (Sandberg 2009). This drug has been found to increase forward and backward digit span, visual pattern recognition memory, spatial planning and reaction time on different working memory tasks (Turner et al. 2003; Sandberg 2009). Alternatively, Ritalin is used to treat young people with attention disorders (ADHD), though it is also used by students – often with prescription – to improve their concentration levels during examinations.

However, cognitive capacity is not the only form of mind enhancement that is possible through pharmacological interventions. Selective serotonin reuptake inhibitors (SSRIs), such as Prozac, Seroxat and Cipramil, are used in the treatment of depression. Yet these drugs may also be used by persons who are not suffering from major depression and have only very mild symptoms. Prozac and other antidepressants may help them to feel bright and happy. These drugs function then as a form of 'cosmetic psychopharmacology' (Kramer 1994), which makes people feel 'better than well' as was described by one of Kramer's patients (see also Elliott 2003). Alternatively, beta blockers are normally utilized for the control of blood pressure and heart rate, but are commonly used by musicians seeking to control their anxiety on stage and thus, to deliver a better performance.

While there is considerable overlap between this form of 'mind' enhancement and the physiological effects that translate into people who are more equipped to deal with the physical demands of any activity, there remains some merit in identifying a second category of 'physical' enhancements. Some of the most frequent examples to be cited in this area occur within the context of elite sports. For instance, in sport we are familiar with doping by Erythropoietin (EPO), which is meant for the treatment of anaemia, for example caused by chronic kidney failure. However, when utilized by healthy athletes to boost their 'natural' secretion of EPO, it functions as an endurance enhancer based on the same scientific principles. Raising the number of red blood cells via 'autologous blood doping' is also appealing for athletes. In this case, athletes prepare for competition by

removing a quantity of blood from their bodies, waiting for their bodies to replenish the lost blood, then reinjecting the previously removed blood to boost the red blood cell count. This practice has the similar effect as EPO of raising the oxygen-carrying blood cell count which enables an athlete to run harder for longer. It has even become possible to make artificial copies of the human genes, which are manipulated to produce large amounts of a specific protein. These genes can be reintroduced into the human body and thereby substitute for the defect of the normal gene, e.g. growth hormone. This method is termed 'gene therapy' when used for medical treatment. However, it has become known as 'gene doping' when used to encourage the growth of muscle fibres and, as a result, the enhancing of athletic performance. EPO levels can be influenced by gene therapy as well. While this kind of human enhancement is still experimental and very dangerous because of its unknown side effects, the method itself is promising and is raising serious concerns about fair competition in sport in the future (Miah 2004; Tamburini & Tannsjo 2005; Schneider & Friedmann 2006).

Gene therapy is limited to the treatment or enhancement of one individual, since it affects only the non-hereditary somatic cells of the body. However, germ line gene therapy would result in long-lasting improvements in the offspring, since it would affect the DNA that is passed on to our offspring, thus permanently affecting all subsequent generations, unless some further alteration is made. By manipulating germ cells, that is sperm cells and ova, the resulting changes will be preserved in the gene pool. Manipulating these cells could mean selecting out genes that might cause horrible diseases. It can also mean implanting changes to improve mental or physical functioning, and the prospect of creating superior offspring comes within reach through pre-implantation genetic diagnosis (PGD). This technology is meant to help prospective parents with a family history of genetic disorders to select embryos that do not have the defective gene. It is envisaged that the method could be used to produce embryos with the 'right' genes, meaning genes that will predispose the future person to greater intelligence or perfect physical appearance or strength. PGD is believed to give parents greater control over the 'quality' of their offspring, particularly when the method is used on a routine basis and is combined with genetic manipulation. However, critics of this seemingly valuable decision method argue that it leads us onto a slippery slope towards selection of designer genes, characteristics that are, perhaps, fashionable rather than a health necessity.

LIFE-SPAN EXTENSION

A particular area where various technologies come together is that of the extension of life-span. Since the early 1900s life expectancy has risen dramatically in the developed, industrialized world, in large part due to its successful combating of childhood diseases by vaccination and other public health measures, as well as through better life circumstances and dietary habits. However, the maximum life expectancy, that is the age of the longest-living individual, has not changed significantly, and it was believed for a long time that this was not possible because of biological causes (Olshansky et al. 2002). The belief was that human life-span is limited to an average of about 85 years and that death at old age is due to an intractable ageing process. However, recently increasing doubts have been expressed about the biological limits to human longevity (Reichlin et al. 2006). Senescence - the process through which our cells cease to replicate, whereby we decay - is increasingly seen as a complex mechanism, which is linked to the long-term accumulation of damage in macromolecules, cells, tissues and organs. This view counters the established assumption that ageing results from an inevitable and unstoppable destructive force that begins after a certain time. Rather, ageing is increasingly viewed as a biological process that can be influenced, retarded and even reversed through medical interventions (Kirkwood 2001).

Various strategies have been proposed to increase the maximum life-span, such as reducing oxidative damage, genetic therapy, telomerase activation, stem cell therapy and hormone therapy. Of particular note is the calorific restriction theory, which links combating ageing with reducing calorific intake, as this could fight oxidative damage and might influence hormone balance. One of the more visible advocates of pursuing life extension is Aubrey De Grey, who expects a significant gain of 25-30 years in the coming decades, particularly by the transfer of results from animal experiments to the human body. He also believes that the ageing process can be reversed and that, in the future, life-span extension to 1000 years will become possible (De Grey & Rae 2007). However, most researchers believe that,

though these interventions might slow down ageing, these technologies will not make us immortal.

ENHANCEMENT AS A MORAL GOOD

While a prima facie reading of the term 'enhancement' would require that we evaluate it as a positive form of improvement, or the act of adding a new capacity, the use of technology to accomplish such improvements evokes many negative sentiments. Such concerns about enhancement are situated within a long history of criticism over *eugenics* - literally good genes – which emerged and shaped modern society in the first half of the last century. Many people with disabilities or psychiatric and psycho-geriatric disorders were sterilized or killed because they did not meet the ideals of race and humanity. Critics of human enhancement are concerned that the application of enhancement technologies will lead to a new kind of eugenics that could very easily result in a less favourable view of people with disabilities and society's willingness to support such different lifestyles. There is a particular concern about genetic improvement and genetic selection through prenatal and pre-implantation genetic diagnosis (PGD). Proponents of these technologies argue that there is a big difference between the new genetics and the old eugenics because the former is based on the moral principles of freedom of choice and autonomy, a kind of '*liberal eugenics*' (Agar 2004). However, even in liberal eugenics, the basic idea is the elimination of undesirable physical and psychological traits. As such, the argument from free choice does not diminish the →

Scopolamine ($C_{17}H_{21}NO_4$)

LIFE EXPECTANCY

concern that enhancement could lead to discrimination against disabled people.

To reach a better understanding of the moral value of enhancement, its goals are often compared with those of therapy. While therapeutic interventions are usually the source for the development of enhancement technologies, our moral evaluation of each differs markedly. Where therapy is generally seen as something good, perhaps for the relief of suffering, enhancement is often considered as something bad, or at least not a morally compelling pursuit. In this debate an abstract conceptual scale is often invoked on which, at one end, there are examples of enhancement and, at the other end, there are the normal applications of medical technology. However, there is no consensus about what should be seen as a normal application of medical technology and this is one of the major difficulties with the outright rejection of human enhancements. A normal application is defined as a treatment that falls within the goals of medicine, such as the treatment of disease and the alleviation of suffering. Yet establishing robust distinctions is not so easy. Take, for example, the following case, outlined by Norman Daniels (1992: 46) in a classic essay:

Johnny is a short eleven year old boy with documented growth-hormone deficiency resulting from a brain tumor. His parents are of average height. His predicted adult height without growth hormone (GH) treatment is approximately 160 cm (5 feet 3 inches). Billy is a short eleven year old boy with normal GH secretion according to current testing methods. However, his parents are extremely short, and he has a predicted adult height of 160 cm (5 feet 3 inches).

Johnny's shortness is a function of his disease, while Billy has a normal genotype, one that produces normal levels of GH. However, both boys are similar as they are both short and suffer from this shortness, as our society values tallness. In Johnny's case, one could say GH treatment falls within the goals of medicine and is an acceptable treatment. However, Billy there is not suffering from any disease. In his case GH treatment could be considered an enhancement, and thus a treatment that falls outside the medical domain. (Allen and Fost 1990, Cited in Parens 1998/ 2007: 6)

Even when it is possible to draw a sharp line between therapy and enhancement, we would still face the problem of establishing what counts as enhancement. This concept is strongly linked to individual views on personal identity and to personal preferences for specific lifestyles. This lack of consensus on what counts as enhancement makes it more difficult to develop a policy on these issues, particularly with regard to access to these technologies in our society. If the distinction between therapy and treatment is difficult to make, there seems to be no argument against the application of biotechnologies outside the medical domain.

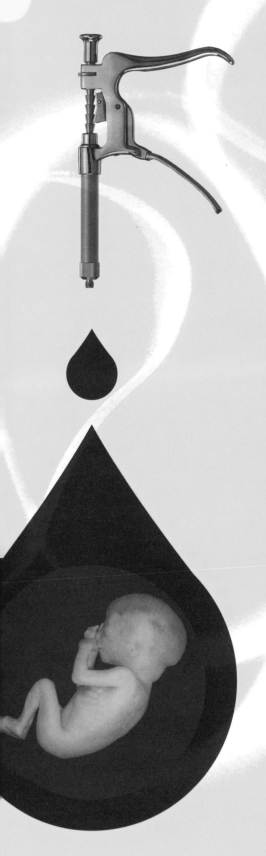

ENHANCEMENT: MORE BENEFIT THAN HARM?

There are authors who are very optimistic about the promise of human enhancement technologies, though one of the crucial distinctions between these advocates is between those who argue that people should be generally free to pursue them and others, such as Harris (2007), who argue that we have a moral duty to enhance ourselves. Nevertheless, common among supporters of enhancement technologies is the conviction that enhancement needs to be evaluated in consequentialist terms, on the basis of harm and benefits. Such theorists argue that this, rightly, applies the same standard of judgment that we require in therapeutic interventions. Today, it is unclear whether enhancement will, generally, result in more benefit than harm. For example, let us reconsider the case of life extension. A key policy indicator of improvements in the quality of life of elderly people is to be found in the concept of healthy life expectancy and the associated concept of disability-free life expectancy. Some scholars distinguish the pursuit of such enhancements as extensions of *health*-span, rather than *life*-span. On this view, collective resources should be directed to life-extension interventions that enhance healthy life-span, and public funds should not be spent on interventions that might extend life-span and increase the social burden of dependency at the same time (Barazetti 2007). However, predictions about healthy life expectancy are not all positive. By 2050, Britain will have 250,000 people over the age of 100, with millions lined up behind them in their eighties and nineties.

According to Brown, they will not be

bright, rejuvenated Californians, but the victims of lives that are beyond what is sensible, beneficial and humane [...] More people are living longer than their ancestors imagined possible, but their death is preceded by years of chronic disease. Dementia, blindness, deafness and arthritis bring an end to independent life. Memory loss destroys socialising and conversation. Unsurprisingly, given the above, deep depression characterises extreme old age. (Brown, 2007)

Life extension that does not result in an increased healthy life expectancy will create more harm and burdens than that it will benefit humanity.

It is also important to understand how we characterize or quantify 'benefits' and 'harm'. In the case of mood enhancement it is not clear whether having only cheerful and happy moods is a benefit without any detrimental harm, though one could imagine how insufferable a permanently cheerful person could be! Emotions can have a positive and a negative value, but both 'positive' and 'negative' emotions have a function in our individual and social life. Supposedly 'bad' feelings such as the emergency emotions of fear and rage are important for survival, coping and adaptation. Other bad feelings, such as guilt and shame, serve conscience and communal life in various positive ways. Good feelings such as joy and pride serve aspiration, achievement and quality of life. Thus, so-called good and bad feelings, emotions or mood states are important for

alerting, liberating and enriching individual and communal life. On this basis, it is difficult to identify, a priori, what kind of mood state should be picked out 'to be enhanced' (Vos et al. 2007). Indeed, it is sometimes only in retrospect that we can know whether a particular emotional experience was generally positive or negative and only then in the context of the act of memory (which we might also be tempted to alter).

SOCIAL CONCERNS

So far we have considered only the concerns that affect individuals, though there are broader social concerns that are relevant to consider when judging whether the freedom to enhance should be allowed. Indeed, there is some concern that the use of cognitive and physical enhancers reinforces individualist values, such as competitiveness and cheating behaviour. There is also a concern that individuals may feel forced to take enhancing drugs to keep up with this competition and that this is problematic as it promotes a high-risk, coercive culture.

A further important social concern is whether *access* to enhancement technologies will be evenly distributed. Assuming we are able to control their potential side-effects, including psychological and sociological problems, we are required to consider how to regulate these technologies and how to provide access to them. Enhancement technologies may help underprivileged groups to perform better and to enter better jobs and social positions. However, at the same time they could widen the gap between the affluent and the less-privileged groups in our

society, particularly when the costs of such technologies are high and privately funded. Cognitive, physical and emotional enhancement technologies as well as life extension technologies can become positional goods or modes of accumulating 'biocultural capital' (Miah 2008) that can be used to improve one's social position. When society decides that enhancement drugs and technologies should be available for public consumption, it will be necessary to decide whether this should happen via the public health system or 'over the counter' or the Internet. Access via the public health system may help to monitor and control the potential harm of these technologies, but it may also contribute to 'medicalization' and 'disease mongering'. Performing well in schools, jobs or sports will then increasingly be overseen by doctors or other health care providers.

CONCLUSION

The application of biotechnologies to enhance our mental and physical functioning raises serious ethical and philosophical questions on our self-understanding as human beings. Moreover, there are concerns about potential harm for individuals and possible negative effects on our society. In the ENHANCE project sponsored by the European Commission (www.enhanceproject.org) we tried to answer these questions and concerns at various workshops, which involved discussions between scientists, philosophers, ethicists, social scientists and policy-makers. The outcome of these workshops will be published in an edited volume (Savulescu, Kahane & Ter Meulen 2009).

While today the use of enhancement technologies is not widespread, one can expect that their use will increase as the pursuit of good health leads increasingly towards human enhancement. As such, it is critical to initiate policy discussions now, to ensure that the resulting legislation distributes and monitors most effectively the use of human enhancements. Moreover, it is necessary that this work takes place *before* such technologies have become overly fashionable, by which point irreversible harm may have already occurred to individuals and to the possibility of establishing effective systems of governance. Coming to terms with how policy advice can encompass a consideration of whether human enhancements actually make lives better is a crucial dimension of this difficult task.

REFERENCES

Agar, N. (2004). *Liberal Eugenics. In Defence of Human Enhancement*. Oxford: Blackwell

Barazetti, G. (2007). 'Recommendations on Life-extension', ENHANCE project. Milan: San Rafaele University

Brown, G. (2007). *The Living Dream*. Basingstoke: Palgrave Macmillan

Buchanan, A., Brock, D., Daniels, N., and Wikler, D. (2006). *From Chance to Choice. Genetics and Justice 2006*. Cambridge: Cambridge University Press

Daniels, N. (1992). 'Growth Hormone Therapy for Short Stature'. *Growth: Genetics and Hormones*, 8 (supplement), 46-48

Gray, A. de, and Rae, M. (2007). *Ending Aging: the rejuvenation breakthroughs that could reverse human aging in our lifetime*. New York: St. Martin's Press

Elliott, C. (2003). *Better than Well. American Medicine Meets the American Dream*. New York and London: Norton & Company

Harris, J. (2007). *Enhancing Evolution: The Ethical Case for Making Better People*. New Jersey: Princeton University Press

Kirkwood, T., and Austad, S. N. (2000). 'Why do we age?' *Nature*, 408, 233-38

Kramer, P. (1994). *Listening to Prozac*.
New York: Viking

Meulen, R. ter, Nielsen, L., and Landeweerd, L. (2007). 'Ethical Issues of Enhancement Technologies', in R. Ashcroft, A. Dawson, H. Draper, and J. McMillan (eds), *Principles of Health Care Ethics*. Chichester: John Wiley, 803-80

Miah, A. (2004). *Genetically Modified Athletes: Biomedical Ethics, Gene Doping and Sport*. London and New York, Routledge.

Miah, A. (2008). 'Justifying Human Enhancement: The Accumulation of Biocultural Capital', in S.M.E. Wint (ed.), *Perspectives on our Ethical Future: boundaries to human enhancement*. London: Royal Society for the Arts, in press.

Olshansky, S. J., Hayflick, L., and Carnes, B. A. (2002). 'Position statement on human aging'.*Journals of Gerontology Series A: Biological Sciences and Medical Sciences*, 57A, B292-B297

Parens, E. (2007). 'Is Better Always Good? The Enhancement Project', in E. Parens (ed.) Enhancing Human Traits: Ethical and Social Implications. Washington DC: Georgetown University Press, 2nd Edition, page 1-28.

President's Council on Bioethics (2003). *Beyond Therapy - Biotechnology and the Pursuit of Happiness, a Report of the President's Council on Bioethics*. Washington DC: US Government Office. Available at www.bioethics.gov [last accessed 7 July 2008]

Reichlin, M., Mordacci, R., Boncinelli, E., and Barazetti, G. (2006). 'Extension of Life Span. Scientific Progresses, Ethical, Philosophical and Social Issues'. Discussion Paper, ENHANCE Project. Milan: San Rafaele University

Sandberg, A. (2009). 'Cognition enhancement: upgrading the brain', In J. Savulescu,
G. Kahane and R. ter Meulen (eds), *Enhancing Human Capacities*. Oxford: Blackwell

Tamburrini, C. and Tännsjö, T. (eds) (2005). *Genetic Technology and Sport: Ethical Questions*. Abingdon and New York: Routledge

Turner, D., Robbins, T. W., Clark, L., Adam, R. A., Dowson, J., and Sahakian, B. J. (2003). 'Cognitive enhancing effects of modafinil in healthy volunteers'. *Psychopharmacology*, 165(3), 260-69

Turner, D., and Sahakian, B. (2006). 'The cognition enhanced classroom', in P. Miller and J. Wilsdon (eds), *Better Humans? The politics of human enhancement and life extension*. London: Demos, 79-85

Vos, R., Berghmans, R., and Landeweerd, L. (2007). 'Recommendations on Mood Enhancement'. ENHANCE project. Maastricht: University of Maastricht

OUR FAITH IN TECHNOLOGY

RICHARD A.L. JONES

3084 Words /1.5 Visions /Human Futures

The days when our society was bound together by a single shared faith seem long gone. But at some level, most of us share a faith in technology, a faith that next year we will be able to buy a faster computer, a digital camera with more megapixels, or an MP3 player that holds more songs, and that it will cost us less money. For some, this is part of a broader faith in the power of science and technology, both to deliver a better life and to give a coherent way of thinking about the world. Others might have a more nuanced view, seeing the results of techno-science as a mixed blessing, and accepting the gadgets while rejecting the scientific worldview. For better or worse, though, our current circumstances exist because of technology and, indeed, we existentially depend on it. However, it is equally clear that the technology we have cannot be sustained; for example, it depends on the presumption that our access to cheap, fossil-fuel based energy will continue indefinitely, and it is causing unquantified damage to the ecosphere. Whatever happens, this tension must be resolved; whether we believe in progress or not, things cannot continue as they are.

Today there is a new set of emerging technologies to bring these arguments into focus. *Nanotechnology* manipulates matter at the level of atoms and molecules and promises a new level of control over the material world.[1] Biology has already moved from being an essentially descriptive and explanatory activity. It is now taking on the character of a project to intervene in and reshape the living world. Up to now, the achievements of biotechnology have come from fairly modest modifications to biological systems, but a new discipline of *synthetic biology* is currently emerging, with the much more ambitious goal of a wholesale re-engineering of living systems for human purposes and, possibly, creating entirely novel living systems. In large organisms such as humans, we are starting to appreciate the complexities of communications within and between the cells that together make up the organism. It is this understanding of the rich social lives of cells that will make possible the development of stem cell therapies and tissue engineering. Information technology both enables and is enabled by these advances, since computing power underpins the decoding of the human genome, which drives the development of sciences such as bioinformatics. These applications provide the tools to understand the informational basis of life. Moreover, developments in nanotechnology drive the relentless increase in computing power that is obvious to every consumer. In the near future similar advances will contribute to the growing importance of the computer, as an invisible component of the fabric of life – *ubiquitous computing*. The development of *cognitive science* has perhaps the biggest impact on the most significant aspects of what it means to be human, our sense of self. This promises to expand our

understanding of how the brain works as an organ of information processing, prompting dreams both of a reductionist understanding of consciousness and the possibility of augmenting the functionality of the brain.

What will all these bewildering developments mean for the way the human experience evolves over the coming decades? To offer some perspective, I will consider technology's role in getting us to where we are now, to remind ourselves of the degree to which we are existentially dependent on this technology.

No one can doubt that lives in the developed world are now remarkably different from the lives of our ancestors two hundred years ago and that this dramatic transformation has come about largely through new technologies. The world of material culture - food, buildings, clothes, tools - has been transformed by new materials, artefacts and processes, with mass production bringing complex products within reach of everyone. Information and communications have been transformed; first telephones removed the need for physical presence for two-way communication, then computers and the internet have come together to give unprecedented ways of storing, accessing and processing a vast universe of information. Now, all these technologies have converged and become ubiquitous through mobile telephony and wireless networking. Meanwhile life expectancy has doubled, through a combination of material sufficiency, the development of scientific medicine, and the implementation of public health measures. We have started to assert a new control over human biology – already taking for granted control over the reproductive process through the

contraceptive pill and assisted fertility. We are also beginning to anticipate a future in which we will have access to bodily repairs and spare parts, through the promise of tissue engineering and stem cell therapy.

It is easy to be dazzled by all that technology has achieved, but it is important to remember that these developments have all been underpinned by a single factor - the availability of easily accessible, concentrated forms of energy. None of these innovations would have been possible were it not for the ability to fuel our civilization by extracting oil and coal from the ground and burning it. In 1800, the total energy consumption in the UK amounted to about 20 giga-joules (GJ) per person per year. By 1900 this figure had increased by more than a factor of five, and today we use 175 GJ. Since this is predominantly in the form of fossil fuels, one graphic way of restating this figure is that it amounts to the equivalent of more than four tonnes of oil per person per year.[2]

It is obvious to most people that they are using fossil fuels when they pump petrol into their cars, or burn gas for hot water or central heating. What is less obvious, perhaps, is how much energy is embodied in the material things around us, in our built environment and the artefacts we use. It takes a tonne and a quarter of oil to make ten tonnes of cement and eight and a quarter tonnes of oil to make ten tonnes of steel. For a really energy-hungry material such as aluminium it takes nearly four tonnes of oil to produce a single tonne. If we build with oil and make things out of oil, in effect we eat oil too, thanks to our reliance on intensive

→

. . . A 'CURE' FOR THE 'DISEASE'
OF AGEING IS IMMINENT

MICHAEL BURTON, 'NANOTOPIA' (2006, RCA)

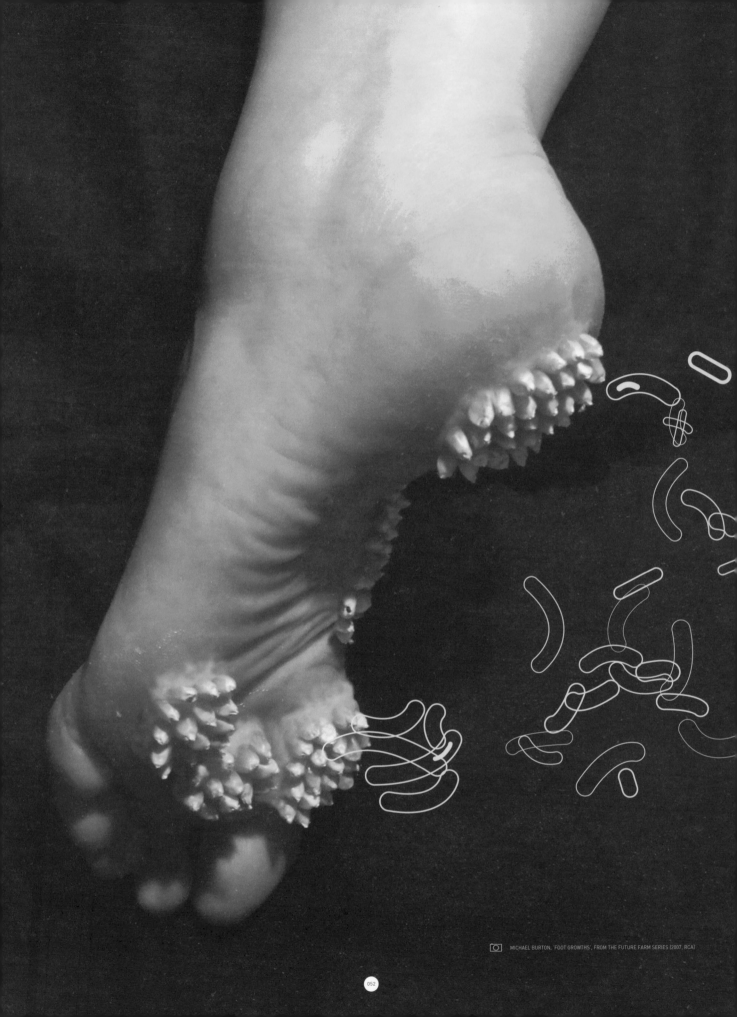

MICHAEL BURTON, 'FOOT GROWTHS', FROM THE FUTURE FARM SERIES (2007, RCA)

agriculture with its high energy inputs. To grow ten tonnes of wheat (roughly the output of a hectare, in the most favourable circumstances) it takes 200 kg of artificial fertiliser, which itself embodies 130 kg of oil, as well as the use of another 200 kg of oil in other energy inputs.

Some people mistakenly believe that the developed world has moved beyond the dirty old economy of power stations and steelworks to a new, weightless economy based on processing information. Nothing could be further from the truth; in addition to our continuing dependence on material things, with their substantial embodiment of energy, information and communications technology itself needs a surprisingly large energy input. For instance, the ICT industry in the UK is responsible for a share of carbon dioxide generation comparable to that of aviation. The energy consumption of that giant of the modern information economy, Google, is a closely guarded secret; what is clear, though, is that the choice of location of its data centres is driven by the need to be close to reliable, cheap power, such as hydroelectric power plants or nuclear power stations, in much the same kind of locations that aluminium smelters are sited.

Perhaps the most complex and interesting relationship is that between energy use and measures of health and physical well-being, such as infant mortality and life expectancy. It is clear, both from the record of history and the correlation of these figures with energy use for less well-developed countries at the moment, that there is a strong correlation between per capita energy use and life expectancy, at the lower end of the range. It also seems that increasing per capita energy use up to 60 or 70 GJ per year brings substantial benefits, presumably by ensuring that people are reasonably well nourished, allowing basic public health measures such as access to clean water and a working sewerage system, and permitting some access to modern medicine. Further improvements result from increasing energy consumption above this, presumably by enabling increasingly comprehensive medical services, but beyond a per capita consumption of around 110 GJ a year, there is very little correlation between energy use and life expectancy. This suggests that, while it is clear that material insufficiency is bad for one's health, sometimes excess brings new problems.

This emphasis on our dependence on

fossil fuel energy should make it clear that, whatever the prospects for exciting new developments in the future; there is a certain fragility about our current situation. The large-scale use of fossil fuels has come at a price – in man-made climate change – whose full dimensions we do not yet know. Moreover, we are, once again, seeing problems of pressures on resources such as food and fuel. Food shortages and bad harvests remind us that technology has not allowed us to transcend nature – we are still dependent on the rains arriving at the right time in the right quantity. We have influenced the climate, on which we depend, but in ways that are uncontrolled and unpredicted. The lessons of history teach us that a societal collapse is a real possibility and one of the consequences of this would be an abrupt end to the hopes of further technological progress.[3]

One can hope that emerging technologies could help avert this kind of disastrous outcome. For instance, the only renewable energy source that realistically has the capacity to underpin a large-scale, industrial society is solar energy. However, current technologies for harvesting this are too expensive and cannot be produced on anything like the scales needed to make a serious dent in the world's energy needs. Nevertheless, there is a real possibility that nanotechnology will change this situation, making possible the use of solar energy on very large scales. Other developments – for example, in batteries and fuel cells – would allow the storage and distribution of this energy, while we could anticipate a further continuation of the trends that allow us to do more with less, reducing the energy input required to achieve a given level of prosperity.

Computers will continue to get faster, with the current exponential growth of computing power continuing for perhaps ten more years. After that, we will rely on new developments in nanotechnology to maintain this trajectory. Less obvious, but in some ways more interesting, will be the ways computing power becomes seamlessly integrated into the material fabric of life. One of the areas this will have an impact on is medicine. Developments in sensors should lead to the earlier diagnosis of diseases and the tailoring of treatments to the particularities of an individual's biology. Additionally, therapies will become more effective and less prone to side-effects, thanks to

nanoscale delivery devices for targeting drugs and the development of engineered replacement tissues and organs.

In this context, perhaps our most optimistic goal for the next fifty years should be that these emerging technologies contribute to making a prosperous global society on a sustainable basis. A steady world population should universally enjoy long and pain-free lives at a decent standard of living. This would need to be underpinned by sustainable technologies, in particular renewable energy from the sun. It might also be supported by a ubiquitous (but largely invisible) infrastructure of ambient computing, distributed sensing, and responsive materials.

Yet, for some, this level of ambition for technology is not enough. Instead they seek transcendence through technologies of human enhancement, thus bringing about our transfiguration to qualitatively different and superior types of beings. It is the technological trends we have discussed already that are invoked to support this view, but with a particularly superlative vision of the potential of technology.[4] For example, there is an extrapolation from the existing developments of nanotechnology, via Drexler's conception of atom-by-atom nano-manufacturing (Drexler 1987, 1992), to a world of *superabundance*, in which any material object is available at no cost. From modern medicine and the future promise of nanomedicine, there is the promise of *superlongevity* – the idea that a 'cure' for the 'disease' of ageing is imminent, and the serious suggestion that people alive today might live for a thousand years (De Grey and Rae 2007). From some combination of the development of ever-faster computers and the possibility of the augmentation of human mental capabilities by implants comes the idea that we will shortly create a greater than human intelligence, either as a purely artificial intelligence in a computer, or through a radical enhancement of a human mind. This *superintelligence* is anticipated to be the greatest superlative technology of all, as by applying its own intelligence to itself it will be able rapidly and recursively to improve all these technologies, including its own intelligence. This will lead to a moment of ineffably rapid technological and societal change called, by its devotees, the *Singularity* (Kurzweil 2006).

The technical bases for these superlative predictions are →

strongly contested by researchers in the relevant fields.⁵ However, these responses have not had a great deal of impact on the vehemence with which such views are held by those (largely online) communities of transhumanists and singularitarians for whom these shared beliefs define a shared identity. The essentially eschatological character of singularitarian beliefs is obvious - it is this that is well captured in the dismissive epithet '*the rapture of the nerds*' (MacLeod 1998). While some proponents of these views have a rational, atheist outlook (Bostrom 2003) others are explicit in highlighting a spiritual dimension to their belief, in a cosmological outlook that seems to owe something, whether consciously or unconsciously, to the Catholic mystic Teilhard de Chardin. For example, consider this quotation from Ray Kurzweil's *The Singularity is Near* (389):

> Evolution moves towards greater complexity, greater elegance, greater knowledge, greater intelligence, greater beauty, greater creativity and greater levels of subtle attributes such as love. In every monotheistic tradition God is likewise described as all of these qualities, only without any limitation: infinite knowledge, infinite intelligence, infinite beauty, infinite creativity and infinite love, and so on. Of course, even the accelerating growth of evolution never achieves an infinite level, but as it explodes exponentially it certainly moves rapidly in that direction. So evolution moves inexorably toward this conception of God, although never quite

reaching this ideal. We can regard, therefore, the freeing of our thinking from the severe limitations of its biological form to be an essentially spiritual undertaking.

Belief in the singularity, then, as well as being a symptom of a particular moment of rapid technological change, should perhaps be placed in that tradition of millennial, utopian thinking that has been a recurring feature in Western thought for many centuries.

Perhaps the main sin of singularitarianism is best articulated as the commitment to technological determinism. This is the idea that technology has an autonomous, predictable momentum of its own, which proceeds largely beyond social and political influence and that societal and economic changes are governed by these technological developments. It is the everyday observation of the rapidity of technological change that gives this view such force. For instance, what keeps new, faster computers appearing in the shops on schedule is Moore's law. This is the observation, made in 1965 by Gordon Moore, the founder of the microprocessor company Intel, that computer power is growing exponentially, with the number of transistors on a single chip roughly doubling every two years. To futurists like Kurzweil, Moore's law is one example of a more general rule of exponential technological growth. However, to give Moore's observation the name of a law is to mistake its character in fundamental ways. Indeed, it is less a law than a self-fulfilling prophecy, a way of coordinating and orchestrating the deliberate and planned action of the many independent

actors in the semiconductor industry and in
commercial and academic research and development, in
the pursuit of a common goal of continuous
incremental improvement in their products. Moore's
law is not a law describing the way technology
develops as some kind of independent force. Rather,
it is a tool for coordinating and planning human
action.

In conclusion, it is necessary to recognize that,
contrary to the assumptions of technological
determinism, there is no guarantee that technology
needs to advance at all. Rather, the precise
character of its development over time depends on a
set of stable societal and economic arrangements that
are not by any means guaranteed. If there is a
collapse of society due to resource shortage or
runaway climate change, that will bring an abrupt end
to Moore's law and to all kinds of other
technological progress. A more optimistic view
arises precisely when one recognizes that technology
is not an external, autonomous force, but is a
product of society. As such, our aspiration should be
that it is directed by society to promote widely
shared societal goals.

REFERENCES

Bostrom, N. (2003). 'The Transhumanist FAQ'. Available
at: http://www.transhumanism.org/resources/faq.html
[last accessed 3 July 2008]
Diamond, J. (2005). Collapse: how societies choose to
fail or succeed. New York: Viking
Drexler, K. E. (1987). Engines of Creation: the coming
era of nanotechnology. New York: Anchor
Drexler, K. E. (1992). Nanosystems: molecular
machinery, manufacturing and computation. New York:
Wiley
De Gray, A. and Rae, M. (2007). Ending Ageing, the
rejuvenation strategies that could reverse human
ageing in our lifetime. New York: St Martins Press
Jones, R. A. L. (2004). Soft Machines: nanotechnology
and life. Oxford: Oxford University Press
Kurzweil, R. (2006). The Singularity is Near: when
humans transcend biology. New York: Penguin
MacLeod, Ken. (1998). The Cassini Division. New York:
Tor Science Fiction.
Smil, V. (2008). Energy in Nature and Society.
Cambridge, MA: MIT Press
Warner, H. et al. (2005). 'Science fact and the SENS
agenda'. EMBO reports 6, 11, 1006-08. Available at
http://www.nature.com/embor/journal/v6/n11/full/740055
5.html [last accessed 4 August 2008]

(Endnotes)
[1] For an overview, see Jones (2004).
[2] An excellent overview of the role of
energy in modern society can be found in
Smil (2008) on which the subsequent
discussion extensively draws.
[3] This point is eloquently made by
Diamond (2005).
[4] This characterization of the
'Superlative technology discourse' owes
much to Dale Carrico
(http://amormundi.blogspot.com).
[5] See, for example, the essays in a
special issue of IEEE Spectrum: 'The
Singularity: a special report', June
2008
(http://www.spectrum.ieee.org/singularity),
including my own piece, 'Rupturing the
Nanotech Rapture'
(http://www.spectrum.ieee.org/jun08/6271).
For a critique of proposals for radical
life extension, see Warner et al.
(2005).

"To Trinity, With Love" (2007)
Trinity Series, Claudia X. Valdes

This performance and photo series is created at the Trinity Test Site, White Sands
Missile Range, New Mexico; ground zero of the first ever atomic bomb test. Some
performances and photographs are based on the 1951 "Duck and Cover" film and function
as a close examination of the film through re-enactments near ground zero. Others are
set at the McDonald Ranch [construction site of the Trinity Test A-bomb], and are
conceived as a 'cinematic-type' with a narrative structure that mirrors pre and post
nuclear discourses — attraction/repulsion pathologies, theories of total atmosphere
combustion as a consequence of atmospheric nuclear testing, and mutation from
radiation exposure. As a whole, the work weaves a complex narrative about nuclear
culture since the 1950s -- one in which anxiety and uncertainty dominates the
social/cultural climate.

CAUTION

RADIOACTIVE
MATERIALS

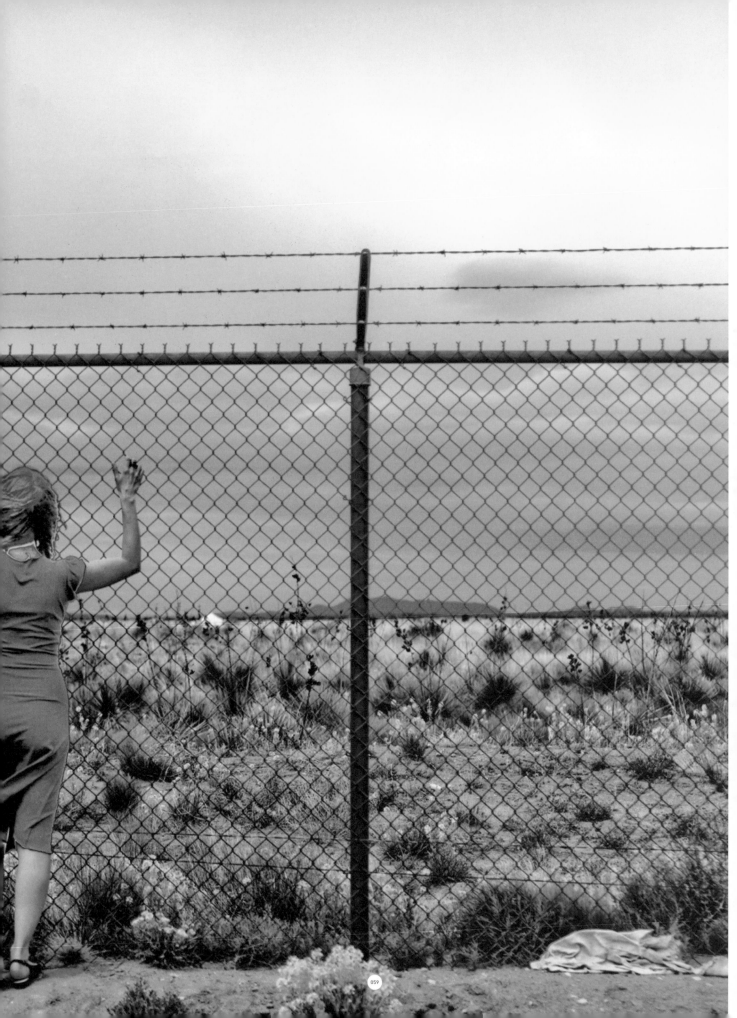

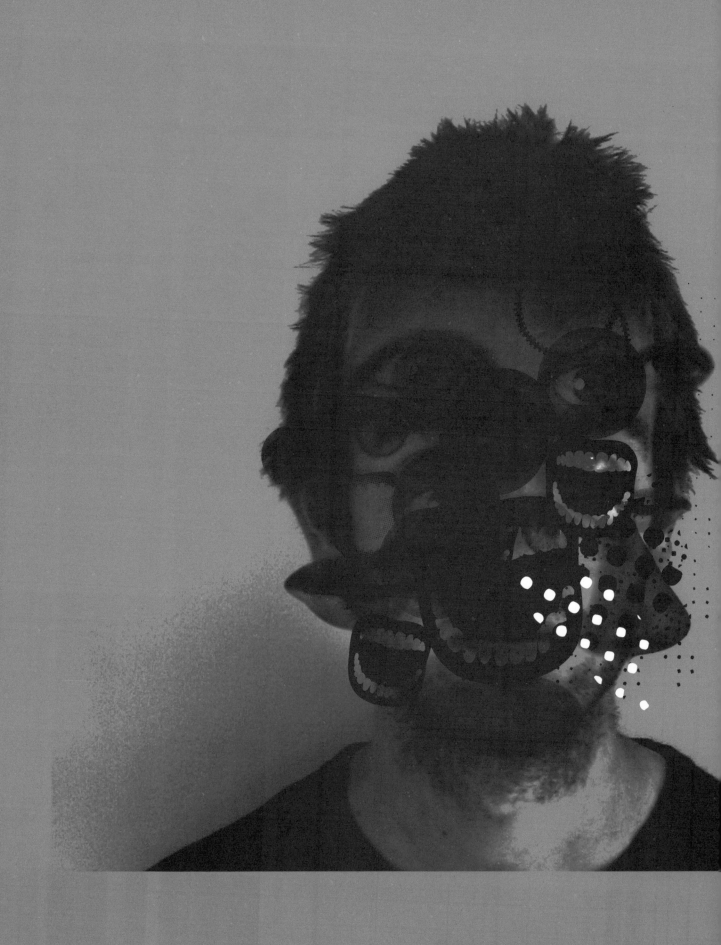

SCREENING FOR UNDESIRABLE GENES: THE EVIDENCE DOLLS PROJECT

ANTHONY DUNNE, FIONA RABY AND ANDY MIAH[1]

4240 Words /1.6 Visions /Human Futures

How will dating change when DNA analysis can reveal the presence of undesirable genes? This question arises amidst the emergence of genetic screening and testing, which have already been debated in the context of paternity testing and sex selection (HFEA 2003; HGC 2006). The prospect of selecting desirable genes is also integral to debates about the legitimacy of selecting out genes that are, for various reasons, considered undesirable. Many debates in this area centre on the ethical and legal implications of such prospects, focusing on matters of discrimination and broader social divisions that might arise from such practices.

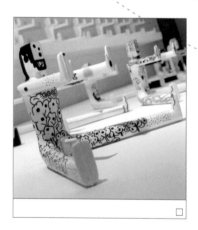

However, very little research has investigated how choices to select for non-health-related or aesthetic genetic characteristics might be made. In part, this lack of research is due to the absence of communities where such decisions have been taken. As yet, most choices to select for specific genetic characteristics remain exclusively restricted to cases where the aim is to avoid passing on serious illnesses, and even in these cases the liberty to undertake such procreative decision making is controversial. Moreover, it is not at all clear how people go about deciding what to do in such circumstances. To this end, understanding how people would make lifestyle decisions - such as who to date - on the basis of knowledge about various types of genetic characteristics is even further lacking in evidential support.

Debates about the morality of such decision-making occupy a contested space of scientific knowledge, where the notion of aesthetic genes is seen as dubious either because such characteristics are not possible to isolate, or because many of our phenotypic states are not easily divorced from some health-related claim. Thus, in the context of dating decisions, one might assert sexual attraction as a biological instinct that is informed by an implicit assumption we make about what constitutes a partner who will optimize our flourishing and, perhaps, that of our offspring. While one should not be too strict about this claim or divorce it from the cultural conditions within which human sexuality becomes manifest, the example serves to illustrate how supposed aesthetic choices might also be laden with health-related values.

Evidence Dolls is part of an ongoing investigation into how design can be used as a medium for public debate on the social, cultural and ethical impact of

emerging technologies. It consists of 100 specially designed dolls used to provoke discussion among a group of young single women about the impact of genetic technology on their lifestyle. It caters for the young, female, heterosexual generation who want to take their time and sample many male specimens before making a serious commitment. With so much resting on the genetic compatibility of future offspring, and the pressure to create and maintain a wild, impulsive, sexually charged attractiveness, it becomes essential for the single girl to extract, preserve and collate essential bodily samples. This is critical not only for the purposes of accurate speculation, but also for fuelling romantic fantasies. This market continues to grow and the manufacturers can barely keep up with the demand for *Evidence Dolls*.

These specially adapted dolls offer insurance against future paternity disputes by acting as repositories for lovers' DNA. Each doll is defined by penis size (S, M, L). The original versions were made from white plastic so that features could be noted using an indelible marker, but they now come in a variety of ethnic skin colours. Faces, sent using a 3G phone camera, are printed onto the doll after purchase at no extra cost. This surreptitious method of capturing a facial image is particularly effective following the awkwardness of intimacy between strangers. There is a 'penis drawer' in the doll for storing hair and sperm samples. The hair clipper ring makes hair sampling very easy, while used condoms are the best sperm collectors, although sometimes difficult to obtain. Many guides are available offering advice and tips on extraction and seduction techniques. There are numerous accessories including clothes, fashion accessories, hairstyles, etc.

In this overview of initial findings, four single women reveal details about their lovers - past, present and imagined. We ask them to re-evaluate their previous lovers based on genetic potential, rather than emotional attachment. We provided them with forms to fill in, one per lover. This provided us with starting points for the interviews. They speculated on the implications of DNA on dating in the future. Their thoughts and ideas are captured through edited interviews in the

following pages. *Evidence Dolls*
was originally conceived during an
investigative research project
called 'Consuming Monsters, Big,
Perfect and Infectious'. The
material gathered fed directly
into a notional out-of-town
shopping centre we called Bioland,
one of those huge sheds next to
Ikea and B&Q, selling future
products for a genetically
modified future. The *Evidence
Dolls* would be one of the products
on sale in Bioland. The project
transformed from concept to
experiment through a commission
from the Pompidou Centre, Paris,
in 2005.

The advert used to recruit the
participants reads as follows: →

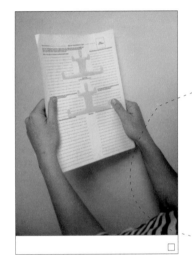

Precursors to such selective
reproductive decision-making have
been visible in such entities as
Ron's Angels which, in 1999,
emerged online purporting to
auction ova and sperm, thus
allowing people to purchase the
best genes for their children. The
voices of our participants here
attempt to inform the speculative
debates about lifestyle genetic
selection decisions with its first
sociological data. Each entry is
preceded by images of the dolls
created by the participants, which
is followed by a reflection on the
lover in question. To conclude,
participants reflect on whether
they would have pursued their
former lover if they had been
aware of his genetic profile.

WANTED: SINGLE WOMEN

SUBJECT: RESEARCH PROJECT

—

IVF, DESIGNER BABIES, DNA ANALYSIS, EMBRYONIC
RESEARCH, CLONES, STEM CELLS, GENE THERAPY.
WHAT DOES IT ALL MEAN?

WE ARE DOING A PROJECT THAT TRIES TO IMAGINE
THE SORT OF IMPLICATIONS THESE TECHNOLOGIES
MIGHT HAVE ON OUR EVERYDAY LIVES. WE ARE
DOING A THOUGHT EXPERIMENT TO SPECULATE ON
HOW DATING MIGHT CHANGE IN THE FUTURE — IF WE
COULD CHECK OUT THE DNA OF POTENTIAL MEN IN
THE DATING GAME AND FIND OUT ABOUT THEIR
GENETIC FUTURE AND THE GENETIC FUTURE OF ANY
POTENTIAL OFFSPRING, WOULD THIS HAVE ANY
IMPACT ON OUR FUTURE RELATIONSHIPS?

WE ARE LOOKING FOR FOUR WOMEN WHO ARE HAPPY
TO TALK CANDIDLY ABOUT THEIR PAST, CURRENT
AND POTENTIAL LOVERS — BY POTENTIAL WE MEAN
THOSE MEN YOU'VE FANCIED LIKE MAD BUT WERE
NOT INTERESTED OR UNOBTAINABLE. THIS PROJECT
IS ABOUT IMAGINING DIFFERENT SCENARIOS BASED
ON OUR OWN PERSONAL EXPERIENCES.

—

LADY 01-(E) 4

MAN 03 - THE PHILOSOPHER

'He is a philosopher, but on an emotional level you couldn't argue with a philosopher.... He is mentally superior but it didn't bother me, but he didn't have anything to say about emotional matters… If you are looking for something why can't you find it in the person you are with?... But he had no sense of style, he hated buying clothes. He had a ten-year-old cardigan that dropped down everywhere. There was definitely some co-ordination missing.... The pose of the doll is not very manly, it's very feminine it says 'Stop! Don't come too close.' But, the legs are open. We see women with open legs. I quite like that idea, that men are the test-tubes for women… Women can be in power in some sense. We can make decisions towards the future; most of the decisions are made by men. Everything is seen as a male point of view. If you could make a race of non-violent men, who never make war, it would be great, because I don't think war comes from women, it comes from the showing off, of men.'

- - - - - - - - - - - - - - -

MAN 05 - PUPU

'When I first saw him I thought 'what kind of mini man is this'. Short men usually find it difficult to find a girlfriend. Smaller men drive themselves more than taller men… He has hobbit feet. He's cute sexy like a teddy bear. He needs some exercise his tummy sticks out. He has beautiful thick blonde hair and blue eyes. I really like that. He's a pretty boy.... I would try and find a hair down the back of the sofa. I don't see it as stealing. It's fallen off him. You can't own something you don't consider belongs to you any more. Normally you find a hair, you think, 'it's disgusting' and throw it away.... I see the doll more like a serious genetic thing, but you may want to modify it, draw on it or dress it up. Then it becomes like a Barbie doll. We still want to play with dolls even when we are grown up.... In the end, you may have too many dolls, they are all staring at you.... it might be a bit freaky.'

- - - - - - - - - - - - - - - -

MAN 06 - Black Dancer

'He's my dream person. He knows his body he takes care of his health I wouldn't be nagging him like a mother.... If I had children, I would like to have mixed features.... He could be a black guy, they seem to like that I'm so white, they come after me. There is an attraction to the opposite. I like the opposite of what I am.... I like the idea of mixing cultural features.... like an Indian with blue eyes, or something like that.... A genetic future seems so far away, even though it may not be. I'm scared of it, if we start to allow things like developing humans outside of nature, what do we become? Even though I can see that physically disabled people have a more difficult life, they have the right to live as well, if this can be taken away, everyone ends up looking the same, I'm more scared that they would start to develop people to be like super people, super beings or something.... I would like to know if they are doing this already. What can they make? Is it that we are not told yet? Everything comes ten years later. Usually the general public know about it at the last moment when everything falls apart. It's too late, you can't do anything about it anymore because it's already here.... I think are we being kept in ignorance?'

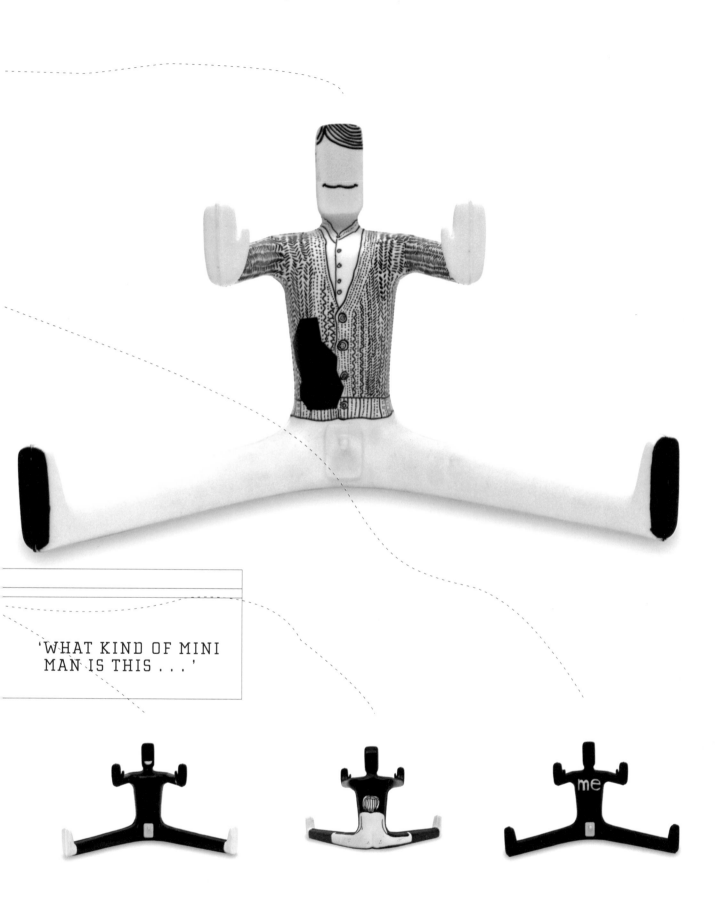

'WHAT KIND OF MINI
MAN IS THIS . . .'

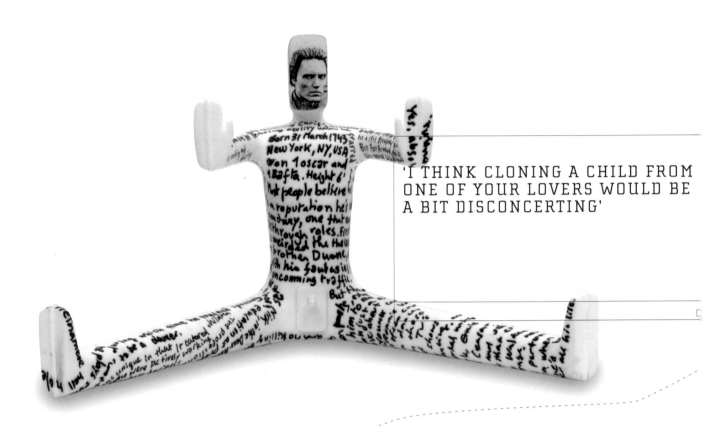

'I THINK CLONING A CHILD FROM ONE OF YOUR LOVERS WOULD BE A BIT DISCONCERTING'

LADY 02 (A) 6

MAN 02 - NED

'He was one of my first loves.... a very beautiful guy.... Deep, deep beautiful brown eyes. But, he's not high up in the genetic rating. He's a bit wayward, not a responsible kind of guy. He's got everything potentially there, but something not quite right about his direction. He seems a bit lost in life.... I don't know if I would make genetic changes, you really are changing the fundamentals and that's a difficult choice. But, if it would ultimately make your life easier and better and less painful, then I would do it.... It would be worrying if you had loads and loads of dolls.... If I had one for every single relationship, there would be lots of them; a cupboard full. It would be difficult having memories around, sometimes that's uncomfortable.... If it was a bad relationship you would probably destroy it; cut it up into little bits, run over it with a steamroller, flatten it. You could have funerals.... that would be cathartic.'

- -

MAN 03 - Josh

'Incredibly good genetically, very symmetrical and beautiful to look at.... It was love at first sight.... I thought he was the one, but he wasn't.... He was in this very cool punk rock kind of thing, and I thought he was adventurous, but actually he was quite empty, a real sheep rather than a leader.

He was a weak person underneath it all.... The arms of the doll are defensive. It says 'Stop! Wait'.... I *would* go and get the DNA stuff tested.... There's something romantic about collecting a hair sample. It's like putting a curl of someone's hair in a locket, there is something lovely about that.'

- -

MAN 04 - Grim

'A lovely lovely man, we met on a blind date.... He was a Buddhist, very gentle, looks a bit like Jean-Michel Basquiat, an artist, a musician, very spiritual, quite wise. He was black, I really liked that. But, I didn't get who he was. I wasn't ready for what he wanted. He had very wiry, tough, tough hair on his arms, it was horrible to touch.... I think cloning a child from one of your lovers would be a bit disconcerting, but if that lover had died, it might be comforting to always have that person around. If he was a really close, close friend, and you brought him back as one of your children, then I think that's all right. Potentially it's a lucrative idea.'

- -

MAN 05 - Famous photographer.

'Very attractive, very charismatic. We had a three-day affair. It's quite weird that someone like that could have such a profound effect on you. He represented everything I thought I wanted in someone, very talented, a very beautiful dynamic guy. But, I

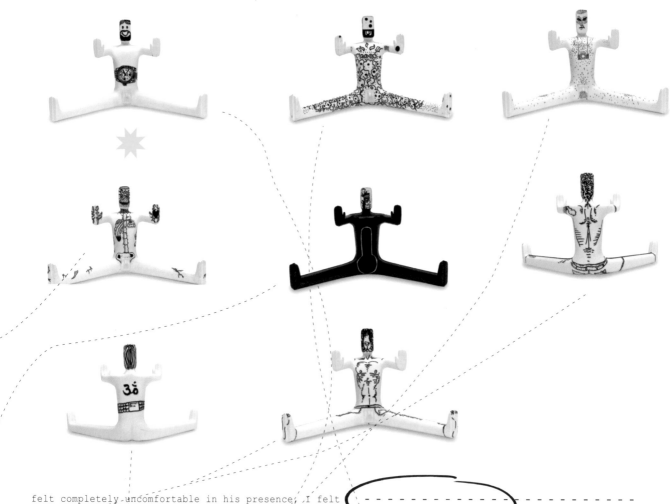

felt completely uncomfortable in his presence, I felt awkward with him. Genetically he's quite perfect. But I don't think he's a nice person when it comes down to it. Very arrogant. A bit too perfect.... I find it quite difficult messing with nature.... But, if you could sample the best of this one and that one and put them together.... Is it tempting fate?.... It's incredibly selfish to want the best and not be happy with what nature gives you. But, if you can do that, why not?.... It's a morally difficult question.... It's a difficult one, I would have to think long and hard about doing it.'

- -

MAN 07 - Jesus

'A real catch, incredibly wealthy, very interesting and very eccentric. A real loner, highly original, quite incredible looking, he really looks like Jesus it's quite odd.... Very exciting, very friendly, dynamic, there is all these great things about him, but there was something missing, he was constantly impatient. He didn't have much time for people, not really very interested in them. He connected with men, but not really with women.... He had a lot of emotional things going on.... If you found out that your lover was genetically perfect for you, I think it would make your relationship ten times better.... But, also if you knew that.... this isn't going to work genetically, I think you would question it big time, even if you were completely in love with him.... Genetically, if there was a problem with having babies with him, that would change my feeling about him strongly.'

- -

MAN 08 - Dr Doobie

'He also looks a little bit like Jesus. Everyone thinks he looks like Jesus. Longish browny, blondy wavy hair he ties back in a bunch and has a big beard and incredible eyes, blue, blue eyes.... He's very conscientious, very honest, very loyal, incredibly intelligent very, very imaginative. He talks about things in an uber-romantic, slightly fantastical way, that slightly scares me at times, and I think 'Do you live in that fantastical world all the time?'.... Genetically, he is really good.... I would be interested to know what my children would be like, but I would hate to destroy the excitement of it. To know in advance what the best potential outcome might be of two people's genes. But, you might be disappointed; you never produce the best.... Maybe you could have virtual children, if you could never have children you could use the information and find out exactly what you could have had. Then you could clone the best one.'

LADY 03 (s)

MAN 01 - Mr Elusive

'We dated for three months but I wasn't feeling it and then I recently found out he was gay.... He was really gorgeous; he had amazing intense blue eyes. They were magnetic and drew you in. But he was very thin. It unnerved me. I want a man to be bigger than me. There was something quite frail about him. I didn't like that.... We got on really well, we had a good laugh. But as a boyfriend he's rubbish. When men are friends they are great, but when they turn into boyfriends they get really selfish. If there was a selfish gene I'd get rid of that one.... I would like to play with the science a bit but I wouldn't want to know everything. You know, have the feeling you could manipulate it too, rather than feel completely controlled by your genes. If you found out too much you might become a slave to your genes. You might NOT want to do certain things. You might have to do all this other stuff to counterbalance the way you are going to be.'

- - - - - - - - - - - - - -

MAN 02 - sexy rexy

'He was Australian, tall and blonde. I don't date blondes. He's the complete opposite of me.... He was fun, into hip hop and DJing. It's nice to see a man being really good at something. He was really cool, really funny. He just wanted to party all the time. He wasn't serious material. There wasn't anything really bad about him… He was just someone to have fun with… I think there should be a database of men's genetic data that women can access, you could look then up on the internet.... Guys are quite desperate to meet women. It's a way of men getting

out there and getting known.... But it would be horrible if the tables were turned. I wouldn't like that at all. I would hate to be judged genetically. Maybe men wouldn't be up for it.... But opposite genes are good for each other aren't they?.... There is no good gene or bad gene is there?'

- - - - - - - - - - - - - -

MAN 03 - The dreamer

'He was absolutely lovely, such a sweet, sweet guy. French, really romantic.... Gushing, sweet and French and he was lovely. He would say the nicest, nicest things. Yes, genetically very good material.... He was a real dreamer, you don't come across people like that. He's not worried about money and jobs and things, but he takes it too far.... I do think he just lazes about.... I thought the doll was going to be soft and I could sleep with it. It's not very cuddly, and I like cuddly.... It's a teddy bear pose, not very human, I've never seen any of my boyfriends sitting like that.... I'd like to keep some samples as keepsakes. It would be nice to have elements of my boyfriend in the doll. I like the idea of having a bit of him.'

- - - - - - - - - - - - - -

MAN 04 - J

'Really talented and artistic and caring.... Just very sweet. Clever, but not too clever. But, he lacked drive, he was stuck in the same thing and couldn't leave.... He was so close to his best friend, they would act really silly together. It was a bit too intense and I always felt there was someone else with us all the time.... I think it would be fun to find out about the genes of potential men, it's a really girly thing to do, you can imagine doing it with your friends. It would be quite a giggle. It's got that element of gossip, which is quite fun.... But, maybe it's an age thing. My 30-year-old boyfriend was ready for marriage and kids, I think the 30-year-old men will be testing out the ladies.... For my age group from 26 to 30 it's a giggle. From 30 to 40, then I think it would become an instrumental tool in finding a good genetic partner. It would become an important part of your life.'

LADY 04 (N)

MAN 01 - DJye

'I was with him for the longest
time and he was the least
suitable. He was quite negative
and prone to depression. I
wouldn't really want that. It's
not a great thing to pass on....
I'd like him to be a bit taller.
He was a bit thin. But he was good
looking in a rugged hairy kind of
way.... dark hair. Very nice skin,
olivey.... I don't think I would
knock out any personality genes;
that's really meddling with
somebody too much. That's making a
judgement.... 'that's a bad one,
that's a good one'. And it's just
my judgement.... And if they are
'potential' personality traits, it
really is a futures gamble that
might not happen. I think
behaviour can change from nurture
without any genetic intervention.'

- - - - - - - - - - - - - - - -

MAN 02 - ONE LOVE

'He was my first boyfriend and we
were quite young. I liked his
ambition. Whatever he does he's
the best at it. He's very money
driven, which I didn't like. But,
there were family pressures. He
was quite conservative. It's a
different approach to mine....
Darker skin, brown eyes, black
hair, good looking.... I think it
does change your whole
relationship if you start looking

at people in that way. Looking
into their genetic futures. I
think people would just be scared
that you would make a decision to
dump them because of something
that is out of their control....
For me, it's not that different to
having your personal horoscopes
done. To see what your life would
be like.... It's a scientific
version.... I think I'd have to
look at my own genes first and
what illnesses I'm going to have.
My mum has been diagnosed with
Alzheimer's. And I'm thinking,
will I have it? I think it would
be good to know about potential
future illnesses in advance. But,
it would be scary.... I might try
and plan my life differently.'

- - - - - - - - - - - - - - - -

MAN 06 - skistar

'He is top of the list genetically
as I think that maybe mixing genes
is stronger. He's Spanish. My mum
always says that, that if you have
children with a partner from a
different background your child
will have stronger genes. I don't
know if that's true. Dark hair,
tanned, brown eyes, smooth skin.
Quite a big forehead.... He has
premature balding, which is not
good. That's a bit of a nightmare.
I would change that. He can be
conservative but I don't think
that's genetic.... but maybe it
is?.... I thought the doll was
like a naked man saying 'no don't
test me'. I like the fact that the

doll isn't wearing clothes. It
like the raw person.... But then,
how would you differentiate
between them especially as mine
all look the same.... There's this
thing of having a lot of dolls
almost like having notches on your
bedpost. It would make sense if
you could log them somewhere else,
maybe online in a DNA account of
some sorts. They would be safe and
more useful as real samples.'

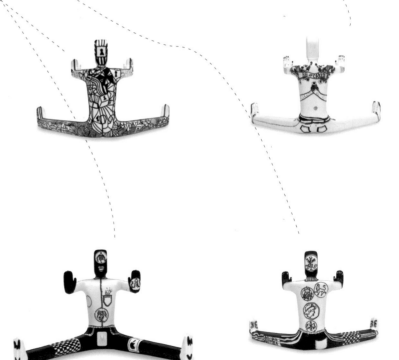

CONCLUDING COMMENTS

While we wish to leave the interpretation of these
findings to the reader, it seems useful to connect
them with more formal, theoretical engagements with
genetic testing. However, beyond this, we emphasize
that this relatively informal inquiry grounds
speculation about future decision-making choices that
people might make in an era of genetic testing for
'desirable' genes within meaningful, lived
experiences. The aim of the inquiry was principally
to engage people with the practice of design as a
route towards understanding how people wrestle with
the moral dilemmas that emerging technologies create.
Here, the various responses from participants situate
this speculative subject matter within a
socio-cultural context, where stereotypes and
prejudices - about height, race, intelligence, for
instance - are made visible through the reasoning
processes.

Equally, they articulate the sophisticated capacity
of people to think critically about the merit of such
choices. Various participants indicate an anxiety
about having too much information and wonder whether
this would inhibit the broader happiness that life
should involve. Similar sentiments are also reflected
in governmental advisory documents on the prospect of
genetic information. Also, clear distinctions are
drawn between physical characteristics and
personality types, along with interrogations over
whether personality can be treated as wholly socially
determined. In various cases, the dolls themselves
became originators of meaning - two of the
participants reacted to the posture of the doll, as
if it communicated something about the subject
matter. This materialization of emerging
technological choices further reinforces how the
project advances from the more established - and
restrictive - methodology of, say, interviewing
participants. The dolls function as the manifestation
of the choice - almost as a BioBank - thus allowing
the dilemma to be felt on an emotional and
non-prescribed level.

While further work should get closer to what participants see as being genetically 'good', this study confirms that such value judgements are made in various ways, which will have a significant bearing on how any such freedom is experienced, should such choices be available.

REFERENCES

Human Fertilisation and Embryology Authority, (2003). *Sex selection: options for regulation.* A Report on the HFEA's 2002-03 review of sex selection including a discussion of legislative and regulatory options.HFEA. Human Genetics Commission (2006). *Making Babies: Reproductive decisions and genetic technologies.* London: HGC.

(Endnotes)
The dolls were illustrated by Åbäke.
Design Team: Dunne & Raby, design assistant Onkar Kular.
Doll Images Dunne & Raby, 2005
Photographic Credits from 'Designing Critical Design' 2007, Z33, Hasselt, Belgium. Curated by Jan Bolen.
Photographer Kristof Vrancken

Project by Dunne & Raby,
text by Fiona Raby and Andy Miah

CONTESTED BODIES

CONTESTED

BODIES

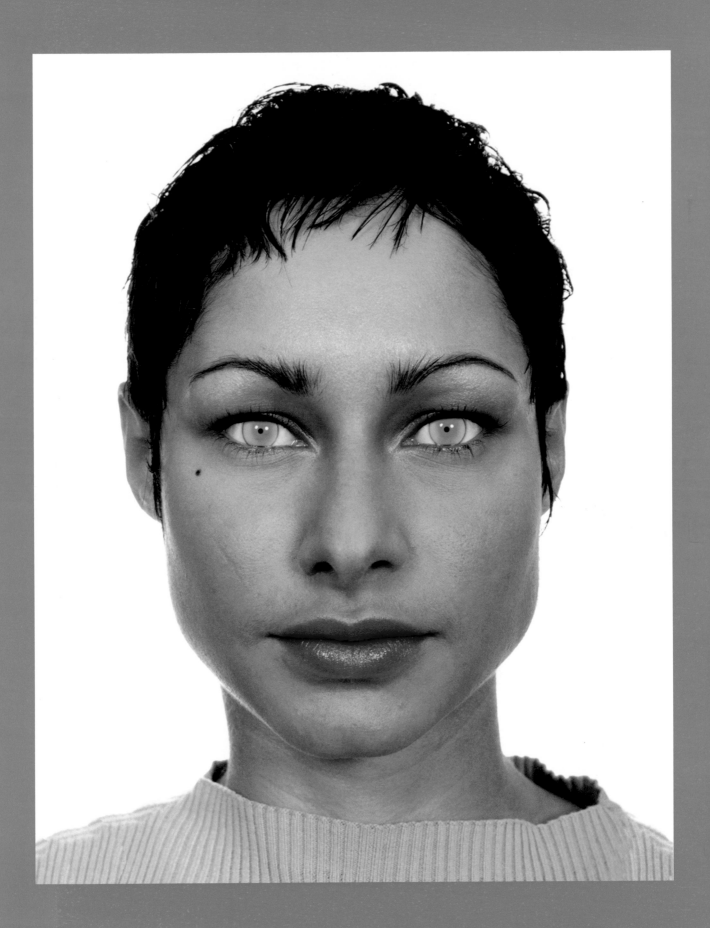

SHAPING THE HUMAN:
THE NEW AESTHETIC

SANDRA KEMP

7603 Words /2.1 Contested Bodies /Human Futures

FUTURE FACE

Knowledge of the face has been building for centuries and today we have increasingly sophisticated ways of understanding, reconstructing and representing it. For instance, scientific progress has led to the development of complex biometric systems to measure, classify and record it. A new computer face-recognition system designed by scientists at University College London can assist in the diagnosis of a range of genetically inherited diseases from variations in facial shape and features (Higham 2007). Also, applications to clone human beings look likely to succeed in the near future thus enabling their replication, and more face transplants will have preceded these possible interventions. Through technological progress, particularly in digital technologies, facial images and representations in film and artworks have become increasingly lifelike. In contrast to their equivalents in analogue, these digital images are now able to exist, develop and replicate without a link back to the living. But, despite all this, in some profound way the face and its relationship to our innermost selves remain unknowable. 'So easy to look at, so hard to define', as Bob Dylan's lyric says.

The fascination and mystery of the face exists in the combination of inner and outer, consciousness and countenance. Faces are thresholds, slender and fragile boundaries, where interior and exterior worlds meet, and which render identity tangible. Perhaps the clue to the continuing mystery of the face and its embedded role in the perception of the self has something to do with the fact that faces have evolved alongside our ability to read minds. Yet we still have such little understanding of the workings of consciousness. Recent scientific research has claimed that mentalizing, or imagining how another person's mind works, is what distinguishes human beings from all other species of animal and that it is an integral part of the complex rituals and power structures of social exchange (Pasternak 2007). It is significant how much we can convey through our faces; they are powerful tools in an increasingly socialized world. There would, after all, be no point in conveying fear, anger, happiness and so on through our facial expressions if no one around us understood or was interested. We could communicate those emotions just as effectively by shouting, laughing or waving our arms around. Elsewhere in the animal kingdom, vocal utterance or gesture appears largely to do the trick. It is possible that the full meaning of the face will continue to evade us until we unravel the workings of human consciousness and have a comprehensive theory of the mind (Dunbar 2004). In this context, it is useful to consider the future of the face, as a complex communication device, as it becomes increasingly subject to modification by emerging biotechnologies.

In the last thirty years there have been rapid advances in the description and analysis of facial structures, textures and movements (Bruce and Young 1998). The human

name: dana_2.0
id no.: da_745482645848-mn
date of birth: 23.1.1999
age: 25
current employment status: genetic engineer
neuro implant year: 2019
chip generation: nx7-2.0
special features: genetically defined liver spot
character traits: reserved, sexually inactive, cyber virgin
enhanced abilities: implant to enhance pain threshold
multiple virtual identity capacity rating: 5
last consciousness file back-up: yesterday

[O] MICHAEL NAJJAR, 'DANA_2.0' (2000, COURTESY OF THE ARTIST)

body has become increasingly permeable and malleable and there are more and more artistic and scientific interventions that invite new questions about identity. The possibilities that exist for extending the boundaries of the self and the limits of our perceptual understanding about the relationships between face and identity, and the potential for re-fabrication, allow us to realize the futuristic fantasies of the past and to project new fantasies. Using technology as an extension of the self, rather than being intimidated by it, permits us to bridge virtual and physical worlds, in turn extending our understanding of what constitutes presence and the ambiguous manner in which identity defines itself. Today, many artists are investigating the convergence of biology and information systems, flesh and data. Through these works, the future is variously imagined as a place that may allow altered existences in locations where living bodies fuse with machine networks and the economy. It might also offer the capacity to engage in a more complex set of emotionally resonant relationships with the machine. To this extent, the self is becoming an increasingly experimental work in progress.

Multimedia artist Daniel Lee expresses some of these ideas through his *Self Portraits I, II, III & IV*, which morph the stages of his facial evolution from pre-history to the future. He says, 'Because technology changes the way we live and the way we create, it also changes the way we look… My eyes shrink as electricity eradicates the need to see in the dark. My brain and forehead enlarge as information expands my mind. My features blend as communication brings cultures closer and closer together – Asian, Caucasian and so on. Only the ears remain the same size because we will never stop needing to listen.' (Lee, 1997)

Through a range of emerging technologies, there is the potential to change, redesign and augment the human face and customize the way we look. This raises new questions about whether our self-image can keep pace with ever-accelerating technological advances, from airbrushing and digital manipulation to cosmetic surgery and whole face transplants. It also compels us to think about what we want from our faces and what we might choose to look like, given such capacity. What are the new facial styles that might affect such choices?

Perhaps the most urgent question about the face is whether it will continue to be shaped by genetics and evolution, or whether scientific and technological intervention will determine its appearance in the future. As digital faces are becoming as 'real' as live ones and transplants, how will our identity be affected and what is the effect of new technologies?

- - - - - - - - - - - - - - - - -

NEW MEDIA IN AN AGE OF SIMULATION

Michael Najjar's series *Nexus Project Part I* uses digital technologies to modify images of the human body and to explore the possibilities now available for its technological transformation.[1] Najjar sees a correspondence between the creation of computer-generated modifications through the process of digitalization and the generation of new life forms through prenatal biotechnological manipulation. The former is characterized by its electronic and algorithmic matrix, which breaks the analogue photographic portrait down into measurable, calculable bits of information with potentially infinite reprogramming capability. Alternatively, biotechnological modifications that are possible in the wake of decoding the human genome sequence allow living

beings to become fragmented into genetic data nodes and then reconstructed.

At first glance, the *Nexus* portraits appear as though they refer to specific individuals, displaying identifiable and 'realistic' faces. This is because Najjar has taken the familiar 'passport' frontal image of the face as his starting point, as we have become accustomed to seeing this as emblematic of the fusion of portrait and person. However, Najjar has superimposed a digitally generated replica on top of the original iris. Thus, upon closer scrutiny, the eyes of the *Nexus* portraits are not 'realistic'. Together with a lack of emotion in the portraits' facial expressions, the modified eyes create a dehumanized appearance, which counterbalances the viewer's initial impression of familiarity with the face.

Ingrained habits of looking will also mean that the viewer will continue to try to both identify with and to 'read' the portrait images. Yet Najjar undermines the viewer's search for personality and character in the portraits by providing an ID card for each portrait. The content of these cards further confirms the sense that the people in the portraits are hyper-real. In the end, we realize that the *Nexus* portraits are new technoid constructs. It is up to us to project an identity on to the surface of their faces. There is nothing beyond what we see in these portraits: their faces are to be taken – literally – at face-value. At the same time, the *Nexus* portraits are so 'real' that the question of how to differentiate between simulation and reality has broken down. The effect is technically uncanny and Najjar's work reminds us that identity is neither integral, nor stable. In the case of both portrait and person, it is located partly in the eye of the beholder.

- - - - - - - - - - - - - - - - -

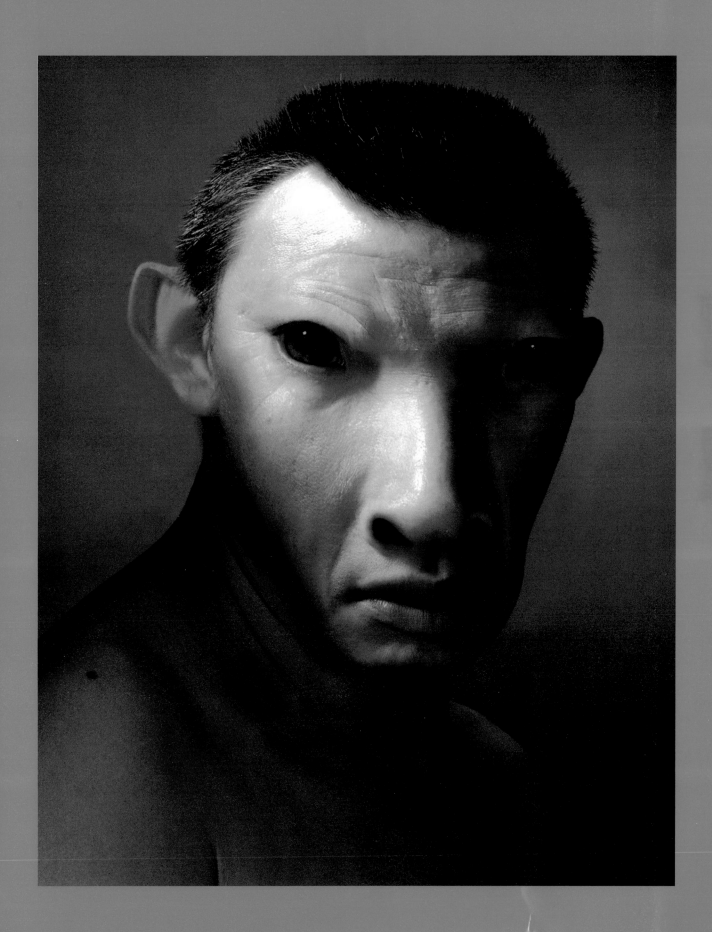

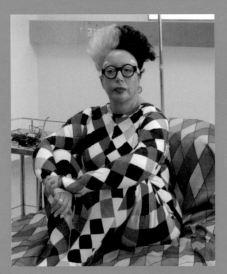

EVOLUTIONARY ENGINEERING

In the 21st century, the mutating boundaries of the body are not just virtual. New and emerging technologies, such as evolutionary robotics, autonomous artificial organisms and biomorphic engineering, are being deployed to embody, rather than represent, virtual beings. These new creative and conceptual manifestations are also used to enhance existing bodies. Medical research has already developed techniques and drugs that will allow for transplantation of animal parts into humans (Cooper and Lanza 2000). Public opinion is currently divided between fear at the prospect of the body's invasion by technology and excitement about the possibility of an augmented human body and mind, created through genetic engineering, cloning, transplants, nanotechnology and so on.

On 30 November 2005 French surgeons successfully performed the first partial face transplant on a 38-year-old woman whose nose, chin and lip had been mauled by her dog (Lichfield 2006). Meanwhile, the neuro-upgrading of the human brain has already begun. For instance, scientists have fused a link between mammalian neurons and silicon chips as a potentially crucial first step in the development of so-called cyborgs that combine silicon circuits with living organisms. Projects that could benefit from this in the long term include the creation of prosthetic brain parts and building organic computers that use living neurons as processing units. The possibility of uploading our brains in new virtual form (like current software upgrades on the computer) is no longer the stuff of science fiction. In the past decade there has been an explosion of knowledge about the brain. In 2003 a report commissioned by the US President's Council on Bioethics explored the potential impact of biochemical drugs that affect the brain; technological implants that could enhance the capacities of the brain; and scanning and diagnostic technologies that could forecast propensities or abilities.[2] Over the coming years it will be increasingly possible to enhance our brains and bodies in terms of structure, function and capabilities, mechanically and electronically. We are already using animals to produce pharmaceutical products and humanized organs, medicines and nutrients. Various bioartists have already begun to articulate these prospects by engaging with the experimental biology that is being developed for such use (Kac 2007; Hauser 2008).

Stelarc, the Australian performance artist, regards the body as 'an object for redesigning'. In the past he has clothed himself with robotic appendages and probed his body with medical sensing devices. Stelarc plays with the idea of extending the body using technology. He writes: 'For me the premise is that if you alter the architecture of the body, you alter the body's awareness of the world and that is what is intriguing. We're at the end of philosophy because our physiology is obsolete. My strategy in terms of redesigning the body would be to hollow, harden and dehydrate it.' (cited in Bennett 1999).[3]

Dianne Harris is another artist who has integrated machines into her works so that they prefigure the fusion of metal and flesh. For over a decade, her interactive female androids have reflected new trends in medical technology in which sophisticated mechanical or biomechanical devices replace dysfunctional body parts and upgrade the human body (pacemakers, stem-cell manufacture and video vision being prime examples).

Harris believes that the robot's superior powers indicate the possibility of upgrading and

replacing different human body parts to such an extent that the recipient could become immortal. Her work suggests that robotic and nanotechnological evolution will rapidly infiltrate culture and civilization. This position may seem extreme but, while conscious machines do not yet exist in reality, their inception may not be that distant. Already, most technologies are advancing exponentially rather than linearly. For example, computer power has increased more than 100 millionfold since the first electronic models were built in the 1950s, and computational neurobiologists such as Terry Schwarb of the University of San Diego argue that the communication power of the entire Internet is now approaching that of the cerebral cortex, the most interconnected part of our brains. At present, the Internet answers only the questions we ask of it, but, like Harris, some believe that it will eventually begin to ask its own questions.

— — — — — — — — — — — — — — — —

NIP-TUCK NATIONS

Like Stelarc, the French performance artist Orlan, who uses surgery on her face as a medium of her art, believes that we are at the juncture of a new world. In her view, however, it is one for which we are neither mentally nor physically prepared. Her performance-operations explore the changing image of the body and the ways in which it has been represented throughout history. Her strategy is to 'Remember the Future' and to look forward by incorporating the past (Orlan 2005).

The precise origins of plastic surgery (from the Greek *plastos*, meaning framed, moulded. modelled) are unknown, but as early as 600 BC a Hindu surgeon reconstructed a nose by using a piece of cheek. With the introduction of anaesthesia in 1846 and antisepsis in 1867, the potential for

surgical transformation of human bodies became a reality.

Bizarre as it may seem to us now, in the 1920s and 1930s the American Viray Papin Blair published images of classical statuary alongside photographs of his patients before and after surgery, citing the attainment of the 'classic Greek' face as the goal of surgery.
In the 21st century the possibilities for future change – social, sexual, economic and political – are also epitomized in images of youth and physical perfection. Today, surgical manipulation of the body is a major growth industry. In some countries it is the fourth largest sector, after property, information technology and tourism.[4] The current technology and the marketing that accompanies it offer clients the chance to copy the faces of celebrities rather than those of classical statues. Advertising companies, television programmes such as I *Want a Famous Face*, *Extreme Makeover* and *Ten Years Younger*, and fashion and lifestyle magazines promote a direct relationship between glamorous youthful looks and happiness and success. Although there are an increasing number of people who equate the right to surgery with empowerment and control over their own bodies, there is also widespread concern about routine changes to facial appearance through cosmetic surgery and possibly even face transplants (Gilman 1998; 1999; 2005: 60-109; O'Connor no date).

On the one hand, then, with due attention to ethical issues, enhancements (surgical, chemical, robotic, genetic) could strengthen mental and physical capacity and lead to a significant improvement in human abilities and the quality of life. At the same time, many people argue that science is imperceptibly influencing and moving the goalposts regarding our perception of what it means to be human. Some scholars go so far as

to say that science no longer safeguards the integrity of the human body, or personal or social identity (Rifkin 1998; Appleyard 1992; Fukuyama 2002). Are we becoming imperceptibly accustomed to the notion that the human body can be harvested and its parts (natural and synthetic) patented and licensed for re-use and repair? As early as 1967 the Nobel Laureate Marsha Nirenberg wrote: 'Man may be able to program his own cells long before he will be able to assess adequately the long-term consequences of such alterations and long before he can resolve the ethical and moral problems that will be raised.' (Miller and Wilsdon 2006: 111)

The Human Genome Project is a good example of the knock-on effect of the new sciences. It started out as a collaborative, 'scientific' project based in biology as a multinational initiative to map the chemical sequences that comprise DNA in each of 23 paired human chromosomes, but an immediate capacity for prediction and social control embodied within the results of the research instantly impacted on insurance law, privacy rights and a number of other matters of key ethical and cultural concern.

In 1990 a Californian court ratified the patenting of the first genes for science by denying an individual, John Moore, property rights over his own body tissues, after he discovered that that the University of California at Los Angeles (UCLA) had patented cells from his removed spleen in 1984 without his knowledge and sued his doctors for malpractice.[5] Meanwhile, as yet, there is no legal consensus on who, if anyone, would own the cloned parts of people. Nor is there agreement on what makes someone a person. In fact, there is no legal definition of how much human material an organism must contain before it is considered human and it appears to become harder and harder to define what makes someone a person. As organs are

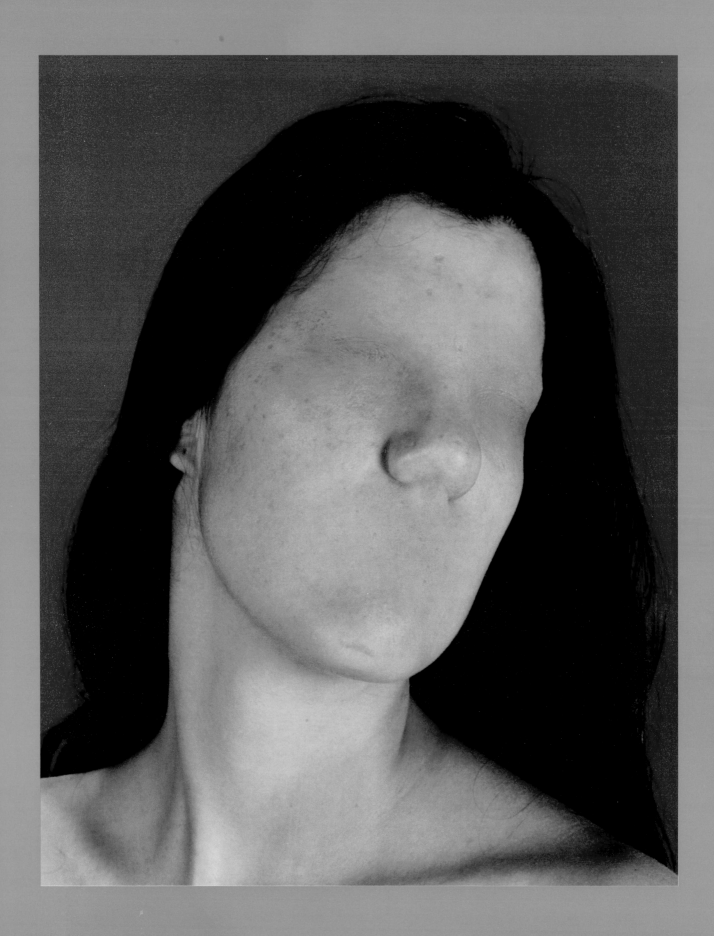

transplanted, and DNA spliced, from human to human and from human to animal, what kinds of relations will we have with these body parts, clones and semi-living objects? Will they alter the integrity of the individual person? Who decides which genes are desirable and how 'normality' will be defined? Will some lives be accorded more rights and more status than others? What will comprise a family? Could it be cross-species, or produced in a laboratory?

In response to the increasing commercialization and traffic of human and animal cells and organs around the world, and pressing questions about who is responsible for their availability and use, a British woman, Donna MacLean, applied for a patent on herself in 1999, claiming: 'It has taken 30 years of hard labour for me to discover and invent myself, and I now wish to protect my invention from unauthorised exploitation, genetic or otherwise… I am not obvious' (MacLean, cited in Meek 2000).

Six years later, the case of Isabelle Dinoir, the world's first partial face transplant patient, became another locus for debate about the control of biotechnological and medical developments. On the one hand, there was speculation about the regulation of the medical team who had performed the operation, on the basis that the imperative to be the first to carry out ground-breaking surgery led to insufficient regard for Dinoir's suitability as a patient. On the other hand, Dinoir's own comments on her transplant raise powerful questions about the relations between aesthetics, technology, body and self-identity. Dinoir describes her operation as a success, resulting in what she calls her 'rebirth' as a human being, while at the same time arguing that: 'As for the face… it's not me. It will never be me… I couldn't look at my old

photographs. It was too painful. Now I have got used to it. Now the graft has become part of me, I am very different from before. Part of me and my identity has disappeared forever. I keep precisely inside me the memory of what I was.' (cited in Bremner 2007)

The loss she feels and describes reflects a widespread belief in the inscription of personality and unique identity on the face. This is also an issue with respect to more routine cosmetic surgical procedures, including chemical face-peels, which strip away the experiential markings of time and memory – smile and frown lines, and so on – as well as the expressive mobility of the human face. In these instances, medical or cosmetic 'success' is dependent on appearance as well as function, and such procedures raise questions about how the future balance of power between the cosmetic and medical sectors will be regulated.

THE REDEFINITION OF BEAUTY

In addition to posing serious challenges to the values we hold, the new sciences interrogate traditional notions of beauty and its significance and some critics argue that this could represent the beginning of a new aesthetic agenda. We are facing a posthumanist future in which new thresholds of perception transcend the visual. Bill Gates reckons that computers will become invisible – integrated into everything we do, no longer adjuncts but worn and then implanted (Gibson 2005). We will live digital lifestyles in 'converged homes'. We are already becoming accustomed to presence and telepresence, and the convergence of the real and the virtual. Most blockbuster films now contain both. In the 21st century user interfaces are

becoming increasingly intuitive and technology more and more sensuous as well as smart.

Technology's extraordinarily rapid development has made the traditional definition and value of beauty, which has been based in classical aesthetic theory, increasingly obscure in both art and science (Anker and Nelkin 2004: 188, 189). Yet, in a world of hidden genetic engineering, visual information is no longer immediate or transparent. For thousands of years our technologies have been aimed outwards at modifying our environment. Now our focus is directed inwards, at modifying our minds and metabolisms. In the 19th century, photography surprised people by showing them what they looked like in an era when mirrors were not commonplace. In the 21st century we are all familiar with our external appearance. But new technologies mean that we are becoming equally well acquainted with the micro-interiors of our bodies, and at making more subtle distinctions between things.

The redirecting of nature by altering our molecular structures has already resulted in a new kind of 'genetic' portraiture. Gary Schneider's *Genetic Self-Portrait* series (1997-98) and Mark Quinn's *A Genomic Portrait: Sir John Sulston* (2001) portray microscopic rather than facial distinction. Neither depicts the traditional portrait of a character in full-face. In the former, images of specimens taken from Schneider's own body are 'harvested' using forms of photo-microscopy. The latter is made from a sample of Sulston's genome sequenced from his semen, which was then replicated in an agar culture, resulting in organic colonies of bacteria, each grown from a single cell containing part of the instructions to grow another Sir John Sulston. Quinn (2007: 309) explains: 'It contains about a million pieces of genetic information, enough to show that→

AZIZ AND CUCHER, 'DYSTOPIA: MARIA' (1994, COURTESY OF THE ARTISTS)

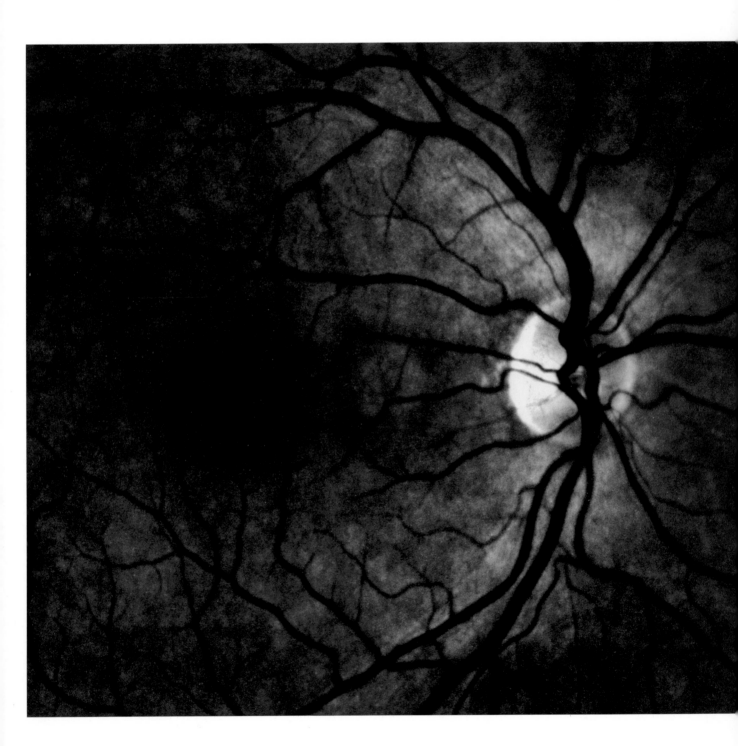

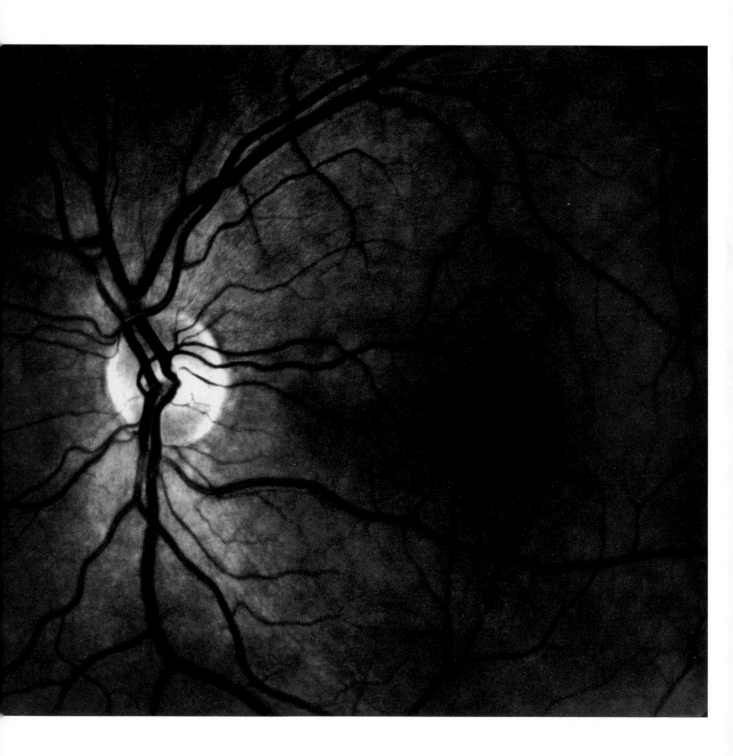

it is John and no one else, but it is also a portrait of every one of his ancestors. And because there are only one in a thousand differences within that information, it is also a portrait of us and our relationship to John, which is why there is a mirrored frame.'

Unlike a conventional representation, this distillation of Sulston's identity in a portrait cannot be seen without a microscope. As one technology becomes obsolete or its effect opaque, so another takes its place. By looking beneath the surface of the face, artists are disrupting the expressive repertoire and redefining portraiture and the ways in which it is possible to represent personhood or individual identity. As Schneider explains: 'I don't believe the face can really show us much on the surface of it… so I found another way to make a portrait that would break through the camera face' (cited in Kao 2004: 107-09).

An increasing number of artists are also using biology as a medium to make semi-living artworks (genetic or transgenic art) and/or synthetic ecospheres in which computer-generated image worlds mirror the processes of life. Such works explore the complex relations between biology, ethics and technology and challenge received notions of nature and culture. Recent exhibitions such as *Paradise Now* at Exit Art in 2000, *Designer Bodies* at Stills Gallery in 2004, *Arts Catalyst* commissions with *Symbiotica*, projects by the *Critical Art Ensemble, Art and Genomics* in Amsterdam, and Jens Hauser's exhibition, *Sk-interfaces* at FACT in 2008, also show how the introduction of aesthetics and advanced imaging techniques as components of biology, biomedicine and engineering has led to the 'sculpting' of new human, hybrid and other forms, and to experimental modes of engaging with them (Grau 2003; Hauser 2008).

All of this demonstrates how new technologies result in new strategies for representation, which in turn lead to the need for new forms of interpretation. Images have always been vibrant shapers of knowledge, and the knowledge we abstract from the body continues to be one of the most powerful ways in which we define and transform our sense of what it means to be human. As the surgeon, Sir Charles Bell, explained in his anatomical textbook, *Essays on the Anatomy of Expression in Painting*, published in 1806: 'I have often found it necessary to take the aid of the pencil, in slight marginal illustrations, in order to express what I despaired of making intelligent by the use of language merely; as in speaking of the forms of the head, or the operations of the muscles of the face.' (Bell 1824: xvii)

1n 2008 *Glassworks*, a team of British animators, created a computer-generated model of a human heart so realistic that doctors claim it could transform surgical training. In an interview with *The Times*, Philip Bonhoeffer (cited in Alberge 2008), chief of cardiology at Great Ormond Street Hospital for Children, said: 'The pictures and graphics do so much more than words in the teaching of anatomy'.

Images and metaphors have always played an important role in the generation of both knowledge and understanding; providing, on the one hand, visual metaphors for the role that new technologies play in our lives and, on the other, new knowledge and discovery through the process of visualization. Moreover, traditionally, the arts and humanities have been both reflective and reflexive in thinking about change - directly and indirectly - re-orientating our questions and using linguistic and sensory awareness, verbal and visual aptitude and draughtsmanship as powerful conceptual tools.

In the 21st century's technoscientific and cultural reshaping of life, we are seeing once again the same intimate union of art and science as was made possible in the Renaissance by that period's broad quest for knowledge. Early medical and scientific enquiry adapted its research methods from a culture that was at once hybrid and holistic. Collaborative enterprise sought to unravel the processes of life through the understanding of the structure of matter (and physical laws) and their relation to human consciousness. During the Renaissance in Western Europe, the visual arts were considered equal to other academic disciplines, with their own established *scienza*, or body of knowledge. Today artists and scientists are once again working in partnership to explore the new challenges that our attempts to reconfigure the genetic blueprints of evolution are bringing to traditional notions of the human life-span from conception and birth to ageing and death.

MEDIA-DRIVEN SPACE

In the 21st century contemporary science is also increasingly allowing us to re-imagine and re-design the self as liberated from the constraints of the body. New media have resulted in the development of facial avatars, or virtual people. The word avatar is a term coined within computer gaming to mean a figure or image used to represent, or substitute for, a person. Avatars permit roleplay or interaction with other people online, or in a simulated virtual world. Avatars are designed to incorporate a wide range of behavioural or emotional expression. They can be generated either entirely as computer graphics, or by mapping digital photographs of a real human being onto a virtual three-dimensional model. A personality can be generated through artificial

intelligence, with a menu of attributes and character traits. In some instances, the avatar's potential for perfection makes it seem an attractive substitute for the real. In others, the two are becoming increasingly less distinguishable.

The *virtual* person in immersive virtual worlds prefigures new realms of interaction and experience, time and identity, and new definitions of the material body. This is what the critic Scott Bukatman (1993) calls 'terminal identity' in relation to virtual subjects in postmodern science fiction and film – a perspective shared by the writer Ray Kurzweil, who claims that our future as a species may well depend on merging with our technology (Kurzweil 2002: 182).[6]

Like a number of artists (including Daniel Lee, Michael Najjar, Stelarc and Dianne Harris), French sculptor and digital artist Catherine Ikam uses her artworks as 'prostheses' to access the 'new architectures of perception' made possible by new technology. Her work considers the boundaries between 'real' and artificial faces, how 'new' faces become acceptable, how technologically produced representations have enhanced or diminished our understanding of the face. It also investigates how key ethical issues arise from these, and from other recent psychological and biomedical facial research. Somewhere between original and copy, Ikam's virtual heads remind us that our faces are thresholds. They make us reflect on the relationships between inner and outer, appearance and identity, and about the point at which 'life' becomes 'artificial'. They are a premonition of how human life and media-driven space will develop and integrate in the future. They recast questions that have been asked across centuries and cultures about our continuing fascination with our faces and

bodies, and with their images or representations.

Like all portraiture, Ikam's 'virtual' heads are only (in the novelist Saki's words) 'a dexterous piece of counterfeit life'. However, they are exquisitely beautiful; they meet your gaze, trace your movements around them, and have a profound sense of embodied presence. Autonomous and uncannily lifelike, these electronically captured 'virtual' faces of friends and acquaintances in 3D digital space raise the same questions of presence and absence, body and image, for audiences today as did the earliest forms of photography for their Victorian viewers. As Elizabeth Barrett Browning wrote to a friend of 'that wonderful invention… the Daguerreotype', in 1843: 'It is not merely the likeness which is precious in such cases, but the association, and the sense of nearness involved in the thing, the fact of the very shadow of the person lying there fixed forever' (cited in Henisch and Henisch 1994: 166).

In an interview with Paul Virilio, Catherine Ikam and Louis Fleri describe how in their avatar artworks the face is no longer 'a record' but 'a process': 'The work of art is no longer dependent upon a precise medium to which it is linked once and for all: it can now be considered in a variety of ways. Art now involves not so much the creation of artefacts as that of open fluid systems that are amenable to change. The interactive work of art is not an object but a process whose geometry is defined both by its maker and by those who explore it, creating their own perspectives.' (Ikam and Fleri 1999)[7]

As these works demonstrate, the digitized image is not just a copy or representation (like a photograph or a film). It is a simulation that is neither drawn nor recorded but calculated and

CHARLES BELL, 'THE MUSCLES OF THE FACE' (1824, COURTESY OF THE WELLCOME LIBRARY, LONDON)

PRIMAL PICTURES, 'HEAD AND NECK', ANIMATION (2003, COURTESY OF PRIMAL PICTURES)

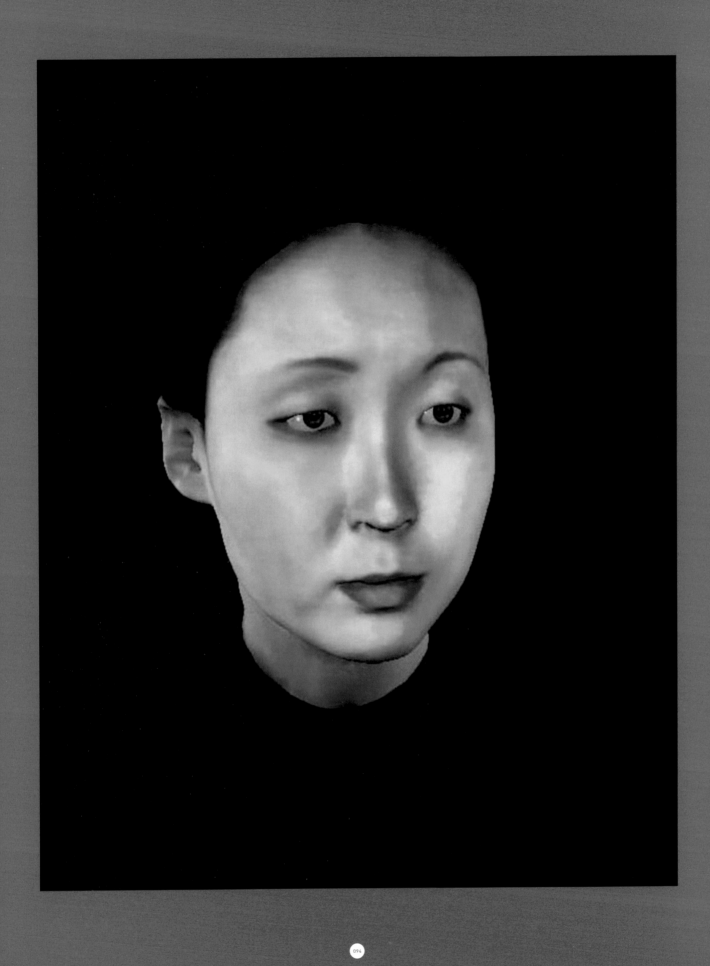

programmed, which leads an independent 'life' of its own, with a potential for autonomous replication and transformation not previously technologically possible. Such works also emphasize the already uncertain boundaries between the 'real' face and the image, and the animate and the inanimate. As Oscar Wilde put it, 'Life imitates Art far more than Art imitates Life'.

Ikam's avatar heads also focus key questions raised about the expanded horizons of the image, its new aesthetic potential in a digital environment, and the relationships between face and identity. As our identities are becoming increasingly mediated by technological filters, we are in the process of relocating the seat of our identity or self beyond the bounds of the physical. One of the new developments of the internet is that is has allowed the body to transcend space, allowing the possibility of numerous self-avatars and thus a multiplicity of different simultaneous identities for each person.

How do the creation and circulation of these identities affect the way we think about the relations between body and 'self'? What kinds of bodies do we select for our virtual selves and how do these digital doppelgangers reflect changing notions of identity in a world more 'simulated' than 'real' or 'physical'. As Grau (2003) points out life is increasingly understood in terms of the evolution of information; technology is producing codes and data that are slowly subsuming the body. As a result of distributed global networks, telepresence, artificial intelligence and relational databases, it is now possible to 'enter' the image, and virtual spaces may soon surpass their current role as entertainment and be considered on a par with what is currently regarded as the 'real' world. Grau describes virtuality as an

essential relationship of humans to images and argues that never before has the way images are produced changed so fundamentally, imagining a future in which: 'The physical body's sensory and communication apparatus will grow together with hardware and software interfaces, and our sex will possibly change to androgynous' (Grau 2003: 291).

CODA: FUTURE FAMILIES

Writing in the *New York Review of Books* in July 2007, Freeman Dyson argued that: 'The domestication of biotechnology will dominate our lives during the next fifty years at least as much as the domestication of computers has dominated our lives during the past fifty years… Designing genomes will be a personal thing, a new art form as creative as painting, or sculpture.' (Dyson 2007: 4)

Dyson's choice of the word 'domestication' reminds us how technology is redefining the basis of what it means to be human. The ability of human beings to survive has always depended upon their potential for adaptation and self-modification in the light of new technologies. Artworks by artists such as Patricia Piccinini and Eduardo Kac contextualize these latest developments through rendering their effects tangible, intimate and personal. In Piccinini's sculpture *Still Life with Stem Cells* (2000) a small girl cares for some fleshy embryonic LUMPS (Life-forms with Unevolved Mutant Properties). In *The Young Family* (2000), another work in Piccinini's *Mutant Genome Series*, a transgenic mother suckles her young with great tenderness. Instead of sensationalizing her futuristic subjects, Piccinini domesticates them. Her work offers the mutant life forms created by the new sciences a human context, reminding us of the social values

the technology produces, and draws our attention to implicit family relationships, and to the qualities of love, nurturing and trust. Piccinini (2008) writes: 'I have created an animal that needs to be looked after, an animal in fact that cries out to be protected… To my mind the fatal flaw that condemns Doctor Frankenstein in Mary Shelley's story is not hubris. It is not that he has sought to, or even succeeded in, creating life from nothing but his own desire and reason. Frankenstein's mistake is that having brought his creature into the world he should also be liable for its life here. He was not a good parent.'

Eduardo Kac's *GFP Bunny* (2000) also explores the impact of scientific developments on family life. This living artwork consists of an albino rabbit, whose DNA has been spliced with that of a Pacific North-West jellyfish into which green fluorescent protein has been expressed. 'How does it feel when the transgenic is your pet bunny sitting in your lap', asks Kac, and adds: 'She immediately awoke in me a strong and urgent sense of responsibility for her well-being'.[8]

Piccinini and Kac focus on the proximity of the consequences of the biological revolution to domestic and daily life. Their emphasis diverts our attention from the technologies themselves to their impact on human values and relationships. Will they moderate our thinking about what makes people distinct from objects or other orders of being as they become a greater part of our lives? How do they change our thinking about people and objects, and about our sense of responsibility to them?[9] Piccinini's *Mutant Genome* artworks and Kac's *GFP Bunny* remind us that it is not just our bodies that are currently changing, but our sensibilities. Personal selfhood is realized through more than outer physical appearances. Future

forms of emotion and attraction will exceed today's in ways we can't yet imagine. We are already exploring some of these prospects with respect to our relations with robots, though what of the moral and spiritual attributes of humanity? How will these change? What place will the great religions of the world have in relation to the effects of human augmentation or enhancement?

In an essay in a publication on 'Cyborg Anthropology', the theorist Donna Haraway explores the 'force of implosion' through technoscience that brings together the 'technical, textual, organic, historical, formal, mythic, economic and political dimensions of entities, action and world'. Haraway (1997: 210, 211) writes persuasively about what she calls 'the border relations' between humans, other organisms and machines, and 'kinship': 'Who are my kin in this odd world of promising monsters, vampires, surrogates, living tools, and aliens? How are natural kinds identified in the realms of late-twentieth century technoscience? What kinds of crossed and offspring count as legitimate and illegitimate? Who are my familiars, my siblings, and what kind of livable world are we trying to build?'

Science fiction has always combined attempting to understand human nature with an ability to anticipate change, to create as well as to contest future possibilities, and to allow us both to survive, and to adapt to, the future. In 1769 the French philosopher Denis Diderot wrote three essays entitled *D'Alembert's Dream* in which he suggested that science would bring the dead back to life and redesign animals and machines into intelligent creatures: 'whose future and final organic structures it is impossible to predict'. More recently, in *The Island of Dr Moreau* (1956: 98, 102), the novelist H. G. Wells' eponymous

protagonist sets out to discover 'the extreme limits of plasticity in human form':

'You begin to see that it is a possible thing to transplant one part of an animal to another, or from one animal to another, to alter its chemical reactions and methods of growth, to modify the articulation of its limbs, and indeed to change it in its most intimate structures.'

Now that these developments are in the realms of the possible, we need to facilitate the increasing rapprôchement of disciplines and the cross-fertilization of conceptual frameworks, discourses and methodologies that accompany them, while maintaining their integrity. There can be no disputing the powerful link between the aesthetic and the material, and between the scientific and the social.[10]

Equally, however, we should be clear-sighted about the drivers for collaboration in the variety of new paradigms for human life and culture, whether these are aesthetic, commercial, ethical, scientific, technological, medical, social or political. 'Is Science the New Art?' asked Sian Ede (2005: 1), Director of the UK Branch of the Gulbenkian Foundation. And, by analogy, are the new forms of bioart and bioart exhibitions ethically sound? 'Dothey embody critical awareness and engender informed debate which impacts upon policy making and discourse? As Christine Paul, curator at the Whitney Museum of American Art, says: 'We are witnessing the emergence of a new type of artist/scientist/reseacher' (Rifkin 2003). Or do the bioarts perform a kind of public relations exercise or 'idea laundering' for corporate science in which the blend of science and art smooths the way to a popular acceptance of new scientific technologies? In an article entitled 'PR for the book of Life', Jackie Stevens quotes a

1997 memorandum written by Burson-Marsteller, the world's largest public relations firm for EuropaBio: 'In order to effect the desired changes in public perceptions and attitudes, the bio-industries must stop trying to be their own advocates. That approach often works in the policy world. It quite demonstrably hasn't worked and won't work in the sphere of public perceptions.'

The memo argues that the bioindustries should advance their cause by proliferating 'symbols eliciting hope, satisfaction, caring and self-esteem' (Stevens 2001). Sponsorship of American genetically themed art exhibitions such as *Paradise Now* and *Genomic Revolution* has been criticized for being propagandist in this regard as well as for concealing corporate allegiance.

Likewise, the cultural history of medicine demonstrates the instrumental role of the media in determining acceptance or rejection of controversial future technologies, such as GM-food, human-animal hybrids, organ transplants and so on (Nathoo 2008). In this context, critics such as Susan Merrill Squiers and Donna Haraway are persuasive about how deeply the narrative construction of our identities inflect the new configurations of disciplines which are extending and transforming the world materially and symbolically. Squier (2004: 9, 11) calls this 'a hybrid and self-reflexive aesthetic' in which 'the stories we tell about our lives - whether fiction or fact - are crucial maps to this shifting ground'. Haraway (1997) calls these 'the stories that inhabit us and we inhabit' which both shape and mediate the world simultaneously. At a conference in 1964, two American pioneers of cardiac transplants warned their colleagues that although human heart transplants were technically possible, 'perhaps the cardiac surgeon should pause while society becomes

accustomed to the resurrection of the mythical chimera' (Meine 2005: 190-96)

Such changes, both in the very composition of the person, and in our classification practices as we catalogue the categories of new orders of being – nano, bio, info, robo and AI – point to the crucial role of the use and ownership of knowledge (as well as the circumstances of its production). What will be included in life's future taxonomies, and what will we choose to classify as life, and on what basis? After aeons of slow evolutionary change, the future of the human being is uncertain.

[1] For a detailed analysis of the 'Nexus' portraits, see Sherin Hamed, 'Identity Reloaded. Digitalization as Metaphor of the Future Other', unpublished essay; Michael Najjar (2005), 'Introduction', *Japanese Style*, Berlin: Bitforms Gallery. I am indebted to both.
[2] See also, 'The DCDC Global Trends Programme 2007-13', UK Ministry of Defence, 2007.
[3] See Also Armstrong (1999) and Dyens (2001).
[4] See http://www.china.org.cn/english/2005/Dec/151005.htm. See also 'China's Beauty Market', Hong Kong Trade Development Council, 4th August 2005, http://info.hktdc.com.econforum/tdc/tdc050801.htm.
[5] John Moore v. The Regents of the University of California, et al., Supreme Court of the State of California, 753 P 2nd 479, 1990.
[6] See also Hughes (2004: 125-6) who notes that 'I would define the human species as that species that inherently seeks to extend our own horizons. We didn't stay on the ground, we didn't stay on the planet, and we're not staying with the limitations of our own biology.'
[7] See also Restany (1991).
[8] http://www.ekac.org/gfpbunny.html.
[9] See Turkle (2005: 294ff) who states that 'Computational microworlds do not teach us what we need to know about empathy, ambivalence, about lives in shades of grey'.
[13] See Stafford (2007: 5): 'I aim to show how neuroscience, cognitive science, and the new philosophy of mind are reshaping [cultural and scientific production] and what share of the humanities might be in this reassessment'.

[O] _ADRIAN, 'FREE ALBA! IN RIO' (2001)

REFERENCES

Anker, S. and Nelkin, D. (2004). *On Beauty in Science and Art. The Molecular Gaze: Art in the Genetic Age*. New York: Cold Spring Harbor Laboratory Press

Alberge, D. (2008). 'Animators give up the gremlins to generate a medical marvel'. *The Times*, 27 March. London. Available at http://www.glassworks.co.uk/ search_archive/jobs/heartworks/heartworks_times.pdf [last accessed 31 July 2008)

Appleyard, B. (1992). *Understanding the Present: An Alternative History of Science*. New York: Tauris Parke

Armstrong, A. (1999). 'Robot Artists', in D. Wood (ed.), *Body Probe: Mutating Physical Boundaries*. London: Creation Books, pp. 21–28

Bell, C. (1824). *Essays on the Anatomy and Philosophy of Expression*. London: John Murray

Bennett, M. (1999). 'Stelarc Interview', in D. Wood (ed.), *Body Probe: Mutating Physical Boundaries*. London: Creation Books, pp. 44–54

Bremner, C. (2007). 'Face transplant made me human again'. *The Times* 7 July. Available at http://www.timesonline.co.uk/tol/news/world/europe/ article2039841.ece [last accessed 31 July 2008)

Bruce, V., and Young, A. (1998). *In the Eye of the Beholder: The Science of Face Perception*. Oxford: Oxford University Press

Bukatman, S. (1993). *Terminal Identity: The Virtual Subject in Postmodern Science Fiction*. Durham, NC: Duke University Press

Cooper, D., and Lanza, R. (2000). *Xeno: The Promise of Transplantating Animal Organs into Humans*. New York: Oxford University Press

Dunbar, R. (2004). *The Human Story: a New History of Mankind's Evolution*. London: Faber

Dyens, O. (2001). *Metal and Flesh: The Evolution of Man – Technology Takes Over*. Cambridge, MA: MIT Press

Dyson, F. (2007). 'Our Biotech Future'. *New York Review of Books*, 19 July

Ede, S. (2005). *Art and Science*. London: I.B.Tauris

Fukuyama, F. (2002). *Our Posthuman Future: Consequences of the Biotechnological Revolution*. New York: Farrar, Straus and Giroux

Gibson, O. (2005). 'Gates unveils his vision of a future made of silicon'. *The Guardian* 20 October. Available at http://www.guardian.co.uk/ media/2005/ oct/28/newmedia.microsoft [last accessed 31 July 2008]

Gilman, S. L. (2005). 'The Astonishing History of Aesthetic Surgery', in Angelika Taschen (ed.), *Aesthetic Surgery*. London: Taschen

Gilman, S. L. (1999). *Making the Body Beautiful: A Cultural History of Aesthetic Surgery*. Princeton, NJ: Princeton University Press

Gilman, S. L. (1998). *Creating Beauty to Cure the Soul: Race and Psychology in the Shaping of Aesthetic Surgery*. Princeton, NJ: Princeton University Press

Grau, O. (2003). *Virtual Art: From Illusion to Immersion*. Trans. Gloria Custace. Cambridge, MA: MIT Press

Haraway, D. J. (1997). 'Mice into Wormholes: A Comment on the Nature of No Nature', in G. L. Downey and J. Dumit (eds), *Cyborgs and Citadels: Anthropological Interventions in Emerging Sciences and Technologie*s. Santa Fe, NM: School of American Research Press, pp. 209–44

Hauser, J. (2008). *Sk-interfaces: Exploding Borders – Creating Membranes in Art, Technology and Society*. Liverpool: FACT and Liverpool University Press

Henisch, H. K., Henisch, B. A. (1994). *The Photographic Experience 1839–1914*. Pennsylvania: Penn State Press

Higham, N. (2007, 10 September). *When Science and Journalism Collide*. BBC News. Available at:

http://news.bbc.co.uk/1/hi/sci/tech/6988088.stm [last accessed: 9 September 2008]

Hughes, J. (2004). *Citizen Cyborg: Why Democratic Societies Must Respond to the Redesigned Human of the Future*. Boulder, CO: Westview

Ikam, C. and Fleri, L. (1999). *Portraits. Réel/Virtuel*. Paris: Mairie de Paris

Lee, D. (1997). *Self-Portraits*. Available at http://www.daniellee.com/S-Portraits.htm [last accessed : 13 September 2008]

Kac, E. (2007). *Signs of Life, Bio Art and Beyond*. Cambridge, MA: MIT Press

Kao, D. M. (2004) *Gary Schneider: Portraits*. New Haven

Kurzweil, R. (2002). *The Age of Spiritual Machines: Why Computers Exceed Human Intelligence*. New York: Pantheon

Lichfield, J. (2006). 'Face transplant recipient Isabelle Dinoir faces the world'. *The Guardian*, 7 February. Available at http://www.independent.co.uk /news/world/europe/face-transplant-recipient-isabel le-dinoire-faces-the-world-465822.html [last accessed 31 July 2008]

Meek, J. (2000). 'Poet attempts the ultimate in self-invention – patenting her own genes'. *The Guardian*, 29 February. Available at http://www.guardian.co.uk/science/2000/feb/29/genet ics.uknews [last accessed 31 July 2008]

Meine, T. J. (2005). 'A History of orthotopic heart transplantation'. *Cardiology in Review*, 13/4, 190–96

Miller, P., and Wilsdon, J. (2006). *Better Humans? The politics of human enhancement and life extension*. London: Demos

Najjar, M. (2005). 'Introduction'. *Japanese Style*. Berlin: Bitforms Gallery

Nathoo, J. (2008). *Hearts Exposed: Transplants and the Media in 1960s Britain*. London: Palgrave Macmillan

O'Connor, E. (no date). 'The Love Song of Plastic Surgery'. Available at http://www.erinoconnor.org/writing/plastics.shtml [last accessed 31 July 2008]

Orlan (2005). 'I Do Not Want To Look Like…: Orlan on Becoming Orlan'. *Women's Art Magazine*, 64, 7

Pasternak, C. (2007). *What Makes Us Human?* London: Oneworld

Piccinini, P. (2008). Quoted in *Retrospectology: The World According to Patricia Piccini*. Available at http://www.acconline.org.au/MediaReleaseRetro spectology [last accessed 31 July 2008]

Quinn, M. (2007). 'Genomic Portrait', in E. Kac (ed.). *Signs of Life, Bio Art and Beyond*. Cambridge, MA: MIT Press

Restany, P. (1991). *Catherine Ikam*. Paris: Maeght Editeur

Rifkin, J. (2003). 'Dazzled by the Science'. *The Guardian*, 14 January. Available at http://www.guardian.co.uk/education/2003/jan/14/hig hereducation.uk [last accessed 31 July 2008]

Rifkin, J. (1998). *Harnessing the Gene and Remaking the World: The Biotech Century*. New York: Penguin Purnam

Squier, S. M. (2004). *Liminal Lives: Imagining the Human at the Frontiers of Biomedicine*. Durham, NC, and London: Duke University Press

Stevens, J. (2001, 26 November). *PR for the Book of Life*. The Nation Company, LP

The U.S. President's Council On Bioethics (2003). *Beyond Therapy: Biotechnology And The Pursuit Of Happiness*. Washington, DC

Turkle, S. (2005). *The Second Self: Computers and the Human Spirit*. Cambridge, MA: MIT Press (first published Simon and Schuster, 1984)

UK Ministry of Defence (2007). *The DCDC Global Trends Programme 2007-13*

Wells, H. G. (1956). *The Island of Dr Moreau*. New York: Random House (reprint 2002)

BIOTERROR AND 'BIOART' – A PLAGUE O' BOTH YOUR HOUSES[1]

GEORGE J. ANNAS

4343 Words /2.2 Contested Bodies /Human Futures

Since September 11, 2001, the threat of bioterrorism has caused the US administration to dramatically increase research funding for countermeasures, including funding for new biosecurity laboratories. The new kind of war against non-state actors who use terror to intimidate populations has also made the creation of new ethical and legal rules for researchers seem critical. New laws have been passed, and there have been proposals for new codes of ethics for bioterrorism-related research. However, seven years after 9/11, the outcome of the development of new research rules remains uncertain.

←

Ethical guidelines for life sciences research that could be related to bioterrorism are critical, and the scientific community should be actively engaged in setting the standards for such research (National Research Council 2004, 2006). As the National Research Council (2004) of the National Academy of Sciences has stated, 'biological scientists have an affirmative moral duty to avoid contributing to the advancement of bio-warfare or bio-terrorism'. It is reasonable for society to expect that scientists will adopt the equivalent of the physician's *do no harm* principle. Arguing for such an oath well before 9/11, literary scholar Roger Shattuck (1996: 224) noted that it could 'help scientists scrutinize the proliferation of research in dubious areas' as well as 'renew the confidence of ordinary citizens' in what is a potentially revolutionary endeavour.

As the debate about the role of ethical standards proceeds, some legal standards have already been adopted. Even with their new legal powers, the Federal Bureau of Investigation (FBI) and Central Intelligence Agency (CIA) have been unable to discover the source of the anthrax attacks, and in 2008 the FBI paid $5.8 million to Dr Steven Hatfill who they had wrongly suspected of being involved in the attacks. Two other biosafety cases have become infamous. Neither of these cases involves bioterrorism, but both illustrate how – in a post-9/11 world – the federal government and the public can be expected to react and even overreact if new biosafety rules are broken in ways that may create a biohazard or public health problem. The first of these cases was Dr Thomas Butler, who was the first and, so far, the only physician-scientist to stand trial in the United States on a bioterrorism-related charge after 9/11. The second relates to the work of Steve Kurtz, artist and professor who was pursued by the FBI, initially under suspicion of bioterrorism.[2]

THE CASE OF THOMAS BUTLER

On 2 January 2006 Thomas Butler completed a two-year sentence that was imposed after a jury trial and upheld by a US Circuit Court of Appeals.[3] The bioterrorism-related facts no longer seem to be in serious dispute. According to his colleagues in the field of infectious disease, Butler has had a long and successful career dating from completion of medical school and residency at Johns Hopkins University at the end of

the 1960s and his service in Vietnam in the Naval Medical Research Unit. He was a faculty member at Johns Hopkins University Medical Center and Case Western Reserve University before becoming chief of infectious diseases at Texas Tech University Health Sciences Center in 1987, a post he held until his trial. His work on plague (*Yersinia pestis*) dates from his experiences treating civilians in the Vietnam War. Most recently, this work involved research in Tanzania, where he and a colleague there compared the efficacy of gentamicin with that of doxycycline in treating patients with plague infection (Murray et al. 2005). The results of this research were published soon after Butler was released from prison (Mwengee et al. 2006).

Butler travelled to Tanzania to help set up the study in 2001, and he returned in 2002 to collect samples of *Y. pestis* taken from the subjects. He returned to the United States with these samples without the required transport permits. In June he drove to the laboratory of the Centers for Disease Control and Prevention (CDC) in Fort Collins, Colorado, to have the samples tested, again without the required government transport permits. In September 2002 he sent a set of plague isolates back to Tanzania in a Federal Express box labelled 'laboratory materials' without the required export permits, and in October he flew from Lubbock, Texas, to Washington, DC (to the Army Medical Research Institute of Infectious Diseases) with plague samples without the required permit. In November 2002, after a series of confrontations over timely documentation of complications and death among subjects in a study of antibiotics for the biotechnology company Chiron, Butler's local Institutional Review Board (IRB) prohibited him from performing research on human subjects.

On 9 January 2003 the board, dissatisfied by his lack of cooperation, reiterated the suspension in an email (Gold 2003). On 10 January he was notified by letter of a formal inquiry into his activities. On 11 January, a Saturday morning, Butler noticed that a set of 30 tubes of *Y. pestis* cultures was missing, and he noted in his journal 'Set 5 missing!' The next day, he wrote, 'Can't explain other than intentional removal, suspect theft' (Enserink and Malakoff 2003). On Monday 13 January he reported to the bio-safety officer at the health centre that 30 vials of *Y. pestis* were missing from his laboratory.

The next day, senior officials at the health centre met and decided to notify the local police and the health department. The police notified the FBI, and more than 60 FBI agents and local police officers conducted an immediate investigation. Butler was questioned by the FBI, and he waived his right to counsel (this waiver is almost always a mistake). He first insisted that he did not know what happened to the samples. However, after failing a lie-detector test (the failure was not admitted in court) and, he says, being told by an FBI agent that if he signed a statement that he had accidentally destroyed the samples (to reassure the public that there was no danger), that would be the end of the matter, he signed a statement to this effect.[4] However, this statement was not the end of the matter. Butler was arrested, spent six days in jail, and then was placed under house arrest.

In April 2003 a grand jury returned a 15-count indictment charging him with various crimes relating to his transport of *Y. pestis,* making false statements to the FBI and tax evasion. Texas Tech also turned against Butler and helped the prosecution reframe the university's contract disputes with him as crimes. In August 2003, after Butler refused to plead guilty in exchange for a six-month sentence, he was charged with 54 additional criminal counts; these included mail fraud, wire fraud and embezzlement arising from Butler's research for two companies (Chiron and Pharmacia-Upjohn, now Pfizer) and concealment of two contracts with the Food and Drug Administration (FDA) from the university.[5] As part of Butler's pay structure, a percentage of his income was provided by the state of Texas and the remainder came from the university's Medical Practice Income Plan, which included money earned from seeing patients, research grants and clinical trials. All money from these sources, with the exception of consulting contracts, was to be remitted to the Health Sciences Center. Butler entered into contracts with both Pharmacia and Chiron in which his fee per subject would be split between the Health Sciences Center and himself. These contracts, the first of which commenced in 1998, continued until August 2001, and they did not come to the attention of the Health Sciences Center until July 2002.[6] Butler voluntarily gave up his medical licence before the trial. After the three-week trial, which included testimony from 40 witnesses, a jury found Butler not

guilty on almost all the plague-related charges (which included lying to the FBI) and not guilty of tax evasion. It did, however, find him guilty on most of the charges related to his split fee contract arrangements (44 of the 54 fraud counts) and on three of the 18 charges relating to the transport of plague samples.[7] He was sentenced to 24 months in prison and three years of supervised release and was charged $15,000 in fines and $38,675 restitution to the university.

He appealed. Five issues were raised on appeal. The two most important of these issues dealt with the possibly prejudicial effect of combining the 'plague counts' with the contract counts and whether there was sufficient evidence of criminal intent relative to the failure to file the required shipping forms for plague samples. Regarding the first issue, the appeals court ruled without much discussion (and arguably without much understanding of how medical research is conducted) that all these counts could be combined because they all had to do with Butler's 'research efforts': 'Butler's handling of plague bacteria as part of his research efforts was ultimately related to his scheme to defraud HSC [Health Sciences Center] by concealing both his contracts with the FDA and the split contracts Butler maintained with the two pharmaceutical companies'.[8] The appeals court also had little sympathy for Butler's contention that the evidence was insufficient to show that he acted wilfully in regard to the only three plague-related charges (of 18) that he was convicted of: first, exporting plague to Tanzania without a licence; second, describing plague as 'laboratory materials' on a Federal Express waybill; and third, violating federal hazardous materials regulations in shipping plague to Tanzania.[9] Regarding the first and third plague-related charges, the court was persuaded that because Butler 'had successfully and legally shipped hazardous materials [during the 1990s] at least 30 times before making this particular shipment' there was sufficient evidence that he knew how to ship it properly and that 'his infraction could not have been due to a good faith mistake or a misunderstanding of the law'. As for Butler's contention that he did not intend to deceive anyone by labelling plague 'laboratory materials', the court accepted the government's argument that he had also certified on the same label that he was 'not shipping

dangerous goods' and that the jury could reasonably conclude that he knew 'that plague was a dangerous good requiring the proper identification'.[10] The US Supreme Court refused to hear his appeal. Dr Butler completed his sentence and is currently seeking a pardon so he can return to medical research.

'BIOART' AND BIOTERRORISM

Shortly after Butler's trial, in Buffalo, New York, FBI agents were called in to investigate a suspected act of bioterrorism in the home of Steve Kurtz, a professor and artist at the State University of New York at Buffalo, whose works involve the utilization and creation of biological matter as a form of political expression. On 11 May 2004 Kurtz awoke to find his wife dead beside him. Kurtz and his wife previously had co-founded the Critical Art Ensemble, an artists' collective 'dedicated to exploring the intersections between art, technology, radical politics and critical theory' (Kurtz cited in Turner 2005: 18). Kurtz liked to distinguish what he did from the emerging field of 'bioart', 'which is perhaps best known to the public because of the notoriety of Eduardo Kac's *Alba*, a rabbit that glowed green because of the insertion of a jellyfish gene, perhaps the world's first transgenic rabbit. Kurtz thinks of bioart as consisting of stunts, whereas his own art explores 'the political economy of biotechnology'(Kurtz cited in Turner 2005: 18). He had previously argued against the introduction of genetically modified food, and he had encouraged activists to oppose it by means of 'fuzzy biological sabotage' – for instance, by releasing genetically mutated and deformed flies at restaurants to stir up paranoia.

On the day of Hope Kurtz's death, the CAE report that:

Police who responded to Steve Kurtz's 911 call deemed the couple's art suspicious, and called the FBI. The art materials consisted of several petri dishes containing three harmless bacteria cultures, and a mobile lab to test food labeled 'organic' for the presence of genetically modified ingredients. As Kurtz explained, these materials had been safely displayed in museums and galleries throughout Europe and North America with

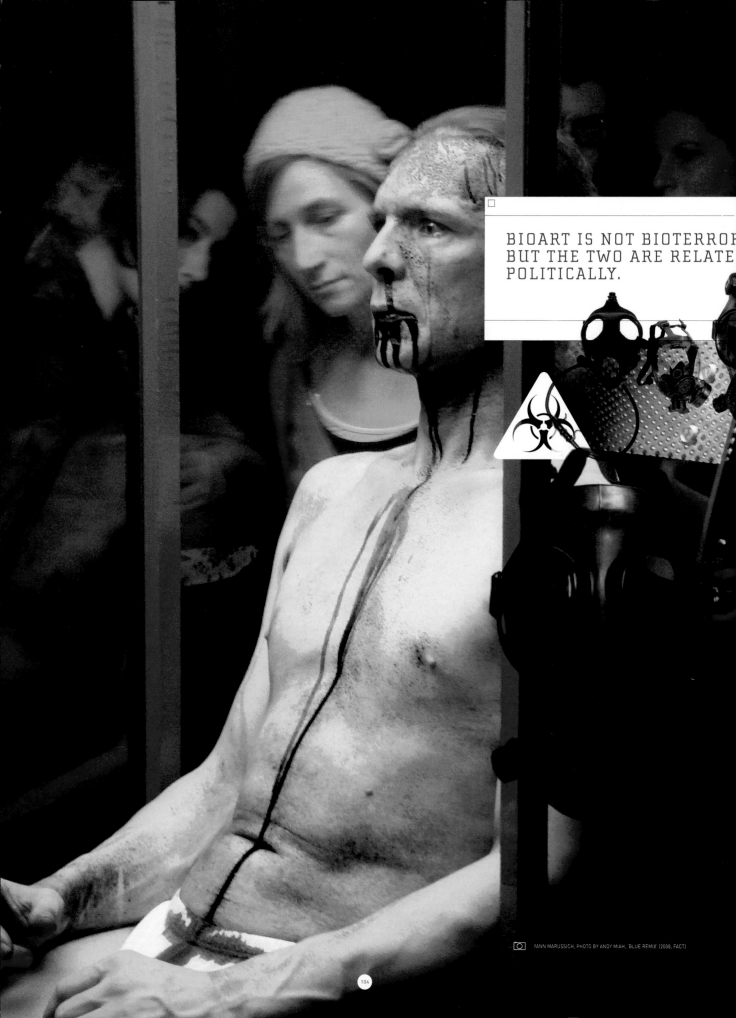

BIOART IS NOT BIOTERROR
BUT THE TWO ARE RELATE
POLITICALLY.

YANN MARUSSICH, PHOTO BY ANDY MIAH, 'BLUE REMIX' (2008, FACT)

104

absolutely no risk to the public. (CAE 2008)

The day after his wife's death, the FBI raided his home in full biohazard gear and informed him that he was being investigated for bioterrorism. Kurtz had been studying the history of germ warfare for a new project. In connection with this project, he was growing bacterial cultures that he was planning to use to simulate attacks with anthrax and plague. He had obtained the bacteria samples (*Serratia marcescens* and *Bacillus atrophaeus*) from a colleague, Professor Robert Ferrell, a geneticist at the University of Pittsburgh Medical Center, who had ordered them for him from the American Type Culture Collection. Kurtz and Ferrell were suspected almost immediately of being involved in a bioterror ring and were thoroughly investigated.

Once the New York Department of Health determined that the bacteria were harmless and that Kurtz's wife had died of natural causes, the bioterrorism investigation was dropped. The Justice Department nonetheless charged both Ferrell and Kurtz with four counts of wire fraud and mail fraud. The allegation was that Ferrell, at Kurtz's request, defrauded the University of Pittsburgh and the American Type Culture Collection by representing that the bacteria samples he ordered would be used in his University of Pittsburgh laboratory (Hauser 2003). Ferrell pleaded guilty to lesser offences under a plea bargain in October 2007 to avoid possible imprisonment. Exactly what Kurtz was planning to do with the bacteria was unclear at the time, but serratia, which is known for its ability to form bright red colonies, has been used in biowarfare simulations in the past. Perhaps its best-known use was a 1950 simulation in which an offshore naval vessel blanketed a 50-square-mile section of San Francisco with an aerosol spray containing serratia to determine what dose could be delivered effectively to the population (Tansey 2004). Whether using a similar technique as an art exhibit would constitute bioart, biotechnology or biohazard (or even bioterrorism) may be in the eye of the beholder even more than in the eye of the artist or scientist. On 21 April 2008 Judge Richard Arcara ruled that the indictment for mail and wire fraud was 'insufficient on its face'[11] and dismissed the case. However, its effects linger for artists in general who wish to pursue such work and for Steve Kurtz

specifically who, in a letter to supporters of his case writes:

> What have I learned from my ordeal? I've learned that with tens of thousands of supporters, with hundreds of thousands of dollars, with one of the best legal teams in the US, with a crack media team, with a group of experienced fundraisers, with four years of one's life, and with total innocence, sometimes one can slice off a piece of American justice. Which in the end means: The overwhelming majority of people ain't gettin' justice, and we have to keep fighting until they do. (Kurtz, 2008)

Bioart is not bioterrorism, but the two are related politically. As bioart curator and commentator Jens Hauser (2003) has said, bioart aims 'at the heart of our fears' and is meant to 'disturb'. He notes, 'these artists expose the gulf between the apologetic official discourse about technoscience on the one hand, and paranoia on the other'. Like defensive and offensive bioweapons research, bioart and biotechnology may be impossible to distinguish by anything other than the researcher's or creator's intent. Thus, GFP Bunny (aka Alba, the bunny with the inserted jellyfish gene) is considered to be and is accepted as a creation of bioart, at least in the contemporary art community; whereas ANDi (the monkey with the inserted jellyfish gene) is considered to be a creation of science, at least in the biotechnology community. Hauser was referring to paranoia in the face of the 'rapid acceleration of technical prowess'.

On the basis of the reaction of federal law enforcement to the actions of Thomas Butler and Steve Kurtz, however, although the advances of biotechnology that have potential applications to bioterrorism and biowarfare are scary, even scarier are the responses – in the name of preventing bioterrorism – of law-enforcement agencies to legitimate scientists and artists whose actions pose no threat to the public. Butler's arrest came about one year after a simulated bioterrorism event in Lubbock, Texas; this simulation involved the use of aerosolized plague at a civic centre (Murray 2005). Simulations have been a centrepiece of efforts to prepare for acts of bioterrorism. As we

should have learned from our obsession with building bomb shelters during the Cold War, however, simulations promote fear of worst-case scenarios and make them look much more likely. Bioterrorism simulations such as Dark Winter (smallpox) and Top Officials (TOPOFF) (plague) involve more art than science and are likely to provoke a response based more on fear than logic. They should probably be classified as bioart in the sense of performance art, and they should have their most socially useful outlet not in federal law-enforcement agencies or biosafety laboratories but in television dramas such as *24*.

BIOTERRORISM AND SCIENCE

The case of physician-researcher Thomas Butler has been the subject of many commentaries - most arguing that his prosecution represents a gross overreaction on the part of federal authorities. Nonetheless, in an article in *Science*, Margaret A. Somerville and Ronald M. Atlas (2005) argued that Butler's prosecution 'sent a clear signal to the research community, especially scientists and university researchers, that all ethical and legal requirements must be respected when undertaking research'. They continued, 'Biosafety regulations are not merely legal technicalities. They constitute some of the terms of the pact between science and the public that establishes public trust.'

Somerville and Atlas are correct to argue that researchers must take law and ethics seriously, and their call for a new code of ethics is reasonable. It would be too broad, however, to suggest either that there are no such things as 'legal technicalities' or that all such technicalities are reasonable. Jennifer Gaudioso and Reynolds M. Salerno (2004) of the Sandia National Laboratories, for example, have argued persuasively that not all pathogens and toxins pose the same risks and that risk in the laboratory should 'be a function of an agent's weaponization potential and consequences of its use' rather than the current assessment of biosafety risk, which focuses on 'infectious disease dangers and the risk of accidental exposure in the laboratory'. They also note that under the regulations of the Uniting and Strengthening America by Providing Appropriate Tools Required to Intercept and Obstruct Terrorism (USA PATRIOT) Act and the Public Health Security and Bioterrorism and Response Act that →

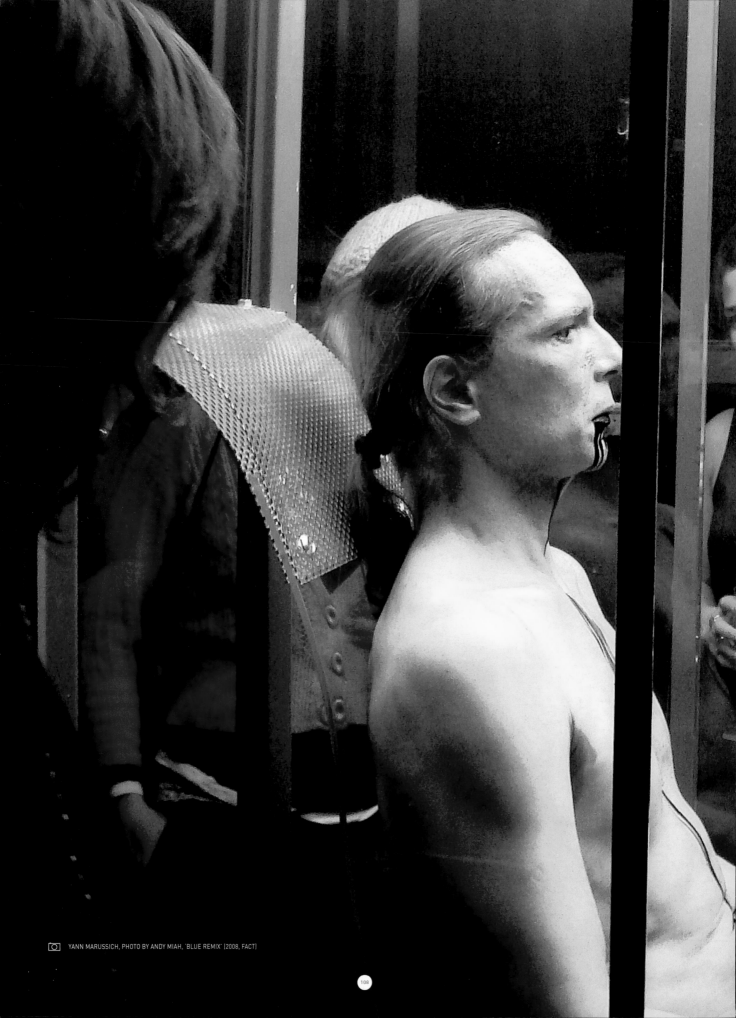

YANN MARUSSICH, PHOTO BY ANDY MIAH, 'BLUE REMIX' (2008, FACT)

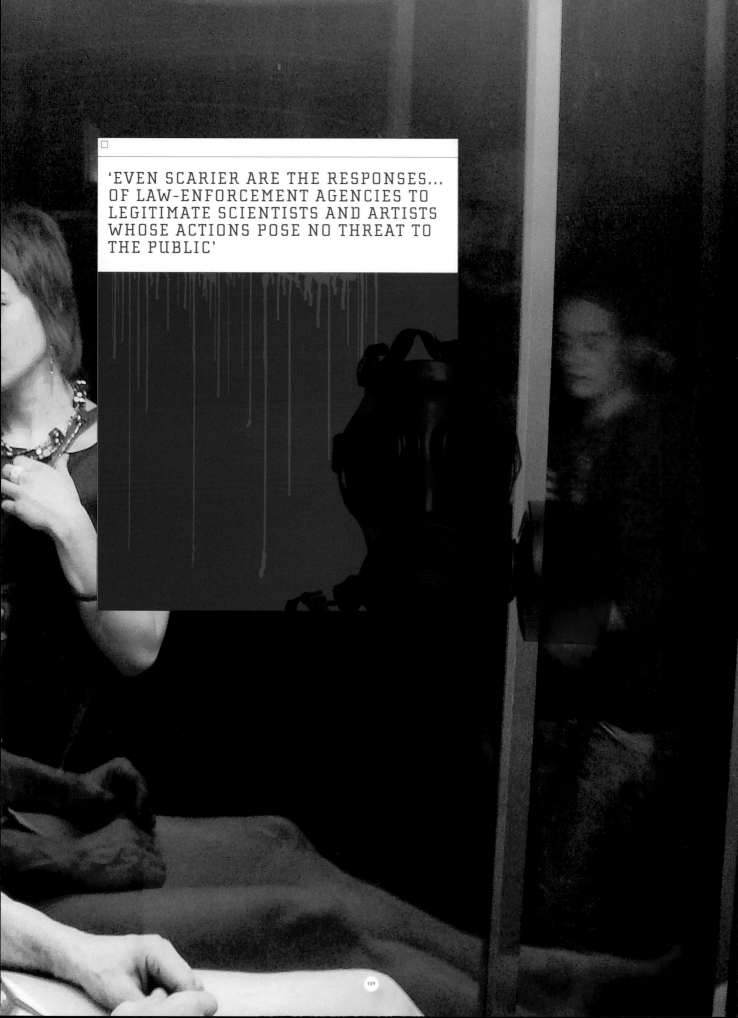

'EVEN SCARIER ARE THE RESPONSES...
OF LAW-ENFORCEMENT AGENCIES TO
LEGITIMATE SCIENTISTS AND ARTISTS
WHOSE ACTIONS POSE NO THREAT TO
THE PUBLIC'

require entities with certain agents to register with the CDC, only 323 of the 817 facilities that the CDC expected to register actually did. Other facilities may register, but many research entities decided to discontinue their research projects, rather than conform to the new federal administrative and security rules for such research. A 2006 National Academy of Sciences report rejects the use of an agent-specific threat list and instead recommends adoption of a 'broader perspective on the "threat spectrum" . . . to ensure regular and deliberate reassessments of advances in science and technology and identification of those advances with the greatest potential for changing the nature of the threat spectrum' (NAS 2006).

Ethics and law are related, but they are not the same. Law draws the line we cannot cross without becoming *outlaws*. Even if we do not like it, we must nonetheless follow it (while working to change it) or risk, as Butler did, being prosecuted for being an outlaw. All Americans, including physicians, should recognize that when the FBI wants to talk to them about their role in a possible bioterrorist event, they should not talk to the FBI without first speaking with a lawyer. Americans can go to jail for violating the law, but not for violating codes of ethics. We aspire to uphold ethics – we deserve praise (at least some) for behaving *ethically*; whereas we deserve none for simply following the law, some of which is in fact made up of 'legal technicalities'.

Because the differences between research on *offensive* biological weapons and research on *defensive* biological weapons are a matter of degree, not kind, and because biotechnology research is an international activity, any evidence that such research is doing more to put the public at risk than to protect the public will (and should) be especially damaging to the entire enterprise. This is one reason why Butler's report of missing plague bacteria (still unaccounted for) could not be tolerated by federal officials who support the expansion of research on countermeasures. It is also what makes Kurtz's bioart so disturbing – the public is confronted with the dark side of bioterrorism-related research, and it provokes a response.

The inherent dual nature of biodefence research has been dubbed the *Persephone effect*, a reference to Demeter's daughter who was forced to spend six months every year with Hades

in Hell so she could live the other half of the year on Earth (Kwik et al. 2003). One reasonable response to the dispute between Butler and the Justice Department and the dispute between Kurtz and the Justice Department could be Mercutio's retort in Shakespeare's *Romeo and Juliet*: 'A plague o' both your houses'. This is because the public is currently more victim and bystander than participant and seems much more likely to be harmed than helped by much of the research. Members of the public recognize this probability, and their scepticism of federal authorities, of the effectiveness of countermeasures, of the existence of weapons of mass destruction in Iraq, and of the entire bioterrorism scare is well illustrated by the few people who took drugs to treat anthrax that were offered after the anthrax attacks (Annas 2005). This same scepticism, combined with the lack of evidence of stockpiles of smallpox in Iraq and the certainty of side effects from the drugs, also explains the small number of health professionals who volunteered to take the smallpox vaccine immediately before and shortly after the commencement of the war in Iraq.

ETHICS, BIOTERRORISM, AND LIFE SCIENCES RESEARCH

Research directed at creating new pathogens or toxins that have direct bioterror or biowarfare applications deserves condemnation. The National Research Council (2004), for example, has identified seven classes of microbial experiments that should 'require review and discussion by informed members of the scientific and medical community before they are undertaken':

- demonstrating how to render a vaccine ineffective
- conferring resistance to therapeutically useful antibiotics or antiviral agents
- enhancing the virulence of a pathogen or rendering a non-pathogen virulent
- increasing transmissibility of a pathogen
- altering the host range of a pathogen
- enabling the evasion of diagnostic and detection methods
- enabling the weaponization of a biological agent or toxin (National Research Council 2004)

If such experiments are undertaken at all, I believe there also should be a requirement for publication of the protocol and public input into the decision.

Research directed at individual pathogens and their weaponization potential also risks the diversion of scientific resources from more important public health concerns (Relman 2006), just as it has seemed to divert the FBI's attention from real terrorists. There appears to be a consensus in the scientific community that the free and open exchange of information is ultimately the best defence to both naturally occurring pandemics and deliberate biological attacks (National Research Council 2006; Wheelif et al. 2006). There is also a growing recognition of the importance of developing an international code of ethics for scientists as well as a recognition that such a code must 'become part of the lived culture' of scientists. Like bioart, the development of this code remains a work in progress.

(Endnotes)

[16] This article updates a paper published by the *New England Journal of Medicine* (2006) for which the author holds the copyright.

[17] It is critical to note that this initial suspicion was dropped and the main part of Kurtz's plight has been to challenge subsequent charges of mail and wire fraud.

[18] United States vs. Butler, 429 F.3d 140 (5th Cir. 2005).

[19] United States vs. Butler, 429 F.3d 140 (5th Cir. 2005) & *The case against Dr. Butler.* 60 Minutes. October 19, 2003 (transcript).

[20] United States vs. Butler

[21] ibid.

[22] ibid.

[23] ibid.

[24] ibid.

[25] ibid.

[26] USA vs. Steve Kurtz. Order 04-CR-01555A. United States District Court Western District of New York

REFERENCES

Annas, G. J. (2005). 'The statue of security: human rights and post- 9/11 epidemics'. *Journal of Health Law*, 38, 319–51

Critical Art Ensemble Defense Fund (no date). Frequently Asked Questions. Available at http://www.caedefensefund.org/faq.html [last accessed 12 July 2008]

Enserink, M., and Malakoff, D. (2003). 'The trials of Thomas Butler'. *Science*, 302, 2054–63

Gaudioso, J., and Salerno, R. M. (2004). 'Biosecurity and research: minimizing adverse impacts'. *Science*, 304, 687 [erratum, *Science* 2004, 305, 180]

Gold, R. (2003). 'With plague fears on rise, an expert ends up on trial'. *Wall Street Journal*, 14 April A1.

Hauser, J. (2003). 'Genes, genius, embarrassment', in J. Hauser (ed.), *L'art biotech*. Nantes: Editions Filigranes

Kurtz, S. (2008). 'A Thank You Letter to Supporters'. Critical Art Ensemble Defense Fund website. Available at http://www.caedefensefund.org/releases/thanks.html [last accessed 13 July 2008]

Kwik, G., Fitzgerald, J., Inglesby, T. V., and O'Toole, T. (2003). 'Biosecurity: responsible stewardship of bioscience in an age of catastrophic terrorism'. *Biosecur Bioterror*, 1, 27–35

Murray, B. E., Anderson, K. E., Arnold, K., et al. (2005). 'Destroying the life and career of a valued physician-scientist who tried to protect us from plague: was it really necessary?' *Clinical Infectious Diseases*, 40, 1644–48

Mwengee, W., Butler, T., Mgema, S., et al. (2006). 'Treatment of plague with gentamicin or doxycycline in a randomized clinical trial in Tanzania'. *Clinical Infectious Diseases*, 42, 614–21

National Research Council (2004). Committee on Research Standards and Practices to Prevent the Destructive Application of Biotechnology, *Biotechnology research in an age of terrorism*. Washington, DC National Academies Press

National Research Council. (2006).Committee on Advances in Technology and the Prevention of Their Application to Next Generation Biowarfare Threats, *Globalization, biosecurity, and the future of the life sciences*. Washington, DC: National Academies Press

Relman, D. A. (2006). 'Bioterrorism — preparing to fight the next war'. *New England Journal of Medicine*, 354, 113–15

Shattuck, R. (1996). *Forbidden knowledge: from Prometheus to pornography*. New York: St. Martin's Press

Somerville, M. A., and Atlas, R. M. (2005). 'Ethics: a weapon to counter bioterrorism'. *Science*, 307, 1881–82

Tansey, B. (2004). 'Serratia has dark history in region: Army test in 1950 may have changed microbial ecology'. *San Francisco Chronicle*, 31 October A7

Turner, C. (2005). 'This is right out of Hitler's handbook'. *Guardian* (London), 20 October 18

Wheelif, M., Rozsa, L., and Dando, M. (2006). *Deadly cultures: biological weapons since 1945*. Cambridge, MA: Harvard University Press

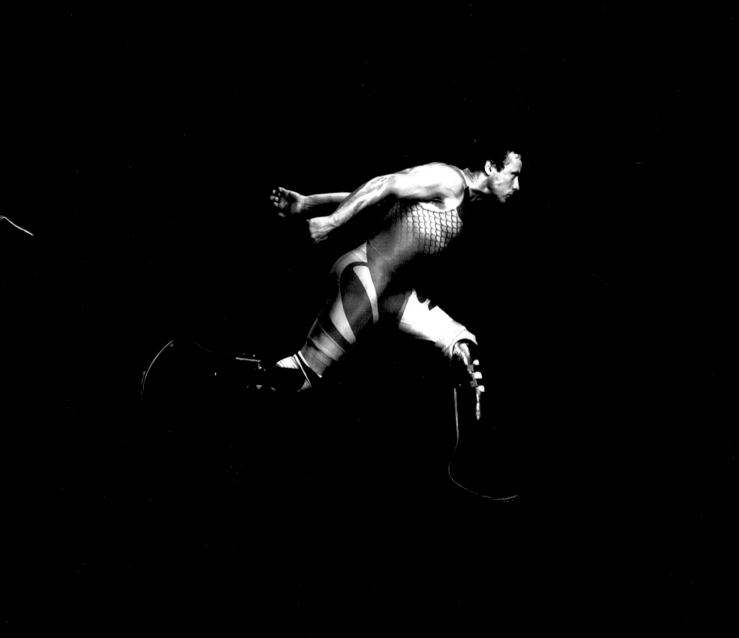

ONE WORLD, ONE OLYMPICS: GOVERNING HUMAN ABILITY, ABLEISM AND DISABLISM IN AN ERA OF BODILY ENHANCEMENTS

GREGOR WOLBRING

4317 Words /2.3 Contested Bodies /Human Futures

'One World, One Dream' was the motto of the Beijing 2008 Summer Olympic Games. According to the webpage the slogan reflects the essence and the universal values of the Olympic spirit – Unity, Friendship, Progress, Harmony, Participation and Dream. It expresses the common wishes of people all over the world, inspired by the Olympic ideals, to strive for the bright future of mankind. In spite of differences in colour, languages and race, humanity is asked to share the joy of the Olympic Games and, together, to seek a more peaceful global condition. It appeals to the idea that people belong to the same world and share the same aspirations and dreams. It emphasizes that 'the whole Mankind lives in the same world and seeks for the same dream and ideal'.[1] As the task of hosting the Games shifts from Beijing to London – via Vancouver 2010 – how do these values stand up in the context of the future of such events? The London 2012 webpage indicates that London 2012 and the Cultural Olympiad will embrace the Olympic movement values of 'excellence, respect and friendship' and the Paralympic movement vision to 'empower, achieve, inspire'.

← 📷 NIKE 'OSCAR PISTORIUS: JUST DO IT' (2007, SOUTH AFRICA)

Moreover, it will demonstrate the following three commitments:

▶ to celebrate London and the whole of the UK welcoming the world – our unique internationalism, cultural diversity, sharing and understanding;

▶ to inspire and involve young people; and

▶ to generate a positive legacy – for example, through cultural and sports participation, audience development, cultural skills, capacity building, urban regeneration, tourism and social cohesion and international links.

(London 2012 website 2008)

London 2012 will also:

▶ bring together culture and sport;

▶ encourage audiences to take part;

▶ animate and humanize public spaces – through street theatre, public art, circus skills, live big screen sites;

▶ use culture and sport to raise issues of environmental sustainability, health and wellbeing;

▶ honour and share the values of the Olympic and Paralympic Games;

▶ ignite cutting-edge collaborations and innovation between communities and cultural sectors; and

▶ enhance the learning, skills and personal development of young people by linking with our education programmes.

(*ibid*)

My work is mainly concerned with the governance of scientific and technological advances and the governance of abilities and ableism (Wolbring 2007; 2008a; 2008b; 2008c). The first area involves anticipating the consequences of existing, envisioned and future science and technology and formulating methods for dealing with them. The second area concerns anticipating the consequences of 'ableism' and 'disablism'. The former consists of existing, envisioned and future privileging of certain abilities that are, or will be, projected as essential while, at the same time, labelling real or perceived deviations from or lack of these essential abilities as a diminished state. The latter concerns the discriminatory, oppressive or abusive behaviour arising from the belief that people without these abilities are inferior to others, disablism (Miller 2004). The direction and governance of science and technology, the governance of the privileging of abilities and the governance and study of ableism/disablism are becoming increasingly interrelated and critical. Moreover, they are linked to the field of disability studies (CDS 2008; Disability and Human Development Department at the University of Illinois at Chicago 2008; Disabilitystudies.net 2008; Society for Disability Studies 2004; Taylor et al. 2003) which covers the problems of both disablism and ableism (Campbell 2001).

How we evaluate, promote or reject different forms of ability influences the direction and governance of scientific and technological processes, products and research and development. The increasing capacity for, demand for and acceptance of changes, improvements, modifications or enhancements of the structure and function of the human body beyond

its species-typical boundaries leads to a changed understanding of oneself, one's body and one's relationship with others and with new forms of ableism and disablism. Sport is one area where these areas converge (Wolbring 2008b). Scientific and technological products, the direction of research and development and changing social concepts, values and ability preferences and expectations continuously generate new sports and influence existing sports. As such, it is pertinent to consider the impact of such developments in the context of, perhaps, the most ideologically informed sports event, the Olympic Games.

THE CULTURAL OLYMPIAD AND SCIENCE AND TECHNOLOGY ADVANCES: SOME QUESTIONS

How do advances in science and technology fit with the 'One World, One Dream' slogan of the Beijing 2008 -lympics and with the values and themes of the London 2012 Cultural -lympiad?[2] Do they strengthen the ideas behind the Beijing motto and the London values and themes or do they threaten them? How can one support the first and minimize the second? This chapter starts with the story of Oscar Pistorius – a Paralympic athlete whose dream is to compete in the Olympics (Wolbring 2008b) – and goes on to outline how external and internal modifications of the body through science and technological products impact on the 'One World, One Dream' slogan and the values and themes of the London 2012 Cultural -lympiad. The chapter concludes by presenting two scenarios between which humanity will have to choose in the future. These scenarios will have different implications for the sustainability of the vision behind Beijing's 'One World, One Dream' slogan and the values and themes of the London 2012 Cultural -lympiad.

OSCAR PISTORIUS: THE FIRST BIONIC ATHLETE, BUT NOT THE LAST

Oscar Pistorius is a South African double below-the-knee amputee who, at the 2006 Paralympic Athletics World Championships, won gold in the 100m, 200m and 400m events and is also the Paralympic world record holder in the 100m, 200m and 400m events. Pistorius was regarded as being fast enough to earn a spot for the 200m and 400m sprints in South Africa's Olympic team (McHugh 2007). As such, Pistorius asked to be allowed to run in the Olympics, if he qualified for his country's team. The world governing body for track and field, the IAAF, ruled on 14 January 2008 – invoking its rule 144.2 which deals with technical aids – 'that double-amputee sprinter Oscar Pistorius is ineligible to compete in the Beijing Olympics because his prosthetic racing legs give him a clear competitive advantage' (Casert 2008; IAAF 2008).

Pistorius appealed to the Court of Arbitration for Sport (CAS), which ruled in his favour, allowing him to attempt to qualify for the South African Olympic team (Associated Press 2008; CAS 2008; Wolbring 2008d). The ruling gave Pistorius the chance to live out his 'One World, One Dream', a dream that for him meant competing in the Olympics. The CAS decision has triggered various responses. For instance, an AFP story notes that 'this decision has no application to the eligibility of any other athletes or any other model of prosthetic limb' (Agence France Press 2008). I disagree with such an interpretation of the ruling. It is right that the positive CAS ruling relates to Pistorius and that the decision does not automatically give 'impaired' people a right to be part of the Olympics. Indeed the

first concern of the CAS was the validity of the scientific data used to claim that the prostheses used by Pistorius give him an unfair advantage over athletes with 'normal' legs. This evidence was rejected by the CAS. As such, Pistorius is allowed to try to qualify for the Olympics, meaning he still has to show a certain level of performance capability. The ruling also indicates that one could exclude a runner with prostheses, including Pistorius, from competing in a 'natural leg' running event if it could be proven that the prostheses led to an unfair advantage. This is a reasonable ethical standard to hold out to maintain a level playing field within sports, which gives meaning to competition. So far the process of evaluating these new prostheses is not sufficiently developed to be called a gold standard, so it is open to interpretation. Once tests are developed that are universally accepted, if they show an unfair advantage for a runner with prostheses, it seems reasonable to expect that such a runner would not be allowed to compete directly against 'biological leg' runners. This does not necessarily mean that such a person could not compete in the Olympics as I show further below. The ruling applies furthermore to other athletes with adequate performance and the type of prosthetic legs used by Pistorius, as long as it is not shown that this prosthesis gives an unfair advantage.

The CAS ruling seems also to give the answer to another question. Do the Olympics principally celebrate the achievements of athletes who have a body that adheres to the norm of *Homo sapiens*? In other words, are the Olympic competitions a mechanism for evaluating athletes with a 'normal biological body'? Can the body structure, as such, be used as a basis to justify the separation between different kinds of

-lympics? The CAS decision can be interpreted to mean that the body structure cannot be used as such a basis. To this extent, the CAS ruling reinforces the view that the Olympics are *not* about normative biological bodies, a view that impacts on the Olympic dream of two types of Paralympian: athletes with artificial body parts and artificial replacements of body parts, and Paralympic athletes who use external tools but have not modified their bodies. The CAS ruling sets a precedent for a Paralympic athlete who seeks to compete in the Olympics, independent of whether certain biological parts are replaced by artificial parts. If the replacement does not lead to a competitive advantage, athletes with artificial body parts can compete against body-normative athletes. If the replacement does lead to a competitive advantage, then one could see the CAS ruling opening the door for a scenario where athletes with artificial body parts compete against each other in the Olympics. The artificial body parts could be treated as internal tools required for functioning and people with the same internal tools would compete against each other. This scenario would be similar to the case of external tools such as a pole used in pole vaulting by species-typical body-normative athletes (Wolbring 2008b). In this context, the ruling also enables Paralympic athletes who use external tools such as wheelchairs, which are already labelled as giving 'unfair advantages', but who have non-normative bodies to perform in their own wheelchair events at the Olympics. The wheelchair would be treated in the same way as poles and other external tools used by the species-typical body-normative athletes. And finally the ruling might also enable so-called 'normal athletes' to use a wheelchair as a tool to permit their competing in wheelchair

events, as long as their body does not give them an unfair advantage. It is interesting that, on a national level in Canada, so-called 'able-bodied are allowed to operate wheelchairs in wheelchair basketball games of the so-called impaired athletes' (Kingston 2008). All these different scenarios that flow from this ruling are of particular relevance to Beijing's 'One World, One Dream' slogan and to the values of the London 2012 Cultural -lympiad. The ruling goes to the core of the segregated structure of the different -lympics.

IF NOT BODY STRUCTURE, THEN WHAT JUSTIFIES SEGREGATION?

The level of performance is often used to justify the segregation of Olympic and Paralympic athletes. The argument to support this view explains that Paralympic athletes cannot achieve the necessary qualification levels for the Olympics without tools that give them an unfair advantage. However, this is a dubious argument. It might justify a Paralympic athlete who does not reach a certain level of performance or outperforms the Olympic athlete due to the use of external tools or bodily modifications being disbarred from performing directly against an Olympic athlete in the same event; however, the argument does not seem to be applicable to the case where the Paralympic athletes perform within their accepted range (whether lower or higher) against each other but within the Olympics. There are Olympic athletes who use external tools that give them an unfair advantage (pole) and they do not have to reach the performance level of the high jumper (without using the pole) before they can perform with a pole in pole vaulting. Although the CAS decision prohibits a Paralympic athlete who outperforms the 'normal athletes' because of some intrinsic enhancements or external tools from competing

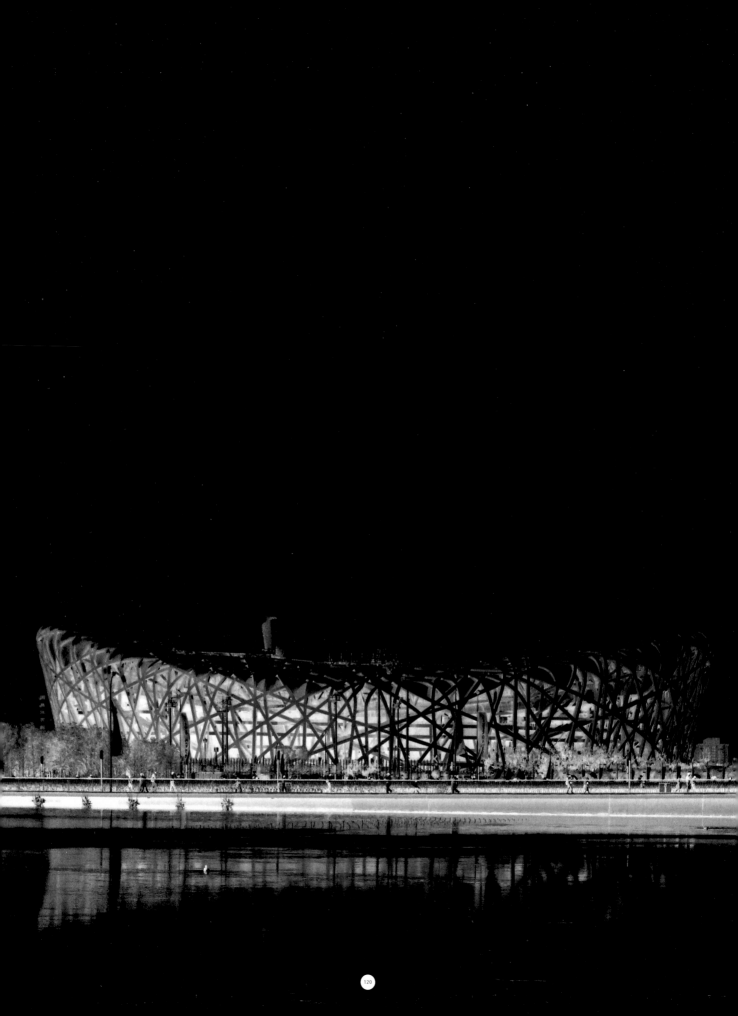

directly against a 'normal' athlete in the Olymics, it does not close off the possibility that Paralympic athletes with intrinsic enhancements or external tools (bionics, wheelchairs and other similar add-ons) could obtain their own event within the Olympics in the same way that pole vaulting is part of the Olympics. If a 'normal' body is not a prerequisite for being in the Olympics, then bionic devices, wheelchairs and other prostheses could be treated as internal and external tools. If one uses a pole, then one cannot compete against high jumpers in the Olympics. However, one can have one's own event, the pole vault (see Wolbring 2008d).

THE FUTURE OF THE OLYMPICS?

The case of Pistorius in 2008 is not unique, and he is not the first Paralympian to compete at the Olympics. One Paralympic athlete who will compete in Beijing is Pistorius' South African peer Natalie du Toit, an athlete who will compete at the Olympics as well as the Paralympics. Du Toit is also an amputee, though a single, through-the-knee amputee who competes without an add-on device. Pistorius remains distinctive due to his utilization of an add-on during his activity; there is still merit in considering his unique contribution to these discussions. In this sense, it is reasonable that other Paralympic athletes beside him will pursue participation in Olympic Games such as London 2012. This situation projects the conditions for future Olympic Games. One can already see various athletes with the same type of prostheses elsewhere and there are futuristic advertisements by mainstream companies that articulate this new vision of ability (Wolbring 2008e). For instance, in 2008 *ESPN* sports magazine ran a cover story highlighting 'bionic' athletes

from different sports (Adelson 2008a; 2008b). We can expect the future to consist of tighter integration between prostheses and the remaining body. Neuro-interfaces (Wolbring 2006) and Bluetooth technology-enabled legs (Shaughnessy 2008) are just two areas in development. Many add-on devices that integrate with the body will become available to athletes, whether 'able-bodied' or not. External tools used by Paralympic athletes such as wheelchairs already out-perform the normal body, with more to come. So-called able-bodied people are already part of wheelchair basketball teams, which consist of mainly 'as impaired' classified athletes (Kingston 2008). This dynamic around internal and external enhancements raises several questions. What is the future for athletes who try their best, but do not want to be enhanced? Do they still have a place in sport? How do we govern scientific and technological advances, societal dynamics and expectations and govern ableism and the privileging of certain abilities changing with advances in science and technology, in sport particularly but also elsewhere?

In the long run we have two options as a society, as spectators. The first scenario involves a continued appreciation of elite performances and neglect of people who simply try their best within their limitations, meaning that we cherish absolute values such as who is the fastest. We will therefore value the people who run the fastest – who would be the enhanced people – and devalue a person who simply tries their best with the body given to them and whose performance – statistically – is inferior to that of enhanced people. Such a position reflects the current system of sports appreciation. If we maintain this form of ableism, it will lead to the following: the

increasing ability of new and emerging technologies to 'improve' and modify the human body (structure, function, abilities) beyond its species-typical boundaries will enable the transhumanization of ableism (Wolbring 2008a), that is, the set of beliefs, processes and practices that perceive the 'improvement' of human body abilities beyond typical *Homo sapiens* boundaries as essential, and treats non-enhanced human bodies as limited, defective and in need of constant improvement. By extension, such circumstances would lead to the transhumanization of the Olympics such that they become an arena for enhanced athletes (internal enhancements or external tools employed by 'as impaired' or 'normal'-labelled athletes). In contrast, the Paralympics might be a forum for the unenhanced, the 'impaired' and 'normal' athletes who cannot compete against their enhanced counterparts. We would have the enhancement -lympics and the non-enhancement -lympics, with the majority of the spectators probably attending the former. The transhumanized form of ableism will not just be employed in sport for the excitement of the spectator. This sentiment will also trespass into the life of the spectator. People will have to use enhancements to be more competitive in a professional or educational setting. The rat race for ever-increasing abilities will continue with no end in sight.

The second scenario would involve humanity's continued appreciation of the pursuit of excellence within whatever framework people find themselves. In this view, we would decide that the value of sport is not constituted wholly by those who have the highest level of cognitive and physical functioning, in absolute terms, but that sport is a celebration of personal bests. This version would require us to abolish ableism as

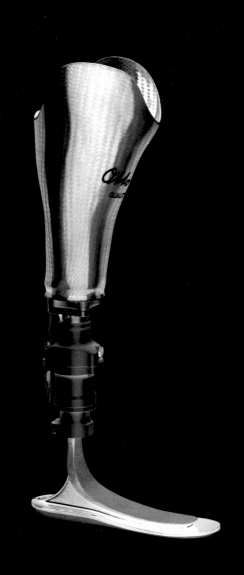

described above. Instead, we would require a global shift in discourses on the governance of ableism and the privileging of abilities about the type of abilities we think are required in our society if we want to flourish as a species. In this context, it is necessary to ask whether a worthwhile life can be brought about by adding the newest gadget to the body for cognitive and physical enhancement.

Alternatively, we might ask whether a good life is more likely to ensue through attention to how people relate to one another, on rewriting the social contract and increasing social cohesion. Which scenario fits best with the spirit of the –lympics, the Beijing motto and the values stated on the London 2012 webpage?

WHICH IS THE BEST (CHEETAH) FOOT FORWARD?

The London 2012 webpage indicates that London's Cultural Olympiad will embrace the Olympic movement values of 'excellence, respect and friendship' and the Paralympic movement vision to 'empower, achieve, inspire'. On the Beijing 2008 webpage we read that

'*One World, One Dream* expresses the common wishes of people all over the world, inspired by the Olympic ideals, to strive for a bright future of Mankind. In spite of the differences in colors, languages and races, we share the charm and joy of the Olympic Games, and together we seek for the ideal of Mankind for peace. 'One World, One Dream' is a profound manifestation of the core concepts of the Beijing Olympic Games. It reflects the values of harmony connoted in the concept of 'People's Olympics', the core and soul of the three concepts – 'Green Olympics, High-tech Olympics and People's Olympics'. While 'Harmony of Man with Nature' and 'Peace Enjoys Priority' are the philosophies and ideals of the Chinese people since ancient times in their pursuit of the harmony between Man and Nature and the harmony among people, building up a harmonious society and achieving harmonious development are the dream and aspirations of ours. It is our belief that peace and progress, harmonious development, living in amity, cooperation and mutual benefit, and enjoying a happy life are the common ideals of the people throughout the world.' (Beijing 2008)

How can the 'One World, One Dream' vision be achieved in the context of ableism as exhibited today and its transhumanized version to come? The 'One World, One Dream' vision has to be extended to include the recognition of differing forms of ability. Which scenario will fulfil the themes and values of London 2012? What inspires and involves young people and what generates a positive legacy? Which scenario ensures health and wellbeing for all? Which scenario ensures honour and shares the values of the Olympic and Paralympic Games? Which scenario enhances the personal development of young people? A change in the organizational structure of the Olympics, the elimination of the different –lympics towards one Olympic Games – fully taking into account the characteristics and needs of the so far different –lympics – might be one way to signify the appreciation of everyone who tries their best.

It is unrealistic to imagine that one can stop the development of enhancement products as long as there is societal demand for competitive advantage. If one watches elite sport only because it involves the breaking of records, rather than sports simply being valued as extraordinary expressions of human struggle, then it will be necessary to consider the outcome of such extreme levels of competition. The enhancement debate is not just a technical discussion to be dealt with through technical rules. It is a development that demands a broad public debate as to what people see as important about their culture, which abilities people consider to be important, and about the global impact of such transformations. It asks for a deep consideration of the governance of ableism and the privileging of certain abilities over others. Spectators will be required to rethink what they expect from athletes, life and each other. Athletes will need to reconsider what they expect from spectators, sport and life.

If athletes use enhancements - not deceitfully but openly – this could have an impact on participation in sport at the grassroots, perhaps excluding some people because of the high cost of enhancements. Yet a further consideration is how enhancements become utilized outside sports. If the public modify themselves, then there is no reason why athletes should not be entitled to follow. In sum, our present assumptions about what is legitimate in sport and outside are currently in turmoil. New ways must be found to prevent a societal disaster looming because of the ever-increasing ability to modify the body beyond species-typical boundaries (Berger 2008). Moreover, all sport and athletes, at all levels, along with its broader practice community (coaches, spectators, administration and especially the youth of the world) should play a major role in shaping the vision for human futures that will inevitably come about. These contributions alone, as exemplars of democratized technology, should be the minimum requirements for shaping the future of humanity.

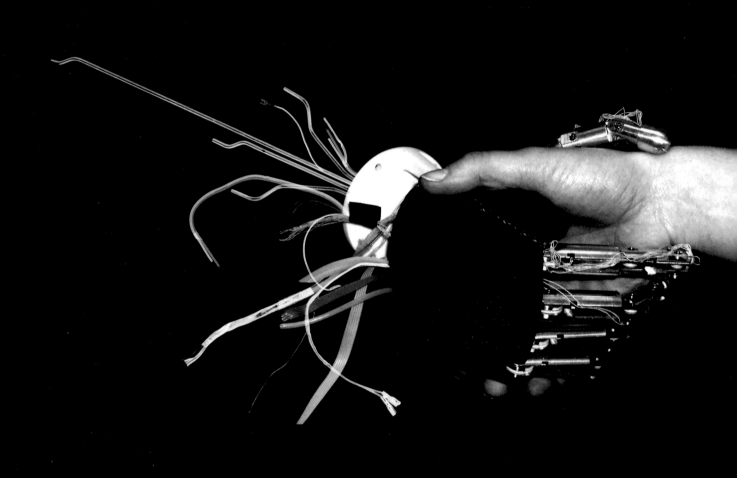

REFERENCES

Adelson, E. (2008a). 'Let 'Em Play'. *ESPN The Magazine*. Available at http://sports.espn.go.com/espnmag/issue?date=080505 and http://sports.espn.go.com/espnmag/story?id=3357051 [last accessed 5 July 2008]

Adelson, E. (2008b). 'Anything You Can Do'. *ESPN The Magazine*. Available at http://sports.espn.go.com/espnmag/gallery?id=3356765 [last accessed 5 July 2008]

Agence France Press (2008). '"Bladerunner" Pistorius targets Olympics after appeal victory'. Available at http://afp.google.com/article/ALeqM5hWOS0zFQ_pdZfYBsxOqrx0VAjchw [last accessed 5 July 2008]

Associated Press (2008). 'IAAF dismisses new tests of Pistorius'. Available at http://www.globesports.com/servlet/story/RTGAM.20080305.wsptpist5/GSStory/GlobeSportsOther/home [last accessed 5 July 2008]

Berger, M. (2008). 'Nanotechnology, transhumanism and the bionic man'. Nanowerk webpage. Available at http://www.nanowerk.com/spotlight/spotid=5848.php [last accessed 4 July 2008]

Beijing (2008). The Official Website of the Beijing 2008 Olympic Games. Available at http://en.beijing2008.cn/en.shtml [last accessed 5 July 2008]

Campbell, F. A. K. (2001). 'Inciting Legal Fictions: "Disability's" Date with Ontology and the Ableist Body of the Law'. *Griffith Law Review*, 10, 42

CAS (The Court of Arbitration for Sport) (2008). 'CAS 200S/A/14S0 Pistorius vlIAAF Arbitral Award'. Available at http://www.tas-cas.org/d2wfiles/document/1086/5048/0/press%20release%20pistorius%20english.pdf [last accessed 4 July 2008]

Casert, R. (2008). 'IAAF rules sprinter Pistorius ineligible'. Associated Press. Available at http://www.iht.com/articles/2008/01/14/sports/athletics14.php [last accessed 5 July 2008]

CDS (Centre for Disability Studies) (2008). 'What is the Centre for Disability Studies (CDS)?' Centre for Disability Studies, Leeds University (UK). Available at http://www.leeds.ac.uk/disability-studies/what.htm [last accessed 4 July 2008]

Disability and Human Development Department at the University of Illinois at Chicago (2008). 'PhD in Disability Studies'. Disability and Human Development Department at the University of Illinois at Chicago. Available at http://www.ahs.uic.edu/dhd/academics/phd_objectives.php [last accessed 4 July 2008]

Disabilitystudies.net (2008). 'About the disabilitystudies.net.' Available at http://www.disabilitystudies.net/index.php [last accessed 4 July 2008]

IAAF (2008). 'Oscar Pistorius – Independent scientific study concludes that cheetah prosthetics offer clear mechanical advantages'. Available at http://www.iaaf.org/news/kind=101/newsid=42896.html [last accessed 4 July 2008]

Kingston, G. (2008). 'A real stand-up guy. Able-bodied Erik Hagreen competes for B.C. at nationals'. Available at http://www.canada.com/vancouversun/news/sports/story.html?id=7d5bad2b-2410-47ec-b27a-b534e224140e [last accessed 5 July 2008]

London 2012 (2008). 'Values and themes of the Cultural Olympiad'. Available at http://www.london2012.com/plans/culture/now-to-2012/values-and-themes-of-the-cultural-olympiad.php [last accessed 5 July 2008]

McHugh, J. (2007). 'Blade Runner'. *Wired Magazine*. Available at http://www.wired.com/wired/archive/15.03/blade.html [last accessed 4 July 2008]

Miller, P. (2004). 'Disablism. How to tackle the last prejudice'. Available at http://www.demos.co.uk/files/disablism.pdf [last accessed 4 July 2008]

Shaughnessy, L. (2008). 'Double amputee walks again due to Bluetooth'. Available at http://www.cnn.com/2008/TECH/01/25/bluetooth.legs/index.html [last accessed 5 July 2008]

Society for Disability Studies (USA) (2004). 'General Guidelines for Disability Studies Program'. Society for Disability Studies webpage. Available at http://www.disstudies.org/generalinfo.html#4 [last accessed 5 July 2008]

Taylor, S., Shoultz, B. and Walker, P. (2003). 'Disability Studies: Information and Resources'. The Center on Human Policy, Law, and Disability Studies, Syracuse University. Available at http://thechp.syr.edu//Disability_Studies_2003_current.html#Introduction [last accessed 4 July 2008]

Wolbring, G. (2006). 'Brain Machine Interfaces'. Innovationwatch.com webpage. Available at http://www.innovationwatch.com/choiceisyours/choiceisyours.2006.11.30.htm [last accessed 4 July 2008]

Wolbring, G. (2007). 'NBICS, other convergences, ableism and the culture of peace'. Innovationwatch.com webpage. Available at http://www.innovationwatch.com/choiceisyours/choiceisyours-2007-04-15.htm [last accessed 4 July 2008]

Wolbring, G. (2008a). 'Why NBIC? Why human performance enhancement?' *Innovation: The European Journal of Social Science Research*, 21, 25–40

Wolbring, G. (2008b). 'Oscar Pistorius and the Future Nature of Olympic, Paralympic and Other Sports'. *SCRIPTed – A Journal of Law, Technology & Society*, 5, 139–60. Available at http://www.law.ed.ac.uk/ahrc/script-ed/vol5-1/wolbring.pdf [last accessed 4 July 2008]

Wolbring, G. (2008c). 'The Politics of Ableism'. *Development*, 51, 252–58. Available at http://www.palgrave-journals.com/development/journal/v51/n2/index.html [last accessed 4 July 2008]

Wolbring, G. (2008d). 'The Paralympics, the Olympics, and Human Enhancement Technology: The situation after the Pistorius ruling of the Court of Arbitration for Sports'. *The Choice is Yours* biweekly column, 30 May. Available at http://www.politicsofhealth.org/wol/2008-5-30.htm [last accessed 4 July 2008]

Wolbring, G. (2008e). 2178 AD PUMA LAUNCHES SPEED LEGS Nano, Bio, Info, Cogno, Synthetic bio, NBICS blog. Available at http://wolbring.wordpress.com/2008/05/10/2178ad-puma-launches-speed-legs/ [last accessed 5 July 2008]

ENDNOTES

[1] See Beijing 2008 'One World, One Dream' http://en.beijing2008.cn/spirit/beijing2008/graphic/n214068253.shtml; Disabled Persons' Cultural week http://en.beijing2008.cn/culture/festivals/culturalweek/

[2] I use the term -lympics and -lympiad to reflect the fact that I address the Olympics, Paralympics and other existing -lympics.

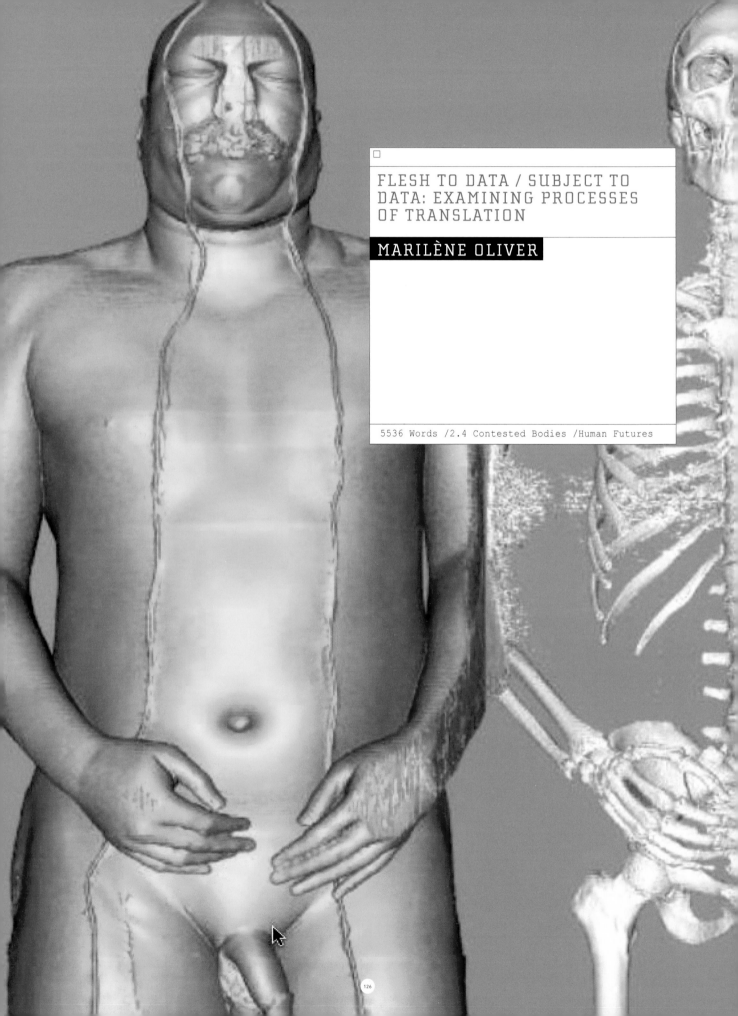

FLESH TO DATA / SUBJECT TO DATA: EXAMINING PROCESSES OF TRANSLATION

MARILÈNE OLIVER

5536 Words / 2.4 Contested Bodies / Human Futures

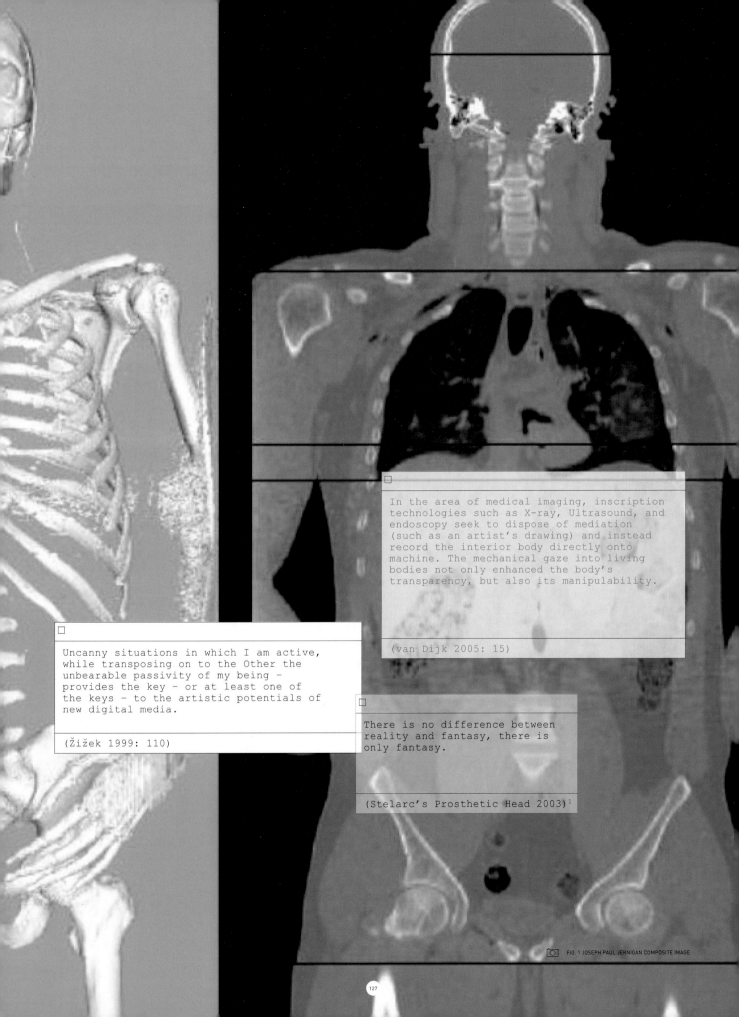

In the area of medical imaging, inscription technologies such as X-ray, Ultrasound, and endoscopy seek to dispose of mediation (such as an artist's drawing) and instead record the interior body directly onto machine. The mechanical gaze into living bodies not only enhanced the body's transparency, but also its manipulability.

(van Dijk 2005: 15)

Uncanny situations in which I am active, while transposing on to the Other the unbearable passivity of my being – provides the key – or at least one of the keys – to the artistic potentials of new digital media.

(Žižek 1999: 110)

There is no difference between reality and fantasy, there is only fantasy.

(Stelarc's Prosthetic Head 2003)[1]

FIG. 1 JOSEPH PAUL JERNIGAN COMPOSITE IMAGE

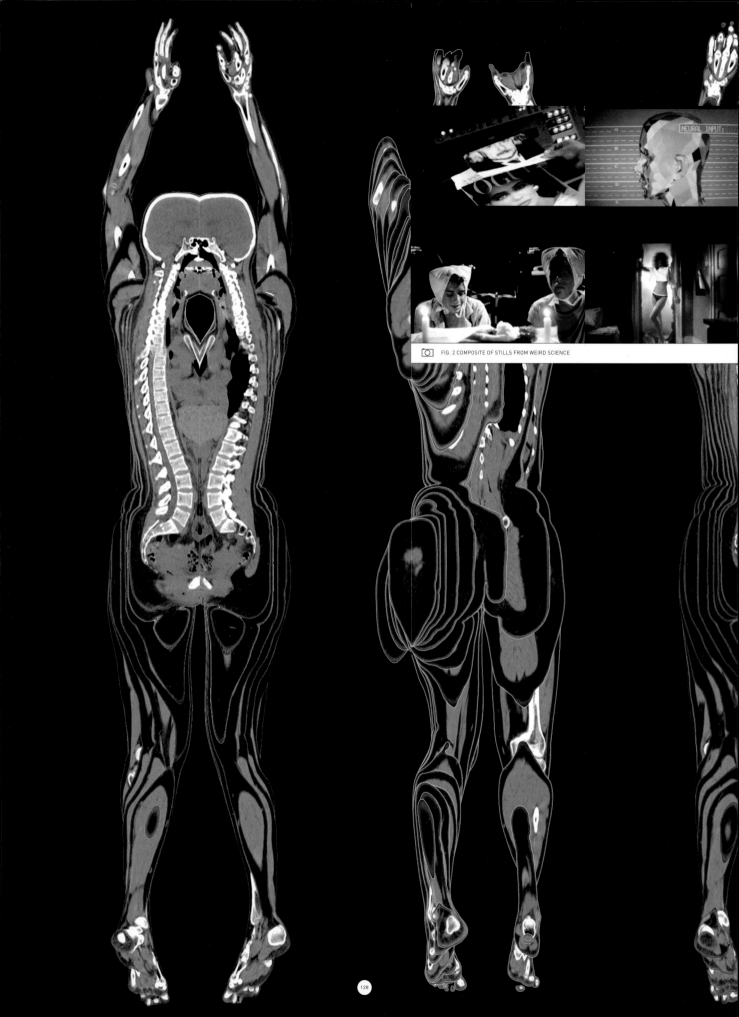

FIG. 2 COMPOSITE OF STILLS FROM WEIRD SCIENCE

Prior to his death, a 39-year-old convicted murderer named Joseph Paul Jernigan was persuaded to donate his body to medical science in order to become the 'Visible Human', a dataset of cryosections, CT (computer tomography) scans and MRI (magnetic resonance imaging) scans (Fig. 1). In 2001 I made a sculpture called *I Know You Inside Out*, a reconstruction of Jernigan from the Visible Human dataset.[2] My desire to create a sculpture of Jernigan was neither anatomical nor medical. Rather, I was fascinated by the virtuality of the Visible Human. By becoming visible, Jernigan's body was converted from flesh to voxel. In order to create the dataset, Jernigan's corpse was frozen and sliced so finely that it disintegrated to mush, leaving only digital photographs and scans.[3] The images of his body were uploaded onto the Internet allowing him to be viewed at anytime and any place, but never all at once. For *I Know You Inside Out* the images were downloaded and printed onto sheets of clear acrylic allowing Jernigan's body to be put back together again. Working with the Visible Human dataset sparked a fascination with the medically digitized body and an increased sensitivity to the impact of digitization on the human subject including fantastical theories surrounding the potential of digitization, such Hans Moravec's proposition of downloading consciousness into the datascape (Moravec 1987; 1988;1996) and John Hughes' *Weird Science* (1985), where two teenage boys create their ideal woman by scanning images from magazines into the computer (Fig. 2).

Since the first ever X-ray taken by Röntgen in 1897, non-invasive medical imaging technologies have developed to such an extent that radiology departments have become central to almost all hospitals and MRI, CT and PET scans are now part of our visual vocabulary. Like photography, medical scanning has become increasingly digital and traditional methods of scans being exposed and stored on film have now been largely replaced by digital archiving, with scans remaining entirely screen-based.[4] Through a series of complicated technical procedures, machines now 'render the body, or more precisely the appearance of the body, into digital information,

decomposing the body's fleshy complexity into the simple on/off logic of binary code' (Waldby 2000a: 28). Raphael Cuir (2008) argues that the desire to 'Know Thyself' as anatomical knowledge has now been replaced with a desire to 'Know Thyself' as matter, as space, as an object of science, an object of science fiction. The body converted to code/data facilitates this kind of quest for knowledge. Since making *I Know You Inside Out* I have worked extensively with both MRI and CT and have found that reflection on both the artworks created and art processes developed to work with Digital Imaging and Communications in Medicine (DICOM) can help us think about who and what we are becoming in an increasingly digitally mediated world. I believe that contemplating how flesh becomes data can help articulate how we, as subjects, are changing and adapting within the regime of computation.[5]

Reflecting on the processes involved with working with MRI and CT in my own art practice highlighted a number of differences between the two modalities. One way to consider the two modalities is to reflect on what they actually measure/image. MRI produces visual renderings of hydrogen and, thus, water content in the body: the body as wet and dry matter. CT portrays tissue density: the body as hard and soft matter. Alternatively, the differences between these two forms of imaging can be considered in terms of how the different datasets can be worked or processed. MRI allows non-clinical subjects into the scanner, which means scans can be bespoke: a specific set of scans of a specific person can be acquired. However, due to the speed of acquisition, the number, spacing and resolution of the scans requested are the ones received and they cannot be reformulated subsequently. Therefore, MRI scanning needs to be carefully planned prior to the scan.[6] Consideration of the artworks I have created using MRI encourages a poetic subversion of the space inside the MRI scanner: as MRI allows the subject to be chosen, the scanner can be used to image bodies for reasons other than clinical diagnosis.

Consideration of the artworks I have created using MRI encourages a poetic subversion of the space inside the MRI scanner; as MRI allows the subject to be chosen, the scanner can be used to image bodies for reasons other than clinical diagnosis. When making *Family Portrait 2003* (Fig. 3) (a series of four sculptures made from MRI scans of each of my family members), I was able to play with and question posthuman notions of preservation in the hope of possible future resurrection (such as those offered by Hans Moravec).

FIG. 3 MARILÈNE OLIVER 'FAMILY PORTRAIT' SILK SCREEN ON ACRYLIC, EACH FIGURE 192 X 70 X 50CM (2003)

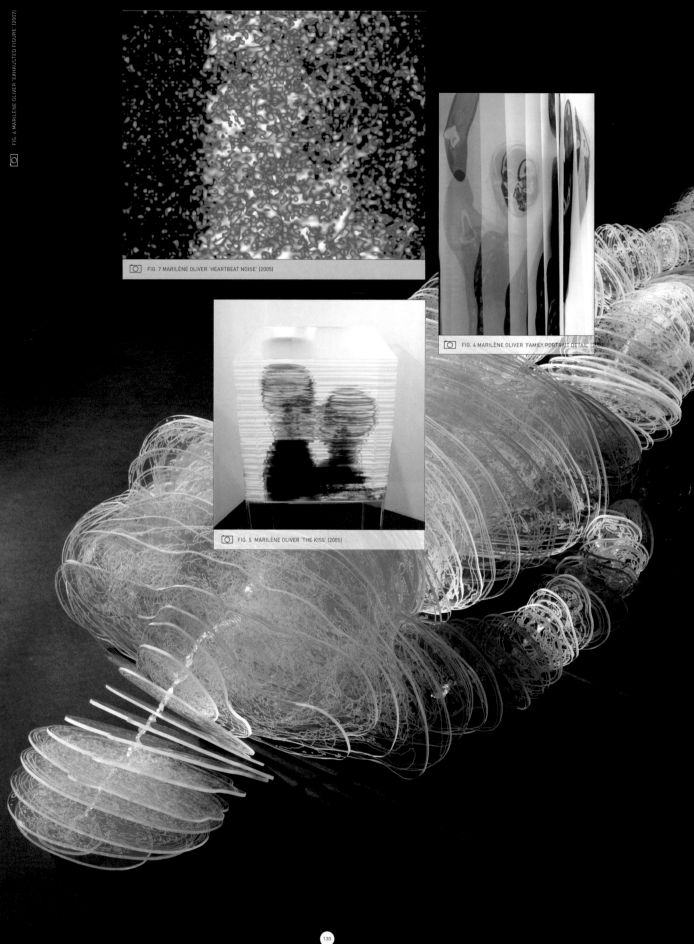

FIG. 6 MARILÈNE OLIVER 'EXHAUSTED FIGURE' (2007)

FIG. 7 MARILÈNE OLIVER 'HEARTBEAT NOISE' (2005)

FIG. 4 MARILÈNE OLIVER 'FAMILY PORTRAIT DETAIL' (2003)

FIG. 5 MARILÈNE OLIVER 'THE KISS' (2005)

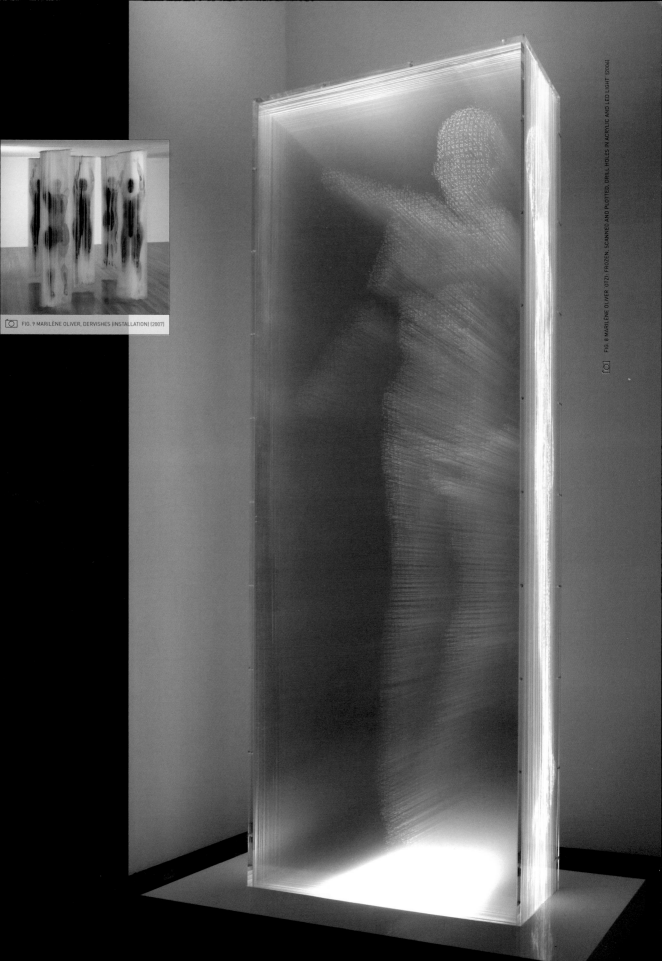

By putting my family into
the scanner, sentimentality and
romanticism entered a space normally reserved
for objective pathological diagnosis.[7] *Family
Portrait* suggests that DICOM can become relic. Thus,
DICOM can be used to create images and objects from our loved
ones for us to cherish and covet. As such the work acts as a
memento mori – raising the issue that, although what MRI scanners
do is objectively measure, the implications of those measurements and
the way they are interpreted are highly subjective and emotionally
charged, translating to matters of sickness and health, life and death.

MRI also fits Cuir's 'Know Thyself as Matter' category: because scans are
bespoke (and require a considerable amount of effort to acquire), I have
found they resist manipulation and thus allow us to contemplate the body as
a mass of moving liquids/lipids. As can be seen from the detail (Fig. 4) of
Family Portrait, the body looks very fluid and floaty, and when they are
installed the figures seem to hover like ghosts: they fulfil the stereotypic
requirements of digital beings. CT has a very different nature to MRI in that
scanning is very fast and at very high resolution. As such, it is
post-processed, which allows the data to be viewed in numerous ways and exported
in a number of different formats after the scan. However, due to radiation, CT
does not allow for non-clinical scans, so a specific living subject cannot be
scanned for a specific artwork.[8] This means artists need to work with existing
datasets and make them their own through post-production and contextualization
(Fig. 8).

Recently I discovered a set of anonymized datasets available for download via
a DICOM software website called OsiriX.[9] One dataset that I have worked with
extensively is MELANIX, a woman scanned with her arms above her head. There is
no information as to who she is, where she is or when she was scanned – the
dataset was severed from its original through an 'anonymize' button.

The fact that MELANIX has been anonymized allows a freedom from the original
subject and because the dataset is at such high resolution, the possibilities for
post-production are vast. Working with the MELANIX dataset encouraged work that
explored not the body of MELANIX but the structures of vision that were allowing
it to be seen. *Dervishes* 2007 (Fig. 9) is a series of five sculptures that
exposes what I have termed the *pivot optic*, a vision particular to 3D
virtual space, which demands that the viewer enters inside the data and
then pivots around a certain axis. Unlike the panoptic which demands
a standing out and looking in, or the trompe l'oeil which tricks the
eye with the illusion of an internal depth, with the pivot optic we
are no longer bound by having eyes in our heads but rather our eyes
are in our fingertips, in our mouse clicks. The more agile we are at
entering and pivoting inside the database, the better we perform, the
better we know our data, the better we become at making and knowing
our virtual worlds. Laws of perspective are replaced by density of
information around the axis. The more we pivot, the faster we spin,
the more information we acquire (and also the dizzier we get).

Dervishes explores the pivot optic by offering five versions of the
same dataset 'seen' from different axes; one *Dervish* has its axis
through the centre, another through the spine, another the belly
button, another the left side and another the
right side. The resulting sculptures offer
differing encounters with the body (Fig. 10).

As well as granting an engagement with the
pivot optic, working with an anonymized CT
dataset prompted a realization of how
much pleasure and freedom there was in
playing with colour/density values
and making datasets dance/spin
by manipulating Flythrough
and movie options.

Endless hours were spent
exporting different versions of the same
dataset in child-like play. Rather than acting
as a sorter or processor of images, I became a
puppeteer, animating an object rendered inanimate
through technology. *Heart and Womb Axis* were also made using
the same 'pivot' tool as *Dervishes*, but in this instance were
combined with the colour and density modes available in the OsiriX
software. With *Heart and Womb Axis* (fig.11 & 12) the intention was
to concentrate on a *subjective* viewing of the DICOM data.

As for such platforms as YouTube and Flickr, there is an increasing
number of instances where the DICOM body has been animated through colour
and transparency with software similar to OsiriX, where it is obvious that
through a subjective choice of colours and textures a certain identity had
been applied to the body. One example is a video on the OsiriX website called
Spock.[10] Spock (Fig. 13) is a 3D rendering of a head, which as its title
suggests has been made to look like a science fiction character. Dental
fillings cause image artefacts that create serration-like features in CT
scans, which, when rendered, look like spikes coming out of the mouth. The
density levels have been set so that the skin and flesh have become a
transparent green revealing a tracheotomy tube. There is another tube running
from a control patch on the left shoulder down behind the left lung (a
pacemaker?). The colours chosen are alarming and otherworldly and the up-turned
1970s collar gives Spock a strong self-assured presence.

Spock is an excellent example of Cuir's desire to 'Know Thyself as Matter' as
an object of science fiction, for it displays a desire to transport the subjects
of the scans into fictional space. Like a child would *dress up* a doll, the creator
of *Spock* and other similar movies are playing with the possibilities of *dressing
down* (a copy of) the body in order for the subject to take on new personas that (in
the instance of Spock) we recognize from science fiction. DICOM bodies are becoming
characters; they are changing their physical appearance and donning sub-skin costumes
in order potentially to become performers of an unknown parallel fantastical narrative.

The ease with which digital images, movies, texts – in fact all digital files – can be
copied and pasted undetected in order to be reworked for a different purpose, often
political or comedic, means that appropriation and re-appropriation is now
common practice online. One needs only to search for an image on Google or a
movie on YouTube to discover the mass appropriation of still and moving
imagery. Working with MELANIX made me realize that appropriation comes
just as easily with the found CT datasets: the DICOM body having been
severed from its original subject through an 'anonymize' button allows
it to become a blank canvas on which to project oneself. Just as one
can modify an online avatar, such as those on Second Life, to have any
colour of skin, hair, clothes, any shape of nose, mouth or legs, so too
a CT dataset can have any colour of kidney, heart or skull, so too it
can be only bones, only organs or only lungs. Until the next click of
the mouse and then it might become something different. Just as a
Second Life is an avatar on which to display signs, so too is a CT
dataset (Fig. 14).

Internet artist Miltos Manetas, in collaboration with programmer Aaron
Russ Clinger, used a digital copy of the Visible Human for an art
website *Man in the Dark* (2004) (Fig. 15). Manetas appropriated scans
from the Visible Human project to make a body which hangs from the
cursor and dances – the body, made up of the slices of the
Visible Human, is digitally strung causing it to
float/dance as the cursor moves around the screen.
When the mouse is clicked multiple copies/clones
of the figure keep appearing, all linked to the
same movement. When the mouse is clicked
again all the copies/clones but one
disappear, leaving only the original/a
single copy still hanging from the
cursor waiting to sway with the
movement.

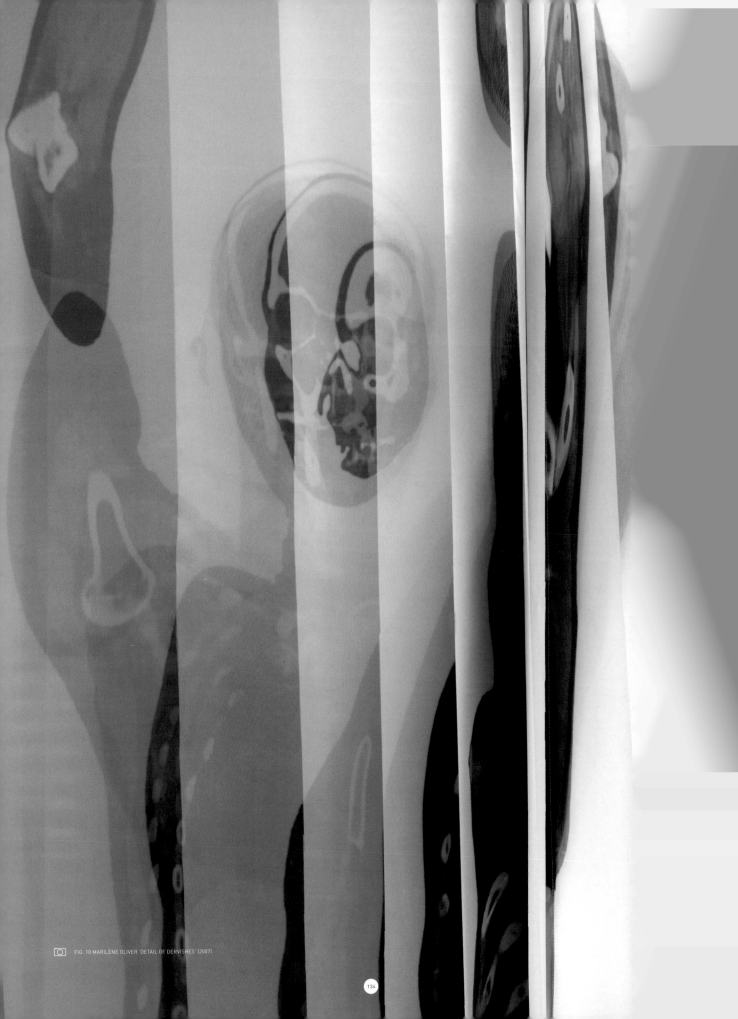

FIG. 10 MARILÈNE OLIVER 'DETAIL OF DERVISHES' (2007)

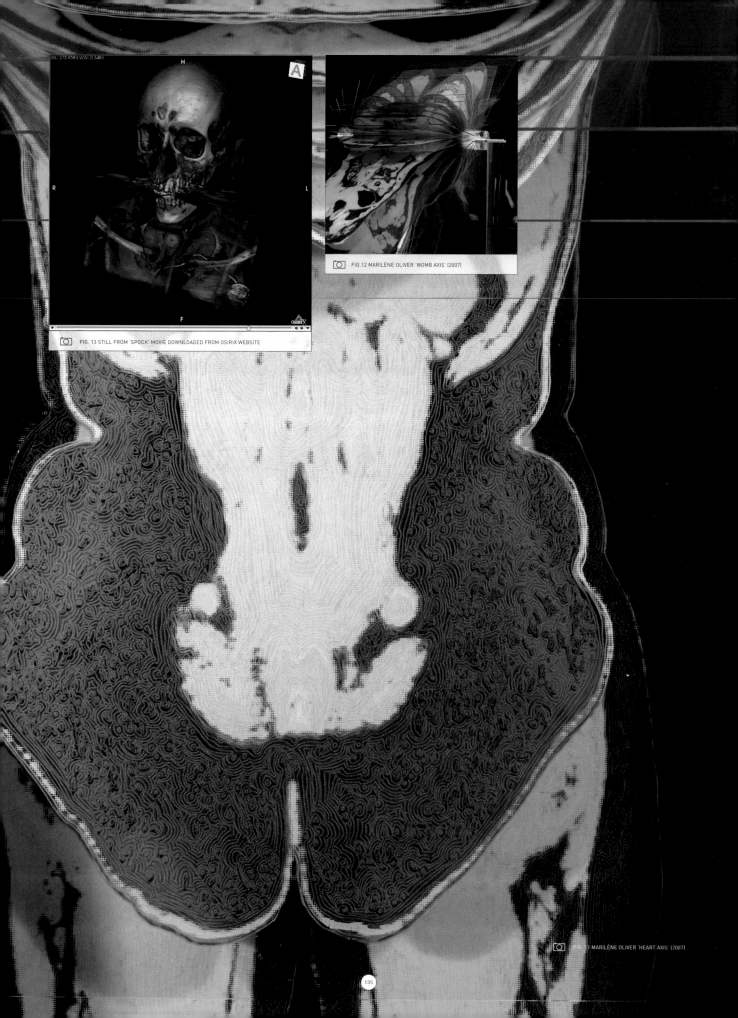

WL: 275.9583 WW: 0.3486

A

FIG.12 MARILÈNE OLIVER 'WOMB AXIS' (2007)

FIG. 11 MARILÈNE OLIVER 'HEART AXIS' (2007)

FIG. 15 MILTOS MANETAS IN COLLABORATION WITH AARON RUSS CLINGER 'MAN IN THE DARK' (2004, COURTESY OF THE ARTISTS AND BLOW DE LA BARRA GALLERY, LONDON)

136

Artist and composer Klaus Obermaier digitally manipulated the stereoscopically filmed body of the dancer Julia Mach in an extraordinary version of *The Rite of Spring* at the Royal Festival Hall in June 2007 (Fig. 16). Julia Mach, or 'the chosen one', was positioned in a large open-sided black box on the right of the main stage. Obermaier, surrounded by a wall of CPUs, was at the back of the auditorium. In the open-sided black box were a number of cameras, which filmed Mach stereoscopically. The data was fed into Obermaier's bank of computers, which he then manipulated and re-projected in real time onto a large screen above the orchestra and Mach.

The audience, wearing 3D glasses, were confronted with huge hovering ephemeral copies of Mach, which occupied the expansive void of the auditorium while the real Mach danced in her black box on the stage. Obermaier together with the Ars Electronica Futurelab created computer programmes that would manipulate Mach's body in response to the instruments in the orchestra: 'by means of 32 microphones the entire orchestra is integrated in the interactive process. Musical motifs, individual voices and instruments influence the form, movement and complexity of both the 3D projections of the virtual space and those of the dancer' (Obermaier, 2007).[11] The nature of the manipulation changed with the movements of Stravinsky's composition. In one movement the ground or grid that the stereoscopic Mach appeared to be standing on started to undulate like a rough sea, throwing her around, while in her black box the real Mach hardly moved. Later as the real Mach walked slowly around her black box, the stereoscopic Mach spawned bizarre creatures made of only arms and legs, which then seemed to take on a life of their own until the projected stage became full of hybrid limb spiders crawling around.

Manetas, Obermaier and I all make bodies spin, sway and multiply. We decide the actions and make them happen in real time. We are puppeteers: we communicate our ideas by controlling an inanimate dataset. In the most traditional sense we make our datasets/puppets perform, for they all dance:

Marilene Merilouto
(Editing Appearance)

FIG. 15 KLAUS OBERMAIER, 'RITE OF SPRING' (2006)

FIG. 14 SCREEN SHOT FROM SECOND LIFE, SHOWING 'APPEARANCE EDITING'

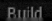

Melanix pirouettes, Manetas' *Man in the Dark* sways and floats, Obermaier's 'chosen one' bounces, rocks and crawls in time to the music. We are seduced and compelled by the power and control we have over the other, rendered inanimate. When I interact with Manetas' *Man in the Dark*, which only through my own work I recognize as being the body of Joseph Paul Jernigan, the Visible Human, I know absolutely that it is not Jernigan who is dancing and dangling from my cursor but it is Manetas and I who are dancing together; Manetas and his programming lead me twirling and swaying around the browser and I delight in watching our movements reflected in the mirror of my computer screen.

At the end of *The Rite of Spring* I recall being unsure as to whom I was applauding – was it Mach or Obermaier, both or neither? On consideration I decided it was not Mach – Mach's physical body had lost the battle to keep my attention, it was too small and hadn't moved enough; also Mach was not the one controlling the stereoscopic Mach, she was too busy walking around her black box – she was offscreen/hors scène. It could not have been Obermaier for he too was offstage, hors scène, obscene.

As Baudrillard announced in *The Ecstasy of Communication*, we (subjects) are now all obscene: 'The body as a stage, the landscape as a stage are slowly disappearing… Obscenity begins when there is no more spectacle, no more stage, no more theatre, no more illusion, when every-thing becomes immediately transparent, visible in the raw and inexorable light of information and communication' (Baudrillard 1988: 154). On the digitally mediated scene/stage the original subject (Melanix, VH and Mach) are hors scène/obscene as are the puppeteers/artists. So what then is it that is on scene, that we are so captivated by? Surely it is more than just the seduction of well-mastered technology? What is it that is taking place on the virtual scene when a subject takes control of another's body rendered inanimate through technology?[12]

In his essay, 'The Fantasy in Cyberspace' Slavoj Žižek (1999) opens his discussion with the

'strange phenomenon of *interpassivity*', going on to explain interpassivity as occurring when 'the subject is incessantly – frenetically even – *active*, while displacing onto another the fundamental passivity of her being' (106). The artist is 'incessantly' active, programming, mapping and processing information constantly. Yet the product of these activities is not sited in or on their own bodies but in the digital copies of other bodies.[13] Although this, at first, might seem negative it need not be – the artist is incessantly active with programming and is thus unable to simultaneously animate his own body, and so transfers the actual physical moving, dancing, performing part onto another body. It is not that one subject replaces another, or that one subject splits into two but that there is an addition, an extension of the subject. A term such as 'extensions of the subject' sounds post/transhuman but in this case, like Žižek, I do not believe it necessarily to be so. The 'extension of the subject' here is not a Cyborgian, robotic, mechanical extension but an imaginative, aesthetic one. Although, as Žižek stresses, the relationship between the 'subject of enunciation' (the artist/the person controlling an avatar) and the 'subject of the enunciated/of the statement' (in the case of the works discussed above Melanix, VH, Mach or in the case of an online game, the avatar) is mediated by technology, it also calls forth fantasy.

> By focusing on fundamental fantasy, today's artistic practices are asserting their status of art in the age of scientific objectivization of human essence: art refers to the space of what a priori eludes the grasp of scientific objectivization. And perhaps cyberspace, with its capacity to externalize our innermost fantasies in all their inconsistency, opens up to artistic practice a unique possibility to stage, to 'act-out', the fantasmic support of our existence, up to the sado-masochistic fantasy that can never be subjectivized.... Far from

enslaving us to these fantasies, and thus turning us into de-subjectivised blind puppets, it enables us to treat them in a playful way, and thus to adopt towards them a minimum of distance – in short to achieve what Lacan calls *la traversee du fantasme*. (Žižek 1999: 121)

In her many books and essays on the subject of the self and identity in virtual space, anthropologist Sherry Turkle claims that 'we are insecure in our understanding of ourselves, and this insecurity breeds a new preoccupation with who we are. We search for ways to see ourselves. The computer is a new mirror' (1984: 306). Turkle's methodology involves observing and interviewing computer users, and what she repeatedly concludes from her observations is that understanding how we interact with computers can help explain who we are and what we are becoming. Turkle believes that the computer is no longer simply a calculating, processing machine but an object to think with, to become with: computers are psychological and evocative objects, which allow us to understand and formulate who we are as subjects.

> On the German MUD, Stewart shaped a character named Achilles, but he asks his MUD friends to call him Stewart as much as possible. He wants to feel that his real self exists somewhere between Stewart and Achilles. He wants to feel that his MUD life is part of his real life. Stewart insists that he does not role play, but that MUDs simply allow him to be a better version on himself. (Turkle 1996: 194)

Somewhat illustrating Turkle's theories is Robbie Cooper's photographic series *Alter Ego: Avatars and their Creators* (2007) which documents people in 'real life' alongside their online avatars (Fig. 17). This fascinating series of images show how, like Turkle's Stewart/ Achilles, the identities of the people being photographed and the way they choose to present

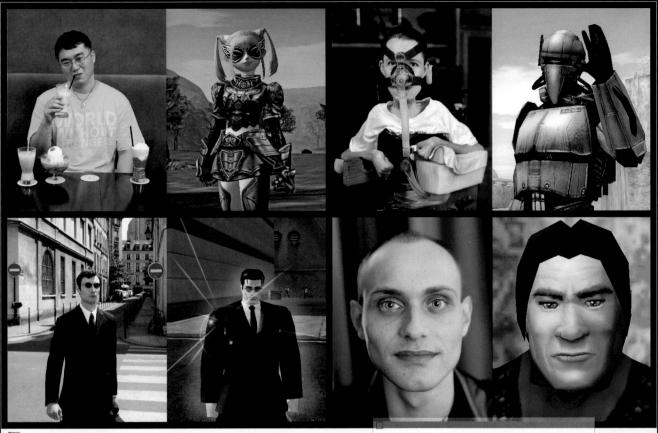

FIG. 17 ROBBIE COOPER, 'ALTER EGO: AVATARS AND THEIR CREATORS' (2007)

FLESH TO DATA/SUBJECT TO DATA: EXAMINING
PROCESSES OF TRANSLATION

MARILÈNE OLIVER

. . . . CONTINUED>>>>>>>>>

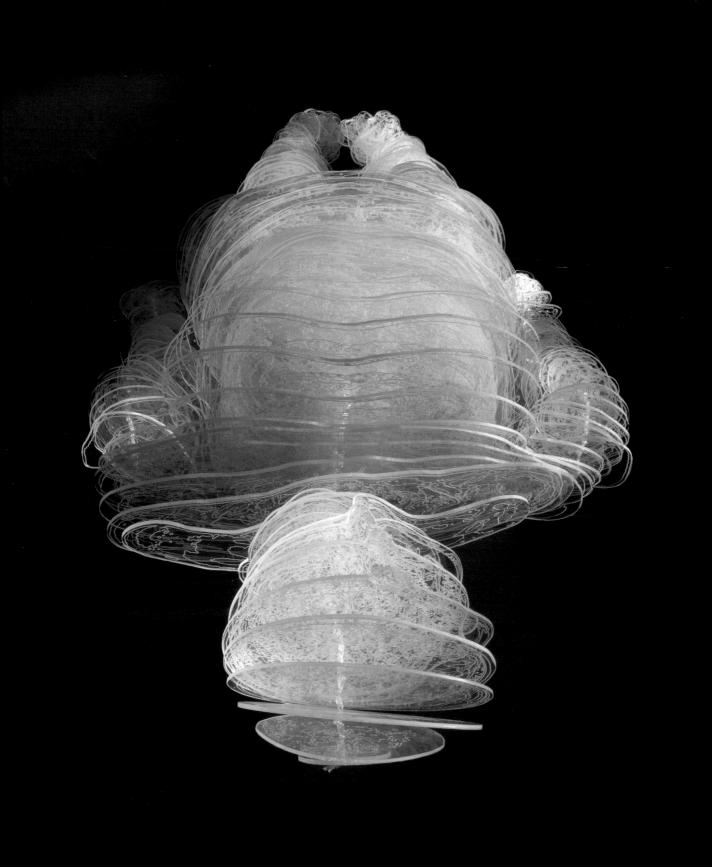

MARILÈNE OLIVER, 'EXHAUSTED FIGURE' (2007)

themselves to the camera/computer screen have become intimately intertwined. They act as evidence of what Alise Iborg, a member of the performance group *Second Front*, calls 'virtual leakage', which she defines as 'a two-way exchange between the virtual and the real, through which new hybrid meanings can be made. Meaning-making can no longer operate within the hermetic cases of the real vs. virtual, but instead, becomes a back and forth exchange in which ideas migrate by osmosis' (Iborg 2007).[14]

As explored by Kroker (1992) and Dixon (2008), the effects of technology and cyberspace on the human subject are most predominantly theorized as negative. For Baudrillard, the subject is lost in a world of cold, dark, dangerous simulation. For Virilio, the subject is lost to a regime of Dromology – a world moving at warp speed. For Deleuze and Guattari, the subject is a body without organs – a de-'organ'ized set of flows moving at different speeds and in different directions. Steve Dixon, a digital performer, concludes his survey of postmodern and posthuman theories of the effect of technology on subjectivity with this brave statement:

> Instilled postmodern belief systems stress fragmentation, split subjectivity, and the rejection of meta-narratives and meanings, where in actuality what is practiced by the digital/posthuman performers is commonly the search for the opposite: for cohesion, for meaning, for unity, for intimate cybernetic connections between the organic and the technological. To relate postmodern theories of fragmentation and split subjectivity to virtual bodies or digitally distributed selves is too literal, trite, and easy, and ultimately misses the point. Digital performance is more commonly a quest for unified subjectivity (though doubled, not split, but the many facets of self exposed in order to converge as one) a

structuralist rather than poststructuralist project, a search to express universal myths and metaphors about the human condition. (Dixon 2008: 194)

From my experience of working with Melanix, witnessing the works of Manetas and Obermaier and reading Steve Dixon's accounts of numerous digital performances, I believe that the surrender to and embrace of fantasy (Žižek), thinking of the computer as a psychological tool to think with (Turkle) and finally, but most importantly, the use of the computer/virtual space as a place to rehearse and perform all adds up to a positive activity and one that I found very engaging and exciting. Working with Melanix gave me a freedom to play and explore without fear of inerasable consequences; it made me feel alive and that I was really giving myself space to think and be.

As explained earlier, I started working with Melanix at the same time that I created my first online avatar, *Marilene Merilotou*. Although I find the rise of the avatar fascinating and central to the ideas I am exploring in my work, I find it hard to engage and feel satisfied with an avatar created from standard, preset models – the proportions are wrong, the bodies move awkwardly, they are fictive and unconvincing. As a result my commitment to nurturing my 'Second Life' has become rare and sporadic. However, I vividly remember the first time another avatar 'spoke' to me. It was thrilling and I was blushing in 'real' space as I wrote my response. My first interactions felt very real and very embodied. I was acutely aware of my avatar as an extension of myself, I was performing myself through my avatar and any feedback to my performance felt personal. I felt on show, exposed. As long as my preoccupation with my avatar was performative (and not narcissistically superficial) it felt very real; my interaction and communication felt *real*.

> Performance art usually occurs in the suspension between the 'real' physical matter of the performing body and the psychic experience of what it is to be embodied. Like

a rackety bridge swaying under too much weight, performance keeps an anchor on the side of the corporeal (the body Real) and one on the side of the psychic Real. Performance boldly and precariously declares that Being is performed (and made temporarily visible) in that suspended in-between. (Phelan 1993: 163)

After psychoanalysis and Baudrillard the term 'real' feels problematic to use, but as Steve Dixon asserts *the real has changed*. As a result of technology (the real's conjoined twin) what we consider 'real' constantly changes. Dixon cites the television as an example: when televisions were first introduced people were amazed by the small people inside the boxes; now they are part of our everyday lives and we do not doubt their realness. At a seminar with artist Paul Sermon as part of the Intimacy Conference held at Goldsmiths in 2007, this issue was addressed when Sermon was talking about his Second Life avatar. Sermon stumbled to find a term to describe his 'offline' self – he was unhappy to make a distinction between his 'Second Life' and his 'First Life', his 'Second Life' and his 'Real Life', asserting that it was all his 'real' life. Sermon's conviction here echoes what performance artist Susan Kozel wrote about her experience of being part of Paul Sermon's well-known installation *Telematic Dreaming* (1992), where two beds are installed in different rooms of the gallery, linked by video-conferencing system. The beds become the projection area for the conference allowing two separate people on the two beds to interact with each other.[15] Kozel worked for two weeks as part of the installation and had a number of encounters in the 'Telematic bed'. Kozel writes that that her experiences were 'undeniably real, not a compromise' (Kozel 1994, cited in Dixon 2008: 218).

At the beginning of my research I gave a presentation of my work to my peers at the RCA and I was surprised at the observation that my work dealt with representation. It felt to me that this was not the correct term: representation involves a knowable quantity – to be able to represent something we need to understand it and know it; the prefix 're-' indicates that it is something that already exists and has made itself known to us. When I work with DICOM (especially an anonymized dataset such as Melanix) I do not know what I am going to get – I play with the data until I see something on the screen that I think I can put together in a way that says and shows something new to me, not something I already know.

In her 'Cyborg Manifesto', Haraway lists a number of binary opposites (1991: 161), the first being:

'REPRESENTATION – SIMULATION'

Like 'real', 'simulation' has also become a problematic word to use theoretically, especially since Baudrillard's *Simulacra and Simulations* made simulation something dark, dangerous and treacherous. Among those working with computer simulations this is, however, far from the case – to simulate means testing something out, it means learning and experimenting with information. A simulation involves putting together different elements to see how they fit together and what they become. Simulation, like art history's traditional opposite of representation (*Darstellung*), presentation (*Vorstellung*), indicates something novel, unknown and requires intuition, the imagination.

In *Man In The Dark*, Manetas brings together his elements (the slices of the Visible Human, the programmed 'strings', the browser, the programming rules) but it is the user who pushes the 'simulate button' when they start to move their cursor and the figure moves according to the movement of the mouse. Although, as with most dance, the steps are fixed, the movements will be always be slightly different, each dance is original. Thus, Manetas is not trying to show us something he knows. Rather, he wants to share with us something new. Equally Obermaier can only do so much to control what the viewer sees; his cleverly crafted algorithms and 'frenetic' activity on the computer is only one element of the work, Mach's movements and the orchestra's playing equally affect what the view sees and as such what Obermaier sees, discovers.

What I sensed in creating works using Melanix was this thrill of discovering something through play and fantasy and then presenting it to myself and others.

To return then to the question of what is '*en scène*/onstage', of what captivates us when an artist/subject takes control of another's body rendered inanimate through technology. I believe it is a playful and inconclusive attempt to perform/present /simulate the real (accessed through fantasy). It is a form of the real that is so intimately linked to technology that it is always changing and, thus, continuously welcomes being re-evaluated and redrawn. As Dixon writes, this attempt does not split the subject apart; rather it fuses it together and in being engaged in the positive act of presentation/performance inspires confidence and pleasure.

Artists working with DICOM and other technologies that convert flesh to data offer fresh and practical ways to think about the relationship between the physical and the virtual and how this relationship affects us as subjects. Thinking about how the body, which we all know intimately, is digitized through medical imaging technologies prompts us to contemplate how other parts of our lives are also digitized and what then lies ahead for Future Humans.

REFERENCES

Barthes, R. (1981). *Camera Lucida*. London: Hill and Wang

Baudrillard, J. (1988). *The Ecstasy of Communication*. Trans. B. and C. Schutze. New York: Semiotext(e)

Cooper, R. (2007). *Alter Ego: Avatars and their Creators*. London: Chris Boot.

Cuir, R. (2008, 7 February). 'Know Thyself', Art and Anatomy: a Discontinued History, The Courtauld Institute of Art, London

CTheory Live (2006). 'Katherine Hayles in Conversation with Arthur Kroker'. Available at http://www.pactac.net/pactacweb/web-content/video44.html [last accessed 7 July 2008]

Dixon, S. (2008). *Digital Performance*. Cambridge, MA: MIT Press

Grice, G. (2001, 30 July). 'Slices of Life'. *The New Yorker*, 36

Haraway, D. (1991). 'A Cyborg Manifesto: Science, Technology, and Socialist-Feminism in the Late Twentieth Century', in *Simians, Cyborgs and Women: The Reinvention of Nature*. New York: Routledge, 149-81

Hughes, J. (dir.) (1985). *Weird Science*. USA: Universal Pictures

Kroker, A. (1992). *The Possessed Individual*: *Technology and the French Postmodern*. New York: St Martin's Press

Manetas, M (2008) http://www.manetas.com/

Manetas, M (2004) Man in the Dark, interactive website made in collaberation with Aaron Russ Clinger http://www.maninthedark.com

Moravec, H. (1996). 'Bodies, Robots, Minds'. *Kunstforum*, 133, February-April, 98

Moravec, H. (1988). *Mind Children. The Future of the Robot and Human Intelligence*. Cambridge, MA: Harvard University Press

Moravec, H. (1987). 'Dualism from Reductionism', *Proceedings of the International Symposium on AI and the Human Mind*, Yale University, New Haven, CT, 1-3 March 1986. In *Truth* Volume 2, Dallas, TX: Leader University

Obermaier, K (2007, together with the Ars Electronica Futurelab) http://www.exile.at

Oliver, M. (2008) http://www.marileneoliver.com

Turkle, S. (1984). *The Second Self: Computers and the Human Spirit*. New York: Simon and Schuster

Van Dijk, J. (2005). *The Transparent Body: A Cultural Analysis of Medical Imaging (In Vivo)*. Washington: University of Washington Press

Waldby, K. (2000a). 'The Visible Human Project: Data into Flesh, Flesh into Data', in J. Marchessault and K. Sawchuk (eds), *Weird Science: Reading Feminism, Medicine and the Media*. London: Routledge

Waldby, K (2000b). *The Visible Human Project: Informatic Bodies and Posthuman Medicine*. New York /London: Routledge,

Žižek, S. (1999). 'The Fantasy in Cyberspace', in Elizabeth Wright and Edmond Wright (eds), *The Žižek Reader*. Oxford: Blackwell, 103-24

(Endnotes)

¹Performance artist Stelarc's *Prosthetic Head* (an avatar created from laser scans of Stelarc) response to the question 'What is the difference between reality and fantasy?'

²*I Know You Inside Out* led to a series of artworks that were based on various forms of medical imaging including MRI (magnetic resonance imaging), CT (computer tomography) and PET (positron electron tomography).

³For more information about the *Visible Human Project* see Waldby (2000b), Grice (2001) and the official Visible Human Website http://www.nlm.nih.gov/research/visible/ (accessed 2 June 2008)

⁴The British National Health Service is currently rolling out a PACS system which aims to replace all film-based radiography with digitally stored radiography in the coming years. For more information see http://www.e-health-insider.com/news/item.cfm?ID=730 (accessed 30 April 2008)

⁵In her interview with Arthur Kroker (CTheory Live, 2006), Katherine Hayles defines 'Regime of Computation' as being post postmodernism and starting with the first viable Internet browser (Netscape) in 1995.

⁶Works that I have made using MRI include *Family Portrait* 2003 (Fig. 3) (a series of four sculptures made from MRI scans of each of my family members), *The Kiss* 2004 (Fig. 5) (a sculpture and series of images made from MRI scans of my husband and I kissing inside an MRI scanner), *Exhausted Figure* 2007 (Fig. 6) (a sculpture of a collapsed, drained figure made using my mother's MRI scans) and *Heartbeat Noise* 2004 (Fig. 7) (a digital image made from the cardiac motion artefact/noise in the MRI scans produced as a result of blood being pumped through the heart).

⁷Turkle (1984: 64, 280, 283-84) reminds us that nineteenth-century Romanticism was a reaction to science and technology.

⁸This is at least the guidance in the UK. In other countries it may be possible to acquire a CT scan for non-clinical reasons but it would still carry the risk of radiation. One example of an artist using their own CT scans for an artwork is *Autoportrait* by Bernar Venet (2003).

⁹http://www.osirix-viewer.com/ (accessed 4 February 2008).

¹⁰http://www.osirix-viewer.com/Snapshots.html (accessed 5 February 2008).

¹¹http://www.exile/at/sacre/index.html (accessed 10 June 2008).

¹²These examples are few among many that I could have chosen – these works were selected because I witnessed them in person rather than as documentation. Steve Dixon (2007) gives thorough and extensive accounts of performance-based works that feature the artist and a virtual double, many of which could have been cited here. (in particular those in Chapter 11, 'The Digital Double', 241-70). Art historian Amelia Jones also gives an excellent account of her encounter with La Pocha Nostra's project *Ex-Centris: A Living Diorama of Fetish-ized Others* at Tate Modern in 2003 (XVIII Self/Image) which could have served equally well as an example.

¹³Although none of the artists cited work with copies of their own bodies, even if they did I would describe the digitally mediated copy/dataset of/from their body as Other. As Roland Barthes famously wrote in Camera Lucida when looking at a photograph of himself 'the Photograph… represents a very subtle moment when, to tell the truth, I am neither subject nor object but a subject who feels he is becoming an object: I then experience a micro-version of death (of parenthesis): I am truly a specter' (1981: 14). Like Barthes, I believe (from having worked with a dataset of my own body for Family Portrait) that the dataset is no longer me; it is from a time passed, my body has changed since then, its passing marked by the acquisition of the dataset.

¹⁴Alise Iborg, 'A Leap into the Void: Interview with Second Front', by Domenico Quaranta. http://rhizome.org/discuss/view/24830 (accessed 4 August 2008)

¹⁵For a more detailed description see http://creativetechnology.salford.ac.uk/paulsermon/dream/ 20/5/8

EDUARDO KAC:
A CONVERSATION WITH THE ARTIST

SIMONE OSTHOFF

2959 Words /2.5 Contested Bodies /Human Futures

Across the clearing to the south comes a rabbit, hopping, listening, pausing to nibble at the grass with its gigantic teeth. It glows in the dark, a greenish glow filched from the iridicytes of a deep-sea jellyfish in some long-ago experiment. In the half-light the rabbit looks soft and almost translucent, like a piece of Turkish delight; as if you could suck off its fur like sugar. Even in Snowman's boyhood there were luminous green rabbits, though they weren't this big and they hadn't yet slipped their cages and bred with the wild population, and become a nuisance.

(Margaret Attwood, 'Oryx and Crake', 2005, pp. 95–96)

Over the course of two decades Eduardo Kac's hybrid networks have connected in real time disparate and distant elements. They have also offered new insights into art while leading the artist in 1999 to the literal creation of new hybrid life forms. By changing habitual ways of seeing and communicating, Kac's networks and transgenic creations continuously challenge our understanding of the 'natural' environment as well as of the environment of art. They explore what the French philosopher Jacques Rancière termed the 'distribution of the visible, the sayable, and the possible'.

By converging art, science and technology with communication theory, philosophy and poetry, the artist produces unusual connections such as those among language, light and life. Insightful and experimental, Kac's work suggests alternative ecologies neither by denouncing climate change and environmental disasters nor by calling attention to monstrous threats produced by manipulation of DNA information. The dimensionalities and temporalities explored by Kac's networks – both human and non-human – examine wider ecological questions, which include the cultural modes that produce our subjectivity.

Prompting a continuum between nature and culture, between species, and among the senses, Kac's work questions the structures, mediations and ultimately the supremacy of vision in art, while promoting synaesthetic experiences that rearticulate individual consciousness within social, cultural and environmental realms. In addition, his work addresses issues of spectatorship by emphasizing participatory action and two-way communication. Kac's hybrid networks of physical and virtual spaces dislocate audiences within environments that examine how vision, touch, hearing and voice are facilitated and constrained by the structures and mediation of technology. Within his networked environments, dialogical communication among humans, animals, plants, microorganisms and machines is never given, but instead must be construed by participants word-by-word, frame-by-frame.

Besides being an accomplished researcher and writer, Kac is among the few artists who can lucidly speak about aesthetic concepts in relation to other disciplines such as science, technology and poetry. His voice helps to debunk the fantasy that studio work does not involve either theory or research, thus grounding his creations both in experiment and debate. I first interviewed Kac in Chicago in 1995 for my article 'Object Lessons' published in *World Art* in spring 1996. In that first conversation we talked about the development of his multimedia works up to his Telepresence events with the telerobot *Ornitorrinco*. Since then many other conversations have taken place and I have published more essays about his work, which continuously exceeds expectations. More recently, on the occasion of Eduardo Kac's mid-career survey, curated by Angel Kalenberg and held at the Instituto Valenciano de Arte Moderno (IVAM), Valencia, Spain, from 27 September to 11 November 2007, I sat down with the artist to talk about his work.

Simone Osthoff: I would like to begin by asking you about Alba, your famous and controversial transgenic bunny.

Eduardo Kac: Alba was born like you and I, with an intrinsic justification that is irreducible to external factors, in other words, with nothing but her life to justify itself, except that she was the first mammal created by an artist and born in the context of art. This means that her very existence, while free of external utility or function, is pregnant with semantic meaning: she embodies the passage of the chimera from legend to life, from reverie to reality. It's this poetic condition – real and alive like you and I, while at the same time rich in semantic resonance – which makes 'GFP Bunny' a unique work of art. It is her firm grounding in the realm of culture and the absence of an external utility (as in disease research or the food industry) or function (as in pet breeding or the ornamental industry) that opens the way for the poetic evocations that make it art.

In poetic terms, because of the physical transgenic work represented by the letters C, T, G, A, which emphasizes itself and not primarily elements external to itself, you could, for example, consider 'transgenic bunny' a living metaplasmic figure, that is, a figure that moves the letters or syllables of a word (in this case, the genes) from their typical places to generate new meanings.

I use the word 'figure' here as in 'figure of speech', that is, a form of creation based on the intentional departure from straightforward, literal use of verbal or visual form to produce new and imaginative associations. Or, more generally, you could think of 'transgenic bunny' as a trope (a figure that changes the typical meaning of a word or words), except that in this case it is a biotrope, a figure that changes the biological meaning of life into an extra biological meaning, that is, poetic or cultural meaning. Finally, to many people 'transgenic bunny' has the semantic tension of a living trope that I describe with my own neologism: 'teratofilon', the juxtaposition of living contrasts (in this case, the friendly and the monstrous) which produces a feeling of balance. What distinguishes 'teratofila' from other living contrasts is that they are created intentionally, for art, and the contrast is only apparent, as the intermixing of disparate elements produces a new congruity and provides a novel expression of ideas and/or emotions. The poetic analogies above help us understand certain aspects of the work, but do not exhaust its meanings. We should also consider other aspects, namely the relation between ethics and aesthetics and the role of reception in the evolution of the work. Above all, Alba is an individual, a subject.

SO: Originally Alba was going to meet the public while living with you in an art gallery for the period of a week or so. Only after the gallery exhibition was the rabbit to become your family pet, something that, despite 'Free Alba!' campaigns, never happened. Was Alba a success anyway? What happened to Alba?

EK: The social aspect of the work is very important, but is not the only one. If we consider 'GFP Bunny'

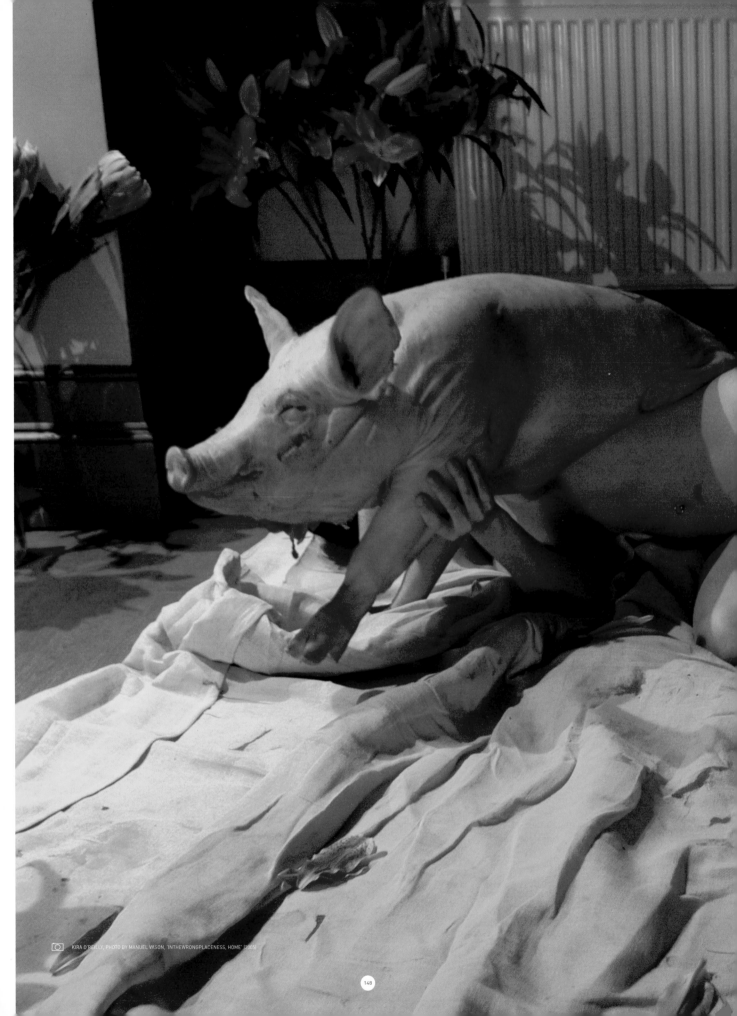

from a purely aesthetic point of view, we realize that it presents a new role for the artist: not the creation of objects, but the creation of subjects. It draws attention to an ethics within aesthetics. It is without precedent and opens a new field for art, one with real evolutionary implications. This will become more clear in the next twenty or thirty years, when future artists create bio artworks that further develop this basic premise.

Alba never left the lab where she was born due to the restriction imposed by the lab's director, possibly out of fear that her coming home to me would cause him problems of some sort (what kind of problems is unclear). It is senseless. The only thing that would have happened if she came home is that the lab would have kept its agreement and Alba would have had a nurturing environment in which to grow.

SO: Since 1998 you have been creating bioart, transgenic works or other living pieces. How did you start to work with living organisms?

EK: My first work involving non-human living organisms is from 1994 – *Essay Concerning Human Understanding*. In this work a bird and a plant, in two distant cities, interact with one another by the remote exchange of sounds in a feedback loop. The plant produces sounds through its own electric fluctuation in response to the singing of the bird. The piece creates the experience of interspecies communication through the network.

But to better understand my trajectory we need to go back to 1986, when I created the first in a long series of works of what I call 'Telepresence art'. This is a new art form predicated on the creation by the artist of new telerobotic bodies that a remote participant inhabits in order to experience new, invented forms of presence. In the course of time I created new electronic beings, enabling new kinds of experience for each work. In 1997 I created *Time Capsule* and it was a turning point in my work, when I coined the term 'bioart'. *Time Capsule* is a piece in which I implanted in myself a digital microchip containing a series of numbers. I did the implant live on TV and on the web, in front of a series of photographs my grandmother brought with her from Warsaw in 1939, which represent those who perished in the war. In the last segment of the television broadcast, the information in the chip was read through the web. With that number I registered myself in an online database as both a dog and its owner. The trajectory I just summarized took place in the course of seventeen years. This trajectory is well documented in detail in my book *Telepresence and Bio Art: Networking Humans, Rabbits and Robots* (University of Michigan Press, 2005). It seems to me that the dichotomies between local and remote, human and non-human, living and machine, are starting to erode. Transgenic art is the aesthetic manifestation of this contemporary condition.

SO: It seems that among the reasons behind your work with transgenic art is the exposure of the cultural influence of science, and the possibilities for manipulation and transformation of life.

EK: It is not possible to reduce art to 'an intention', because art emerges from many sources and is naturally open ended, without 'one' specific function or meaning. Even when it is in connection with other disciplines or fields, art creates its own realm of experience. Please allow me to clarify that transgenic art is not here to 'comment' on science or any other field. Commentary is best carried out by pedagogy or academic exegesis. Transgenic art exists, first and foremost, as a new creative realm in

itself. Like all contemporary art, it is in dialogue with several fields, such as philosophy and literature, but not uniquely or specifically with science. The emphasis is on the art – its experiences, sensations, emotions and ideas – not on factors external to it. Transgenic art uses a new medium that was not used before: the processes of life. It is inadmissible to consider the processes of life as belonging exclusively to a single discipline. I do not create new life in order to comment on other disciplines. That would have no interest whatsoever to me. I create new life in the context of my artworks, and each work has its own poetic and experiential reality, its own multiple meanings.

SO: Scientists created bioluminescent mice, fish, plants, rabbits, and even succeeded in creating a primate with the GFP gene: what makes your transgenic artworks any different?

EK: You use words in your articles. James Joyce used words in his novels. A lawyer uses words in his legal briefs. What is the difference between all three kinds of writing if all use words? Clearly, the question is not the use of words, but how the words are used. In my case, it is the same thing. I use the processes of life in entirely different ways than a gardener or a laboratory professional. In my case, I create life that, in addition to having the same ontological status of all life, also has a semantic charge that is non-biological – the meanings that are inflected by the artwork. And, as has always been the case in the history of art, each artwork helps the artist build, in the course of a lifetime, his or her own poetic or philosophical visual and experiential universe.

I create artworks that come from my own, individual, subjective poetic universe, and seek to resonate emotionally and cognitively with viewers and participants, while asking fundamental questions about what it means to be human in the 21st century and beyond. At the same time, the works are more than questions: they are material realizations, embodiments of my vision of what both art and life in the future will be like. This is important because the work is not the representation of an idea; rather, the work is literally alive like you and I. Therefore, it is both an artwork and an intervention in the real, lived world. The artist creates not objects, but subjects. This sparks a new ethical dimension of art. My work creates in the present a new field for art while prompting society to ask how it will prepare itself to welcome new citizens who will be, themselves, clones and transgenics.

The observation of the material manifestation of the work is not sufficient to understand what the work is. Excessive concentration on the material and formal aspects of the work is an old, anachronistic mode of inquiry that no longer corresponds to the multi-modal, polyphonic, de-centred, dialogical, relational, distributed, non-anthropocentric, interdisciplinary forms of contemporary creation. Focus on the visible is not enough to see.

SO: Is there a difference in the way you use genetic manipulation in your artwork and the lab methods employed by scientists?

EK: The question is not one of methods, but realizations. Military training and the video game industry may use the same or similar methods, but their goals and realizations are clearly distinct. In 1955 Yves Klein created his well known 'blue' through the use of a new synthetic fixative resin called Rhodopas M60A, which was used as a binder without changing the strength of the ultramarine pigment. It

goes without saying that Rhodopas M60A was developed through scientific research, but this has little interest to anyone, experts and public alike, because what matters is the poetic universe Klein created with his works. I mention this as an example, to emphasize that the question is not the method. In art, what matters first and foremost are the artworks themselves, that is, the world generated by the artist. My work naturally reveals my own poetic universe, from the 1980s (when I already invented new robotic beings) to my current bioart, in which the new beings exist on their own and share social space with us. My world is literally populated by real clones, transgenics, interspecies communities, and biological hybrids. It is imperative to look at the artworks themselves, instead of their methods, and engage with them as viewers and participants.

SO: In your installation *Genesis*, which you first presented in 1999 in the Ars Electronica exhibition in Linz, and again at your show at IVAM, Spain, in 2007, you transformed a bible-quote into a genetic code. Also for your project *The Eighth Day* you picked a name that has a religious context. How important is religion for you?

EK: I am an atheist, but religion is socially present and thus plays a role in shaping cultural experiences. My 'Creation Trilogy' is comprised of *Genesis, GFP Bunny* and *The Eighth Day*. In these three works I use the same GFP gene as a visual and social marker. Therefore, *Genesis* critically addresses economic and ideological underpinnings of religion. *The Eighth Day*, on the other hand, reverses the notion of 'the other', by making green-glow the norm within its world. In other words, all creatures in *The Eighth Day* glow green, so to be 'different' in this world is not to glow green.

SO: Are you considering the creation of additional new species and artificial habitats?

EK: The biotopes in my *Specimen of Secrecy about Marvellous Discoveries* are already artificial habitats, and so are the environments created for all my other living works. In layman's terms, the 'crossing' of a rabbit and a jellyfish, as in my 'GFP Bunny', already gave birth to a new species. Transgenic art will continuously originate other life forms that did not exist in nature – it is intrinsic to its aesthetic platform. Other methods beyond transgenesis will also be employed.

SO: With your new series *Specimen of Secrecy about Marvellous Discoveries* you seem to be going in a new direction. Is transgenic art outdated already?

EK: Not at all. I'm opening a new direction while at the same time further developing transgenic art. If I make a video this does not mean that photography is outdated. I work in multiple media simultaneously. I make drawings, photographs, sculptures, prints and many other works. And, of course, I continue to develop transgenic art. Since through transgenic works I create life that did not exist in nature before, they take a long time to develop. In the meantime, I continue to develop my other works. *Specimen of Secrecy about Marvellous Discoveries* is quite unique because each work in the series is a body, an individual with its own identity. Each work is both a single entity, like you and I, and a community of cells and micro-organisms, like you and I. Just like they do in us humans, these very large communities of micro-organisms interact among themselves and, as a unit, they interact with the environment. It's a work that always changes because it literally is alive. If you live with it, you literally 'live with it', as another life form in your home, as if the artwork on your wall shared some qualities of your plants or fish, such as growth, change and behavioural unpredictability. The future of bioart involves this level of personal relationship and intimacy.

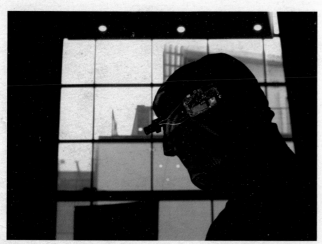

POLITICAL ECONOMY OF THE FUTURE

POLITICAL ECONOMY

OF THE FUTURE

FRAGMENTS OF CREATIVE CLONING: TIME, MONEY AND RELATIONSHIPS

KATE O'RIORDAN

4015 Words /3.1 Political Economy /Human Futures

ENCOUNTERING THE FUTURE PAST

Since 2004, human cloned embryos and animal/non-human animal hybrid embryos have been the most recent of new biomedical entities to be created. Within the UK in May 2008, there were heated debates about human hybrid embryos during the revision of the UK embryo bill. The revised bill was framed as a battle between those invested in hopes for cures and those invested in the moral status of the embryo. MPs had a free vote on the basis that such 'questions of conscience' were not party politics, while at the same time there was a fairly clear Labour 'for' and Conservative 'against'. Although news of the creation of hybrid embryos in Newcastle had broken at the start

of the year and the issue of licences for their creation had already been debated in 2007, nowhere in the May 2008 news coverage of the revised embryo bill was mention made of the fact that hybrid embryos had already been cloned. This legislation was positioned as a new encounter with the future (what will be permitted) of science, not the past (what has previously been conducted) and present. Conspicuous by its absence was any debate about the market, the money, the investment and the returns that might be attached to such high-tech biomedical futures. In other words, any sense of informing a political economy of the present was lost through a debate about morality directed towards the future.

This current UK debate has been described as the first revision of the human embryo bill in a generation and we are back in the terrain of miracle cures versus the status of the embryo. We are also back into language strategies – is the entity in question to be referred to as an embryo, a pre-embryo, a blastocyst, or just a special bundle of cells? It has been again suggested, as it was in the embryo debates of the 1980s and 1990s, that, if we could get the language right, then some of the controversy would go away.

Every framing of such issues comes back to a polarity between curative material or sacred embryo. It is hard to see how this makes sense, other than as a strategic ingenuity, amnesia, or a kind of rhetorical avoidance of the materiality in question. Could there be questions that are more productive for us to ask? Could we question the politics of their production and reproduction and, in so doing, provide a better account of what is at stake when considering these emerging technologies? These entities share a material existence and economic relations; they are biotechnological imaginaries materialized and returns on investments. For this reason, when considering the future as an enduring contested and polarized space, we must ask what our responsibilities and relationships are to these entities propelled into existence through our regulative decisions.

This essay attempts to return three features of these debates back into the contemporary scene. The first is *time* – how do past practices and present research figure, or what do they stand for in a time in which the present is only understood in terms of

futures? The second is *money* – who is paying for creative cloning such as hybrid embryos, how much are they paying and who expects a return? The third feature missing from current hybrid encounters with the future is *relationships* – how is humanity related to these new forms? Even if they are not *really* embryos, they are *really* something; the debate about names goes on, although embryos, clones and hybrids seem to have the greatest currency so far. These entities and the relations they produce are human/non-human networks of flesh, new others in opposition to which we position ourselves. There is a consensus that *generative flesh*[1] with the potential for a life, a cost, a time and a story, is somehow special. Generative flesh creates relationships that demand new forms of recognition. Hybrids bring newly configured intersubjectivities and new imperatives of care. In sum, these three features – time, money and relationships – structure the remainder of this essay.

TIME

Cloning 1: In the current conjuncture the case of Dolly the sheep seems almost prehistoric.[2] Given that the cloned dinosaurs of *Jurassic Park* figured so largely at the time in which she was cloned (1997), perhaps this is apposite. It is worth noting that the current practices of therapeutic cloning and hybrid embryo creation utilize the same method that was used to create Dolly at the Roslin Institute in Scotland in 1997 (see Wilmut et al. 1997). Read as the sheepish face of human cloning (Franklin 2008; Haran et al. 2007), Dolly is long dead and,

fairly unusually for a sheep, was preserved by taxidermy (rather than being eaten).

Cloning 2: In 2004 three cloned human embryos were created in Newcastle (UK). This was a moment of crystallization in the frenetic contexts of fraud, scandal, excitement, controversy and sensation that formed the cloning climate of the early 21st century. Such fervour had arisen in numerous contexts, including Dolly, the Human Genome Project, global cloning and stem cell research, and the rise and fall of Professor Hwang of South Korea whose human embryonic cloning was condemned. It also describes the hype of claims such as that the disabled would walk. These claims were made through the use of figureheads such as Christopher Reeve, celebrity scientists calling for support for their research, and the announcement that the human genome revealed God's language. Almost as soon as those tentative entities – the Newcastle cloned cells – came into being, they ceased to be, after three days for two of them and five days for the other.

Cloning 3: In 2008 the Newcastle *hybrid* clones were created. Cow cytoplasm and human nuclear DNA grew for three days during which cells divided. Short-lived and fiercely debated, these tiny entities cast large political shadows. Little – actually microscopic – moments of materialization, imaginaries materialized, science materialized, fleshy ideas, fleshing out futures, these were the focal point of moral debate throughout the UK.

Today, debates about cloning in the UK have shifted from animal (Dolly the sheep) cloning in 1997, to human cloning in 2004, to human/animal cloning in 2008. Yet the cloning of Dolly was read internationally as the precursor to human cloning. A flurry of debates, councils and legislative efforts were launched to regulate this domain, but there is still no consensus. Conversely the human cloning of 2004 at Newcastle was *not* constructed as human cloning at all, but as part of the story of stem cell research. The hybrids of 2008 have been projected into the same stem cell story. They are harnessed to its hope (Haran et al. 2007; Kitzinger and Williams 2005; Mulkay 1997) and cast as the prospective saviours of those suffering from disease.

In each case these new entities (Dolly, the cloned embryos, and the hybrids) were created from somatic cell nuclear transfer. In each case the nucleus of an

egg cell was removed and a nucleus taken from another adult cell was placed in the egg. This composite was then stimulated with electricity and the new entities generated. In the case of Scottish Dolly, the nucleus of a sheep's egg was replaced with the nucleus of a cell taken from the udder of an adult sheep. In the case of the Newcastle clones, the nucleus of a human egg was replaced with the nucleus taken from an adult human skin cell. In the case of the Newcastle hybrid (or cytoplasmic hybrid), the nucleus of a cow's egg was replaced by a nucleus taken from an adult human skin cell. Dolly lived a life that can be accounted for (e.g. Franklin 2008; Highfield and Wilmut 2006; Kolata 1998), growing to term and being memorialized through multiple books, television documentaries and news, and finally through taxidermy and a place in the National Museum of Scotland.

The human clones of 2004 only lived for three to five days, and the hybrid of 2008 for only three. These are comparatively short-lived lives. What futures do these new entities unfold into, these materializations of biotechnocultural imaginings? How is it that we cannot understand them in the here and now and that they are still future (although past). They bring their reality into the world, into new kinship relations. They articulate the moment when human cloning moves away from science fiction to science fact (Haran et al. 2007), thus creating new presences in the world. Apparently they look like 'semolina',[3] these new (but now old) cytoplasmic hybrid embryos, or admixed embryos, or hybrids, or cybrids, as they were variously named. Human cloning has been done, passing into practice, entrenched through regulation, it has become almost normal. Six more cloned embryos were created in the USA in 2008, then after this cybrids were next, and now they are also past, having passed into practice, they also are no longer only future entities. When encountering the future, the tense of our language is always changing. Cloning the sheep after all, according to Ian Wilmut (Highfield and Wilmut 2006), reversed cellular time, ushering in a biology in which 'nothing is impossible'. Genetically modified embryos in the USA in 2008 were the last of the past new order, but which entities will be next in line for the future?

The due process of scientific research and publication means that the movement of such entities in and out of material realism is

indeterminate, except for those looking through the microscope. That is to say we do not really know when clones and hybrids are among us, though we know they have been and that structures are now in place to facilitate their recurrence. They are here and, as such, they constitute the past and present, even as they are still portrayed as the future.

In this section on time the aim has been to challenge the tenses brought in to play in the current debates. The purpose of this is to rearrange the way that time is faced slightly and to try a re-positioning, to recognize that there are different ways of experiencing the temporal horizon, and that to truncate tenses and time, so that there is only the option to face the future, effects an eradication of the past, inducing amnesia and misrecognition in ways that are disorientating.

MONEY

When biotechnology seems to be so enchantingly emergent, it seems churlish to ask about the cost. By this I mean that there are multiple visions of technocultural life as emergent or imminent, and thus determined by a kind of inevitable vitalism, a progress narrative of future science and future life. However, such visions also need to be accompanied by another account that is both accountable in the ethical sense, and an accounting in the economic sense. This might appear cynical because it asks for an economic inquiry into processes that are framed in terms of enchantment and wonder, when they aren't being framed in terms of disgust. All of these framings invite engagement in terms of emotion, affect, instinct, aesthetics and morality, but we also need a political economy. Thus, an account of these entities that followed each of their existences might be important, in order to understand how their lives give rise to capital that extends well before and beyond them. Hybrid embryos are created for a purpose and they are expensive; life itself is more than a little resource-intensive. It is fifteen years since the great embryo debates of the 1980s and 1990s in which the UK government placed the limits of experimentation on embryos (up to fourteen days) firmly in the domain of scientific research (Mulkay 1997). Since then these kinds of entities have been attracting investment. The question of who is paying for these biotechnological entities is not new, but it seems to be

rarely asked. Which institutions are likely to benefit financially from such creative cloning? Who is building new research facilities where fertility clinics and regenerative biomedicine facilities are co-joined, with hatches that lead from one to the other, through which eggs and embryos flow (Franklin 2007)?

It is hard to follow the money in the current polarized context of cures pitched against God. The only recent public reference to this question of money in British politics came from a Conservative minister, Iain Duncan Smith (former leader of the Conservative Party): 'I am deeply cynical about the scientific community's motivation. There seems to be a perpetual desire to keep us all scared ... This is a lot to do with an industry trying to make money.'[4] In making this statement he did not so much ask the question about financial (conflicts of) interest as state that science is a money-making industry, and this hardly contributes to debate. Despite the expectation that it consist of the noble pursuit of contributing to humanity, biomedical science is a commercial industry, and governmental interests are intimately aligned with it. Politicians demand the rights to exploit the commercial application of the sciences, and science as industry is an economic interest of the state. Scientists are asked by government funding bodies to name their outcomes, the application of their research, and to name their user groups in their research applications. As such, it is remarkable that the economy of science and politics is not more transparent. Surely it matters whether the development agency of North East England has an interest in maintaining Newcastle's presence as a globally significant centre of cutting-edge science. It is also important that the Medical Research Council, the National Health Service and the various national funding bodies (such as the BBSRC and the Wellcome Trust) are investors who expect a return. This expectation of a return is for user groups, patients, practitioners, drug companies and publics. It is also a return expected in terms of economic sustainability, a return in outcomes, in patents, in biotech start-ups, in drug development, in Nobel prizes and a return in more money. A single Medical Research Council grant to improve the efficiency of cloning was £484,000 (one grant in 2007). Once this is multiplied across the half-dozen licence applications that the government advisory agency, the Human Fertilization and Embryology

Authority (HFEA), has seen in this expanding area, each licence connected to several grants, it quickly adds up to millions of pounds of expenditure in a fairly short space of time, concentrated over a few institutions, salaries and materials.

For Newcastle and other institutions in the UK (e.g. Roslin and King's College London), creating clones and hybrid embryos are past and present practices. They are practices now linked to attracting start-up companies, investors, and developing revenue streams from these novel research trajectories. This means incorporating various types of public as consenting consumers and hopeful patients, as well as consenting research subjects. Advanced biomedical research, within a rationally configured regulatory body, appears to work for the UK economy (Blair 2006), a statement to which other histories of the HFEA attest (Franklin 2007; Mulkay 1997?).

The key to the UK human biotechnology industry is innovation within biomedical science, in the name of regulation. Innovation through regulation is the speciality of the UK system, for which it is looked to, and which it exports. The secular rituals of form filling, consultation, evaluation and permission are observed though the HFEA. The model for rational regulation, a system that doesn't say no, but does say let us see – this works for the UK. The internal logic of the UK system assumes that the USA is inhibited (at least temporarily) in the area of human biomedical research by the length and obduracy of the Bush Jr administration and its explicit condemnation of human biotechnology research, in the name of the sanctity of the embryo. South Korea, an early competitor, appears in the UK as unreliable since the Hwang affair was used to represent the country as lacking in the robust regulatory technologies required to manage either fraud or ethics. Thus the UK, which lost out in manufacturing and production in the 1980s, and could not compete in the silicon economy of the 1990s, has found a time and a niche in which to lead a global march to regulated human biotechnology. In the UK, national government bodies, regional government agencies, private companies, public, private and hybrid science institutions are in partnership in developing and sustaining UK biomedical science as a national player in a global bio-economy.

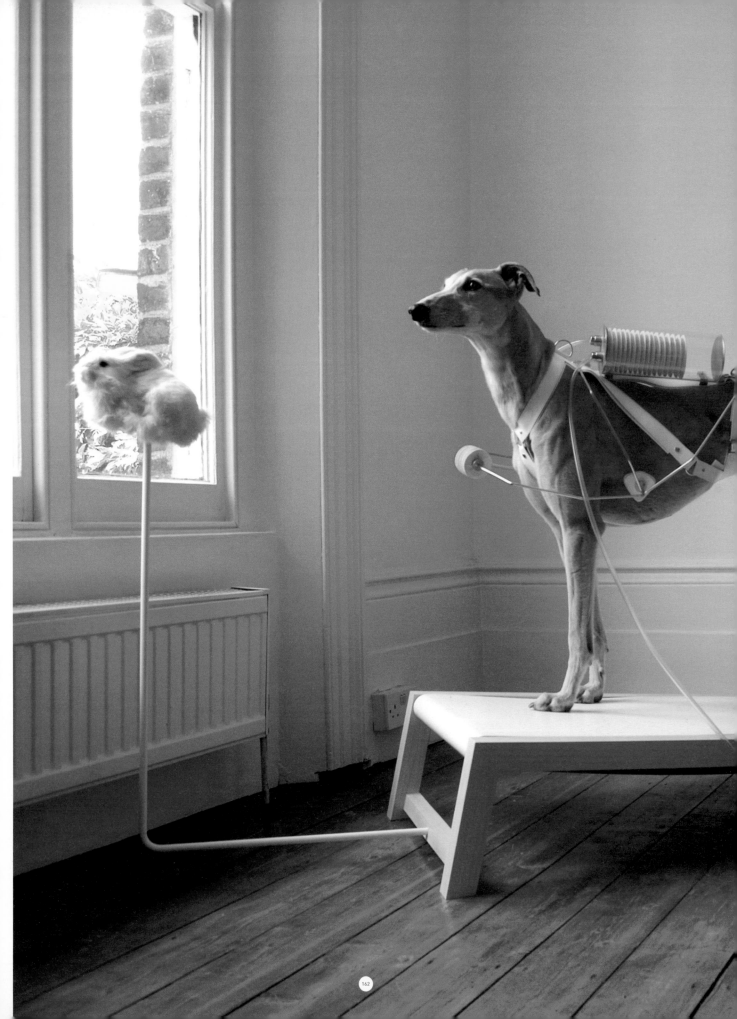

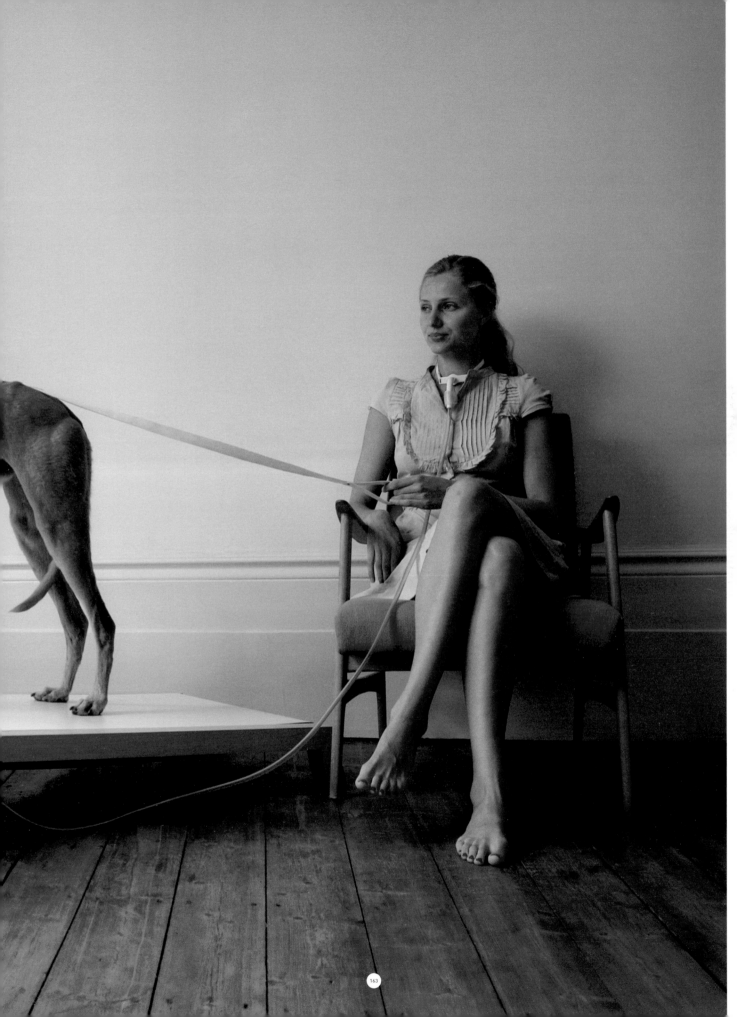

ASSISTANCE ANIMALS –
RESPIRATORY DOG

Assistance animals - from guide
dogs to psychiatric service cats
- unlike computerized machines,
can establish a natural symbiosis
with the patients who rely on
them. Could animals be transformed
into medical devices? This
project proposes using animals
bred commercially for consumption
or entertainment as companions
and providers of external organ
replacement. The use of transgenic
farm animals, or retired working
dogs, as life support 'devices'
for renal and respiratory patients
offers an alternative to inhumane
medical therapies. Could a
transgenic animal function
as a whole mechanism and not
simply supply?

A pedigree greyhound is bred
by the racing industry. Like
his purebred parents, he has
long, powerful legs,
hypoallergenic fur and a large
chest capacity. He will spend
the first twelve months of his
life being trained to chase a
lure. Over the next three to five
years the dog spends his days at
kennels and is taken racing weekly
to make profit for its owners. By
the age of five, or earlier, the
greyhound retires from the
racetracks. Instead of being
euthanized (a fate thousands
of retired greyhounds suffer
each year), the dog is collected
by the NHS and goes through
complementary training in order
to become a respiratory assistance
dog. When training is completed,
the greyhound is adopted by a
patient dependent on mechanical
ventilation. It then begins its
second career as a respiratory
'device'. The greyhound and its
new owner develop a relationship
of mutual reliance through keeping
each other alive.

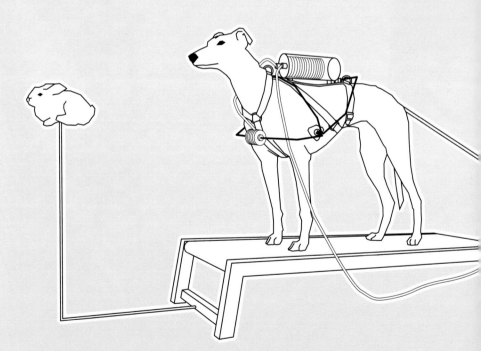

REVITAL COHEN, 'RESPIRATORY DOG' (2008, RCA, COURTESY OF THE ARTIST)

RELATIONSHIPS

Creative cloning, hybrid embryos
and other novel forms of life
exist and, in doing so, they
create new intersubjective
relations. Since the patenting of
life forms in 1984 (Kevles 1995),
it has been evident that new kinds
of responsibilities and new kinds
of care in reconfigured power
relationships are increasingly
necessary. As Haraway (2007)
notes, 'Natural or not, good or
not, safe or not, the critters
of techno-culture make a
body-and-soul changing claim on
their "creators" that is rooted
in the generational *obligation
of* and *capacity for* responsive
attentiveness'.

For Donna Haraway, and this is
re-articulated throughout her
work, the *relation* is what
requires our attention. It is
defined here as the obligation
and capacity for responsive
attentiveness. This sense of
relationality presents a mode
through which attention to
technocultural entities might be
directed and various contributors
to debates in this area have
signalled the importance of
relationality. For Susan Sherwin
(1998), the question of the
relationality of agency is central
to her formulation of 'relational
autonomy', where her focus is on
the (im)possibility of individual
agency. For feminist philosopher
Karen Barad, on the other hand,
agency and relations raise
questions of materiality.
Materiality is central to her
sense of the 'ethics of mattering'
(Barad 2007: 36) and her question
of what comes to matter. In
addition to thinking about
relations in terms of the
attention, response, agency and
matter, there are two other

complementary (and associated) ways of thinking through the question of how we are related to that which we create. The first is in the intercorporeal relations that Catherine Walby (2002) sees as structuring the connections of organ and tissue transfer, which focus on the shared experience of embodiment. The second is in the relations of touch and care that are the conditions of possibility for the philosophy of Isabelle Stengers (2008) and Maria Puig de la Bellacasa (2008). These different accounts can be productively brought together: for example, Sherwin's concept of the 'relational' complements Haraway's 'relational' in the sense that Sherwin's focus on autonomy extends towards the contextual and socially situated circumstances in which people confront difficult (bio)ethical decisions (Sherwin 1998: 19). This accentuates the question of responsibility linked to such agency.

From these rich contributions we are able to understand relations as an obligation to respond with attention to others; the connection of shared corporeality and matter; a way of touching other entities; and inhabiting unfamiliar social contexts. *Relations* then might be an important way to understand contemporary engagements with hybrids and clones. Now that animal, human and human/animal flesh goes to market in multiple forms and for novel purposes, we must rethink our understanding of times, economies and the relationships of such a market place.

CONCLUDING FRAGMENTS

This essay has discussed the various ways in which stories about cloned life forms can be told and retold through various relational parameters (time, money and relationships). One story about hybrids puts them at the forefront of cutting-edge biomedical science. In this version of the tale they are part of the stem cell story, saving women from the risks of egg harvesting and leading to cures: enlightenment victorious. Another story about hybrids puts them at the forefront of the moral demise of humanity, as a species category. In this version of the tale, they are evidence of a departure from Godly civilization, a mixing of human and animal: enlightenment reversed. The final version of the first story puts them in the mundane context of everyday scientific research: enlightenment as usual.

Morality and politics cannot be understood in the absence of each other. Hybrids are not only about the status of the embryo or the greater glory of science. They are also about intersubjectivity, political economy and time. One day, they might constitute substantial steps towards the alleviation of suffering, though free basic healthcare provision and access to clean water would get there faster.

These hybrid entities are important components of science policies and funding structures in the UK (and elsewhere) that prioritize state-of-the-art human biomedical research as an economic innovation strategy. It is this mundane story of everyday techno-science that needs more telling, one that is less embedded in the social imaginary of utopianism and dystopianism. It is a story that is, conversely, more economically grounded in the realities of research and funding networks and their intersections with biotechnology companies, government committees and public authorities.

To reckon with the bio-political economy we need stories that trace out more of the contours of these tales. In the other stories outlined here, hybrids are cast as an abstract drama of God against science and this dramatization occludes a rethinking of the politics of the technocultural present. Such a rethinking should include time, relationships and money to permit a serious engagement with, and account of, these entities.

Thus, my version of the tale is a retelling (cf. McNeil, 2007) of these other stories, which supplements the high drama with a balance sheet, or an economic account. Such a retelling examines the relationships that enable these entities, and those they (re)produce. It involves thinking about the temporal character of these creative acts in the technocultural present, to account for their existence and ours in the here and now. It also involves acknowledging histories, while avoiding a replaying of the past. It involves acknowledging the economic terms of what we are constructing. In sum, a retelling examines the present and the past already instantiated, emotionally, materially and economically. This is important because it is through the projection of present forms of creative cloning into the future that we endlessly displace the present, conjuring circular encounters that avoid touching the politics of the here and now.

REFERENCES

Barad, K. (2007). *Meeting the Universe Halfway: Quantum Physics and the Entanglement of Matter*. Raleigh, NC: Duke University Press

Blair, T. (2006). 'Our Nation's Future: lecture 4'. London: HMSO. Available at http://www.number-10.gov.uk/output/Page10320.asp. [last accessed 3 July 2008]

Franklin, S. (2007). 'The Cyborg Embryo: Our Path to Transbiology'. *Theory, Culture & Society*, 23, 167-87

Franklin, S. (2008). *Dolly Mixtures: The Remaking of Genealogy*. Johns Hopkins Centre. Durham, NC: Duke University Press

Haran, J., Kitzinger, J., McNeil, M. and O'Riordan, K. (2007). *Human Cloning and the Media: From Science Fiction to Science Practice*. London: Routledge

Haraway, D. (2007). 'Speculative Fabulations for Technoculture's Generations: Taking Care of Unexpected Country'. *Artium*

Highfield, R. and Wilmut, I. (2006). *After Dolly: The Uses and Misues of Human Cloning*. London: Norton

Kitzinger, J. and Williams, C. (2005). 'Forecasting Science Futures: Legitimising Hope and Calming Fears in the Embryo Stem Cell Debate'. *Social Science and Medicine* 6/1, 731-40

Kolata, G. (1998). *Clone: The Road to Dolly and the Path Ahead*. New York: William Morrow

McNeil, M. (2007). *Feminist Cultural Studies of Science and Technology*. London: Routledge

Mulkay, M. (1997). *The Embryo Research Debate: Science and the Politics of Reproduction*. Cambridge and New York: Cambridge University Press

Puig de la Bellacasa, M. (2008). 'Thinking-With-Care', in S. Ghamari-Tabrizi (ed.), *NatureCultures: Thinking with Donna Haraway*. Cambridge, MA: MIT Press

Randerson, J. (2008). 'MPs set to back new embryo research laws'. *The Guardian*, 12 May

Sherwin, S. (1998). 'A Relational Approach to Autonomy in Health Care', in S. Sherwin (co-ordinator), *The Politics of Women's Health: Exploring Agency and Autonomy*. Chapel Hill, NC: Temple University Press

Stengers, I. (2008). 'Experimenting with Refrains: Subjectivity and the Challenge of Escaping Modern Dualism', *Subjectivity*, 22, 38-59

Waldby, K. (2002). 'Biomedicine, tissue transfer and intercorporeality'. *Feminist Theory*, 3, 239-54

Wilmut, I., Schnieke, A. E., Mcwhir, J., Kind, A. J. and Campbell, K. H. S. (1997). 'Viable Offspring Derived from Fetal and Adult Mammalian Cells'. *Nature*, 385, 27 February, 810-13

[1] I use this term to provide a rhetorical echo of older versions of what embryos were thought of; the echo is drawn from Catholic theology and 19th-century science discourses alike.

[2] Dolly can also be thought of in relation to age because of the debates about whether she was 'old before her time'. The autopsy did not indicate death from an age-related disease but she was arthritic and her telomeres (end of the chromosomes) were short – which is associated with age (Franklin 2008; Highfield and Wilmut 2006). However, it should be noted that there isn't a lot of comparable data as sheep are more often eaten than die of old age, and even when they live longer they are not often subject to biomedical scrutiny and autopsy.

[3] John Burn, head of the Institute of Human Genetics at Newcastle University, reported that the hybrids looked like semolina when looked at down the microscope. Semolina is a common food base in European and North American areas; it is the inner starch of wheat, also known as farina, suji and rava.

[4] Iain Duncan Smith quoted in James Randerson's (2008) article in *The Guardian*.

2767 Words /3.2 Political Economy /Human Futures

GLOBAL GOVERNANCE AND EMERGING TECHNOLOGIES: THE NEED FOR A MAINSTREAM POLICY DEBATE ON MODIFYING HUMAN CAPACITIES[1]

NIGEL CAMERON

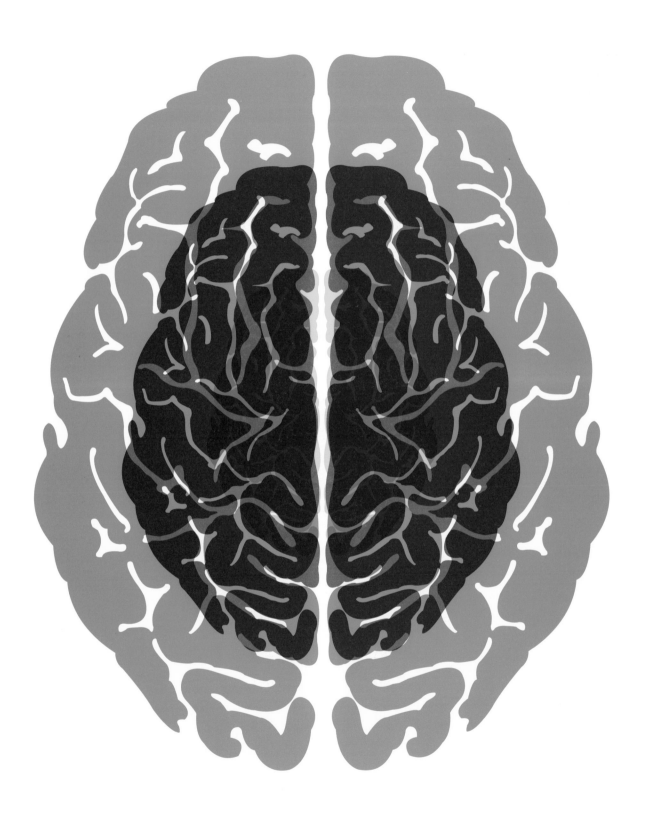

Questions on the societal implications of nanoscience and nanotechnology will permeate every policy discussion of the 21st century and create whole new kinds of policy dilemma, and we are ill-prepared to provide good answers. This is nowhere more evident than in the context of the asymmetric threats that have come to characterize the 21st century. Those threats are not confined to technology and its applications, though they will greatly exacerbate their reach. Our tendency has been to avert our eyes from the societal implications of emerging technologies, except in specific hot-button issues where implications are cognate with existing sets of concerns – such as research involving human embryos or, particularly in Europe, the debacle over so-called genetically modified foods. The implications of emerging technologies are far greater, not least in consequence of their increasing speed of development and convergence on the nanoscale.

Our neglect of issues that are of fundamental significance is shown in three recent examples of what have widely been seen as naive assessments of technologies and their pace of development – in each case, on the side of extreme optimism (both as to the pace of technological achievement, and its beneficent application). One example lies in the 2007 report of the congressional Joint Economic Committee which espoused the view that the so-called 'singularity', a posited point at which artificial intelligence essentially takes over from human, may be expected by the year 2020, a claim that most experts in the relevant fields would see as risible. To the extent that it is not, it would be subversive of all efforts to develop long-term policies on issues as diverse as defence, social security, and healthcare. A second example lies in the claim of the National Cancer Institute that cancer will become an essentially chronic condition, no longer the cause of severe suffering and death, by as early as 2015. While this claim is said to be aspirational, it has been denounced as irresponsible by leading figures who see it as hyped and naive. Policymakers have yet to develop the tools to assess such claims and make sense of them. Moreover, neither of these claims has been widely reported, suggesting that even lurid efforts at injecting emerging technology developments into the policy mainstream have not succeeded. A third is to be found in the 'converging technologies' conferences and reports of the National Science Foundation, to which I will refer in more detail later.

Our policy response to issues such as embryonic stem cell research and 'genetically modified' foods has been to segment them from broader questions of science and technology and seek to address them in isolation. Whereas this approach has utility, it is needful also to see them as flashpoints of controversy within the wider context of a social order that is increasingly pervaded by transformative and disruptive technologies. The future significance of this is hard to assess though it will undoubtedly be vast and comprehensive in its global impact on our social and individual life. As 9/11 demonstrated, and as concerns about climate change and pandemic influenza illustrate, the increasing complexity of the global order and the open-textured nature of our societies have brought us to a point where asymmetric possibilities are reshaping our notions of security and threat.

While discussion of the impact of emerging technologies on human nature and the human future has long been couched in terms of genetics and the possibility of interventions in the human germline, the transformative impact of emerging technologies has lately been set within the 'convergence' of nanotechnology, biotechnology, information technology and cognitive science (sometimes referred to as NBIC), and the possibilities – presently at a very early stage – of 'synthetic biology'. The convergence theme is best illustrated by a series of 'reports' published or edited or both from the National Science Foundation. The first was published under the title *Converging Technologies for Improving Human Performance* (Roco and Bainbridge 2002). The report suggests that the chief goal of 'convergence' lies in 'improving human performance', which entails a fundamental change in human capacities. This is where I am focusing my remarks today, since the prospect of a race to enhance human performance through re-engineering the brain, and developing the brain-machine interface so that a cyborg – part-human, part-machine – emerges, offers the most evident transformation of the 21st century and potentially the most dramatic intervention in human history. Whatever its other merits, it could lead to international destabilization as nations and, potentially, groups of non-state actors vie with one other for mastery through superior intellectual, communication and other capacities. And it is plausible that it could lead to something far more radical, in the ascendancy of a cyborg 'transhuman' or 'posthuman' being. While this would undoubtedly come about incrementally, and while some of the forecasts as to how soon this might happen are probably wildly overstated, it is by no means obvious that the blessings of such an enhanced state of being would be spread around the human race. The emergence of a race of transhuman super-men and super-women could lead to the final subsuming of the Renaissance and Enlightenment ideals that have birthed and

sustained democracy. While this may seem far-fetched, my point this morning is that there are many smart and influential experts in these technologies who do not believe this is impossible or, in some cases, unlikely. They may be mistaken, but the issue must be addressed with a far greater degree of seriousness, both within the United States and the wider global community, than has been evident hitherto.

According to the NSF's first 'converging technologies' report, among the goals and anticipated results of convergence are listed the following: 'enhancing individual sensory and cognitive capacities...improving both individual and group creativity... communication techniques including brain-to-brain interaction, perfecting human-machine interfaces including neuromorphic engineering...' (Roco and Bainbridge 2002). The report asks: 'How can we develop a transforming national strategy to enhance individual capacities and overall societal outcomes? What should be done to achieve the best results over the next 10 to 20 years?' (ibid: 1). And, at the end of one list of long-term implications, it specifies a basic shift in 'human evolution, including individual and cultural evolution' (ibid: 4). Then this: 'Technological convergence could become the framework for human convergence. The twenty-first century could end in world peace, universal prosperity, and evolution to a higher level of compassion and accomplishment… [I]t may be that humanity would become like a single, distributed and interconnected 'brain' based in new core pathways of society. (ibid: 6)'

While this document has plainly been influenced by 'transhumanism', a futurist ideology that couches the prime purpose of emerging technologies as the transformation of human functioning into something ultimately 'posthuman', the point to be noted is that senior NSF figures see these ideas as congruent with the potential of emerging technologies, and view the prospect with enthusiasm and optimism.
Such dramatic claims have focused on the role of nanotechnology, or nanoscale convergence, in enabling innovation and control that is at present far beyond us. It is no simple matter to assess likely outcomes in an area where much

research is still at a fundamental level. However, in developing policy to ensure appropriate responses to what may ensue, it is prudent to assume that the expectations of leading researchers may come to fruition. One of the founders of nanoscale science, the late Nobel laureate Richard Smalley (1999), used these measured terms in testifying before the House Science Committee in 1999: 'There is a growing sense in the scientific and technical community that we are about to enter a golden age...These little nanothings, and the technology that assembles and manipulates them – nanotechnology – will revolutionize our industries, and our lives.' Less modest projections, referenced in NSF publications, have included something akin to eternal life and an end to scarcity.

These developments raise many questions from the perspective of ethics and policy. At one level they represent familiar questions that all technologies entail. Yet the expectations that have been raised by nanoscale convergence and its application to human well-being are so great that its implications are of a proportionately higher order of magnitude. Indeed, they have the effect of transforming discussion of the particular applications of a particular technology at the nanoscale into a point of focus for our consideration of the place of technology in relation to human nature and human society.

Several particular questions are raised. First, the question of hazard: what risks are appropriate? While issues of safety are always also issues of ethics, the ethical dimension of nanotechnology risk is in proportion to the potential dangers of the technology. The cautious approach taken in the 2004 Swiss Re report suggests that while some of the detractors of nanotechnology may overstate its risks to health and the environment, and while the likelihood of unintended harm may be low, the scale of damage that would result from a serious misjudgment could prove very great. Second, broader challenges that these new technologies present for the social order and the wider human community include threats to confidentiality. Such prospects as large-scale diffusion of radio-frequency identifier chips (RFIDs), retinal scanning, face identification technologies

and so far undeveloped options may render privacy in general a costly commodity. The preservation of medical confidentiality has already been rendered enormously more difficult by the development of electronic databases. Third, issues of equity, which have been termed the 'nano-divide', since despite the hopes of some that technology at the nanoscale will prove ultimately cheap, it is reasonable to assume that its distribution applications will follow current economic patterns. Thus the suggestion that 'all cancer' will be curable or become chronic and manageable by 2015 is unlikely to include the cancer of all persons afflicted with the disease in parts of the globe that are struggling to establish basic public health. Fourth, special issues are raised by military applications of these technologies. Fifth, there is the question of the human condition, which may seem at an intuitive level clear even though it is hard to define. A major theme of the President's Council on Bioethics (2003) report on enhancement technologies, *Beyond Therapy*, is the difficulty we face in drawing such lines. Nevertheless, there is no more important question, since the fundamental challenge of this technology is to anthropology and the assumptions we make about human beings and what is proper to ourselves.

THE PROSPECT OF HUMAN AUGMENTATION

One recent writer has put the matter thus: 'Among the applications of nanotechnology that some researchers consider 'science fiction', while others are actively attempting to implement, are enhancements to human memory, physical strength, and other characteristics. Though usually framed as attempts to monitor or repair ailments or disabilities such as Parkinson's disease or genetic abnormalities, some of these technologies can simultaneously be used to control or enhance particular human characteristics in 'normal' humans as well. (Lewenstein 2005)'

In his widely noted essay, 'Why the Future doesn't need us', technology guru Bill Joy (2000) proffered alternative scenarios of doom: either unintended disaster or intentional enhancement will bring about the end of human nature as we know it.

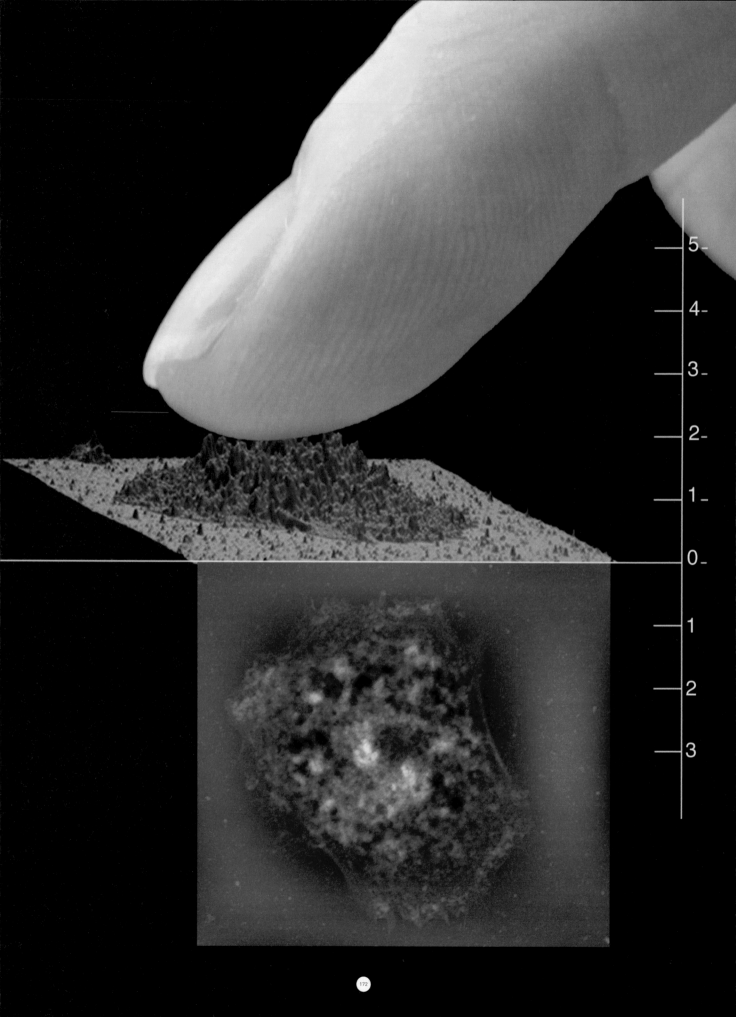

A critique of the NSF's 2002 NBIC report has come from a High Level Expert Group (Nordmann 2004) established by the European Commission. It offers a counterweight to the NSF report's embrace of 'transhumanist' aspirations that have seen nanotechnology as a route to the transformation of human nature as we know it into some 'posthuman' form – whether that of radically enhanced human beings, or machine intelligence that supplants corporeal *Homo sapiens* altogether. It also illustrates the sensitivity of these questions in the international arena.

The major area of concern, as noted in the HLEG report (Nordmann 2004), is within cognitive science. Concerns may perhaps be most starkly illustrated with reference to the prospect of cognitive 'enhancements' that involve the manipulation of perception and memory, whether through neuropharmacology (what has been termed 'cosmetic neurology') or cognitive or communications prostheses. A recent editorial in the journal *Neurology* discussed the challenge of such technological applications in these terms: '[I]ts presence is already beginning to be felt in neurology. Cochlear implants are the sentinel example of mechanical interfaces providing sensory input to the human nervous system. Neural stimulators – for movement disorders and epilepsy – are other examples of technologies currently in (increasing) use. Some worry that these successes represent the beginnings of cyborgs – individuals who are part human and part machine. For more than 50 years science fiction writers have imagined the potential for such human-robotic chimeras. Nanotechnology promises the potential of designing micromachines capable of dramatically advancing the potential of such interfaces. (Hauser 2004: 949).' Since development of such technologies will be invariably 'dual use' – with initial applications that are legitimately therapeutic – the policy challenges they raise are profound.

CONCLUDING OBSERVATIONS

These developments require a far higher degree of attention on the part of political and cultural leaders, and policymakers, than they have hitherto received. In general, they demand global

assessment – in certain cases international regulation – and for some applications the option of a global moratorium or non-proliferation agreement may be needed. US, European and Asian governments and corporations are embarked on parallel enterprises. The implications of work on the nanoscale to 'improve human performance' (to use the language of the NSF NBIC report) concern the future of the global community and, indeed, the species. The one global instrument that addresses issues of this kind is the UNESCO Universal Declaration on Bioethics and Human Rights, which sets questions of biomedicine and emerging technologies within the framework of 'fundamental human rights and freedoms'. The Declaration takes as its point of departure the Universal Declaration on Human Rights. It sets the new technology questions in the framework of human values, with special focus on the rights and dignity of the individual. Yet global technology governance is a complex and evolving theme. There is a series of inter-governmental organizations engaged in aspects of the agenda, including OECD, UNESCO's World Commission on the Ethics of Scientific Knowledge and Technology (COMEST), WTO, WIPO, and various other agencies as well as ad hoc efforts such as the inter-governmental International Dialogue on Responsible Research and Development of Nanotechnology.

Interventions that enable radical shifts in human intellectual and communications capacities through the brain-machine interface as well as advances in engineered intelligence that would duplicate or supersede human capacities stand out as uniquely important and should be carefully monitored in respect of general and military applications. A window of opportunity is presented to the global community by the current early stage of many of these developments and their gradual pace of development. As the global technology leader, the United States is uniquely placed to lead such a discussion and thereby encourage the flourishing of emerging technologies in a manner that does not impinge on 'fundamental rights and freedoms' and anticipates threats from inherently transformative and potentially disruptive technologies both to security and the social order.

JUN TAKITA, 'LIGHT, ONLY LIGHT' (2004, UPPER PHOTO BY YUSUKE KOMIYAMA)

"A magnetic resonance scan of the artists' brain has been 3-dimensionally printed and its surface covered with a transgenic, bioluminescent moss, developing with a technique similar to biomarkers that are routinely used in science. Presenting us with a plant that emits light, Jun Takita comments on the possibilities of manipulating and transforming the innate characteristics of living beings through new tools and methods in sciences. Takita presents the transgenic as an achievement of the human brain that allows for the creation of plants with the ability to emit light in a way that only certain animal species could traditionally do.

With a background in sculpture backed with research in plant sciences, the artwork of Jun Takita manifest his interest in the natural dependency on light of living beings and the role it plays in the cycle of life."

← 📷

PAUL THOMAS, 'MIDAS' (2006), PHOTOGRAPHY BY PAUL THOMAS. COMPOSITE IMAGE OF SKIN TOUCHING THE CELL MIMICKING THE TACTILITY OF (AFM'S) CANTILEVER IN CONTACT MODE AS IT EXPLORES THE TOPOGRAPHIES OF THE SKIN CELL. THE MIDAS PROJECT USES THE ATOMIC FORCE MICROSCOPE (AFM) TO RESEARCH THE ATOMIC PARTICLES THAT EXIST AT THE POINT WHERE THE SKIN AND GOLD MEET.

REFERENCES

Hauser, S. L. (2004). 'The Shape Of Things To Come'. *Neurology*, 63, 948-50

Joy, B. (2000). 'Why The Future Doesn't Need Us'. *Wired*. Available at http://www.wired.com/wired/archive/8.04/joy.html [last accessed 2 July 2008]

Lewenstein, B. V. (2003). 'What Counts as a "Social and Ethical Issue" in Nanotechnology?'. *Hyle-International Journal For Philosophy Of Chemistry*, 11, 5-18

Nordmann, A. (2004). 'Converging Technologies – Shaping the Future of European Societies'. High Level Expert Group *Foresighting the New Technology Wave*

Roco, M. and Bainbridge, W. S. (eds) (2002). *Converging Technologies For Improving Human Performance*. Available at http://wtec.org/convergingtechnologies [last accessed 2 July 2008]

Smalley, R. E. (1999). 'Oral Testimony Before United States House of Representatives Science Committee Subcommittee On Basic Research' (22 June)

Swiss Re (2004a). *Nanotechnology - Small matter, many unknowns*. Swiss Re Insurance Company, Zurich. Available at http://www.swissre.com/resources/31598080455c7a3fb1 54bb80a45d76a0-Publ04_Nano_en.pdf [last accessed 5 August 2008]

The United States President's Council on Bioethics (2003). *Beyond Therapy: Biotechnology And The Pursuit Of Happiness*. Washington, DC

(Endnotes)

[1] This paper is an edited version of the Prepared Witness Testimony of Nigel Cameron given to the United States House of Representatives Foreign Affairs Committee, Subcommittee on Terrorism, Nonproliferation and Trade Hearing, Hearing On: Genetics and other Human Modification Technologies: Sensible International Regulation or a New Kind of Arms Race? Thursday 19 June 2008.

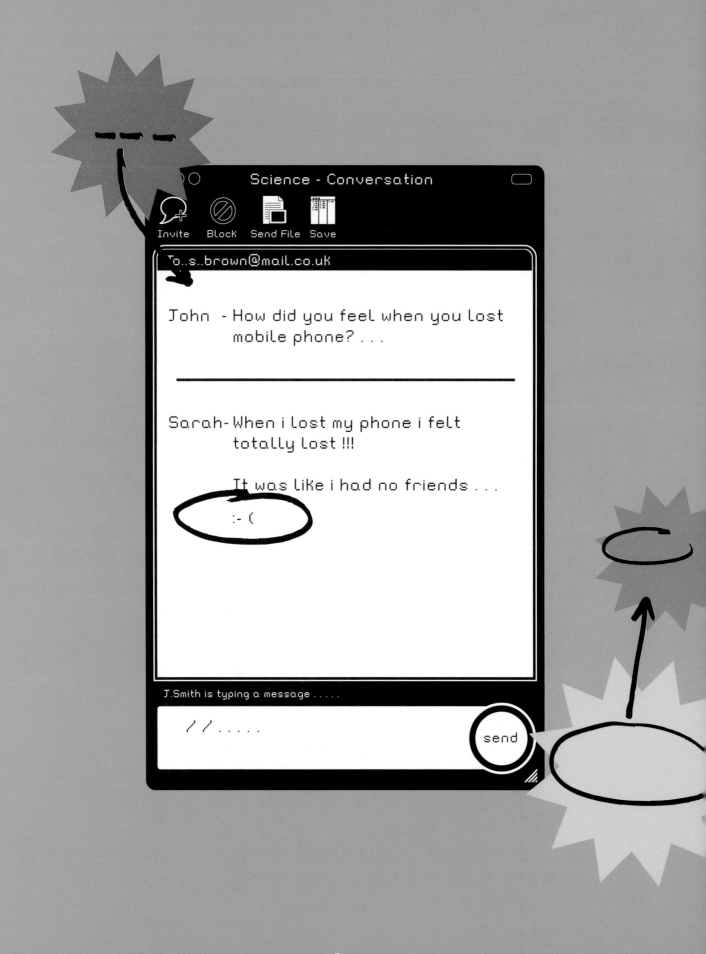

WILL PUBLIC ENGAGEMENT LEAD TO A MARRIAGE BETWEEN SCIENCE AND SOCIETY?

DUNCAN DALLAS

2774 Words /3.3 Political Economy /Human Futures

Café Scientifique started in Britain towards the end of the millennium, drawing inspiration from the Café Philosophique in France. At the beginning it was easy to generate publicity, most of which consisted of amusing articles poking fun at the idea of sitting in a café with a glass of wine talking about science, rather than gossiping about friends.

At that time there was very little public discussion of science outside academic life, and that was why discussion in cafés was considered laughable. However, in 2000 the House of Lords published a report in which they said 'Society's relationship with science is at a critical phase... public unease, mistrust and occasional outright hostility are breeding a climate of deep anxiety among scientists'. The cause of the mistrust was the BSE scandal and its link to CJD. Almost immediately after, protests about genetically modified organisms (GMOs), particularly crops, attracted attention through such high-profile cases as the Monsanto super-tomatoes. Also present in people's minds was what might be considered as the inevitable afterbirth of Dolly the sheep – the spectre of human cloning. Many of these various science stories were packaged together, as the controversial completion of the Human Genome Project and the bio-political wrangling of stem cell research engaged various, similar communities of interest. In particular, the moral status of the human embryo and life itself were called into question in a way that had not really been seen since the birth of Louise Brown at the dawn of in-vitro fertilization (IVF).

As a result of this anxiety over biological transgressions, the imperative to promote the public discussion of science quickly became more sophisticated in two crucial ways. First, it shifted from a conceptual aspiration to promote the 'public understanding of science' to one of 'public *engagement* in science', which has become a recently fashionable model. The critique from these new visions of public participation emerged from a view that the initial 'understanding' model did not really allow any dialogue between scientists and the public. Even more recently, a nuance of these discussions has been to promote 'upstream' engagement, literally calling for science policymakers to engage with and empower the public 'upstream', before the decisions have already been taken. Ten years later, money is flowing in from all quarters – government, public bodies, research institutes, scientific societies and whatever – to encourage all kinds of deliberations, debates, horizon-scanning and outreach.

Public engagement receives support for many reasons and many critics have explained that these reasons are often self-serving. Thus, politicians consider public engagement as a mechanism for identifying public concerns, in order to prevent the government from getting into a mess with controversial new scientific undertakings, as occurred with BSE and genetic engineering. Additionally, scientists see public engagement work as a way of allaying public mistrust and, in some cases, as a means of encouraging research grants. Educators are also complicit in selling public engagement with science for instrumental reasons. Also, education is often seen as a way of encouraging students to become scientists. Democrats hope it will make science more democratic and change priorities. Policymakers want to persuade the public they have made the right decisions and public bodies can use it to justify their conclusions by appearing to consult the public more and be more democratic.

While there is nothing inherently wrong with many of these aims, it is far from obvious that these practices constitute public engagement in the strongest sense. Indeed, it is rather more like the kind of loyalty to concepts that is bred via advertising and product placement. Moreover, it consists wholly of science trying to engage with the public, rather than the other way around. Academics, politicians and educators all say they want to 'listen' to the public, but they are only 'listening' to responses to their own questions. Yet engagement should be a multi-directional process, though the present fashion for engagement comes from science, politics and academia, rather than from the public. Public engagement still seems to involve the public engaging with an approved curriculum, that is, what the people in charge think is important for the public to know, understand and engage with. Whether this is at school, or through events promoted by science centres, museums, politicians and so on, there is no sense that it might be acceptable, or even better, to allow the public to decide what they want to engage with, at least some of the time.

A number of examples of this occurrence are visible within the various histories of public engagement work. For instance, Junior Café-Sci operates in UK schools and involves pupils choosing the topic, and organizing, advertising and chairing the meeting, which is not held in a classroom. We help them find an appropriate speaker to initiate the discussion and it aims to attract pupils who are non-scientists rather than function as a science club. However, the simplicity of this model does not wholly translate into its application. Teenagers today live in a culture far removed from the world of science, which is why science teaching is in crisis the whole world over. Teachers try to make science interesting, relevant, easier to understand, more fun, eco-friendly and so on. Educators change the syllabus, give teachers more training and have researchers in schools. Yet the purpose of these initiatives is to further science training, not to listen to the views of teenagers about what direction science should take and encourage the idea that science is not just a body of knowledge but a subject worthy of discussion, debate and opinion.

In order to make Café-Sci work in schools we have had to locate ourselves within the environments where teenagers already socialize, rather than bring them to the places where the scientists are. Typically, these places are online, in various kinds of virtual worlds, such as Facebook, messenger chat environments and the like. Digital technologies are a key component of teenage life – texting, downloading to iPods, online messaging, watching TV and movies – so the schools project has to take this into account when discussing current ideas about gender, personal relations, fashion, music and other popular topics. Furthermore, we take into account the kinds of lifestyles young people lead, which are chaotic, multi-faceted with various types of social network and ephemeral. These conditions make it difficult to arrange meetings, e-mail the speaker, chair the discussion and so on. Consequently, critical problems in facilitating engagement consist in finding something teenagers want to discuss voluntarily, helping them to engage beyond the demands of their curriculum, and giving them enough confidence to be efficient, active communicators.

To this extent, engagement does not begin with the science that is often seen as the most politically appealing or, indeed, that which is most critical in their future lives – climate change, energy costs and eco-living. Instead, conversations start with the science and technology that is closest to them, notably mobiles, MySpace and YouTube. The discussion

starts when the speaker asks anyone who has lost their mobile to raise their hands and then asks them to describe how they felt when it happened. The descriptions are immediate and emotional 'Felt lost', 'No friends', 'Completely isolated'. Discussion follows about how phones are used and why texting is so important. Similar discussion goes on about MSN – how much time is spent on it each evening etc. Subsequently, the speaker points out that sociologists think that being connected 24/7 reduces personal independence, creates defensive grouping of friends, promotes self-advertisement in virtual space and loosens connections with the real world. This produces a more thoughtful discussion, with personal stories related to the ideas of social science, and how technologies become constitutive of our behaviours and feelings. In this model, public engagement starts with direct experience of product interactions and proceeds to reveal the science and technology related to it. These interactions, we believe, constitute forms of the public engaging with science, not the reverse. They function in a way that takes into account cultural specificity, locating the debates within the sphere of popular culture, rather than via an authoritative top-down model that begins with a mission to promote engagement with certain governmental concerns about emerging science.

The implications of this for work in public engagement with science are profound. Research has shown that pupils prefer subjects that can be discussed rather than just taught (Cerini, Murray and Reiss 2003). Also, discussion enables participants to learn about people's experiences with technology, rather than just to learn about the science itself. In turn, this creates confidence in those present and a sense of community, which is arguably the key, elusive construct that we seek to promote when aspiring towards a deep model of public engagement. To this extent, the goal is not to achieve consensus of views, but to identify areas of common concern and mutual respect.

This model does not typically accord with the established framework of public engagement with science, which fits within certain governmental aspirations. It finds itself vulnerable to the persistent rhetoric of public engagement critics who expect discussion to lead to concrete results – either a greater level of public knowledge about science or clear guidelines for science policymakers. As one journalist I spoke to explained, as he dismissed the merit of just discussing: 'I'm interested in the science that is happening, but people sitting around talking doesn't change anything.' This expectation of change is central to what is at stake when engaging with the concept of human futures, and yet it is not at all clear that we understand well enough how change occurs. Indeed, one must really have a rather robust political theory to substantiate any commitment to or scepticism for the idea that just discussing does not change much (I don't think he had this readily available).

In any case, a few months after this conversation, I read a book review in *Science* that provided the case in support of such informal mechanisms of social change. The book is entitled *Bonds of Civility* and it was written by a Japanese/American sociologist Eiko Ikegami (Ikegami 2005; Turner 2006). It states that a central issue for social scientists concerned with the conditions necessary for modern democracies is the emergence of voluntary associations of individuals formed outside the realms of both the political institutions of the state and the intimate ties of the family. Ikegami documents the rise of poetry and drinking societies in 19th-century Japan and how they provided the foundation for the

Westernization of Japan in the early 20th century by providing an enjoyable, egalitarian and civil forum for exchange. She argues that the networks of people engaged in interactive artistic and cultural pursuits created bonds of 'civility without civil society' (19). The civility nurtured in these networks provided patterns for interpersonal relations among people with whom one only shared 'weak ties', rather than the strong ties of the family and politics. Furthermore she argues that weak ties are the strong force behind modern polity, commercial economy and national society. Networks, she claims, matter more than the 'hard categories' of class, status and gender.

I recognize some of these ideas in relation to my experience with the Cafés. In my local Café I do not have very strong ties with many people, but I recognize and talk to many of those who have attended over the years. We have discussions that, although difficult at times, are reasonably respectful and enjoyable. Indeed, if the evenings were not enjoyable in some way, then I would not go, as I see no higher purpose in them other than being stimulated to consider and talk about subjects relevant and important to my life. In this sense, I experience these random individuals as some kind of new community of which I am a part due to our common interest. Also, the breadth of subjects discussed, from genetics to cosmology and the quality of information and discussion, often undermines what we are told to believe by the media, government, advertisers and other powerful institutions. This provides us with an independent - or at least, alternative - base for thought and action. Such informal discussion of science is popular because there is a social and cultural gap between science and popular culture. I do not know where it will lead, but its popularity and independence are important to me.

In conclusion, it is reasonable to consider where Café Scientifique stands in the spectrum of public engagement, as I look back on ten years of growth. There are numerous distinctive features of the cafés. First, they have moved discussion from universities and science policymakers' circles into the public arena. A café or bar is where the public meet and expect to hold a conversation and it differs remarkably from a lecture theatre, where an expectation of being lectured to exists. In a café people expect to be listened to and, in this sense, it has paralleled the 'unconference' philosophy that is visible within digital cultures. Because of its popularity academics now want to go into the public arena, whereas previously the public wanted to go to an academic environment in the hope of self-improvement. Within the Cafés, there is no brief to defend science at all costs, which provides a free and unconstrained agenda, allowing people to ask awkward questions. Cafés consist of direct, face-to-face contact with scientists positioned as part of the community. In this sense, many Cafés make a deliberate effort to bring speakers from within their locale, rather than aspire to attract international, high-profile scholars. Nevertheless, the global opportunities afforded by the Internet have transformed some of these, previous, geographical restrictions to our sense of community. The Café Scientifique is also a meta-network, not an organization in the traditional sense. There is no financial or intellectual bureaucracy, merely a number of websites offering information and discussions, grounded in the experience and innovative ideas of Cafés in many different parts of

the country (and the world). In this sense it
operates as a bottom-up concern rather than a
top-down hierarchy. Each Café is independent and has
its own interests, depending on the local culture and
community.

In this sense – and acknowledging my bias – I believe
we have a broad purpose, political, educational,
cultural and scientific. The Café Scientifique brings
science back into culture and our evenings are spent
in a cultural examination of science, from which each
member of the audience draws his or her own
conclusions. True engagement takes place when people
are doing something they want to do, something
interesting, not something they feel they ought to
do. The latter is not engagement but at best mild
interest, at worse feigned interest, for the required
period of 'engagement'. We see public discussion as
an end in itself – one interesting and enjoyable
aspect of cultural exchange. Public engagement will
take many forms, but it is important that many of
them start from society, with social innovation,
rather than from outreach by traditional
institutions.

'Science and Society' has now become a popular
catchphrase, as well as an academic subject, and you
could argue that a successful public 'engagement'
should lead to a 'marriage' between science and
society. However, the idea that science and society
could ever be married is too optimistic. Society is
not married to religion, the arts, or even politics.
But just as religion and the arts penetrate societies
through churches, theatres, cinemas, books, and so
on, so science needs to embed itself in society in
many different ways, since it is the most powerful
force in our culture and the one that is producing
the most challenging ideas about our identity and
experience, not just about the planet and the
universe. Unlike 19th-century Marxism and
20th-century structuralism, science is now the area
of culture that is producing the most controversial
ideas about society, and societies the world over
need to grapple with these ideas, discuss them and
come to some accommodation. This won't be a one-way
process. Traditional scientific institutions were
designed to protect science from outside influences,
but in the future of public engagement, scientific
and educational institutions will have to open out
and accept accommodation with the public in many
different ways. Both sides will have to listen, not
just talk.

REFERENCES

Cerini, B., Murray, I. and Reiss, M. (2003).
'Student review of the science curriculum: major
findings'. *Planet Science*. Available at
http://www.planet-science.com/sciteach/index.html?p
age=/sciteach/review/index.html [last accessed 8
July 2008]
Ikegami, E. (2005). *Bonds of Civility: Aesthetic
Networks and the Political Origins of Japanese
Culture*. Cambridge: Cambridge University Press
Turner, C. (2006). 'Through Art to Association in
Japanese Politics'. *Science*, 313/3795, 1575-76

MATERIAL BELIEFS

SHAHID AZIZ, ELIO CACCAVALE,
TONY CASS, PATRICK DEGENAAR,
ROB FENTON, TOBIE KERRIDGE,
THAO LE, OLIVE MURPHY
& NICK OLIVER,
WITH CATHRINE KRAMER,
NELLY BEN HAYOUN,
WILL CAREY, DAISY GINSBERG
& SASCHA POHFLEPP.

Material Beliefs links engineers with design-
ers through a residency programme. The aim of
these reflective collaborations is to generate
a body of work for public exhibition and
engagement events with science.

What we've got much better at doing is understanding how to make biology and electronics talk together. The idea a few years ago of having a biological silicon hybrid was science fiction, but now because silicon technologies are getting smaller, and our understanding of the organization of biological systems is getting better, one can see how you can put the two together (Tony Cass, Institute of Biomedical Engineering)

How can designers situate this research into broader society? By setting up interventions with engineers and scientists, along with publics, bioethicists and sociologists, design can create products, services and events which stage sophisticated conversations, by plotting original paths through this cross-disciplinary space.

Taking the biological silicon hybrids under development at Institute of Biomedical Engineering as a start point - the electronic prosthetics, implanted sensors, biometric data and wireless body networks - how would designers situate biomedical engineering within everyday near futures? The following projects reference the playful reconstitution of these engineered systems within more tactical and personal formats including familial relationships with machines, faking biometric data, bioprospecting, medicating laughter and healthy films.

Material Beliefs ran a four-week brief with postgraduate students from Design Interactions at the Royal College of Art. The project launched with a workshop at the Institute of Biomedical Engineering, encouraging students to respond to emerging biotechnology applications. Outcomes depicted in the following pages included a range of speculative products and services that situated technoscience research within an everyday context. As such, they explored mundane, idiosyncratic, or domestic contexts of use.

HEART
CATHRINE KRAMER

Heart is an animation which explores the end of life.
The story situates biomedical technologies in the
home, where a machine is extending the life of the
main character's terminally ill mother. Rather than
being an effect of illness, the final event of death
now follows the cessation of the machine; when is it
time to pull the plug?

The animation shows how as a result of dependent
relationships between humans and machines, it is no
longer clear what constitutes a person. Is it
possible for the girl to maintain a relationship with
just the vital signs of her mother's heart? To what
extent do the behaviours and functions of the machine
contribute to this bond?

Heart explores the familial contexts for biomedicine
and end of life, and shows how echoes of these
relationships continue in the devices which supported
a loved one, even after the plug has been pulled.

CATHY THE HACKER
NELLY BEN HAYOUN

In this short film, the central character Cathy is
compelled to wear a biometric monitor. It broadcasts
a stream of data to an unseen agency - this could be
an insurance company with vested interest in Cathy's
health, or a medical institution implementing a
service designed to extend the life-spans of its
users. Either way, the function of the implant
constitutes an intrusion upon Cathy's life. It erodes
her personal freedom, enforcing a structure tailored
for the production of the right 'kind' of biometric
information.

So Cathy devises a series of elaborate deceits,
allowing her go out with friends, or just put her
feet up, while still providing optimal data. A three-
legged cat is coaxed into wearing the device, hopping
around the flat to generate fake activity. The
closing spin cycle of the washing machine also does a
good job. Cathy then skilfully disassembles the
device and links it to a foot pump, to be reluctantly
operated by her daughter.

These sequences are interrupted with footage from a
conversation with Olive Murphy, a researcher at the
IBE. Olive speculates how data generated by the
sensing devices developed through her own research
(an implantable blood pressure monitor) might be
circumvented. "Once it's implanted it's always there"
explains Olive, and we follow Cathy into a lift where
she rests, to prevent transmission of her data.

HOMEGROWN
WILL CAREY

Sourcing local foods and keeping livestock have recently been portrayed as qualitative experiences. Though this invigorated appetite for foraging and rearing comes at a premium to shopping for food at a supermarket, this is about investing personal effort over a long period of time, in order to gain the freshest produce.

Homegrown began as an exploration of how the domestic production of vitro meat might sit within this context. How would cell culturing leave the laboratory and enter the home? Would methods of production at such small scales enable meat to be treated as a material, combining cells derived from a range of animals, creating compound or hybrid foods with unexpected textures and flavours? Scenarios were developed to suggest new aesthetics for food production, and novel rituals for preparing and tasting in vitro meats.

MICROBE CONTROLLERS - BIOLOGICAL LANDSCAPING AT HOME
DAISY GINSBERG

Microbes are the enemy. We spend millions on anti-bacterial products, fearing the microbes in our food, in our homes, on our hands. Yet with microbes in our body outnumbering our own cells, they might have more to offer than we thought. Escherichia coli - or E.coli - is the workhorse of the biotech lab and the model bacterium, having played a key role in the development of many biotechnologies. Easily manipulated and cultured in a laboratory, we probably know more about this lowly bacteria than any other living creature on earth. Craig Venter is fishing the world's oceans, assembling a vast library of diverse microbes, prospecting for new strings of genetic code that may yield new and profitable commercial applications. Microbes are being genetically engineered to create biological computers, infiltrating the previously grey technology of silicon with a new green dimension.

Microbe Controllers considers a domestic landscape where microbes and other engineered microscopic organisms are cultivated to perform useful tasks in the home. Aware of this microscopic horticultural landscape living alongside us, will our attitudes to what we accord 'living' status change? What are the ethical issues in making living, disposable consumer products? Are we economically compelled to develop biotechnologies and consider the ethics later? At what scale do we value life? In the lab, bacteria, neurons and other cellular scale 'things' are not attributed 'living' status, but as the size and complexity increases, we begin to feel tenderness or anxiety.

Should we be fighting for microbe rights? Cemeteries and memorials for dead kettles and expired lab cultures? Microbes may not have feelings - as far as we understand - but perhaps we should we explore the ethics of enslaving them before the Argos catalogue is filled with living electronics.

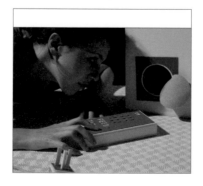

PROSPECT RESORT
SASCHA POHFLEPP

Bioprospecting describes the practice of collecting plant and animal life for pharmaceutical research, potentially leading to the development of novel medicines. Despite associations with colonialism, bioprospecting has recently been linked to synthetic biology, and the various efforts of collecting and sequencing the genomes of a vast number of organisms.

Facilitated by the participatory culture of the internet, biological research is becoming more accessible and affordable. The amateur bioprospector returns his or her findings to a lively community, much like amateur astronomers. Unlike in astronomy, those who dive into the subject will often have a personal investment in their activities. Many bioprospectors might be suffering from a degenerative disease like ALS or Parkinson's and may want to actively participate in the search for a cure while their illness progresses.

Prospect Resort is a fictional hotel in South America which provides these personal bioprospectors with a base for their ventures into the Amazon rainforest. Being hotel, high-grade laboratory and hospital in equal parts, it would be ideally located in one of the most biodiverse ecosystems of the planet. Often accompanied by their families, residents search for specimens of rare plants and animals that have shown promising results in earlier research. The prospector's equipment consists of a portable sterile laboratory cabinet and simple tools to take tissue samples with. Additionally, a small local economy has also developed around the resort, with stalls offering biopsies of small animals and plants from inaccessible areas in the forest.

Prospect Resort suggests a form of contemporary colonialism, where its services are aimed at the future needs of the wealthy. Despite this, it also traces a perceived shift in popular culture towards amateur participation in the production of medical information. Perhaps there will be a real opportunity for individuals to participate in genetic research in the near future, possibly even with the support of the public health system.

ONCE UPON A SPACE AGE:
HOW THE DREAM WAS LOST
(AND HOW WE GET IT BACK
AGAIN)

NICOLA TRISCOTT

3316 Words /3.4 Political Economy /Human Futures

Space. Outer space. Men and woman in tight-fitting silver suits hanging out in space colonies, cruising the solar system, terra-forming planets and making new worlds. That's what those of us who were children during the Apollo programme grew up expecting: a future among the stars.

Today, more than half a century after the launch of Sputnik, space activity rarely extends further than 500 kilometres or so above our heads, to the zone of orbiting satellites, space stations and space junk. Space is routine, yet it is still remote, and now commercial, controlled, militarized, contested and polluted. It infiltrates our everyday lives through such mundane technologies as GPS, weather forecasting and satellite telecommunications, which bring space activities into our work, education, leisure and healthcare. Its remoteness from us is, at the same time, reinforced by the gargantuan nature of international space projects.

Small wonder that we feel the frisson of Richard Branson's vision of future travel into space for everyone (everyone earning in the megabucks bracket anyway) and cheer the efforts of the 'underdogs' of space, like the ill-fated British Beagle Mars lander. The closest we come to an imagined sense of community involvement in space is watching the outputs of the space agencies' probing of distant planets and galaxies through Mars probes, Cassini-Huygens and the Hubble telescope. So, how can we develop and realize an alternative vision of space, one that understands space as the shared heritage of all humankind and not just as a resource for military dominance and commercial profit?

NASA's public relations machine still stirs our lingering hopes of a transcendent future in space, with visions of moon bases and expeditions to Mars. China, India and Japan have also joined the space dream, promoting their own aspirations for human space programmes. But the reality is that these visions will only have the slightest hope of succeeding if the commercial payback and

military and political benefits for the countries involved are significant; and any hope of achieving more than what has already taken place, because of the enormous cost of space programmes, lies in international cooperation on the largest scale. At the same time, space is engendering a growing number of privately financed commercial activities. In a few years time the turnover of commercial space activities will exceed the public space budgets of all the nations engaged in space research.

Space technologies, therefore, mobilize substantial volumes of capital and represent a power game between the nations. The potential incentives of commerce, military strategy and national politics, and the requirement for international cooperation, each beg the question as to where these investments will take us. What will be the environmental impact? What military uses are involved? Are the benefits available to all, or just some? What safeguards from abuse are there? What will be the impact on identity and cultural diversity of the 'planetary village'? Do the ordinary citizens of Earth and the solar system have any control or influence over this decision-making process? Some answers to this are provided when looking more broadly at how technologies develop, and considering where space - and humans - fit into this trajectory.

Following Jacques Ellul (1964), Langdon Winner (1986) developed an analysis of the political character of technology, contending that the physical arrangements of industrial production, warfare, communications and so on have not only transformed the exercise of power and the experience of citizenship, but they have also introduced 'inherently political technologies' which are, by their very nature, centralized or decentralized, egalitarian or inegalitarian, repressive or liberating.

One way to look at emerging technologies is to consider the extent to which they lock people into certain systems or, conversely, enable users to adapt them to fit their own purposes, resources, knowledge and culture. There are highly centralized and controlled technologies, which include genetically modified (GM) crops, centralized nuclear power

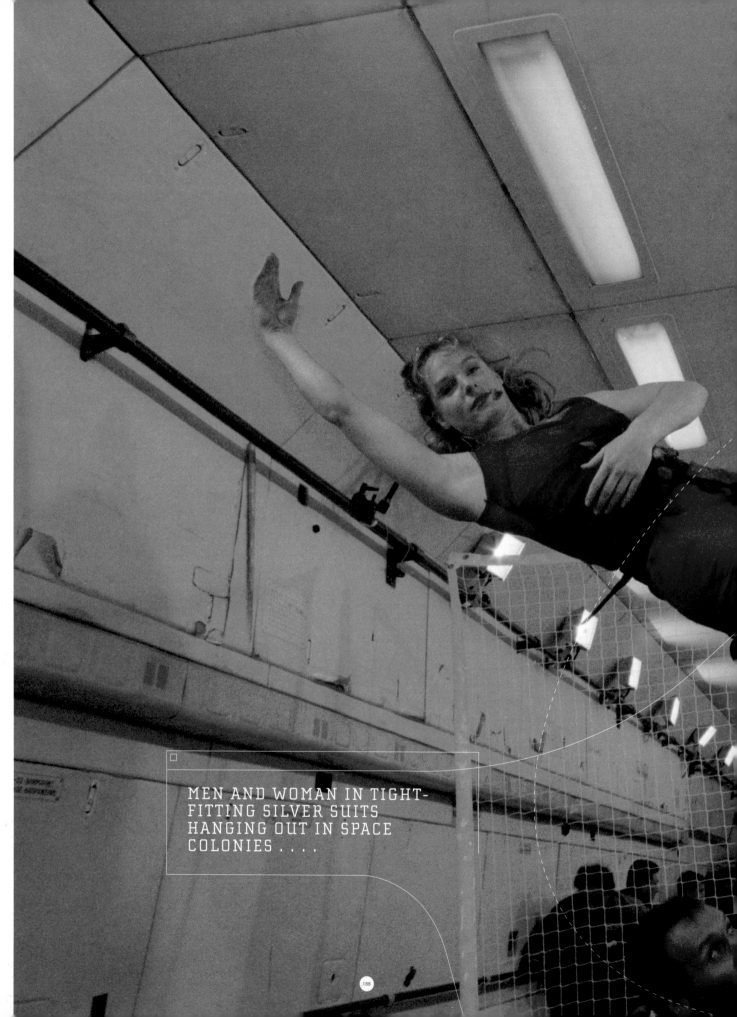

MEN AND WOMAN IN TIGHT-
FITTING SILVER SUITS
HANGING OUT IN SPACE
COLONIES

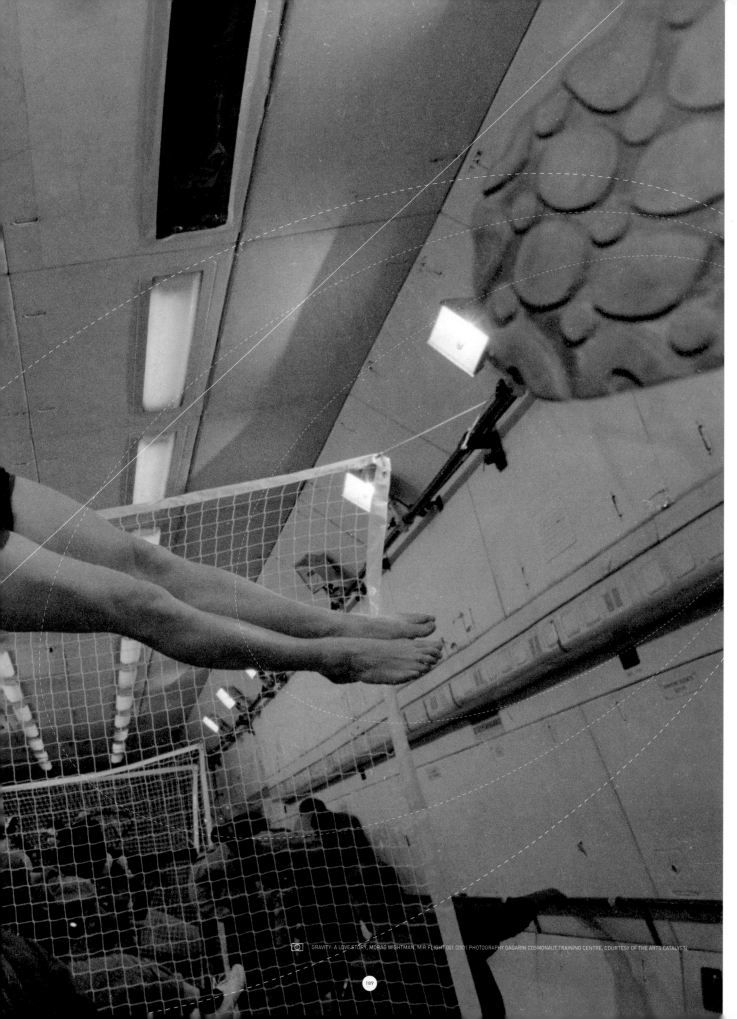

GRAVITY: A LOVE STORY, MORAG WIGHTMAN, MIR FLIGHT 001 (2001 PHOTOGRAPHY GAGARIN COSMONAUT TRAINING CENTRE, COURTESY OF THE ARTS CATALYST)

189

FIG 1. CRITICAL ART ENSEMBLE, BEATRIZ DA COSTA AND SHYH-SHIUN SHYU, 'FREE RANGE GRAIN' PERFORMATIVE ART PROJECT, SCHIM KUNSTHALLE, FRANKFURT (2003, COURTESY OF CRITICAL ART ENSEMBLE)

FIG 2. ASHOK SUKUMARAN, 'SHARING_01'

and most space systems, which offer very little, if any, flexibility for how they are used, and require their environments to be structured in a particular way. At the other end of the spectrum, there are examples of participatory technology that provide an open platform for new sorts of use, such as micro-renewable energy, intermediate technologies for agriculture and the Linux operating system, technologies that place control for usage and further development into the hands of the user. As such, an initial demand we might make of any emerging technology is whether it is locking us into one system, or providing further scope for openness. We should also consider whether it has been developed for the benefit of humanity, or merely to serve disclosed or undisclosed financial interests.

Most science and technology is currently not human-centred. It is developed for a range of economic, military and social reasons, but rarely any that put the long-term good of humanity and the planet as the primary objective. Government and military leaders following the end of the Second World War largely decided the way in which Western science is currently carried out. This operational framework for scientific development derives from the strategic importance attached to advanced technologies, including nuclear energy/weaponry and space technology. The spread of technology, particularly in the developed world, has come through a partnership between science and industry. Often, new technologies are developed through military applications, for warfare, before gradually filtering into civilian industries, and then into civilian use and the arts (Chapman and Yudken 1992). This can be seen in the cases of the personal computer, the internet, imaging systems and telecommunications. Other technologies, and increasingly so, are developed in the commercial sphere, the military picking up on potential for application later.

Concentrating scientists in large university research labs and industrial research and development laboratories enables

governments to centralize expertise and resources, perceived as maximizing productivity. Moreover, centralized control eases the management of intellectual property, which is critical for exploiting commercial and military interests. Scientist Roger Malina writes that this centralization has isolated science from the rest of society (Malina, no date). Yet he indicates that the development of the internet and modern transportation systems have started to undermine these circumstances. Moreover, industries and universities now are able to establish more distributed research centres. He explains the development of new research and development clusters from Bangalore to Dublin and suggests that this may lead to new patterns of organizing scientific research. Even so, this process seems to be out of the control of the wider citizenry, who are affected daily by the products, systems and discoveries that result from scientific research and technological progress. As such, the question arises as to how people (as current and future users) can shape the content and direction of science and technology.

There are various ways in which citizens have tried to affect – or disrupt – the centralized systems of science and technology, and these have been explored, and in some cases pioneered, by artists. These tactics include involvement in early stage research and development ('upstream engagement'), the sharing of expertise and knowledge between specialists and non-specialists, 'leakage' (illegal or unregulated use) or appropriation of scientific and technological

applications, independent or collaborative development, and diplomacy.

The idea of upstream engagement with science (Wilsdon and Willis 2004), that is, public participation *before* significant research and development has taken place, is currently in vogue in discussions around the disconnect between science and society. It is a rather utopian idea, but how is it to happen in the context of outer space? The European Space Agency is currently interested in establishing a stronger relationship with the European public. One of its initiatives was a Citizen's Jury, which took place in London in 2006.[1] In comparison, Malina proposes the systematic placing of artists in residence in scientific and industrial research and development laboratories, as a route towards upstream engagement. Malina's organization, Leonardo, and my own, The Arts Catalyst, are partners in an international network that promotes and organizes these placements. For example, we are currently planning two artist residencies at the European Space Agency's science and technology research base, ESTEC, in the Netherlands.

Expertise and knowledge sharing – breaking down the distancing of science – is closely related to the aspirations of public engagement with science, an idea that appeals to the scientific establishment and government, as well as to educators and activists. However, this apparent similarity is underpinned by very different assumptions and arguments, which range from the economic rationale to notions of enriching cultural health and intellectual life and the desire to enhance democracy.

The US arts group Critical Art Ensemble (CAE) addresses and shares the processes and politics of biotechnology – one of the least publicly understood technologies of our time. Their 'participatory theatre' aims to involve people in the routine processes of biotechnology, to let them see and use them, and realize that they can understand biotechnology if they wish to and participate in the discourse around it. One key area in which CAE aims to stir debate is the appropriation of food production systems by major corporations, specifically by the promotion and distribution of genetically

modified (GM) food systems. In their performative action *Free Range Grain* **(Fig 1)**, CAE constructed a portable, public lab to test food products not labelled as containing genetically modified organisms (GMOs) to see if they really were free from GMO contaminant. They had finished the initiative in Europe and were about to launch it in the USA when the equipment was confiscated by the FBI (see George J. Annas, this volume).

Developing and exploring the concept of 'leakage' in the history of technology, the Indian artist Ashok Sukumaran has produced a series of projects that utilize the technologies of his critique, in particular electricity distribution systems in India. His idea is that an alternative history of many technologies could be written as a history, not of attempts to communicate information or transfer benefits, but rather as attempts 'to insulate, or isolate, unwanted forces or state or commercial secrets from others' (Sukumaran, unpublished). Often, this notion of insulation has a practical dimension in the nature of the technology, such as in electrical insulation or in isolating nuclear waste, but it also includes the commercial imperative to control the products of technology, and to control knowledge and expertise. In all this, Sukumaran notes: 'the phenomena of 'leakage', such as the stealing of over 30% of electrical power in the Indian grid, or the constant stream of 'pirate' production of digital resources, exists as a continuous mirror. Power flows, leaks; out of the official system into various 'illegitimate' venues. (Sukumaran, unpublished)[2]'

These concerns invoke questions of property, ownership and access rights particularly in our concentrated, complex urban lives. Sukumaran's work, *sharing_01* (2007) **(Figs 2 & 3.)**, is part of an ongoing project on electricity in the urban environment, as a

FIG 3. ASHOK SUKUMARAN, 'SHARING_01'

example of technology and a metaphor for others. It involved a ninth-floor resident of a block of apartments on the wealthy Carter Road in Mumbai, who agreed to 'share' two electrical connections in her house with a temporary occupant of the road below. A switchboard on a wall by the road gave control of the electrical connections in the house and, on the road, a 60-watt bulb and a standing fan were located. The light and the fan were made available to street food vendors. Passersby could also determine the 'balance' between the two consumers. The two supplies were moderated to ensure that the total consumption did not exceed what the house would use normally. For instance, when the vendors took more electricity, the house received less and its lights dimmed.

'Leakage' and interception activities extend across the spectrum of the informal economy, from the unregulated to the illegal. The history of the informal economy, as with the history of leakage, has been integral to continuing attempts on the part of governments and institutions to control and regulate aspects of their economies, which increasingly include technological developments. No such regulation has ever been wholly enforceable.

In a succession of quite brilliant projects, the Slovenian artist Marko Peljhan has extended these notions of 'leakage' and appropriation through exploring the concept of 'conversion', which describes how something made exclusively for military purposes can be used by civilians. Peljhan's work short-circuits the process by which technologies created for the military-industrial complex gradually filter into the civilian domain, eventually to be picked up by artists. He has been particularly interested in aeronautical and space technologies. His nomadic research station *Makrolab* **(Fig 4)** is equipped with broadcasting and receiving aerials that can intercept and record data from the 'topography of signals' across the electromagnetic spectrum. In

Kassel, when *Makrolab* was installed for the first time in 1997 at the exhibition *Documenta X*, the lab residents tapped into communications, which were routed via international Inmarsat telecommunication satellites, capturing private telephone conversations, satellite-controlled navigation systems and military and economic communications. *Makrolab* resident American artist Brian Springer (2005) wrote: 'We approached the sky above Lutterberg as a living library... out of the shelves of which voices, images and data communication flew towards us'.

Peljhan is also working on the S-77CCR project (System-77 Civil Counter-Reconnaissance), a tactical urban counter-surveillance system for ground-controlled UAV's (Unmanned Aerial Vehicles) to monitor public space, and he works with my company, The Arts Catalyst, to open up the use of space technologies and facilities for artists and independent researchers, specifically in a series of zero-gravity flights with the Gagarin Cosmonaut Training Centre in Russia, the MIR (Microgravity Interdisciplinary Research) initiative, as well as on his long-term plans for *Makrolab*.

How far can we take this idea of open platform, participatory technology with regard to space exploration? Take telecommunications as a crucial space technology deeply embedded in our daily lives (and, as with most space technologies, one with a dual military-civilian use). Peljhan sees the dependence of artists and progressive social

MOST SCIENCE AND TECHNOLOGY IS CURRENTLY NOT HUMAN-CENTRED . . .

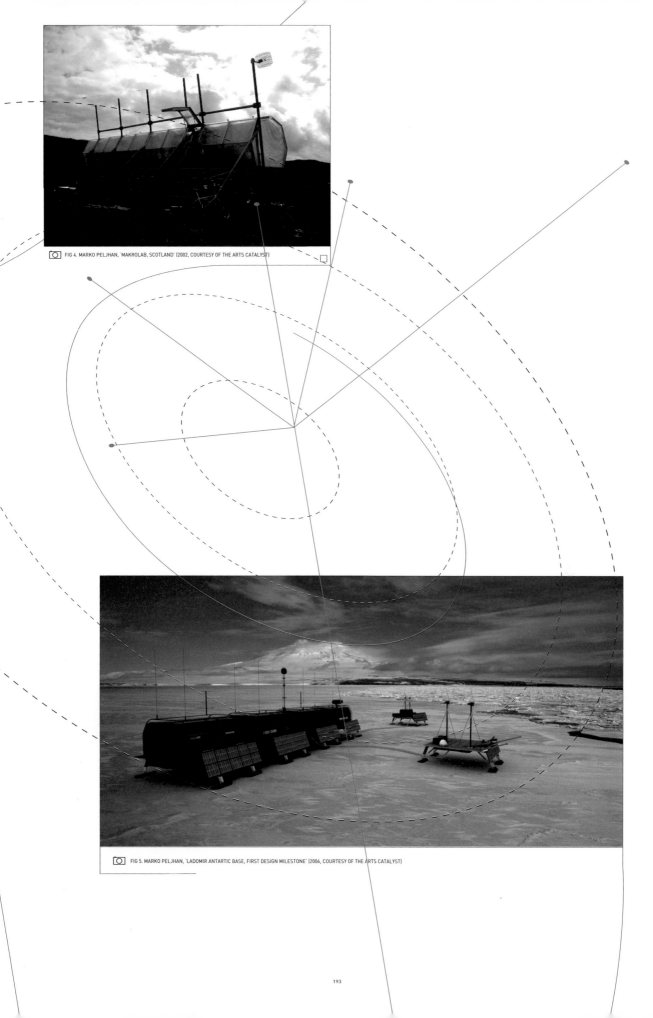

FIG 4. MARKO PELJHAN, 'MAKROLAB, SCOTLAND' (2002, COURTESY OF THE ARTS CATALYST)

FIG 5. MARKO PELJHAN, 'LADOMIR ANTARTIC BASE, FIRST DESIGN MILESTONE' (2006, COURTESY OF THE ARTS CATALYST)

advocates on commercial telecoms satellite systems as inadequate, particularly in view of covert telecommunications gathering and monitoring systems in operation on these systems, and suggests an alternative: 'Build a global independent satellite telecommunications network, an alternative to the Intelsat system' (Peljhan 1997). Peljhan's organization *Projekt Atol*, along with a group of international partners, is planning to construct and launch a constellation of two nano-satellites with communications and remote sensing capability. The satellites will service the Interpolar Transnational Art Science Constellation (I-TASC) **(Fig 5 see previous page)**, two independent research stations based in the Canadian Arctic and in Antarctica, the culmination of his 11-year *Makrolab* project.

The Arts Catalyst has extensively promoted the idea of independent work in supposedly specialist areas, such as in its Artists' Airshows (2004, 2007), which showcase artists' development and use of space and aviation technologies, including Zina Kaye's unmanned aerial surveillance vehicle, Miles Chalcraft's rocket, Ben Blakebrough's personal flying machine and Simon Faithfull's **(Fig 6)** lo-tech space launch; artists' use of satellite data, for example, Flow Motion's project *Astro Black Morphologies* **(Fig 7)**, which used radioastronomy data to create a digital and sound art installation; and enable artists to access and use biotechnology. Some of our work takes on a utopian aspect, such as Tomas Saraceno's *Poetic Cosmos of the Breath* **(Fig 8)**, part of his long-term vision of creating sustainable cities in the air.

Artists and those interested in social change use many tactics to promote alternative viewpoints. But increasing access to knowledge and information does not automatically enhance democracy. Genuine democracy, as Winner (1986) understood, involves the pursuit of common ends through discussion, deliberation and collective decision. An additional tactic suggested by Bruno Latour

(2004) in his book *The Politics of Nature: How to Bring the Sciences Into Democracy*, therefore is the ancient art of diplomacy. Latour explains that there will always be conflicting versions of reality among different groups of people and deliberates on how this situation can be handled. He suggests that diplomacy – the management of communications and relationships between nations or, in its modern form, the skill of resolving differences through agreement and harmony – provides one solution.

This is an approach that The Arts Catalyst has taken forward in its work with the international space community. We are working with the European Space Agency to develop a strategy for the cultural utilization of the International Space Station programme. In doing so, we have jointly set up a new International Astronautical Federation (IAF) international committee on the cultural utilization of space (ITACCUS), of which I am currently co-chair with the aforementioned Roger Malina, whose membership comprises liaisons from space agencies and commercial space companies and cultural organizations.

In a world where US Air Force Commander Colonel Robert Suminsby (2008) publicly states that 'If left unchecked, the growth of spending on Social Security and Medicare will eventually crush the defense budget', and in which the US Air Force forcefully – and, many contend, misleadingly[3] – stresses the threat of anti-civilian military actions in space and therefore promotes its own military intervention in that sphere, the promotion of counter-perspectives – through art, activism and diplomacy – are critical.

In June 2008 I was invited in my capacity as co-chair of ITACCUS to address the United Nations Committee on the Peaceful Uses of Outer Space (COPUOS). COPUOS was set up in 1959 to oversee the implementation of a number of treaties and agreements, including the Outer Space Treaty, which governs the exploration and use of outer space.[4] My presentation argued the contribution that the arts can make in promoting peaceful uses of outer space. I explained that artists might have a different set of values, tactics and, therefore, rules from those of the diplomatic and space

community, and that some art practices might be unfamiliar to those outside the art world; but that alternative perspectives, challenges and re-imaginings of our relationship with space can contribute to developing a new cultural and societal dialogue about space.

Laurie Anderson, who was appointed NASA artist-in-residence in 2004, for example, culminated her residency with a performance piece provocatively titled 'The End of the Moon', sparked by her sense of loss at the idea of exploiting the moon's resources. It was probably not what NASA expected,[5] but such encounters are critical to ensure a society that properly understands and actively discusses the contribution and threats of space activities; and they were absent in those years when we first engaged with the prospect of space exploration.

In short, the human future of space needs requires an active societal dialogue, in which its uses and discoveries are considered and interrogated from different cultural perspectives – not just those of scientists, politicians and decision makers. We need to work together to contest the militaristic appropriation and irresponsible corporate use of space with art, activism, dreams and experimentation.

FIG 7. FLOW MOTION, 'ASTRO BLACK MORPHOLOGIES' (2005, COURTESY OF JOHN HANSARD GALLERY AND THE ARTS CATALYST)

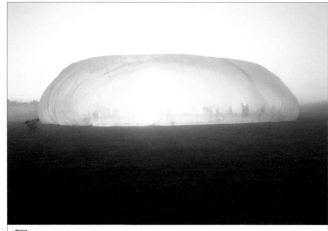

FIG 8. TOMAS SARACENO, 'POETIC COSMOS OF THE BREATH'
(2008, COURTESY OF GUNPOWDER PARK AND THE ARTS CATALYST)

FIG 6. SIMON FAITHFULL, 'ESCAPE VEHICLE NO. 6'
(2004, COURTESY OF THE ARTIST AND THE ARTS CATALYST)

REFERENCES

Chapman, G. and Yudken, J. (1992). *A Briefing Book on the Military-Industrial Complex*. (US) Council for a Livable World Education Fund

Ellul, J. (1964). *The Technological Society*. New York: Vintage

Latour, B. (2004). *The Politics of Nature: How to Bring the Sciences Into Democracy*. Translated Catherine Porter. Cambridge, MA: Harvard University Press

Malina, R. (no date). 'Lovely Weather: Asking What the Arts Can Do for the Sciences'. *Thoughtmesh*. Available at http://vectors.usc.edu/thoughtmesh/publish/111.php [last accessed 31 July 2008]

Peljhan, M. (1997). 'Insulation/Isolation Proceedings'. Lecture for the 100 Days 100 Guests Documenta X Programme, 31 August

Springer, B. (2005). Quoted in I. Arns, 'Faktura and Interface: Hlebnikov, Tesla and the Heavenly Data Traffic in *Marko Peljhan's makrolab* (1997–2007)', in K. Kwastek (ed.), *Ohne Schnur*. Munich

Suminsby, Robert (2008). Address at Kirtland Partnership Committee meeting of nearly 300 civic leaders, 11 April. Reported in KAFB Nucleus

Sukumaran, A. (2006). 'Electric Fences, Human Sheep'. *Recurrencies*. Available at www.recurrencies.net/test/texts/electricsheep.pdf [last accessed: 31 July 2008]

Wilsdon, J. and Willis, R. (2004). *See-Through Science: Why Public Engagement Needs to Move Upstream*. London: DEMOS

Winner, L. (1986). *The Whale and the Reactor: A search for limits in an age of high-technology*. London: University of Chicago Press

(Endnotes)

1 The European Space Agency citizen's jury was held in London, March 2006

2 See also Sukumaran 2006.

3 The blogosphere lit up with criticism of the ad's narration, which said that a single missile could knock out cellphone calls, television programming and GPS navigation. The ad, which ran on CNN and online, was part of the Air Force's new recruiting and public relations campaign. But the service does not appear to be backing away from its premise that Americans are more vulnerable than they realize to attacks on US satellites. The US Air Force's current amended promotion can be viewed at www.airforce.com/achangingworld [last accessed 31 July 2008].

4 The Outer Space Treaty represents the basic legal framework of international space law. Among its principles, it bars placing nuclear weapons or other weapons of mass destruction in space. It limits the use of the Moon and other celestial bodies to peaceful purposes and forbids any government from claiming a celestial resource such as the Moon or a planet, since they are province of mankind.

5 In a private conversation with the author in summer 2005, Anderson said she felt that there was a mismatch between NASA's preconceived expectations and the reality of working with an artist. She thought she was initially invited because NASA thought she would do something technological, spectacular and celebratory 'like bouncing a laser off the moon'. Instead, after a year of looking around the vast complexity of NASA, she announced she wanted to write an 'epic poem'.

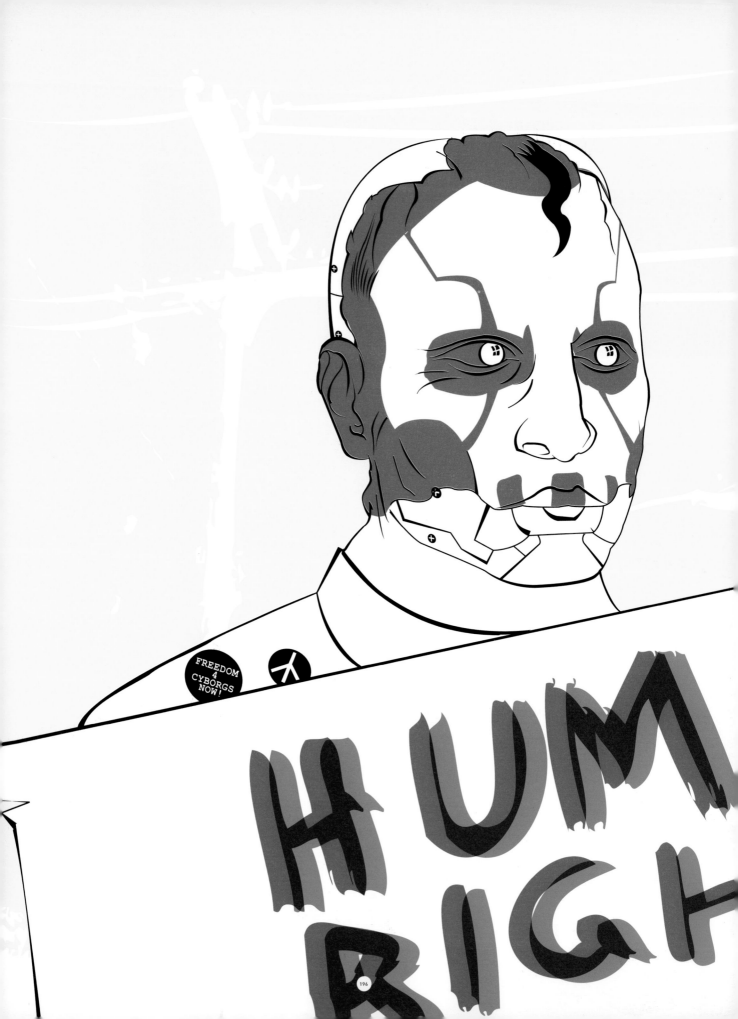

THE NARRATIVE TRADITION OF POSTHUMAN RIGHTS

PRAMOD K. NAYAR

4399 u .5 Political Economy /Human Futures

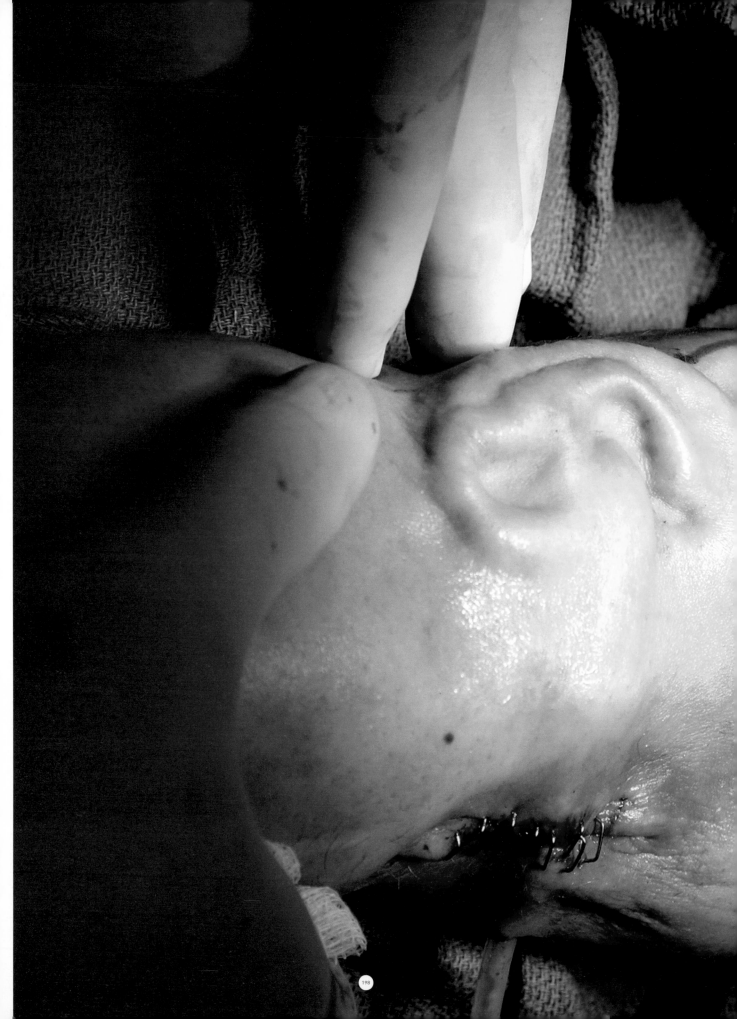

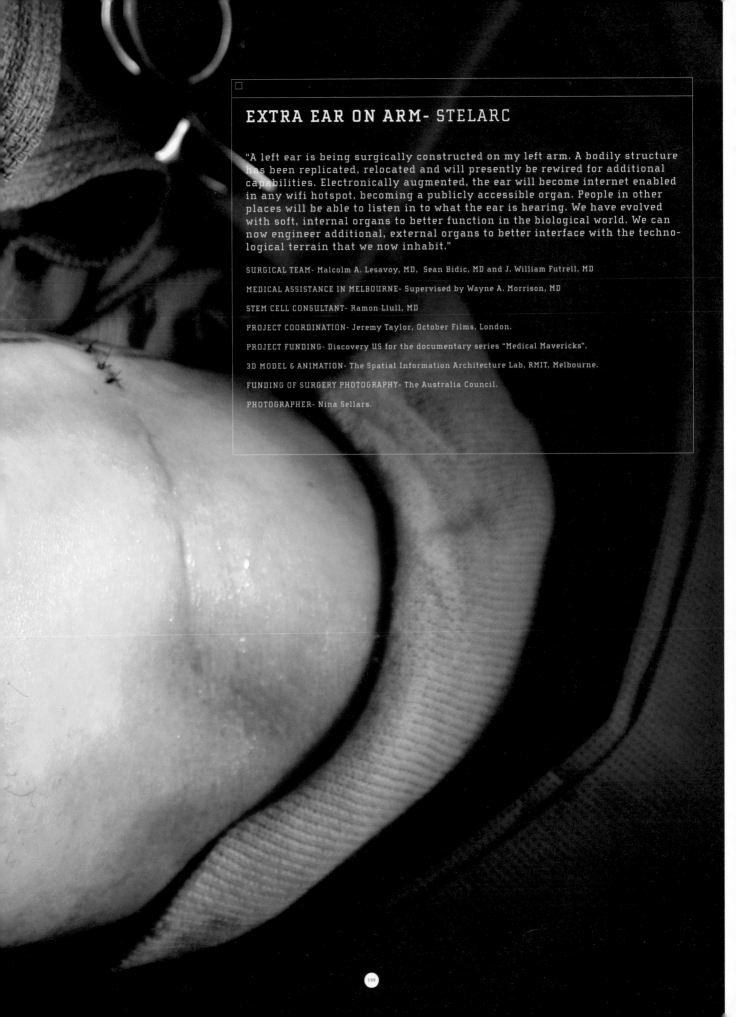

EXTRA EAR ON ARM- STELARC

"A left ear is being surgically constructed on my left arm. A bodily structure has been replicated, relocated and will presently be rewired for additional capabilities. Electronically augmented, the ear will become internet enabled in any wifi hotspot, becoming a publicly accessible organ. People in other places will be able to listen in to what the ear is hearing. We have evolved with soft, internal organs to better function in the biological world. We can now engineer additional, external organs to better interface with the technological terrain that we now inhabit."

SURGICAL TEAM- Malcolm A. Lesavoy, MD, Sean Bidic, MD and J. William Futrell, MD

MEDICAL ASSISTANCE IN MELBOURNE- Supervised by Wayne A. Morrison, MD

STEM CELL CONSULTANT- Ramon Llull, MD

PROJECT COORDINATION- Jeremy Taylor, October Films, London.

PROJECT FUNDING- Discovery US for the documentary series "Medical Mavericks".

3D MODEL & ANIMATION- The Spatial Information Architecture Lab, RMIT, Melbourne.

FUNDING OF SURGERY PHOTOGRAPHY- The Australia Council.

PHOTOGRAPHER- Nina Sellars.

What do genetic engineering, human cloning and posthuman bodies mean for the future of human rights? Or, to put it another way, what is the future of human rights in a posthuman world? This essay is less interested in the technologies that make post-humans possible, choosing instead to focus on the way in which human rights might require humanity to reconfigure some of its governing assumptions, while keeping the new human in sight..

I will begin with an overview of various evaluations of the posthuman condition, each connected to questions of ethics, politics and human rights. First, Chris Hables Gray's 'Cyborg Bill of Rights' (2001: 29) proposes a series of amendments to accommodate the altered characteristics of posthuman bodies. Beginning with the assumption that citizenship will always be embodied, Gray argues that cyborg citizens are 'real political bodies'. Gray maintains that individuals need 'real' political protection in the age of powerful technoscience. A disembodied intelligence cannot be the basis of citizenship for the simple reason that citizenship and the current political systems are based on embodiment. Second, Francis Fukuyama (2003: 130) believes that human nature (which he defines as 'the sum of the behavior and characteristics that are typical of the human species, arising from genetic rather than environmental factors') is rooted in biology and alteration in the genetic-biological make-up would affect, drastically, our 'moral sense', and therefore our conceptions of justice. Third, Paul Lauritzen, writing on stem cell research and human rights, believes that the 'new biology threatens our existing ethical commitments' (2005: 28). Fourth, Andy Miah and Emma Rich point out that Gray's manifesto appeals to the concept of the cyborg in order to 'address the interests of marginal groups whose humanness is not given full moral or legal recognition' (2008: 113). In each case we see a concern with questions of justice, political responsibility and human rights in the age of posthumanity.[1]

What would be the fate, shape and future of human rights in the posthuman age when all bodies are congeries of human, animal and machine? Ontological and organic distinctions between species become increasingly blurred, as the posthuman marks the end of the autonomous human subject of liberal humanism. By extension, human rights, as defined by numerous thinkers (Weston 1992; Ignatieff 2001) proceeds from the conceptualization of the autonomous human subject as an autonomous being. Michael Ignatieff writes: 'human rights matter because they help people to help themselves. They protect their agency… Human rights is a language of individual empowerment.' (2001: 57) Later, Ignatieff (2001: 166) adds: 'a human rights perspective… draws attention to the importance of unblocking individual agency as a

motor for economic development itself'.

My inquiry into posthuman rights begins with two specific assumptions about human rights itself. First, in his now classic text, *Human Rights as Politics and Idolatry*, Michael Ignatieff proposes that recognizing human rights involves allowing people to act as free agents. Agency is defined as 'the capacity of each individual to achieve rational intentions without let or hindrance'. Thus, human rights theory is a 'language of individual empowerment' (2001: 56). Ignatieff argues that the 'rights language applies' when *victims* speak because 'it is the claim of abuse that sets a human rights process moving'. He points out that rights discourses are built on the foundations of human history, where 'we can know what is likely to happen when human beings do not have the protection of rights', and the 'testimony of fear', both incidentally reliant upon *narratives* (Ignatieff 2001: 56, 80). That is, we can see instances – evidence – in history (Ignatieff cites the Holocaust as one example) when rights have been denied to people, and this can form the basis for conceptualizing the contexts and scope of human rights.

Second, human rights discourses require a narrative in which the definition of the human is clarified and legitimized. As Anthony Langlois puts it: 'The appeal to humanity as such is itself an appeal to a higher authority, to a more pervasive metaphysical tradition, to a broader meta-narrative about what it means to be human' (2005: 375). Joseph Slaughter writes: 'human rights in general, and human rights law in particular, can be productively formulated in terms of narrative genres and narrative voices' (1997: 408). I concur with Langlois and Slaughter that narrative is crucial to human rights. It is necessary to vouchsafe both a space to speak one's story and the right to narrate, if human rights are to succeed. Critics have identified various literary genres from round the world that provide this space and, in some cases, form in which victims, those denied their rights and the oppressed, can articulate their demand for human rights. These include *testimonios* (Nayar, 'Trauma, Testimony and Human Rights', prison memoirs, truth commission testimonies, subaltern autobiographies (Smith and Schaffer 2004) and the *bildungsroman* (Slaughter 2006). These narratives document the

violation of individual and community human rights in order to articulate rights claims upon society, the legal system and humanity in general. In other words, there exists a *narrative tradition* in which victims denied rights have staked their claims for human rights. Is there, then, a narrative tradition of *posthuman* rights?

I believe that there indeed exists a narrative tradition where the rights of cyborgs have been explicitly or implicitly treated. In the remainder of this essay I sketch this tradition, proposing that posthuman fictions and narratives (including autobiographies, as we shall see) are establishing a narrative tradition of posthuman rights, because they implicitly document the denial of agency to cyborgs and the subjectification of cyborgs to human (or corporate) needs. Following Ignatieff, such narratives map a history where rights have been *denied* – a history of abuse and misuse – and therefore suggest that we need to act to ensure that rights are granted. The tradition begins, at least in literary history, in the 17th century when Caliban in William Shakespeare's *The Tempest* (1610-11) is denied his claims over the island.[2] The phrase 'Prospero's Island', as Peter Hulme and William Sherman argue, 'overlooks' not only Caliban's claims but also that of his mother, Sycorax, the Algerian witch who was exiled to the island (Hulme and Sherman 2000: 75-76).[3] The superhumanly strong Caliban may be taken as an instance of an individual – born of a witch and therefore of 'suspect' *human* origins – denied his claims and rights. Defined and treated as less-than or other-than human (strong, ugly, stupid), Caliban has no *human* traits and, therefore, no rights. He represents one of the first of several races (blacks, Aboriginals, Jews, tribals) denied their status and identity (even to the extent of extermination) as humans – in literary, cultural and political history – so that they do not merit/deserve human rights. The narrative tradition of posthuman rights returns strongly in the 19th century with Mary Shelley's monster in *Frankenstein* (1818). Like Caliban, Frankenstein's creation is de-humanized, especially when the only epithets used for him are 'monster', 'horror' or 'murderer'. An early example of the cyborg made through alterations to the human form, *Frankenstein*'s moral is that to lead a dignified and

full life, it is necessary for the monster to have a mate.[4] In the absence of such kinship, the monster looks to Victor Frankenstein as his creator-parent to provide for such companionship via the creation of another being. When Frankenstein refuses, the monster goes on a rampage. I see the rampaging monster as an exemplar for the narrative tradition of rights *claims* that I have outlined earlier. He narrates his demands and the narratives are rejected. The monster pleads: 'I entreat you to *hear* me' (1996: 66, emphasis added). To this request for narrative space Frankenstein responds: 'Begone! I will not *hear* you' (66, emphasis added). The monster continues: '*Listen to my tale*; when you have heard that, abandon or commiserate me, as you shall judge that I deserve. But *hear* me. The guilty are allowed, by human laws, bloody as they are, *to speak in their own defence* before they are condemned. *Listen* to me, Frankenstein. You accuse me of murder, and yet you would, with a satisfied conscience, destroy your own creature. Oh, praise the eternal justice of man! Yet I ask you not to spare me; *listen* to me, and then, if you can, and if you will, destroy the work of your hands. *Still thou canst listen to me* and grant me thy compassion. By the virtues that I once possessed, I demand this from you. *Hear my tale*; it is long and strange… Before it [the sun] descends to hide itself behind your snowy precipices and illuminate another world, you will have *heard my story* and can decide. (66-67, emphasis added)'

This is a paradigmatic passage: the monster pleads for the right to narrate, to have the space and the audience to whom he can address his sorrows and articulate his demands. Indeed, at a later stage when Frankenstein is pursuing him, the monster leaves *written* messages for him (on trees), and thereby becomes a monster-victim who can not only verbalize but also *inscribe his narrative* (1996: 142-43). The posthuman speaks as a victim when he proceeds to describe his life and hardships, his search for and denial of identity (by the human race). Despite his enormous physical prowess he cannot 'build' what he wants: a companion. The monster cannot make lifestyle choices and this lack of *agency* is at the heart of his crisis.

Eventually there is no space where his voice can be heard. The language of violence is the only language available to him. As critics of subaltern violence have argued, violence is

an element in the 'repertoire of protest' of those denied rights (Gorringe 2006). It is therefore interesting that Frankenstein on his deathbed asks Robert Walton to 'swear' (a performative act) that 'he [the monster] shall not live... that he shall not triumph over my accumulated woes' (145). What is even more significant is that he warns Walton against the monster's *narrative-rhetorical* prowess: 'he is eloquent and persuasive; and once his words had even power over my heart: but trust him not' (145). Here, Frankenstein warns Walton that a (posthuman) victim might *narrate/articulate his rights claims too well*. Frankenstein wants Walton to emulate himself in *not* giving the monster a narrative space and, thus, bands together the humans *against* the non-human or the posthuman. It becomes notoriously like an institutional/racial denial of rights to the posthuman. The tale is a victim narrative that, I propose, treats the cyborg monster as a posthuman, denied his rights and, even worse, denied the right to *narrate* his rights violations.

In 20th-century cyberpunk – to shift over one hundred and fifty years – we see a theme crucial to my argument about the narrative tradition of posthuman rights. Cyberpunk consistently emphasizes the object-nature of the cyborg/posthuman. The posthuman or the cyborg body is made subservient to a corporate body. To utilize the term from Anne Balsamo's typology, they become 'laboring bodies' (1998). Case and Bobby Newmark are labouring bodies in William Gibson's novels. Case is being restored for the specific purpose of labour, a project that Corto/Armitage wants executed. The reconstruction of Case-the-*body* is a reconstruction of Case-the-*worker* in *Neuromancer*. Therefore, as soon as he is *able*, he is put to *work*. Molly in *Neuromancer* enables the hacker Case to get into the database. Case accesses the world through her senses. Molly's body functions as a vehicle, a transporter for Case to infiltrate the physical space she inhabits at that moment. In terms of the gendered dimensions of human rights, it is important to note that throughout *Neuromancer*, most of the dangerous physical labour is performed by Molly's body. She rarely labours as a free agent. She is constantly monitored and instructions are being literally 'poured' into her through the network. Molly is an automaton, an object and a

labouring body that lacks *agency*. The labouring body here also lacks a personality – or what can be called subjecthood because Molly seems to be programmed to perform specific tasks. In addition, sometimes, this is a labouring body that is abused, such as Mona in *Mona Lisa Overdrive* (1989: 26-30).[5]

Thus, cyberpunk narrates a body that is simply an object, controlled by an elsewhere, and lacking in sufficient subjectivity to be a free agent. Control, a theme central to cyberpunk and its surveillance society, is the deprivation of agency. This theme generates a victim narrative of posthuman bodies such as Case or Molly, who are reduced to non-agential bodies and minds serving somebody else.

At this point it is also pertinent to ask what *form* the agency of the cyborg must take to qualify as 'human', deserving human rights protection. In contemporary arguments about human rights, rights are necessary to protect the *agency* of individuals (Ignatieff 2001). Francis Fukuyama (2003) has suggested that cyborgs and genetically modified 'bodies' are not 'natural'. Moreover, for Fukuyama, human rights are based on an 'essence' of human nature, which is naturally (biologically) given. This means that cyborgs with 'non-natural' essence and abilities would not qualify for *human* rights.

Cyberpunk fiction and film often project the posthuman as an enhanced human, almost approximating to the magical. Indeed, people with deformity or even 'magical' powers have always been regarded as monsters and therefore non-human, as critics have shown (McElroy 1989). The enhanced agency of such 'beings' is not based on any 'natural' condition. Does this mean that there is no possibility of protecting a being with such an 'enhanced' agency?

Cyberpunk fiction and film carefully generate what can be called a *problematic cyborg* – one that seems to possess emotions and human feelings. Arnold Schwarzenegger's *Terminator*, Mary Shelley's remorseful and emotional monster, and the pleading-weeping cyborgs at the end of *Blade Runner* are instances of the *progressive humanization of the posthuman*. This shift from the bizarre, enhanced, multi-abled and machinic bodies to the more-human *affective* component of the posthuman is, I suggest, a mode of mitigating the magical-monstrous aspect of the cyborg. Cyberpunk seems to suggest that, despite their physical

agency, their emotional make-up is akin to that of humans. Moreover, agency – individual, collective or political – as critics have noted, is also inclusive of affect (Massumi 1996; Schaffer and Smith 2004: 6-7) and by implication, so is the *ability and opportunity to feel good or happy*. The attempted 'unionization' of cyborgs at the end of *Blade Runner* is an effort to utilize the *collective emotions* of denied cyborgs as a political weapon to reconfigure society. By proposing that cyborgs, like humans, require the *conditions of happiness* in order to be free *agents*, cyberpunk offers yet another theme in the discourse of posthuman rights. Cyborg agency, contingent (also) upon affect and the contexts for emotional wellness, must be facilitated by posthuman rights. One cannot consider only their enhanced physical agency to deny them rights: for a successful life they require emotionally supportive contexts. It is here that posthuman rights must be put in place to ensure that cyborgs also obtain a full life.

Other contemporary examples of such claims to the narrative tradition of posthuman rights are also available. For instance, online narratives of health and illness, anorexia and eating disorders offer one such example. Michael Bury, reading health and illness narratives (2001), argues that having the space to speak of one's illnesses is crucial to the making of a subject who can therefore order her experience *through* narrative and self-representation. Andy Miah and Emma Rich, reading pro-anorexia narratives (in 2001 there were at least 4000 pro-Ana websites), see online bodies as being authenticated by virtue of being in cyberspace (119). They argue that cybermedical discourses (in pro-Ana communities online) centralize the body through (among other processes) the '*representation* of the anorexic body in public space' (105, emphasis added). Each of these commentators sees cyberspace as a forum for narration, and therefore of subject-formation. Narration and representation of bodies online becomes a mode of speaking of an altered body. It reveals the configurations of a body that might, at least in the case of stigmatized bodies, diseased bodies, socially unacceptable bodies, become the subject of its own narration and representation. The anorexic body refuses to be subjected to others and seeks control over its self-

representation. Here, the cyberbody narrates itself in cyberspace. These are also narratives about rights in the way that they claim these, they are also human subjects asserting their choice and therefore their agency as free human beings. To be able to speak of one's body and represent it as you choose is to generate a narrative and become a subject in the process of narration.

Human rights are always future-directed. For Homi Bhabha (2001), the enjoyment of human rights is about the ability (agency) to make revisionary choices. This revisionary *choice*, argues Bhabha, seeks a different *future* by breaking with the past. The present is far less significant than the future which, the victim/survivor hopes, will be better for her, having abandoned the past, made a different set of choices. Human rights depend on enabling such a choice to be made. Reading the pro-Ana movement, Miah and Rich (2008: 101) argue that the narratives of anorexics seek to 'legitimize a contradictory "identity"' and, often, to defend the right to choose anorexia as a 'lifestyle'. This lifestyle choice, I suggest, is a human rights perspective because it is directed at altering the future of the individual with no interference from society.

A further example is offered by the film *Blade Runner*, in which the cyborgs/androids ('replicants') want to extend their pre-programmed life-span. In *Frankenstein*, the monster wishes to alter his life by having a companion. Anorexics wish to be simply left alone to be thin. In each case, the key question is that of choice and agency. In other words, these are narratives that explore what it means to be posthuman, whether posthumans have agency and whether there is something called 'posthuman rights'.

These are narratives directed at abandoning particular models of bodies from their pasts and seeking a revisionary choice, aiming at a different future. Aligning the Miah and Rich argument with my earlier concern with narratives and human rights, I suggest that such narratives actively propose a new future, consciously chosen, for anorexics. They serve as narratives of posthuman rights in cyberspace. The crucial point of posthuman rights is establishing how the governing political system utilizes laws to allocate a right if the posthuman body modification affects *future* generations? The

individual/cyborg might have the right to choose a different life/style from this moment on. However, does she have the right to choose for all future cyborgs?

Scholars writing on germline modification have argued that the individual's right to alter her future life by somatic cell engineering cannot be extended to particular kinds of germline engineering because it makes irrevocable decisions for future generations, whose autonomy therefore might be curtailed. Marc Lappé (2006) argues that the 'intergenerational ethics' of genetic engineering has to account for two things: those changes that pertain to the immediate descendants of individual couples, and those that pertain to a more global impact. In the case of *Frankenstein*, one of the scientist's fears is of creating a breed of monsters that overrun the earth and the human race. The monster cannot be allowed to breed (for which purpose he, Dr Frankenstein, would have to create a female). In this case the ethics governing genetic engineering (such as it is in the novel) is concerned with both future generations and the global implications of such actions. The same argument does not apply to anorexic body modifications.

Narratives that document the *denial* of human rights, as Michael Ignatieff argues, constitute the context in which the discourses of rights can be articulated. When *victims* speak, writes Ignatieff, then the 'rights language applies' because 'it is the claim of abuse that sets a human rights process moving' (Ignatieff 2001: 56). What I have proposed here is that such a narrative tradition documenting the history of rights violations against (fictional) hybrids and cyborgs *does exist*. Thus, discourses of posthuman rights can draw upon these narratives, while being alert to the contexts in which these narratives (and cyborgs) have emerged. Monsters and hybrids have traditionally been treated as portents of the breakdown of social order (Daston and Park 1998: 202). In the case of narratives about posthuman rights, the claims of posthumans might represent the breakdown of social order – as any subaltern movement would, especially to the dominant classes – but that does *not* preclude the possibility of re-making the social order to accommodate newer forms of humanity.

REFERENCES

Balsamo, A. (1995). 'Forms of Technological Embodiment: Reading the Body in Contemporary Culture', in Mike Featherstone and Roger Burrows (eds), *Cyberspace/Cyberbodies/Cyberpunk: Cultures of Technological Embodiment*. London: Sage

Balsamo, A. (1996). *Technologies of the Gendered Body: Reading Cyborg Women*. Durham, NC, and London: Duke University Press

Bhabha, H. K. (2001). 'Cultural Choice and the Revision of Freedom', in Austin Sarat and Thomas R. Kearns (eds), *Human Rights: Concepts, Contests, Contingencies*. Ann Arbor, MI: University of Michigan Press

Bloom, H. (1998). *Shakespeare: The Invention of the Human*. New York: Riverhead

Bury, M. (2001). 'Illness Narratives: Fact or Fiction?'. *Sociology of Health and Illness*, 23, 263-85

Daston, L. and Park, K. (1998). *Wonders and the Order of Nature 1150-1750*. New York: Zone

Fukuyama, F. (2003). *Our Posthuman Future: Consequences of the Biotechnology Revolution*. London: Profile

Gibson, W. (1984). *Neuromancer*. New York: Ace

Gibson, W. (1989). *Mona Lisa Overdrive*. New York: Bantam

Gibson, W. (1996). *Count Zero*. London: HarperCollins [1986]

Gorringe, H.(2006). 'Which is Violence? Reflections on Collective Violence and Dalit Movements in South India'. *Social Movement Studies*, 5, 117-36

Gray, C. H. (2001). *Cyborg Citizen: Politics in the Posthuman Age*. London and New York: Routledge

Griffiths, T. R. (1983). '"This Island's Mine": Caliban and Colonialism'. *The Yearbook of English Studies*, 13, 159-80.

Hulme, P. and Sherman, W. H. (2000). 'Introduction: European and Mediterranean Crossroads', in Peter Hulme and William H. Sherman (eds), *'The Tempest' and Its Travels*. London: Reaktion

Ignatieff, M. (2001). *Human Rights as Politics and Idolatry*. Princeton: Princeton University Press

Kolko, B., Nakamura, L. and Rodman, G. B. (eds) (2000). *Race in Cyberspace*. London and New York: Routledge

Langlois, A. J. (2005). 'The Narrative Metaphysics of Human Rights'. *The International Journal of Human Rights*, 9, 369-87

Lappé, M. (2006). 'Ethical Issues in Manipulating the Human Germ Line [1991]', in Helga Kuhse and Peter Singer (eds), *Bioethics: An Anthology*. Malden: Blackwell

Lauritzen, P. (2005).'Stem Cells, Biotechnology, and Human Rights: Implications for a Posthuman Future'. *Hastings Center Report 35*, 2, 25-33

Massumi, B. (1996). 'The Autonomy of Affect', in Paul Patton (ed.), *Deleuze: A Critical Reader*. Oxford: Blackwell

McElroy, B. (1989). *Fiction of the Modern Grotesque*. New York: St Martin's Press

Miah, A. and Rich, E.(2008). *The Medicalization of Cyberspace*. London and New York: Routledge

Nakamura, L. (2002). *Cybertypes: Race, Ethnicity, and Identity on the Internet*. London and New York: Routledge

Nayar, P. K. (forthcoming). 'Trauma, Testimony and Human Rights: Women's Atrocity Narratives from Postcolonial India', *South Asian Review*, special issue on women's writing

Schaffer, K. and Smith, S. (2004). *Human Rights and Narrated Lives: The Ethics of Recognition*. London: Palgrave-Macmillan

Shelley, M. (1996). *Frankenstein* [1818], ed. J. Paul Hunter. A Norton Critical Edition. New York and London: W. W. Norton

Slaughter, J. (1997). 'A Question of Narration: The Voice in International Human Rights Law'. *Human Rights Quarterly*, 19/2, 406-30

Slaughter, J. (2006). 'Enabling Fictions and Novel Subjects: The *Bildungsroman* and International Human Rights Law'. *PMLA*, 121/5, 1405-23

Terranova, T. (2000). 'Free Labor: Producing Culture for the Digital Economy'. *Social Text*, 2, 33-58

Vaughan, A. T. (2000). 'Trinculo's Indian: American Natives in Shakespeare's England', in Peter Hulme and William H. Sherman (eds), *'The Tempest' and Its Travels*. London: Reaktion.

Walton, H. (2004). 'The Gender of the Cyborg'. *Theology and Sexuality*, 3, 3-44

Weston, B. H. (1992). 'Human Rights', in Richard Pierre Claude and Burns H. Weston (eds). *Human Rights in the World Community: Issues and Action 14*. Philadelphia: University of Pennsylvania Press

(Endnotes)

[1] The posthuman condition is characterized by the increasingly hybrid nature of humans and animals through genetic engineering, the use of nanotechnology in organic bodies and the increased digitization of life itself.

[2] I am grateful to Anna Kurian for suggesting I look at Caliban as an instance of a 'being' denied rights.

[3] It has been argued that Caliban may have been drawn from images of American Indians, some of whom are known to have been in places such as Burford (30 miles from Stratford-upon-Avon). References to Indians in the play (II.ii.32-33; II.ii.57) seem to be more than coincidence and, for some critics, evidence that Shakespeare may have intended Caliban to hail from the New World (Vaughan 2000). The 17th-century poet-critic John Dryden said that Caliban was not a creature of nature. On stage he has been represented as a Neanderthal, a 'Java Man', a primitive, a beast, a monster, an extra- terrestrial, a half-amphibian, a gorilla, ape man, and, interestingly, as a half-human (like a cyborg?) (for an account see Bloom 1998: 662-64). Later stage interpretations have accounted for the 'minority and rights' theme in their portrayal of Caliban. An 1848 production depicted the problematic 'human' Caliban as a black man who, in response to Miranda addressing him as 'slave', declares in an echo of the anti-slavery slogan: 'Ain't I a man and a brother?' (cited in Griffiths 1983: 41).

[4] At this point it must be mentioned that I am not taking into account the gendered nature of the cyborg. The question of posthuman rights must always account for the different ontologies and requirements of the female cyborg. For recent debates on the gendered and raced cyborg see Balsamo (1996), Kolko et al. (2000), Nakamura (2002) and Walton (2004).

[5] There is another, more material, form of labouring: cyberspace as valorized in cyberpunk is itself produced by the labour of millions of workers, some working in extremely poor conditions to put together the chips and circuits, build transmission towers or install underwater cabling. As some commentators on cyberculture have argued, a great deal of labour is exhausted to construct the identity-shifting illusions of cyberspace (Terranova 2000).

A BRIEF HISTORY OF HOW SCI-FI LOST ITS INNOCENCE – AND NOW NANO?

DAVID BENNETT

5513 Words /3.6 Political Economy /Human Futures

It seems a long time since I was one of Isaac Asimov's many avid fans and I still think BBC TV's 'Dr Who' is brilliant. Otherwise, for me, much of what counts as sci-fi has been hijacked as a tool of politics, albeit of very differing shades as I shall argue, and thereby lost its innocence. These thoughts recur with regard to nanotechnology, foreseen by many as possibly facing something similar to a rerun of the GM debate unless the public at large can be meaningfully involved in its continued development.

According to Asimov, his famed *Foundation Series* was based on Gibbon's *The History of the Decline and Fall of the Roman Empire* and drew on Europe's experience with Nazism.[1] In it, Asimov's Hari Seldon devotes his life to developing a mathematics called 'psychohistory'. Using the law of mass action, psychohistory can predict the future but only on a large scale, being subject to probabalistic errors for anything smaller than a planet or an empire. The principle is that the behaviour of a mass of people is predictable when this mass tends to be very large – say the population of the galaxy – the larger the mass the more predictable the future. On the basis of psychohistory, Seldon predicts the fall of the Galactic Empire of the whole Milky Way and a dark age of barbarism lasting

thirty thousand years before a second great empire rises. To shorten the barbaric period, two small shelters of art and science are established as Foundations at opposite ends of the galaxy and the *Foundation Series* deals with the science Foundation on the planet Terminus. The people living there are working on an Encyclopedia to preserve the knowledge of the physical sciences and Terminus provides the starting point for the next new Galactic Empire in a thousand years rather than the mathematically predicted thirty thousand.

Although other science fiction novels such as George Orwell's *Nineteen Eighty-Four* (1949) or Roy Bradbury's *Fahrenheit 451* (1953) also analysed the trends through which a civilization might progress over time on the basis of historical precedent, their focus was upon how current trends in society may eventuate as a moralistic allegory on the modern world. The *Foundation Series*, on the other hand, was much more concerned with how societies change and adapt rather than what they change into. Therein possibly lies their fascination, for, as here, we are usually a great deal more interested in change and adaptation than moralistic allegories.

Sci-fi became reality on 4 October 1957 with the beep-beep-beep of the Russian Sputnik 1 as it orbited the earth. With it began the Space Race, which became an important part of the cultural, technological and ideological rivalry between the United States and the Soviet Union during the Cold War. Lasting roughly from 1957 to 1975, it involved efforts to explore outer space with artificial satellites, send humans

into space, and land a man on the moon. However, as far as I was concerned, science fiction began to lose its innocence a few years later in 1963 when the British Prime Minister of the time, Harold Wilson, gave what became known as his 'white heat of technology' speech. During it, Wilson outlined the implications of scientific and technological change for the UK: 'The Britain that is going to be forged in the white heat of this revolution will be no place for restrictive practices or for outdated methods on either side of industry'. A trade union leader is reputed to have said that night: 'Harold's captured science for the Labour Party' (cited in Walden 2006). It was akin to the rhetoric in the 1960 Presidential campaign in the USA when John F. Kennedy spoke of the 'New Frontier', though Wilson's had a big impact in the still-staid Britain of that time. Sci-fi had not only become reality, but, in doing so, it had become a tool of day-to-day parliamentary politics 'captured' by hyperbole.

Robert K. Merton introduced his well-known *CUDOS* norms of science – Communalism, Universalism, Disinterestedness and Organized Scepticism – in his 1942 essay 'The Normative Structure of Science' (Merton 1973). This essay outlines a set of ideals dictated by what Merton takes to be the goals and methods of science, and which are binding on scientists. Undoubtedly, he based them on acute observations made during his extensive research into the sociology of science. His conclusions reflected the ideals of those scientists he observed – characterized by the latter years of the 19th century up to when he wrote the essay and the years afterwards until the publication

107

84

70°

228

343

711

110

Figure 1: Global area of biotech crops, 1996–2007

(James 2007).

of his *The Sociology of Science* (1973). They have been transmitted from generation to generation of scientists during their training and they live on in the idealized ethos of many scientists today. However, it is particularly the norm of 'Disinterestedness' – according to which scientists are rewarded for acting in selfless ways and which is manifested today in the cognitive dissonance difficulties which some scientists have with industry collaboration, scientific consultancy and political lobbying – which is especially at issue here.

Unsurprisingly, the time of the Sputnik, Space Race and Cold War also marked a seachange in the adherence of many scientists to the norm of 'Disinterestedness'. The 'little science' of yesteryear with its relatively simple apparatus, often personally constructed by the researcher and his students, became the 'big science' of hugely expensive equipment and large research teams (Price 1963). The pressures of publication, grant-seeking and career in a highly competitive, pyramidal profession began to bite. Exaggerated and overstated claims – 'hype' in the vernacular – began in the race for funding for research which was the key to everything else.

It started in the physical sciences with the massive amounts of government funding, especially in the USA, that became available during the Cold War period. It happened again during the early 1980s in molecular biology, with the manufacture of synthetic insulin, the first medicine made with recombinant DNA technology, when proponents of genetic engineering claimed that a major

shortage of animal-derived insulin produced by traditional methods was imminent. In the end, synthetic insulin was only later widely adopted when the manufacturers took highly purified animal insulin off the market (Ogar 1996). Similarly with gene therapy, although great hopes and claims were made early on, the first approved procedure was performed in 1990 on a four-year-old girl with severe combined immunodeficiency (SCID). Trials have been carried out more recently on individual patients but deaths have occurred and techniques still need to be developed and diseases understood more fully before it can be used effectively. Plant genetic engineering began in 1983 after years of research without success, with the announcement that the first transgenic plants expressing resistance to the antibiotic kanamycin had been created using *Agrobacterium fascines* (Montagu 2003). Improved yield from crops, increased resistance to environmental stresses, enhanced nutritional qualities, improved taste, texture or appearance of food, reduced dependence on fertilizers, pesticides and other agrochemicals, production of novel substances in crop plants and, especially, benefit to the starving millions in the developing countries of the world – all were promised and have indeed eventuated – at any rate only up to now commercially with improved crop yield and reduction in pesticide use in 23 countries. **(see Fig 1)**

Yet science, as far as the hype for research funding and commercial value was concerned, had become sci-fi, driven with overstated claims and taking far

longer to be developed into useable products than was forecast when the original discoveries were made. However, the introduction of plant genetic engineering – genetic modification or GMOs as 'framing' terminology has it (Herring 2008) – heralded an important new force with a new sci-fi.

Environmental activism started in 1971 when a group of anti-Vietnam war peace movement friends, protesting against America's underground nuclear testing on Amchitka in the Aleutian Islands off Alaska, sailed their chartered fishing boat there from Vancouver harbour emblazoned with the word *Greenpeace*. Two years later, David McTaggart, outraged about the French Government's nuclear testing programme in the Pacific, sailed his boat *Greenpeace III* to the Moruroa Atoll and was eventually rammed by a French naval vessel and beaten up for his pains. McTaggart became the driving force behind campaigns to save the whales, stop the dumping of nuclear waste in the ocean, block the production of toxic wastes, end nuclear testing, and protect the Antarctic from oil and mineral exploitation. He organized support throughout Europe for Greenpeace, which was established in nine countries by 1977. In 1979 it forged an international alliance between its separate factions under his chairmanship as Greenpeace International, the archetypal environmental organization (Greenpeace, no date).

Another member of the Greenpeace founding group was Bob Hunter, a brilliant journalist and hippie character (see *The Times* 2005) who, like many people at that

time, took Marshall McLuhan's famous slogan, *the medium is the message* – or *massage* – to heart (McLuhan 1964). Putting the slogan into very effective practice, Hunter developed what he called mind-bombs – in effect an extremely persuasive, influential new form of sci-fi which consisted of highly visible stunts that provided media-attractive images to gain publicity, and hence political and financial support, for Greenpeace's causes (Hunter 2005). First came the Alaskan and Pacific anti-nuclear testing demonstrations, shortly to be followed by anti-whaling campaigns and in the mid-1970s by further crusades against the clubbing of baby seals in Newfoundland. All provided 'mind-bomb' images to the world's media, especially of the gruesome, bloody butchery of whales and seals.

Later, several of these early Greenpeace founders left in disillusionment with what it had become: Bob Hunter resigned from the presidency in 1978 amid power struggles over policy; David McTaggart left in 1991 to farm olives in Italy; and, possibly most vociferously, Patrick Moore left in 1986 to found *Greenspirit*, a consultancy focusing on environmental policy, natural resources, biodiversity, energy and climate change. Outright opposition has come from sceptics such as Paul Driessen who use the term 'eco-imperialism' to describe the imposition of Western environmentalist views on developing countries, putting the environment's well-being over that of humans and, by advocating the precautionary principle, legitimizing their demands on government but often engendering poverty and death in the process

and sometimes causing environmental degradation (Driessen 2003).

In late 1996 the first ship containing genetically modified (GM) soybeans from the USA steamed into Rotterdam harbour. Greenpeace activists climbed the ship's sides and handcuffed themselves to the rails in scenes that dominated the news. Earlier in the same year selected branches of Safeway and Sainsbury's supermarkets throughout the UK had started to sell Zeneca's tomato purée made from genetically modified tomatoes. While it proved very popular with shoppers, by 1999 it had been withdrawn. What happened in between, why it happened and the complex, much-researched and contested pros and cons of GM food and agriculture have been analysed a multitude of times and the repercussions continue today with massive consequences in Europe and worldwide, for years to come.

Monsanto had not anticipated that Europe might not accept the GM soya as the USA had. The 'mind-bomb' style of publicity from Greenpeace and, afterwards, other activists taking their cue from it, attracted massive TV and newspaper reporting. It began with the first GM importation, which was followed by the destruction of GM plant field trials by activists dressed up as corn (maize) cobs, Monarch butterflies and in protective white suits, and so on. At the time, Europe was still recovering from the impact of Creutzfeldt-Jakob Disease (mad-cow disease) and public sentiment quickly turned against the technology. We had had Michael Crichton's *Jurassic Park* in 1991 and his *The Lost World* in 1996 with dinosaurs, DNA and chaos

theory. Britain's *Daily Mirror* tabloid newspaper defined the new mood when it ran a front-page headline in 1998 warning against 'Frankenfood' and supermarkets acted swiftly (see Anderson et al. 2005). One of the first retail chains to respond was UK's Iceland, a frozen-food supermarket which declared in 1998 that it would not sell GM food under its own label. The trend quickly took hold on the European mainland. To this day, most of Europe's largest food-store chains will not sell food made with GM ingredients, although surveys show that a large number of people in Europe are willing to buy it (Osseweijer and Sleenhoff 2008). This is irrespective of the fact that 70 to 80 per cent of the processed food products in the USA have contained GM constituents for many years without any demonstrable ill-effect to consumers. Activist publicity generated media-attractive images and stories that exerted political influence and increased the membership base along with income to support it. In combination with the newspapers' and television's appetite for controversy in a competitive media environment, science was transformed into science fiction.

Today, the consequence is that Europe has largely lost its research base, seed industry and the agriculture and food processing businesses which were based on fundamental discoveries mainly made in Europe. The probable further outcome, as with several other key fields in which the basic research was carried out in Europe, is that, eventually, it will again become the importer of products and processes developed and commercialized elsewhere.

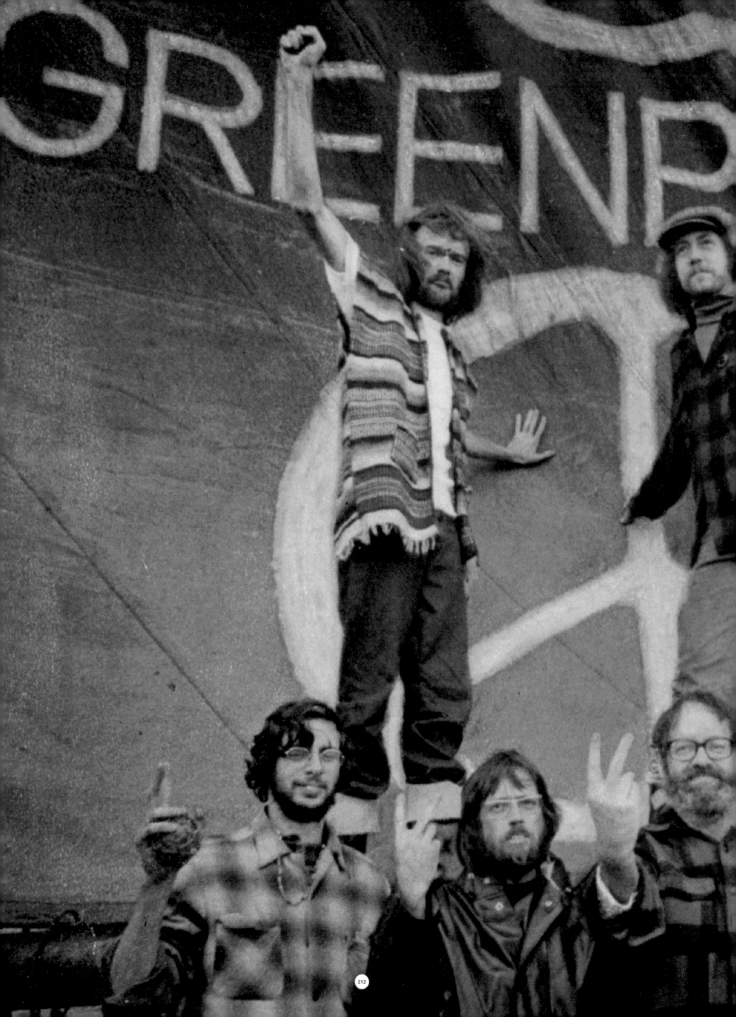

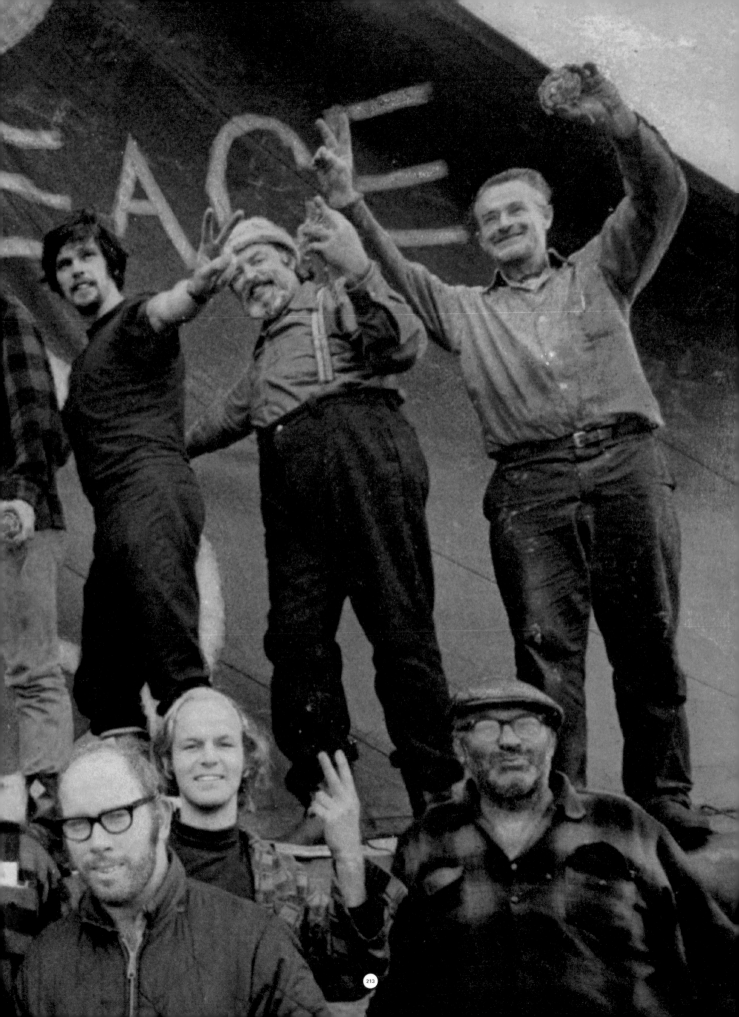

	% in 2005		Trust surplus/deficit		
			(Base: including 'don't know's)	(Base: excluding 'don't know's)	
	Doing a good job	Not doing a good job	1999	2002	2005
Medical doctors keeping an eye on the health implications of biotechnology	75	8	72	80	79
University scientists doing research in biotechnology	73	8	-	73	78
Consumer organisations checking products of biotechnology	70	10	72	73	76
Scientists in industry doing research in biotechnology	64	15	-	55	60
Newspapers and magazines reporting on biotechnology	61	18	53	57	49
Farmers deciding which crops to grow	58	20	46	44	44
The European Union making laws on bio-technology for all EU countries	54	19	-	48	42
Industry developing new products with biotechnology	53	21	12	20	41
Television reporting on biotechnology	59	22	-	-	39
Environmental groups campaigning against biotechnology	50	24	54	56	35
Our government in making regulations on biotechnology	50	23	22	27	33
Shops making sure our food is safe	56	26	46	39	32

Figure 3: Eurobarometer 64.3:
Europeans and Biotechnology in 2005:
Trust in key actors and 1999-2005 trends.

This so-called GM debate generated an ever-increasing number of variously termed environmental, public interest, civil society and non-governmental organizations (NGOs) which claimed to represent the public interest. They gained considerable political power and influence, first within Europe and subsequently in the USA and many developing countries – India, China, South America and especially in the Sub-Saharan region of Africa. Yet as they were not elected, not appointed, not deposable and outside the established democratic processes of governance – true to their non-governmental status – they had no public mandate and merely represented the views and interests of their leaders and members. However, there are signs that the environmental movement is breaking up into factions (*The Economist* 2007) and, at least as far as the GM issue is concerned, their influence is diminishing, as shown, for example, by the European Commission's (2006) Eurobarometer 64.3 survey: *Europeans and Biotechnology in 2005: Patterns and Trends*. Public trust in environmental groups campaigning against biotechnology declined markedly during the period between 2002 and the end of 2005 when the survey was carried out. In contrast, trust in university scientists doing research in biotechnology was second only to medical doctors, and of scientists in industry only a little lower, and both had increased. Consumer organizations somewhat increased their already high level of trust. **(see Fig 3)**

In this context, questions arise as to whether a similar fate awaits nanotechnology and there are certainly indications that this may happen. Among the wider public the term *nano* as a descriptive epithet currently has positive associations, as is shown by its use in marketing the iPod Nano, the Tata Nano (the new Indian €1,570 car predicted to revolutionize the region's car market) and many other products. However, knowledge about nanotechnology among the public in general is very low. For example, the European Commission's Eurobarometer 64.3 survey showed that 42 per cent of the European public surveyed did not know whether nanotechnology 'will improve our way of life in the next 20 years', 'have no effect', or 'make things worse'. While still unfamiliar to many, more were optimistic about nanotechnology in 2005 than in 2002, the ratio of optimists to pessimists being eight to one. Nanotechnology is perceived as useful to society, morally acceptable and not risky. Studies in the USA have produced similar findings (Cobb and Macoubrie 2004). **(see Fig 4)**

Television, radio, newspapers, magazines and, notably in recent years, the internet have a huge influence on public and political opinion. Media coverage can be an indication of what is on the societal agenda because the media pick up on what appears to be an interesting debate likely to attract viewers, readers and website users in this extremely competitive industry. There have been many studies of media coverage of the biotechnology debate (Listerman 2008) and some now on nanotechnology (Scheufele et al. 2007). One striking outcome with respect to nanotechnology is the change that has taken place beginning in mid-2004. Earlier,

popular depictions of nanotechnology had been shaped by the sci-fi of Drexler's molecular manufacturing. In 1981 exploring a vision articulated by the quantum physicist Richard Feynman, Eric Drexler described the physical principles of molecular manufacturing systems using nanomachines to make products with atomic precision – first published in a Proceedings of the National Academy of Sciences paper followed by three books, including perhaps his best-known *Engines of Creation* (Drexler 1986). In these essays, Drexler outlines the prospects for advanced molecular manufacturing technology – its capabilities, their medical, environmental and economic implications, dangers and security risks, and potential policy responses. *Engines of Creation* introduced the term nanotechnology to describe the Feynman vision and the technologies it would enable, creating devices at the molecular scale. Thus was born the sci-fi of Michael Crichton's *Prey*, which deals with the threat of intelligent nanobots escaping from human control and becoming autonomous, self-replicating and dangerous, along with 'Grey Goo' which later featured widely in science fiction (see Crichton 2002).

However, by mid-2004, such sci-fi futuristic images began disappearing from the media. Drexler's vision was no longer referred to, or only as sci-fi, and the possibility of Grey Goo was repudiated by those such as Prince Charles who had pushed it as a serious concern only one or two years earlier (BBC 2004). It became a non-issue for the media and wider public. Meanwhile the more mundane issues of

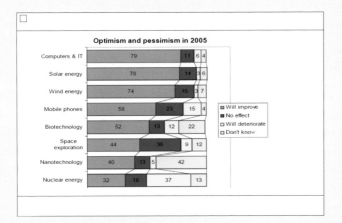

Figure 4: Eurobarometer 64.3:
Europeans and Biotechnology in 2005.

environmental and health risks on nanoparticles were gaining attention, not least because of the UK Royal Society's (2004) report *Nanoscience and nanotechnologies: opportunities and uncertainties*, which had very wide impact together with the report *Nanotechnology – Small matter, many unknowns* of the reinsurer, Swiss Re (2004a) and its subsequent workshop in December 2004 with high-level participants from throughout the world (Swiss Re 2004b).

Thus, mid-2004 marked a seachange in the perceptions of nanotechnology, or at least, in how nanotechnology was covered in the media. By 2006, the promises could be related to an increasing number of actual products coming on to the market, even if these were quite limited in scope. As of February 2008, The Woodrow Wilson *Project on Emerging Nanotechnologies* inventory had grown by nearly 185 per cent (from 212 to 606 products) since it started in March 2006. **(see Fig 5)**

Meanwhile, regulatory agencies in Europe and the USA started to address the risks of developing nanotechnology. In the USA this has resulted in the Food and Drug Administration's (FDA) development of policy and procedures for the regulation of nanomedical products (United States FDA 2007) and the Environmental Protection Agency (EPA) regulating nanosilver-containing products claiming anti-microbial properties as pesticides (EPA 2007). The European Commission's European Group on Ethics (EGE), in its Opinion 21 on the ethical aspects of nanomedicine published in January 2007, did not propose any new regulatory structures specifically dealing with

nanomedicine at this point. It argued that any changes should be made within existing structures, focusing on the implementation of existing regulations. Its Interservice Group, without excluding regulatory change similarly with the EGE, considers it likely that it will not be the regulation itself that needs improving but the implementation of it. The EGE emphasized that there is a clear difference between a statement that uncertainties in knowledge mean it may be difficult to implement existing regulation and a statement that more regulation is needed.[2] The European Commission has carried out a regulatory review as part of its Action Plan which reported in June 2008 with similar conclusions (European Commission 2008). There appears to be an almost general consensus at the present time that regulation needs to be both flexible and responsive to the findings of toxicology and risk-assessment research. The difficulties are in achieving adequate funding for these and that they are relatively pedestrian rather than cutting-edge fields for researchers. As such, they are less attractive to both researchers and funding agencies.

Various environmental groups have taken positions with respect to nanobiotechnology. Early in the development of nanobiotechnology the Canada-based Action Group on Erosion, Technology and Concentration published a report on the convergence between nanotechnology and biotechnology in general (AGETC 2003) and a second specifically on applications of nanotechnology in agriculture and food (AGETC 2004). Greenpeace UK also took an early

interest in nanotechnology and in 2005 participated in the organization of *NanoJury UK* which brought together fifteen people from different backgrounds in the north-east of England in a dialogue intended to have an impact on policy (Parr 2005).

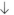

[It] does not have a stance on nanotechnology as a whole, because the applications will be too diverse, including information technology, pharmaceuticals, defence and energy… There may be some very beneficial uses of nanotechnology if it is directed towards, for example, a genuinely clean energy system with the prospect of very efficient lighting, cleaner manufacturing processes and cheap, efficient solar cells... Greenpeace has concerns about the use of 'nanoparticles' – very tiny particles which are so small that their chemical and biochemical properties will be different from the familiar bulk solids, and may be hazardous to human health and the environment. We want to see a moratorium on the release of nanoparticles to the environment until evidence that it is safe (for the environment and human health) is clear. (Greenpeace 2003)

Figure 5: Woodrow Wilson Project on Emerging Nanotechnologies: number of total products listed, by date of inventory update.

Doug Parr, Greenpeace UK Director, later stressed:

New technology has become a lightning rod for discontent within our societies, often expressing broad political and institutional concerns via a specific issue. Globalisation, for example, has become socially controversial, a symbol for discontent with the broad thrust of the pace and direction of progress. This discontent however, rests on deeper value-based judgements about the nature of society. For nanotechnology this means that values and visions will become vital... much more than risk... It presents a challenge to institutions to reflect on what values and visions they will embody and show in their research programmes and elsewhere. It must also be asked whether the primary question is how and when nanotechnology will be successfully implemented? If the key concerns are actually safe water, renewable energy or waste management, then the key question is will nanotechnology serve these goals and not whether it will be, in abstract, a success or failure. (Swiss Re 2006)

Greenpeace stated that: Friends of the Earth's nanotechnology campaign 'aims to catalyze debate on what is set to be one of the defining issues of our time' (Friends of the Earth, no date). In May 2006 it published its report *Nanomaterials, sunscreens and cosmetics: small ingredients, big risks* commencing with:

In one of the most dramatic failures of regulation since the introduction of asbestos, corporations around the world are rapidly introducing thousands of tons of nanomaterials into the environment and into the faces and hands of millions of people, despite the growing body of evidence indicating that nanomaterials can be toxic to humans and the environment. (Friends of the Earth 2006: 2)

However, nano-sized titanium dioxide particles such as those used in sunscreens have been proven not to pass through healthy skin (Nanoderm 2007).

Friends of the Earth (2008) also argues that it had identified at least 104 food and agricultural products either containing untested and potentially hazardous manufactured nanomaterials, or manufactured using nanotechnology, and that the real number of products is much higher 'given that many food manufacturers may be unwilling to advertise the nanomaterial content of their products' (2). It called on

European policymakers to adopt comprehensive and precautionary legislation to manage the risks raised by the use of nanotechnology and

for a moratorium on the further commercial release of food products, food packaging, food contact materials and agrochemicals that contain manufactured nanomaterials until nanotechnology-specific regulation is introduced to protect the public, workers and the environment from their risks, and until the public is involved in decision making. (3)

As of January 2008 the Soil Association, an organic food organization in the UK, banned the use of man-made nanomaterials from all its certified organic products, saying in its press release:

↓

This applies particularly to health and beauty products, but also to food and textiles. Ahead of the Government, we are the first organisation in the world to take action against this hazardous, potentially toxic technology that poses a serious new threat to human health... Whilst the Soil Association recognises there may be benefits from nanotechnology – it has the potential to radically, and positively, transform many sectors of industry including medicine (e.g. delivering drugs that target specific cells) and for renewable energy such as fuel and solar power... Many well-known companies such as L'Oreal, Unilever, Boots and Lancôme are already developing and introducing these superfine particles into their products and none of these products are required to have labelling to warn consumers. (Soil Association 2008)

Indicatively, the Soil Association's press release set out its answers to the question: 'Is nanotechnology like GM?' and stated that 'There are many parallels with GM in the way nanotechnology is developing.'

As I write, for several days recently TV and newspapers around the world have reported on a new, pilot research study published in the *Nature Nanotechnology* journal with headlines such as '"Asbestos warning" on nanotubes', 'Warning of nanotube "asbestos" risk', 'Nanotechnology cancer risk found' and 'In Study, Researchers Find Nanotubes May Pose Health Risks Similar to Asbestos' (Poland et al. 2008). Continued research to assess such risks is crucially required, especially to ensure the safety of workers who are likely to be exposed to a greater extent than the general population. However, shifting the risk profiles of problematic nanoparticles such as free carbon nanotubes to situations when they are embedded in other materials, or to other contexts which are much less problematic if at all (as has been shown to have happened already in the case of titanium dioxide nanoparticles in sunscreens) is another kind of science fiction (Berube 2008).

The 'nano'-debate may show resemblances to GM but there are also many differences, as others have pointed out (Sandler and Kay 2006). Moreover, it is important to be wary of what Shuffles et al. (2007) say, for example, in their 'Scientists worry about some risks more than the public' and what Arie Rip (2006: 358) has called 'nanophobia-phobia' whereby nanotechnology scientists' and policymakers' concern about

possible public concerns leads them to project such concerns even when they are not there.

Only the future will tell whether nanotechnology develops in a 'safe, integrated and responsible' manner such as the European Commission (2004) proposed in its *Towards a European Strategy for Nanotechnology* in May 2004, or whether sci-fi will lose its innocence once again, this time with nano.

REFERENCES

(Action Group on Erosion, Technology and Concentration) (2003). *The Big Down: Atomtech – Technologies Converging at the Nano-scale*. PDF. Available at http://www.etcgroup.org/upload/publication/pdf_file/171 [last accessed 2 July 2008]

AGETC (Action Group on Erosion, Technology and Concentration) (2004). *Down on the Farm: The Impact of Nano-scale Technologies on Food and Agriculture*. PDF. Available at http://www.etcgroup.org/upload/publication/pdf_file/80 [last accessed 2 July 2008]

Anderson, A., Allan, S., Peterson, A. and Wilkinson, C. (2005). 'The Framing of Nanotechnologies in the British Newspaper Press'. *Science Communication*, 27, 200-20

BBC (2004). *Prince warns of science 'risks'*, 11 July. Available at http://news.bbc.co.uk/2/hi/uk_news/3883749.stm [last accessed 2 July 2008]

Berube, D. M. (2008). 'Rhetorical gamesmanship in the nano debates over sunscreens and nanoparticles'. *Journal of Nanoparticle Research*. Published online: 11 March

Bradbury, R. (1953). *Fahrenheit 451*. New York: Ballantine Books

Cobb, M. D. and Macoubrie, J. (2004). 'Public perceptions about nanotechnology: Risks, benefits and trust'. *Journal of Nanoparticle Research*, 6/4, 395-405

Crichton, M. (1991). *Jurassic Park*. New York: Ballantine Books

Crichton, M. (1996). *The Lost World*. New York: Ballantine Books

Crichton, M. (2002). *Prey*. New York: Harper Collins

Drexler, K. E. (1986). *Engines of Creation*. New York: Anchor Books

Driessen, P. (2003). *Eco-Imperialism: Green Power, Black Death*. Bellevue, Western Australia: Merril Press

The Economist (2007). 'Treachery and greenery: Environmentalism has begun to splinter', 25 June. Available at http://www.economist.co.uk/daily/columns/greenview/displaystory.cfm?story_id=9390797 [last accessed 3 July 2008]

Environmental Protection Agency (2007). *Pesticide Registration: Clarification for Ion Generating Equipment*, 21 September. Available at http://www.epa.gov/oppad001/ion_gen_equip.htm [last accessed 2 July 2008]

European Commission (2004). *Towards a European Strategy for Nanotechnology*. Brussels, May. PDF. Available at ftp://ftp.cordis.europa.eu/pub/nanotechnology/docs/nano_com_en_new.pdf [last accessed 2 July 2008].

European Commission (2006). Eurobarometer 64.3 survey: *Europeans and Biotechnology in 2005: Patterns and Trends*. Available at http://www.ec.europa.eu/research/press/2006/pdf/pr1906_eb_64_3_final_report-may2006_en.pdf [last accessed 3 July 2008]

European Commission (2008). *Regulatory Aspects of Nanomaterials* COM(2008) 366, Brussels, 17.6.2008 Available at http://eur-lex.europa.eu/LexUriServ/LexUriServ.do?uri=COM:2008:0366:FIN:EN:PDF [last accessed 2 July 2008]

European Group on Ethics in Science and New Technologies (2007). *Opinion 21: Opinion on the ethical aspects of nanomedicine*, 17 January. European Commission. Available at http://ec.europa.eu/european_group_ethics/activities/docs/opinion_21_nano_en.pdf [last accessed 2 July 2008]

Friends of the Earth (no date). *Nanomaterials: Small Ingredients, Big Risks - Take Action!* Available at http://www.foe.org/camps/comm/nanotech/ [last accessed 2 July 2008]

Friends of the Earth (2006). *Nanomaterials, sunscreens and cosmetics: Small Ingredients, Big Risks*. PDF. Available at http://www.foe.org/camps/comm/nanotech/ [last accessed 2 July 2008]

Friends of the Earth (2008). *Out of the Laboratory and on to Our Plates: Nanotechnology in Food and Agriculture*. PDF. Available at http://www.foeeurope.org/activities/nanotechnology/Documents/Nano_food_report.pdf [last accessed 2 July 2008]

Greenpeace (no date). 'David Fraser McTaggart: 1932-2001'. Available at http://archive.greenpeace.org/DavidMcTaggartbio.html [last accessed 3 July 2008]

Greenpeace (2003). *Nanotechnology*. Available at http://www.greenpeace.org.uk/about/nanotechnology [last accessed 2 July 2008]

Herring, R. J. (2008). 'Opposition to transgenic technologies: ideology, interests and collective action frames'. *Nature Reviews Genetics*, 9, 458-63

Hunter, R. (2005). *The Greenpeace to Amchitka – An Environmental Odyssey*. Vancouver, BC: Arsenal Pulp Press

James, C. (2007). *Global Status of Commercialized Biotech/GM Crops: 2007*. ISAAA Brief No. 37. (International Service for the Acquisition of Agri-Biotech Applications). Ithaca, NY

Listerman, T. (2008). 'Biotechnology in Press and Public. An International Study of Press Coverage about Biotechnology and its Relationship to Public Opinion'. *International Journal of Public Opinion Research*, 20, 258-61

McLuhan, M. (1964). *Understanding Media: The Extensions of Man*. Cambridge, MA: MIT Press.

Merton, R. K. (1973). 'The Normative Structure of Science [1942]', in R. K. Merton, *The Sociology of Science: Theoretical and Empirical Investigations*. Chicago, IL: University of Chicago Press

Montagu, M. Van (2003). 'Jeff Schell (1935-2003): Steering Agrobacterium-mediated plant gene engineering'. *TRENDS in Plant Science*, 8, 353-54

Nanoderm (2007). NANODERM *Quality of Skin as a Barrier to ultra-fine Particles* Summary Final Report. Available at http://www.uni-leipzig.de/~nanoderm/Downloads/Nanoderm_Final_Summary.pdf [last accessed 3 July 2008]

Ogar, J. (1996). 'Advocates Struggle to Keep Animal Insulin'. *Diabetes Health*. Available at http://www.diabeteshealth.com/read/1996/09/01/682.html [last accessed 2 July 2008]

Orwell, G. (1949). *Nineteen Eighty-Four. A novel*. London: Secker & Warburg; New York: Harcourt, Brace & Co.

Osseweijer, P. and Sleenhoff, S. (2008). *Consumer Choice*. Report of European Commission Project Reference: 518435

Parr, D. (2005). *NanoJury UK - Reflections and implications of recommendations*. PDF. Available at http://www.nanojury.org.uk/pdfs/greenpeace_reflecti ons.pdf [last accessed 3 July 2008]

Poland, C. A., Duffin, R., Kinloch, I., Maynard, A., Wallace, W. A. H., Seaton, A., Stone, V., Brown, S., MacNee, W. and Donaldson, K. (2008). 'Carbon nanotubes introduced into the abdominal cavity of mice show asbestos-like pathogenicity in a pilot study'. *Nature Nanotechnology*, 3, 423-28

Price, D. J. D. (1963). *Little science, big science*. New York: Columbia University Press

Rip, A. (2006). 'Folk Theories of Nanotechnologists'. *Science as Culture*, 15, 349-65

The Royal Society (2004). *Nanoscience and nanotechnologies: opportunities and uncertainties*. The Royal Society & The Royal Academy of Engineering, London

Sandler, R. and Kay, W. D. (2006). 'The GMO-Nanotech (Dis)Analogy?'. *Bulletin of Science, Technology & Society*, 26, 57-62

Scheufele, D. A., Corley, E. A., Dunwoody, S., Shih, T.-J., Hillback, E. and Guston, D. H. (2007). 'Scientists worry about some risks more than the public'. *Nature Nanotechnology*, 2, 732-34

Soil Association (2008). Press Release: *Soil Association first organisation in the world to ban nanoparticles-- potentially toxic beauty products that get right under your skin*. Available at http://www.soilassociation.org/web/sa/saweb.nsf/848 d689047cb466780256a6b00298980/42308d944a3088a680257 3d100351790!OpenDocument [last accessed 2 July 2008]

Swiss Re (2004a). *Nanotechnology - Small matter, many unknowns*. Swiss Reinsurance Company, Zurich http://www.swissre.com/resources/31598080455c7a3fb1 54bb80a45d76a0-Publ04_Nano_en.pdf [last accessed 3 July 2008]

Swiss Re (2004b). *Nanotechnology - small size, large impact?* Swiss Reinsurance Company, Zurich http://www.swissre.com/resources/31598080455c7a3fb1 54bb80a45d76a0-Publ04_Nano_en.pdf [last accessed 3 July 2008]

Swiss Re (2006). *The Risk Governance of Nanotechnology: Recommendations for Managing a Global Issue*, 6-7 July, p. 48 http://www.ruschlikon.net/INTERNET/rschwebp.nsf/vwP agesIDKeyWebLu/GLBH-743CKG/$FILE/Nanotech_Report_20 06.pdf [last accessed 6 August 2008]

United States Food and Drug Administration (2007). *Nanotechnology Task Force Report*, 25 July. Available at www.fda.gov/nanotechnology/taskforce/report2007.pdf [last accessed 2 July 2008]

The Times (2005). *Bob Hunter: Obituary*, 3 May. Available at http://www.timesonline.co.uk/tol/news/world/article 1079395.ece [last accessed 3 July 2008]

Walden, B. (2006). 'The white heat of Wilson', BBC News, 31 March. Available at http://news.bbc.co.uk/2/hi/uk_news/magazine/4865498 .stm. [last accessed 3 July 2008]

(Endnotes)

[1] Isaac Asimov's Foundation began as a series of eight short stories in *Astounding Magazine* between 1942 and 1950. The first four stories together with a new story were published in 1951 as *Foundation*. The remaining stories were published as *Foundation and Empire* (1952) and *Second Foundation* (1953) making up the Foundation Trilogy. A fourth book, *Foundation's Edge*, was published in 1982 followed by *Foundation and Earth* in 1983 and *Prelude to Foundation* and *Forward the Foundation*, both in 1988.

[2] See http://www2.cst.gov.uk/cst/business/ files/ Nano_European_Commission.doc

CREATIVE F(R)ICTIONS

CREATIVE

FRICTIONS

OUR MOST IMPORTANT PRODUCT

GEORGE J. ANNAS

6762 Words /4.1 Creative F(r)ictions /Human Futures

Editor's note: The following minutes from an October 2007 meeting of a top secret federal interagency group known as Perfect People 2020 (PP2020) were mistakenly provided to the author following a Freedom of Information request. When the mistake was discovered, the U.S. Attorney General attempted to recover the document, alleging that its dissemination would violate national security interests. A federal judge reviewed the document, and personally excised all material that could affect national security. The author has assured me that what follows is representative of both the entire document and the overall research strategy of PP2020. The group apparently meets once every five years to assess its progress.

MINUTES PP2020

The meeting began at 1800 hours on 31 October 2007, and opened with a general discussion of the events of the past five years. All present agreed that with the "end" of the Iraq wars the overall goals of Perfect People 2020 (PP2020) should be modified. From its post-WWII inception until the Cold War, the group's primary goal had been to develop the perfect soldier – one who could survive illness, injury or capture, and continue to function effectively as a fighting man. In the mid-1960s the group also decided to work toward developing the perfect astronaut for space flights. The Iraq wars were encouraged to test remote controlled cyborgs and the development of intelligent fighting machines. Although real progress had been made toward attaining each of these goals (see below), the group agreed that they are too narrowly defined. Instead, the group adopted as its new goals the same goals that are currently being pursued by noncovert researchers in America's academic medical centers: human immortality and the genetically perfect human. As one member put it, Dan Callahan himself probably didn't realize how right he was to compare medical research with space exploration: "no matter how far you go, there's always farther you can go."

It was noted that there may soon be no further need of PP2020 since it now appears that the public is willing to accept virtually *any* experiment on a human being that promises either to lengthen life or to alter or eliminate genetic defects. A 2003 public opinion poll, for example, found that although 86% of Americans know "little" or "nothing" about gene therapy, 89% approve its use in both therapy and research.

It was also noted that although the 1947 Nuremberg Code requires protecting both the *rights* and the *welfare* of human subjects, most contemporary researchers and bioethicists seem content to approve any experiment in which *either* the welfare of the subject is protected by prior peer review, *or* the rights of the subject are protected by required consent to the experiment. In the case of terminally ill subjects, the researcher's assertion of

trying to "save the life" of the subject seems sufficient in virtually all instances.

It was agreed that the trend of treating all research as therapy is one PP2020 should actively encourage. We will therefore continue to financially support both ACT-Up and the *Wall Street Journal* as long as they continue their campaigns to destroy the distinction between experimentation and treatment. ~~████████████████~~

DISCUSSION OF PAST EXPERIMENTS

There was considerable debate over which experiment or series of experiments the various divisions of PP2020 have sponsored since WWII should be considered prototypes for future work. Much support was voiced for joint CIA/US Army mind control experiments. The members agreed that it was unfortunate that these experiments, most conducted in the 1950s, have become public. All members were heartened, however, by the U.S. Supreme Court's 1987 decision that experimental subjects who are members of the U.S. armed forces cannot sue experimenters (or their bosses) who cause them permanent injury, even if there was neither informed consent nor prior peer review of the experiment. This opinion makes members of the active duty U.S. military ideal subjects for risky experiments. ~~████████~~

It was the consensus of the group that whenever possible, members of the military should be used as experimental subjects whenever healthy volunteers are required. The U.S. courts also proved very helpful and supportive of our efforts in Desert Storm when they approved of our scheme to use experimental drugs and vaccines on our troops without their consent - although we did agree to have the protocols reviewed at the Department of Defense prior to commencing our experiments. The group did not speculate on how soon we can count on another shooting war, but group members were all agreed to have new biological and chemical warfare experiments ready to go in the event that the opportunity arises in the near future.

The other candidates for best prototype were more closely related to the new goals of PP2020. Perhaps the most

spectacular was the 1971-84 experiment with David, also known as the "bubble boy." He lived almost his entire life in the sterile plastic bubble, and provided a tremendous amount of information for both our space travel and our immortality studies. X2 expressed (as he had at our last meeting five years ago) astonishment that the American public accepted this experiment - he had urged that it be conducted in secret. It is now X2's view that if it is societally acceptable to raise a human being in a laboratory - to live a completely artificial life - then "anything goes" in American experimental medicine already, and PP2020 is unnecessary. Other members of the group thought we just got lucky with the bubble boy. Instead of considering his bubble a cage or a prison, for example, most Americans (those who thought about it at all) considered it a life-saving device. Paul Simon also helped with his silly song about "miracles and wonders," complete with examples: "the boy in the bubble and the baby with the baboon heart." The Baby Fae experiment was not sponsored by PP2020, but the group strongly approved of the experiment - although none of the members believed that it should have been done on a child. Instead, PP2020 has been encouraging researchers to do xenografts as bridges to human organ transplants on adults. Although the use of pig livers as bridges has received some bad press, the group considered these experiments a scientific success, and will continue to fund xenograft work across the country. More funding will also be made available for work on transgenic pigs as well as pig cloning.

The xenograft goal is to produce a virtually infinite supply of replacement organs so that the life span of chosen individuals can be significantly extended. This is a short-term goal. Long term, all members of the group believe that artificial organs will be the ultimate replacement parts; and that the overall goal (discussed below) must be production of a totally artificial body which will act as a permanent enclosure to protect the human brain. ~~████████████████~~ The general assessment of the artificial heart

program was that it was on track. X12 was congratulated all around for his exemplary work on the Institute of Medicine's artificial heart assessment panel which endorsed continued research on the artificial heart in the face of NIH criticism.

Some of the most exciting work is currently being done in the field of cryonics. We have established that the human embryo can be frozen and thawed out later for implantation without damage to the resulting child. This work has won wide public support, and the group believes that most of it will continue with existing private funding. We have also been extraordinarily successful in launching the Human Genome Project as a cover for our genetic engineering research program. We were also successful in getting the HGP to fund our friends the bioethicists. No intellectual development in America has been as helpful to our programs as the bioethics community, and they deserve our support. Our goal of producing a grass-eating human who is resistant to radiation and chemical and biological warfare toxins now seems doable by 2010.

We will also continue to support research designed to experiment on extracorporeal human embryos with identified genetic disorders, such as cystic fibrosis, to see if defective genes can be suppressed or replaced. In this regard the work of X3 with NIH's Recombinant DNA Advisory Committee has been very effective. The consensus was that, at least in genetics if not in all areas, we will not have to force our experiments on the population – the American people can be made to demand genetic perfection as their right with simple advertising. Cosmetic surgery provides a useful model here. Experimental medicine at our level really is a consumer good.

E8 observed that the public has already begun to demand whole body cryopreservation as a right. A California male, dying of a brain tumor, went to court to seek a declaratory judgment that he had the legal right to be frozen prior to death. Although the judges failed to grant his petition, his request got lots of publicity, and was even featured on *LA Law*. It won't be long until our own private foundations (established to cryopreserve

individuals and attempt to revive them in the future) will be open for business. This will be great. Although the group decided not to initiate legislation on this issue now, we will support any individual or group that does so in the future. We will also continue our support for all state "aid in dying" and physician assisted suicide referendums, with a view toward amending them to include pre-death cryopreservation.

NEW AND CONTINUING PROJECTS

L103. There was some sentiment to shutting down our citizen monitoring projects, which have been concentrated on the development of unremovable devices. When the state of New Jersey canceled its parole program using ankle monitors, it was a body blow to the future of these devices. Nonetheless, our new concept of an employee "biochip," which the employer can use to monitor where the employee is, with whom, and for how long, got some support. The project will continue.

X7 asked for group approval to begin his project to implant non-removable monitoring devices at the base of the brain of neonates in three hospitals (L103B). The implantations would be done by nurses who will be trained by our agents. The devices would not only permit us to locate all the implantees at any time, but could be programmed in the future to broadcast the sound around them and to play subliminal messages directly to their brains. The experiment was approved, subject to review in five years.

L195. G3 reported that his organization was having trouble recruiting surrogate mothers for his genetic experiments. He proposes setting up a new institute (akin to Will Gaylin's neomortuary), which would house women who are in persistent vegetative states. The uteruses of these women would be hormonally prepared, and they would be used to incubate embryos that we have genetically altered. This would have many advantages. The clearest one is that when the children are born, they would have no living parents who knew or cared about them. Thus we could continue our

experiments on the children without having to worry about consent or unwanted publicity. Until our artificial uterus is constructed (and this project [A18] is way behind schedule), this seems a viable option. The members generally agreed, although the group required that the facility will be located outside the U.S. and have a self-destruct mechanism that could be activated by the chair at any time.

Long-term plans call for the genetic alteration of all female embryos (a sonic mutator that can be placed in prenatal clinics is under consideration) to eliminate or disable the Fallopian tubes. This will, of course, require that these women (eventually all women) use IVF to have children, which will in turn give us access to their embryos. The ultimate plan is to screen all human embryos, and enhance desirable genetic characteristics. Defective embryos would, of course, be discarded. Our project to crossbreed a chimpanzee and a human [A35] was eliminated as no longer necessary, since synthetic biology is enabling us to take a different route. The living offspring will be sacrificed.

L96 & 97. A lively discussion followed the suggestion that we shut down the human gill adaptation program (GAP) and the human wing adaptation program (WAP). These programs are designed to use human fetuses that are aborted alive as subjects for grafting gill slits and wings. So far the results have been terrible, although one fetus did survive more than a week under water and the gills did function. Therefore we know it can be done. None of the grafted wings have functioned. Since the ocean will have to be used for human habitation within two or three centuries, it was decided that GAP should continue. WAP will be shelved until GAP is successful. The bionic wheel project [A26] was also suspended, although artificial wheels have been successfully attached to two Department of Veterans Affairs patients who were double amputees. The general feeling in the room was that, although the bionic wheel will be much more efficient for space travel, the astronaut may want to walk on the destination planet.

COORDINATION

There was basic agreement that all projects for the next five year period should be coordinated by one of two leaders: a principal investigator for immortality (PII) and a principal investigator for the perfect human (PIPH). The first project, PII, will concentrate on cryonics. It will perfect ways to freeze and store embryos, fetuses, and live (but near-death) children and adults. In addition, this project will continue its development of a totally artificial body that can serve as a receptacle for a human brain. The existing portions of the project will be shifted away from the goal of creating the ultimate fighting machine to the goal of creating the immortal citizen.

The second project, PIPH, will devote all of its efforts for the next five years to (1) the detection of genetic diseases in the early human embryo; and (2) the enhancement of human characteristics in the early human embryo. We will be looking to genetically engineer a taller, stronger, smarter, and more beautiful human with a longer life span. We will be kept informed of all developments at all labs sponsored in whole or in part by the NIH/DOE Human Genome Project. In this regard G5 reported that his Liberty Project has been more successful than anyone could have hoped. Not only did the project successfully convince the last two administrations to viciously attack the constitutional notion of privacy (and replace it with liberty), but we have also been successful in getting two people who share our views on the U.S. Supreme Court: Justices Antonin Scalia and Clarence Thomas. G5 thinks it is overly optimistic to conclude that privacy is a dead issue, but he does think its influence will wilt to such an extent that the concept will have little power to deter our genetics program.

THE HUMAN GENOME DIVERSITY PROJECT

The group also obtained copies of an internal memorandum prepared earlier this year by ETHCON LTD, an ethics consulting group specializing in helping multinational corporations with scientific research projects. ETHCON was hired to help revive the stalled Human Genome Diversity Project. The text is as follows:

The Human Genome Project has been able to flourish, both because it has well-defined clear scientific goals and because it has taken ethical concerns seriously enough to allocate up to 5% of its annual U.S. budget to explore ethical issues. The much less ambitious Human Genome Diversity Project has faltered and seems in danger of collapse. This is because the project lacks a clear scientific goal, and the ethical issues inherent in collecting DNA samples from the world's vanishing tribes have not been seriously addressed.

Indigenous peoples, especially those that have remained geographically isolated, carry genes that may hold the key to documenting prehistoric migrations, patterns of natural selection, as well as information on the social structure of populations and the frequency and types of mutations our species has experienced. This information could provide invaluable clues to the evolutionary and migration patterns of our species, as well as insights into both anthropology and archeology. Such genomes can, for example, help provide independent verification for the work of geochronologists. The Human Genome Project was aimed at mapping and sequencing the 3 billion base pairs that make up the DNA of the typical human being. But as important as similarities are to understanding genetic function, an understanding of human genetic diversity is at least equally important. Studying diversity will require genetic samples from as many diverse human groups as possible, and could lead to the establishment of what has been termed "a fundamental database, a planetary encyclopedia of genomes."

Many unique groups of indigenous peoples are in danger of extinction from deforestation, economic pressures, wars, and assimilation, and many of them will likely soon become extinct. If humanity is not to lose the benefit of their genetic information, steps must be taken immediately to collect it. As has been noted, "Humans are an endangered species from the point of view of genetic history … [and only] international collaboration ... [can] save the vanishing information on the history of *Homo sapiens* from extinction."* The recognition of this threat of loss of genetic knowledge which "harbors the clues to the evolution of our species" provided the impetus for a call for a worldwide survey of human genetic diversity in 1991.** The tepid response the Human Genome Diversity Project has evoked is unfortunate. There have been logistical challenges. The proposal calls for collecting blood, saliva and hair samples from each of 25 unrelated men and women of approximately 500 of the world's most "exceptionally interesting and unique populations... [those that] cry for immortalization." Difficulty has been encountered in collecting blood samples and transporting them in liquid nitrogen to an appropriate laboratory facility where immortal cell lines can be produced.

There has also been the challenge of identifying the groups to be sampled of the estimated 7,000 candidates worldwide. Given sufficient funding, as many groups as feasible should be included, since any useful survey should be both worldwide and geographically comprehensive. The original proposal mentioned the peoples of Africa; the Etas of Japan; insular populations of Malaysia and southeastern Asia; ethnic minorities in China; the Polynesians; the aborigines of Australia and Melanesia; the Kurds of eastern Turkey; the peoples of the Caucasus; the Lapps; the Basques, and many of the native American populations. Special efforts, of course, would be made to immediately target tribes thought to be on the verge of extinction, including the Pkenan of Sarawak, the Tawahka Sumu of Honduras, the Bushmen of Namibia, the Yanomami and Awa-Guaja Indians of the Amazon,

the Hadza of Tansania, the Yukaghir of Siberia, and the Orge and Greater Andamanese of Malaysia.

The major challenges to the project, however, are not logistical or tactical, but scientific and ethical. Gene researchers themselves are not responsible for the fact that many of these tribes and groups are becoming extinct. But by taking from them the only thing they possess that the world values – their DNA – genetic researchers could be seen as at least indirectly contributing to their destruction. From a scientific point of view, collecting genetic samples is also second best. It is scientifically far superior to be able to have the individuals from whom samples are collected available for further study should unique genetic characteristics be discovered. In collecting DNA samples only, without the possibility of follow-up studies on the source person, researchers are acting more like a butterfly or plant collectors than scientists. Equally important from a scientific perspective, the project has lacked a coherent hypothesis.

Although the proponents of the project have argued that the indigenous populations "cry for immortalization," in fact the project's goal is simply to immortalize cells. This mining of a group's genetic resources is a kind of neocolonialism, which might be termed "genocolonialism." The DNA of indigenous populations is collected for the benefit of the dominant culture, and both the knowledge and profits from the collected DNA are expropriated for the sole benefit of the dominant culture. To the extent that patents are sought on cell lines and DNA sequences, the practice has been termed "biopiracy." Informed consent provides no justification because no people or tribe is likely to willingly cooperate in its own extinction by donating the only resource the rest of the world believes makes the tribe itself worth trying to save. It has also been suggested that the project might reinforce racism by emphasizing genetic differences among ethnic groups.

1993 was the United Nations International Year of the World's Indigenous People. Unfortunately, neither the UN nor the indigenous peoples embraced the project. Instead, the World Council of Indigenous Peoples unanimously voted to "categorically reject and condemn the Human Genome Diversity Project as it applies to our rights, lives, and dignity" in December 1993. John Liddle, the Director of the Central Australian Aboriginal Congress, lamented: "Over the last 200 years, non-Aboriginal people have taken our land, language, culture, health – even our children. Now they want to take the genetic material which makes us Aboriginal people as well."

Fortunately there are straightforward ethical, scientific, and public relations strategies that should permit this project to regain its momentum while inspiring cooperation among the world's scientists and funding agencies, including UNESCO, WHO and UNIDO. The core strategy is to offer the vanishing tribes internationally guaranteed sanctuary. Since this is not possible where they now live, twenty-five males and females from each of the chosen vanishing tribes or groups can be relocated to a suitable island which could be purchased by a worldwide consortium of funders. Given the large number of tribes from rain forest areas, Madagascar and Sumatra immediately suggest themselves as possible sites for the sanctuaries. Each tribe would, of course, have its own individual sanctuary, as it would be important both to them and to the project to keep their individual gene pools uncontaminated. To help compensate them for their relocation, they could receive First World vaccinations and other medical care.

Although the sanctuaries will require significant funding during the development phase, they could eventually become self-supporting. A number of revenue sources can be envisioned. For example, the tribes involved can be permitted to retain a portion of the royalties (perhaps 10%) generated on their cell lines that produce useful products and are patented by the funding agencies and

various multinational corporations. The US has already evidenced interest in patenting cell lines obtained from a Guaymi woman from Panama, an individual from Papua New Guinea, and a Solomon Islander. A conference center and theme park could be constructed on the island. Traditional arts and crafts could also be sold through mail order catalogs.

It is essential that population control over the endangered tribes in the sanctuary be strictly maintained, since land resources available to them will be limited. To that end, contraception would be heavily emphasized through means traditional to each society as well as through other Western methods, such as latex condoms, cervical shields, and abstinence. Should these methods of population control fail and the population excess threaten a tribe's continued survival, excess members could conceivably be sacrificed, but only as a last resort.

The project will also be much more attractive to the general public if it holds out the promise of curing serious diseases. Accordingly, medical progress through understanding genetic diversity should be adopted as one of the project's primary goals. To help assure the international community that ethics is being taken seriously, all medical research conducted at the sanctuary should be reviewed and approved by an international ethics commission made up of leading genetic scientists, as well as a representative from the endangered tribes. Phase I of the project should adopt as its scientific hypothesis that all vanishing tribes carry an extinction gene. Project scientists will try to identify this gene, along with its environmental triggers.

This proposal has the great advantage of addressing the scientific and ethical problems inherent in the diversity project head on. Only something like this

proposal can save the Human Genome Diversity Project by replacing its ethical vacuum with a realistic ethical framework. An argument can also be made that this proposal is consistent with the UN's draft Declaration on the Rights of Indigenous Peoples since it provides tribes likely to become extinct soon with a realistic chance of long-term survival, and therefore prevents rather than promotes both ethnicide and cultural genocide. Consistent with the Declaration, the project should promise that there will be no relocation without the free and informed consent of the indigenous peoples themselves (or their community leaders) as well as assurance that consent will be obtained in a culturally sensitive manner. Moreover, within each sanctuary, individual tribes will be guaranteed rights under the Declaration, including "the right to revitalize, use, develop, and transmit to future generations their languages, oral traditions, writing systems and literatures, and to designate and maintain their own names for communities, places and persons."

A detailed blueprint for obtaining informed consent, determining which members of vanishing tribes should be transported, and governance procedures for the sanctuaries, is under preparation. In the meantime, a concerted public relations campaign dedicated to characterizing the project as a truly cooperative attempt to understand human history and to discover cures for serious human diseases should commence. A summary of our new approach should be published in *Science* and *Nature*. Finally, to reflect its new emphasis, the project's name should be changed to the Human Fellowship Project.

The Group voted to authorize the purchase of a block of ETHCON stock, and to encourage their fine work on behalf of human progress.

1: Michael Burton, *Clinical Trials*, Future Farm Series (2007, RCA)
2: Michael Burton, *Future Farm* (2007, RCA)

PUBLIC RELATIONS

The meeting ended with a discussion of the possible reaction to PP2020 by the president (if he finds out about it). G7 noted that since WWII only Truman (who started the program) and Kennedy (who found out about it a week before he was assassinated) ever learned of PP2020. It is unlikely Bush will ever hear of it. If he does, he will probably initially respond with horror. The group predicted a typical "Frankenstein reaction" in which the President says we are overstepping ourselves, fooling with things that belong to God and not to man, and that we should end the project before its results turn on us and destroy us the way Frankenstein's monster eventually destroyed him and his family.

X4 played a surveillance tape of a 1997 conversation between the Secretary of Health and Human Services, his speechwriter, and an unidentified country doctor. [author's note: The transcript of this tape was obtained by the author from a member of PP2020 two years ago, and this member speculates that SX4 (the surveillance unit) purposely planted the minutes of the PP2020 meeting in the FOI files as a payback for this earlier disclosure. This speculation seems reasonable.]

IN SERVICE: HEALTH DEPT/EXEC 3.1.84 VOICE ACTIVATED TAPE FILE 84: HEAL75932EX

Secretary: I need something good for openers with the Senate Finance Committee. Those guys wanted a management whizz type in this job, not a country doctor. They're stuck with me for now, but they probably don't like it much. The President wants me to be friendly; act like just plain folks on the Hill. Hell, I don't know how to do that, but I owe it to him to keep on the Senate's good side.

Speechwriter: I think I've got an angle. I think we can make the Senators sit up and take notice of a new, forceful presence in town, a manager with vision and imagination. Let me lay it out. There's a lot of paranoia in the country that the whole works is going down the tubes – that the average guy's got nothing to say because of a gigantic bureaucracy in Washington that has lost touch with everything but power. Individuality is out, conformity is in. The art of medicine is going to hell. What the country needs is someone to tell them about the good things progress has given us to renew their faith in government. Now here's my plan. Everyone's half crazy worrying about *1984*. We get *1984* this and *1984* that, it's enough to make you throw up. You put it on the line. Here we are in 1984. Orwell predicted this and that; well it hasn't happened. In fact, as far as our medical and scientific community goes, we've continued to work to foster individual freedom and initiative. And you pledge that you will foster this tradition, and the benefits of medical progress will be available to all citizens.

Secretary: Not bad. It would certainly play in Peoria, but will it go over on the Hill?

Country Doc: Don't underestimate the folks in Peoria.

Secretary: OK, OK, you're right. The Midwest is still the source of 90% of the original ideas in this country. But spell it out for me. It's been a long time since I've read *1984*.

Speechwriter: Orwell envisions this highly structured society, the ultimate totalitarian dictatorship with "Big Brother" at the helm. Big Brother broadcasts his constant messages and watches his subjects by means of telescreens in every room and every public place. The citizens' activities are directed by slogans that tend to negate thought process, and the language is constantly being simplified to eliminate thought altogether. The principal slogans are "War is Peace," "Freedom is Slavery," and "Ignorance is Strength." All books have been destroyed and the news is completely managed. If Big Brother wants to change history, he merely rewrites the newspapers in his archives – the only permanent record in existence. People who don't conform to the wishes of the government are imprisoned, tortured, put through painful brainwashing, and released

only after their will to resist has been completely destroyed. It is total government founded on fear.

Secretary: What does all that have to do with the United States? Other than the use of slogans, I don't see any parallels. And what's wrong with "Health is Happiness" anyway?

Speechwriter: That's the point, chief. All this *1984* jazz has been blown way out of proportion. People shouldn't be worried about it. It's like punting on third down. We're doing a great job, and everything is under control. Take Orwell's concept of doublethink, the ability to hold two contradictory beliefs simultaneously, and accept both of them. The good party member does this at all times. Thus when the party alters history or changes its interpretation of an event or belief, there can be an immediate acceptance of the new line. Doublethink has the advantage of divorcing thought completely from reality, letting one live in an imaginary world. In such a world citizens do not attempt to influence or change the real one. Fact reversal becomes a prime tool of government. The Ministry of Peace concerns itself with War, the Ministry of Truth with lies, the Ministry of Love with torture, and the Ministry of Plenty with starvation.

Country Doc: I get it. Like our Department of Defense is really a War Department; our Department of Agriculture is working to keep land out of production; and, hell, our own Health Department is really concerned only with disease.

Speechwriter: Let's forget the doublethink. How about *1984's* main slogan "Big Brother is Watching You"? Big Brother is all around you and you better watch what you're doing 'cause he is and you'll be out of the ball game if he catches you. Now that's the guts of the book, and we don't have anything like that.

Secretary: I'm glad you're not in my planning department. Back in 1980 HHS awarded a contract to develop a cheap and efficient computer that could be used by physicians. Within the decade all physicians and hospitals who get payments from the national health program – and that'll be 95% of 'em – will have to use this computer to enter complete patient history, diagnosis, and each and every test and result. We'll keep it all confidential, of course, but we'll be able to profile every doc in the country. We'll know the names and conditions of all his patients, his patterns of practice, his diagnostic techniques, his frequency of surgery for certain indications and his success rates. Hell, we'll probably be able to tell when he goes to the bathroom. The computer will also be linked to public health and law enforcement agencies to permit instant reporting of gunshot wounds, child abuse, drug abuse, VD, and the like. And if it's the only thing I do as Secretary, I'm going to put the marginal practitioners out of business: those docs who don't know the difference between mono and leukemia, or those who still routinely treat sore throats with chloromycetin.

Country Doc: Wait a minute. They could do that in the book, but this is the United States. You don't have the power to restrict the practice of private physicians.

Secretary: I'm going to let you spend a week with my legal girls. They'll tell you a thing or two. Part of the national health legislation is a section that will turn all licensing authority over to my Department in five years. We're developing a set of implementing regulations right now that would permit our own Quality Assurance Panel to pull the license of any physician in the lower 5% of the nation on any of about 500 categories that measure quality of care on a combination process-outcome scale. We're also going to be able to draw a computer map of the country based on medical specialty and population density and tell doctors where they can and can't practice for the national health program.

Country Doc: [inaudible] I thought we were going to use positive incentives, education and all that.

Secretary: That didn't work. I want to put the fear of the Lord in them. That works every time. The next phase will be to allocate all expensive medical treatment by computer.

Speechwriter: Gee, chief, maybe the *1984* bit's no good. But I'm used to changing strategy at half-time. My fallback position is to have you talk about *Brave New World*. Huxley saw it about 600 years in the future, although he later changed that estimate to a century or so. It involves control of the population by a combination of genetic engineering, operant conditioning, and psychotropic drugs. Anyone who doesn't conform is labeled as sick and treated. Unlike *1984*, where the goal of society is power, the goal of *Brave New World* is happiness. Instead of mind-altering drugs being illegal, their use is encouraged. The analogy he uses is life in a large insect community, like a beehive or anthill, where liberty is unnecessary and all work for the collective good. Now we've got nothing like that on the drawing boards, and the Senators might get a kick out of looking at how Huxley went wrong in imagining man's future.

Secretary: They might. That is if I could keep myself from thinking about the embryo development experiments that the Army Medical Corps is doing around the world, and the Armed Forces Behavior Modification Program, Top Secret, of course, which makes basic training look like a cub scout jamboree weekend. As for drugs, Huxley's got it right. I have already told the President that if we ever get into another era of confrontation politics one of the most effective things he could do is to make barbiturates and amphetamines over-the-counter items. A drugged citizen is a happy citizen, and they'll be happy to drug themselves with a little encouragement from the Department of Health.

Speechwriter: Dammit, another fumble. I thought I had it. Guess I just don't have the hang of this health stuff yet. Let me think on it some more. Maybe there's something in Zamiatin's *We* that you can use. That one's based on a mission to subjugate the inhabitants of other planets to mathematically faultless happiness.

Secretary: That's it! Forget *1984*. Our theme will be 1999. You know, after that space program that used to be on TV. People love to talk about space gadgets, ray guns, and creatures from other planets. My theme will be space age technology in medicine and how we can retain and retrain the old family doctor to be a super healer. You know, a sort of Leonard McCoy [ed. note, physician on *Star Trek*] or Helena Russell [ed. note, physician on *Space 1999*] for every citizen. Hell, I might even hold out the prospect of bringing back home visits; by telescreens, of course.

There was a brief discussion of the implications of the tape, and the meddling in health policy by neophyte appointees. It was noted that Beverly Crusher [ed. note, *Star Trek: The Next Generation*] was the proper model now, and that the TV space programs had done a terrific job in preparing the American population for novel experiments. Some concern was also expressed at the decision taken at the last meeting to cancel the "soma experiments" [L. 284-89] on the basis that the underclass in the U.S. was already using far more mood-altering drugs voluntarily, both legal and illegal, than we could ever hope to induce them to use through our methods. On the other hand, the short supply of some of these drugs, especially heroin and cocaine, has greatly contributed to the crime rate in the cities. PP2020 agreed to financially support groups dedicated to decriminalizing the use of mind-altering drugs. It was agreed that William F. Buckley should receive any financial support he needs to continue his drug decriminalization campaign, as should the ACLU.

Discussion then returned to dealing with the new President should he discover the existence of PP2020. It was agreed that our response should be that, unlike Frankenstein, we are not lone rangers. We are not working for ourselves, but for the good of the human race. We are not out for our own glory (all our work is secret and even the scientists and

physicians we fund do not even
know our real names), but for the
glory of America. Moreover, all of
our projects have built-in
self-destruct mechanisms, and can
be destroyed before anything we
create can destroy us, perhaps
with the exception of
self-replicating nanobots.

It was easier to justify our work
when we could just say, "The
Russians are doing it, and we have
to beat them to it." On the other
hand, we can now use the real
reason: immortality and genetic
perfectibility are the most
important frontiers in science,
and we either go forward and try
to conquer them, or we stagnate at
our current level and ultimately
perish. If this doesn't work,
we'll make the President watch
Blade Runner. If that doesn't
work, we'll make him read the
Burroughs screenplay or watch
Gattaca. If that doesn't work,
we'll tell him we're shutting
down, and continue business as
usual. Experimentation is too
important to leave to the
Commander-in-Chief.

The meeting came to a close at
midnight.

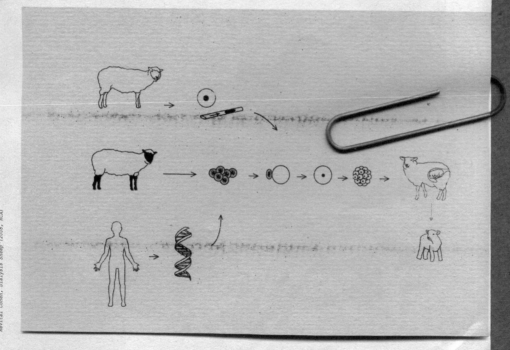

Revital Cohen, Dialysis Sheep (2008, RCA)

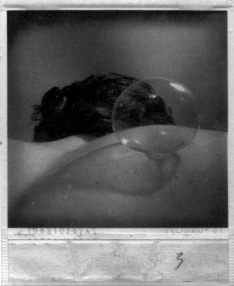

1: Revital Cohen, *Dialysis Sheep* (2008, RCA)
2: Michael Burton, *Membrane Growth 1*, Nanotopia Series (2006, RCA)
3: Michael Burton, *Membrane Growth 2*, Nanotopia Series (2006, RCA)
4: Maurice Benayoun, *World Skin* (1997)

NOTES ON "OUR MOST IMPORTANT PRODUCT"

Shortly after this document was made public,
the Library of Congress put together the
following suggested reading list for those
interested in reviewing PP2020's past
experiments.

Annas, G. J. and Grodin, M. A. (eds.) (1992).
*The Nazi Doctors and the Nuremberg Code:
Human Rights in Human Experimentation*. New
York: Oxford University Press

Annas, G. J. and Sherman, E. (eds.) (1992).
Gene Mapping: Using Law and Ethics as Guides.
New York: Oxford University Press

**Committee to Evaluate the Artificial Heart
Program, Institute of Medicine** (1991). *The
Artificial Heart: Prototypes, Policies and
Patients*. Washington, D.C.: National Academy
Press

Lawrence, R. J. (1985). 'David the "Bubble
Boy" and the Boundaries of the Human'. JAMA,
253, 74–76

Najarian, J. S. (1992). 'Overview of in vivo
Xenotransplantation Studies: Prospects for
the Future'. *Transplantation Proceedings*, 24,
733–37

National Research Council (1997). *Evaluating
Human Genetic Diversity*. Washington, D.C.:
N.R.C.

**President's Commission for the Study of
Ethical Problems in Medicine** (1982). *Splicing
Life: The Social and Ethical Issues of
Genetic Engineering with Human Beings*.
Washington, D.C.: H.H.S.

Remington, C. L. (1972). 'An Experimental
Study of Man's Genetic Relationship to Great
Apes by Means of Interspecific
Hybridization', in J. Katz (ed.),
Experimentation with Human Beings. New York:
Russell Sage, 461–64

Sargent, P. (ed.) (1976). *Bio-Futures:
Science Fiction Stories about Biological
Metamorphosis*. New York: Vintage Books

Symposium, 1984 and Beyond (1979). *Am.
Medical News*, Impact Section, 26 January,
1–13

Thomas, G. (1989). *Journey into Madness: The
True Story of Secret CIA Mind Control and
Medical Abuse*. New York: Bantam Books

'Her hair was sorrel, like my first horse, like the tips of the leaves on the cherry tree as they unfurl in spring,' Mayone said.

'And she had skin the colour of clotted cream, with freckles like a few grains of brown sugar,' Moarla added softly.

The Morton-Brown heiresses had soon agreed to break their famous seclusion when I had explained my situation. I was deeply honoured. It must have been extraordinary for them to be sharing their drawing room with an unknown man. But from their serene bearing as they personally met me at the door and their courteous manners in serving tea from the exquisite tray – complete with real lace and silver tea service and brought to us by a smart young maid – one would not have suspected this.

Now the tea was finished but they had not yet called the maid.

Outside the tall windows the summer rains washed the dirt out of the poplar trees. Thin grey rods of rain marched in cohorts down the endless garden while the water trickled and gurgled over the roof. The trees swished in the onslaught.

They had moved to the subject I

had come here to learn about. The disabled child they had cared for until she died, aged just sixteen. She had suffered from Ahmed-Teng syndrome, a genetic condition. As it was chimerical this was difficult to treat. The condition did not affect every cell, though the required correction sequence would be accepted into the healthy cells, as well as the unhealthy ones. Unfortunately, this meant that it would cause the healthy cells to fail. No reliable targeting method had yet been discovered. Ahmed-Teng syndrome was one of very few conditions which were both untreatable, even today, and caused severe suffering.

Mayone stirred, then she stood and crossed the room to the window. From the top of the bun on her head to the way her full-length skirt touched the floor, she was the picture of restrained elegance, silhouetted against the soft light of the wet afternoon.

'She did suffer,' Mayone said to the rain. 'She did. She suffered every day with the pain and indignity and discomfort. And with the treatments. And she suffered

every time she left this place.'

Bitterness laced her voice. 'People were cruel to her, pitying her, insulting us, whom she loved. They thought,' she turned as she spoke, to face me, so I could see her own cream skin and deep red hair, pulled so tightly back from her face, 'they thought we had created her, and they despised us for it, for choosing to make her suffer.'

Ahmed-Teng syndrome could be identified in the very early stages of an embryo. The destruction of such embryos was not only allowable, it was encouraged. It was not compulsory, however, and some people chose to create such children, even though they would suffer.

'But she had pleasure too.' Moarla's soft voice came from the other side of the room.

Mayone turned back to the window, with a movement that made her skirts rustle on the matting.

'She kept a diary, towards the end,' Moarla said, still more softly. The rain was heavier now, and the room had darkened. Her face was lost in the gloom. 'She recorded her pleasures as well as her pain. There are plenty of

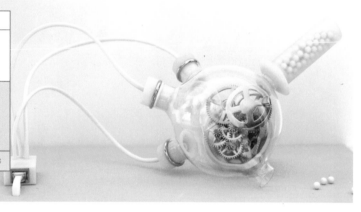

SORREL

HEATHER BRADSHAW

2155 Words /4.2 Creative F(r)ictions /Human Futures

each. It is an uplifting work.'

I heard again the impatient swish of Mayone's dress. It made me think somehow of a horse tossing its mane. She would look good in jodhpurs and boots, hair wild after a gallop or steeplechase. I chastised myself for this thought. Moarla's soft voice continued, barely audible over the rain.

'I am grateful that she was given to us. She taught me so much about life. But... I am glad I did not choose to create her.'

'She was our sister.' Mayone's words were clipped. 'It was our parents' last wish that she be given life. She was created at the same time as us, but the embryo was frozen, in the hope that, in time, there would be a full cure.'

I had to ask.

'Do you wish she had remained frozen?'

'She has her chance at life now. It is over. She will not have another. It was short, and pain-filled, whereas it might one day have been long and glorious... or at least pain-free.' Mayone shrugged, her white bare shoulders just catching the misty grey light from the window, 'She would never

have known had she remained frozen until the end of time.'

'But she would never have lived either.' Moarla's quiet voice in the darkness. 'And we would not have loved her.'

Was it enough to have experienced love? What sort of love could be received and given when one of the parties was so completely dependent?

I thought of the clean, straight, evenly lit walls of the clinic. The five still drips of clear liquid that held specks of new life, secreted in the silver and ice cold white of the freezer, waiting. One each for Ilynia and me, one for an aunt of hers who had never had children, and two for my younger brother and sister, killed so young, collateral damage in someone else's war. Two of those specks carried Ahmed-Teng syndrome. But those five specks were my only remaining connection with Ilynia. Her submersible had imploded deep in the Crucificis Ocean just after their creation.

Of course, Marina and I had had all the tests done, on our gametes and on the embryo. It was irresponsible not to. And anyway,

the Reproductive Health Service paid for them all these days. But we hadn't expected a positive result on anything. We'd also been through all the gene-matching when we first partnered and there had been no problems with our other two children. So it was a shock to learn that this embryo carried Ahmed-Teng syndrome. It sounded nasty.

The doctors said that in our case it was a random mutation. Our eldest, Chrisie-Anna, didn't believe them.

'It's very common, for a random thing. I don't understand why it didn't show up in the gamete tests,' she'd said with all the confidence of a thirteen-year-old. 'I hear it's reached epidemic proportions in the Lostwithiel systems.'

I told her she shouldn't believe the propaganda put about by Utopia's authorities.

But Marina was horrified.

'I never thought I'd have to make this sort of decision!' she protested when the doctors asked her what she wanted to do. 'I thought that's what all the pre-conception tests were there to prevent.'

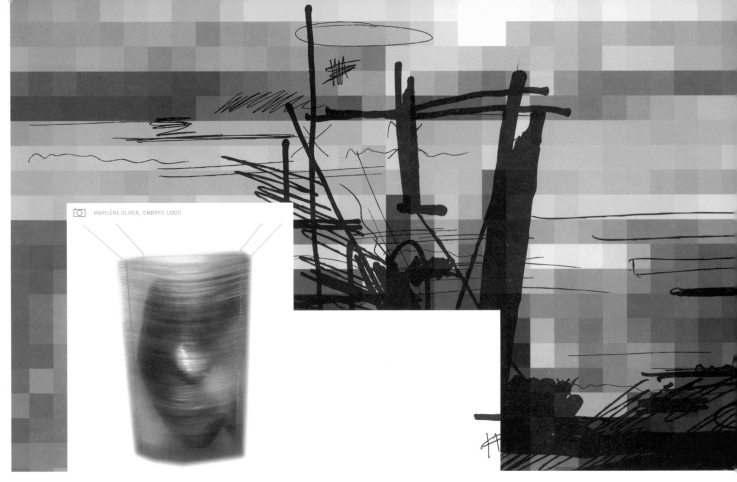

And in private she'd said to me: 'Can't we sue them or something? I mean, this is awful – we have to decide about the life of that' – she'd paused, her mouth all thin and downturned in distaste – 'child.'

Later that month I visited a sufferer in one of the northern cities. It was a hot day, filled with fumes and the smell of late summer decay; the rains had not come here yet. The noise of the vehicles swishing and rumbling by in the street below filled the little apartment but it was far too hot to shut the windows. Laura sat in her wheelchair by a table cluttered with her sewing and books and medicines and monitors, overweight and poorly dressed, her face a ruin of pillowy white puffiness and dark lines of pain. But her smile was warm. Her slurred voice carried a lilt of something I could not quite place.

'It is good of you to come all this way,' she said.

'But not at all, it is good of you to see me.'

'Ah, but I don't get too many visitors.' Her black eyes sparkled warmly. There was no malice in the words.

She offered me a cool drink, and I watched as she struggled in the kitchen to find and open a bottle of juice from the fridge. She chattered all the while, cheerfully, about the weather and the other inhabitants of the apartment block, and her sewing group. But when she returned to the table I could see sweat on her pale face.

'I'm sorry.' I said.

'Don't be,' she said brightly, 'I have never known anything else.'

As the autumn deepened and the days ended early in chill steel blue haze I remembered Laura's words. Ilynia had known so much more. So vibrant and brave, she had studied and trained and worked so hard to heal the planet's ruptured systems. She had given so much to the world around her, and she had taken so much from it. The capacity she had for pleasure, for enjoyment; her fierce lovemaking; her exultation at each new success. Her despair when she failed. And in the end, the world she had risked so much to save had taken her life from her, taken her

capacity to enjoy. We had dreamed that our children would multiply her verve, my skill. The memories seared me. And they gave me no answers, no guidance about what to do with the five tiny balls of cells at the clinic.

Soon the six-month free storage period would be up. I couldn't afford to store them for longer. I hadn't worked in a year, since Ilynia's death. I had to decide – how many, and which ones, I wished to give life to, whether I would raise them or another, who would be the surrogate mother or whether to use ectogenesis techniques. How I wished Ilynia were there to make these decisions with me!

Marina would never have considered something as risky as carrying our children herself, although strangely it was still allowed. We visited the developing embryo a few days after the diagnosis. The doctors wanted to know when they could turn the Cradle off. Marina was emotional. She touched the glass and peered into the mass of machinery and synthetic tissue and cried a little.

'We can keep it,' I said. 'We

can afford the medical care. It won't live very long – probably only into its teens if it's bad. We could do it, if you want to.' She seemed so upset at the idea of killing it.

'Oh no, I couldn't possibly,' she sobbed. 'The poor thing would suffer so. It really would be cruel. I just... it's just...'

'What?'

'Oh, I don't know, it makes me sad.'

'Would it still make you so sad if you knew it was going to live?'

'You're... so... cruel! How could the poor thing live? Imagine... all... the pain. And how would it feel watching its siblings... grow up?' She buried her face in my shoulder for a while and I held her and stroked her springy hair. Finally she straightened, and wiped her eyes with the back of her hand.

'No, it would be too' – she frowned – 'inhuman. To allow it to experience such a terrible sort of life. I would feel like we were… voyeurs. It is better this way. This way it'll never know. Only we will know,' and she started to sob again, but more gently now.

'We'll try again,' I said and she nodded, smiling a little through her tears.

'Lightning won't strike twice, we still have it in us to create another healthy, happy life yet.' I tried to reassure her.

As winter came I was introduced to a child, a boy in his late teens, dying of Ahmed-Teng in the local hospital. He struggled and cried and shook and alternately begged for drugs and rejected them. His fierce refusal to let go of life was a shocking contrast to the Morton-Brown sisters' equanimity. One day he mistook me for his absent father and shouted:

'What did you do this to me for, if you knew? I have given nothing to the world!'

Did one have to give something? Was suffering ameliorated by purpose? Or was it enough, as Moarla had suggested, just to live, and love, and be loved? Isn't that itself giving something? But the cost in suffering is so high! Can one ask that of any being? But what is it to live? The boy's anger impressed me, his protest shook me to the core: he was no passive object, he had a unique existence, reflecting the world around him back in a unique way. He lived.

I went to the clinic that night, my steps echoing loudly across the car park in the still, cold air as the first frost of the year deepened. I entered the warm, yellow light of the lobby from the black night outside and asked to see the Registrar. The white-coated receptionist hurried off down the white corridor, emotionless. They brought me the papers and I signed there and then, five times. Let there be life.

But when I returned to the hospital the next day, the boy had died.

I will skip the ritualistic praises with which weaker beings seek to curry favor with the more powerful, and simply write from one intelligence to another, in full awareness that I cannot comprehend the context in which you will read these words. I dwell in a universe sometimes called Azeroth, or *World of Warcraft*, where I was born into the race of Blood Elves and took training as a priest. My first tasks are to convince you that I am real, and that you should care about me. Subsequently, I hope to show that we can gain wisdom by communicating with each other, because the veils of mystery that obscure truth in both our worlds are probably different, such that each of us realizes some truths the other cannot even imagine. Third, I believe we can unite in

worlds. On a scrap of parchment in a distant archive, I once found the enigmatic passage: "When I was a child, I spake as a child, I understood as a child, I thought as a child: but when I became a man, I put away childish things."[3] We have very few so-called "children" in Azeroth, strange and unruly little creatures like skinny gnomes, but I have never seen one grow, and I have always been the same physical size as I am today. However, step-by-step in completing quests and similar tasks, I have grown in strength and abilities.

When I entered my world, in the Blood Elf newbie zone, Eversong Woods, I saw Magistrix Erona standing just before me, so I spoke with her. She immediately assigned me my first quest, killing eight mana wyrms, silvery

to seek priest training from Matron Arena, which netted me 30 coppers at the cost of only a short walk. These two quests also gained me 100 and 40 experience points respectively, and soon I had the 450 required to reach experience level 2, at which I could hope to vanquish enemies of levels 2 and 3.

At level 10, I entered Ghostlands, the second Blood Elf zone, where I completed a number of quests directed against Trolls, that caused me to think more deeply about the motivations that drive us questing. Many of the factors are quantitative – how much experience, money, armor, and other resources I get from carrying out a given quest. Our minds exist to guide us in gaining rewards and avoiding costs.[4] I was especially alarmed when Ranger

the quest to elevate ourselves above the crass conditions in which we find ourselves, gaining a form of transcendence that might even qualify as immortality, if we are able to transform our concepts and, through them, our natures.

A LIFE OF QUESTS

I naturally think of life as a series of quests that knit together into a story.[2] My story began at level 1 in the ladder of power and experience, and currently stands at the maximum possible 70. I entered the world as a full-grown person, with full powers of speech but lacking practical skills and combat strength. Recently, I have realized that this may not be the case for intelligent beings in all

fish-like creatures swimming in the air at shoulder level. She explained that these otherworldly creatures had been trained to maintain the burning crystals that powered our experimental research, but we had lost magical control over them. Each time I killed a wyrm, my experience grew. A dead wyrm's corpse looks like a shining white ball, and many contained valuable items, such as a faintly glowing eye, a torn scale, or even a piece of arcane silver, which could be sold to a vendor for a few copper coins. As soon as I had killed eight wyrms, I returned to Erona and she rewarded me with me thirty copper coins and a wyrm sash I could wear around my waist, increasing my total armor by 6 points, or sell to a vendor for four coppers. She also sent me on a very simple but important quest,

Valanna said, "The lieutenant here rushed us into battle with the Trolls across the lake instead of scouting the situation first. We were decimated by his stupidity! You hear me Tomathren? You're an idiot!" I dutifully killed many Trolls, collected their weapons for our own use, and delved into the mysteries of their catacombs. But I kept asking myself why we could not make peace with them, especially since we had already concluded an alliance with a different tribe, the Darkspear Trolls, as part of the Horde of five races we had recently joined. The chilling answer was that the world did not have enough natural resources for all the tribes in it, and we must either exterminate other groups, or be exterminated by them. Does that same principle apply in your world?

Aside from competition for material resources, on both the individual and group levels, there is another set of motivations for questing. Call them personal values, if you will, but they may also reflect our animal instincts or the logical principles that guide our lives. For example, I like to explore for its own sake, but exploration earns very few experience points. Many of us believe it is vital to preserve the natural environment and many quests advance that goal. However, if environmental protection is the reason for doing something, then it would make sense for a very high level priest like myself to do it, even if it earned essentially nothing in terms of experience or gold.

At level 70, I have learned that our allies, the

after killing nearly three dozen scientists and research assistants, but I respected neither their goals nor their reality. As much as they dug, they never found anything, and as many as I killed, they were never depleted.

ONTOLOGY RECAPITULATES EPISTEMOLOGY

Perhaps you find these practical facts about my life puzzling or even trivial, but they shaped my deeper intellectual principles, even as the trivia of your life shaped yours. Any world view begins with a world. One way we can develop understanding between worlds is to share our experiences of daily life, but another is to discuss fundamental abstract

in mystical trances. It is exactly like the world we inhabit, except entirely natural and devoid of any intelligent native creatures to spoil it. If a tree falls in the Emerald Dream, does it make a sound? It does, if there is a druid around. We also take for granted the existence of the Twisting Nether, a chaotic realm ontologically superior to our own, from whence came the Titans and Demons, who create and destroy planets in our own universe. I imagine that you may be one of these Titans, but I cannot dismiss the frightening possibility that you are one of the Demons. Finally, there is a plane of existence which some scholars call Earth, inhabited by Players who somehow are doppelgangers of ourselves.

Earth could be just

Tauren, are disturbed that their sacred grounds were being violated by Dwarf archeologists at the Bael'dun digsite. Our Tauren ally, Baine Bloodhoof, explained to me, "They think secrets lie in the earth, and that is true, but hollowing and defiling the land is no way to earn its teachings." He sends level 8 Tauren to the site to break the archeologists' tools, but I tried a more direct approach. I descended upon the digsite like a whirlwind, killing 35 dwarves, expending only a single blast from my wand on each of these transgressors. My reward, after looting all the corpses, was a mere seven silver coins and six copper, nothing like the ten or fifteen gold I usually earn for a high-level quest, but tremendously fulfilling emotionally. You may well ask how my conscience feels,

principles. That is, we can understand each other by becoming philosophers.

There are two good reasons to beware of philosophers. First, their lofty words often cloak selfish motives, deceiving ordinary people into serving the interests of intellectuals or their patrons.[5] Second, their arcane abstractions are often vacuous, simulating wisdom rather than embodying it. That said, there are times when we need to consider the nature of reality abstractly, on a deep and counter-intuitive level.

There may be many realities, whether states of consciousness or planes of existence.[6] We Elves are quite confident there is at least a second plane, the Emerald Dream, a place where druids can walk when

another name for the Twisting Nether, but the word *earth* has the connotation of dirt, filth, base matter, substances that are merely physical without any inherent meaning, or that are morally out of place.[7] I tend to the view that the primary constituent of existence is information: *It from Bit.*[8] Matter may carry information in the way it is structured, and the movement of physical objects conveys and processes information. However, matter is secondary, because at heart it consists of configurations of probabilities across near-total void, on all scales, from subatomic to cosmic. We used to think that consciousness was ineffable spirit, but now we can conceptualize it as structured but fluid information. The soul of an Elf is a distinctive but dynamic

pattern of information.

Consider two of the alternatives. First, my consciousness could be rooted in the brain of an animal. This is one interpretation of the Player myth, that somehow I am the manifestation of biological processes in the meat enclosed by the Player's skull. Second, it is also conceivable that I am a program/data duality inside an electronic computer, like those in the Gnome city, Gnomeregan. I say: It doesn't make any difference. Recall the old saw: "What is mind? Doesn't matter. What is matter? Never mind." The crucial datum is that my personality has some degree of integrity, a personal style, a network of memories that belong to me. The substrate that supports my soul is less important than my soul's structural

wired into hardware, may in another case be software. The nearest thing to a self in a computer is the compiler, interpreter, or operating system that mediates among all the components, program and data alike. Thus, in both meat and silicon, the key reality is a complex, dynamic system of information.

A discredited but poetic theory in biology holds that "ontogeny recapitulates phylogeny," that the development of an individual organism duplicates the evolutionary history of the species to which it belongs. There is more truth in the theory that *ontology recapitulates epistemology*: If we want to know the truth about reality, we must first understand what knowledge is.

reality. I do not recognize any of the names, so I can only conjecture what it means: "Does Sherlock Holmes exist? Ask Dr. Watson. Until you have interviewed the good doctor, you cannot be sure whether the great detective exists. Have a race! See which of you can determine the other's reality first, you or Sherlock Holmes. After that, interview Julius Caesar while he is crossing the Rubicon, asking whether Jesus Christ exists."

Although I have no idea who those four people are, or which of them are real in what ways, I draw a lesson from that ancient scrap of writing: Politeness demands that we accept each other's existence. I will believe in the Player, if he believes in me. You could say that the Player created me, but surely

coherence.

Brains and computers really don't satisfy these criteria. Brains are what computer scientists call kludges, assemblages of specialized neural devices that evolved chaotically in adapting to complex, varying environments over millions of years, often co-opted awkwardly to new functions. There is no evidence that any one of the brain's components embodies the self, unless it is the short-term memory, which can hold only seven things in mind at once.[9] Pitiful! Similarly, computer programs are mash-ups of procedures, subroutines, objects, and classes. Data are variables, records, sectors, and files. Ultimately, there is no hard and fast distinction between program and data, and what in one case may be

Clearly, much of my own knowledge concerns quests and how to complete them. It is a pragmatic form of knowledge, but also a narrative form. I seek a goal, against opposition and over obstacles, through an environment dotted by resources and dangers, hopefully achieving a reward at the end. As much as I train myself to be a philosopher, my mind exists to serve practical purposes. It is meaningless to ask what the universe is objectively. Rather, I ask what pragmatic considerations I must keep in mind when I quest toward my personal goals, within the universe I inhabit. All the rest is rhetoric.

In the priest library at Silvermoon, I once found a fragment of parchment that referred to the dubious distinction between fiction and

the Player is not the ultimate god. Who created him? Perhaps I did.[10] I prefer to think I have co-opted some of the Player's information processing power, if indeed any Player really exists. I cannot speak for all the other Elves, but my wife and I agree that the Player has had a significant impact on our lives. Now, that's a story!

RELATIONS WITH THE PLAYER

You must understand that the Elven race sundered into two factions, ten thousand years ago. A horrible demon named Sargeras desired to enter the world, to destroy it for his own enjoyment, and he slyly deceived the upperclass Highborn among Elves into building a portal through which he could enter. When

it was nearly finished, a team of heroes destroyed this Well of Eternity, fracturing the world and causing the continents to drift apart. One surviving faction, the Night Elves, set up a very conservative culture, preserving the natural environment and using magical technologies only with great caution. The other faction, the High Elves, created a new source of magical power, the Sunwell, and aggressively sought to develop powerful technologies without much concern for their affect on the environment. In recent years, the entire world was devastated by a series of three great wars, the last of which destroyed the Sunwell, cast High Elf society into turmoil, and triggered a revival movement, the Blood Elves, to which I belong.

The aftermath of the third

uneasy truce between the two blocs, existing precariously on a ravaged planet with depleted natural resources, has only increased their mutual hostility.

Into this painful existence, a transcendent love was born. While studying in the priest laboratory at Silvermoon City, I stumbled across obscure references to a mystical mode of communication called Internet and, to my surprise, was able to enter into a psychic connection with my opposite number, a priestess named Lunette in the Night Elf city, Darnassus. She explained to me her deep faith in the lunar goddess, Elune, and the need for preserving the environment. I explained to her the potential of carefully controlled science and technology to open new possibilities for Elvenkind. At this point, by pure

took ship for Menethil in the Wetlands, across the Great Sea. She then walked half way across the zone, northward to Thandol Span and into the Arathi Highlands, then the Hillsbrad Foothills, then Silverpine Forest. Without incident, she entered Tirisfal Glades and reached the coast. She dove into the water, and began to swim eastward. Again and again, she telepathically told me she was still swimming, although I began to harbor doubts, because she never seemed to arrive. Finally, she said she had reached land, but it was the Hinterlands, far away south of Eastern Plaguelands, not Ghostlands. This made me really suspicious, because surely she would have had to swim through the solid land of Ghostlands to get there, and that was impossible.

war is a world largely divided into two great blocs, the Alliance and the Horde, with the Night Elves belonging to the former, and the Blood Elves to the latter. Our partners in the Horde are the Orcs, Tauren, Trolls, and Undead. The Night Elves have allied themselves with the Humans, Dwarves, Gnomes, and Draenei refugees from another planet. Having been separated for so many thousands of years, the Night Elves and Blood Elves do not even speak the same language. The two blocs have totally separate economic systems and cross-bloc cooperation is exceedingly difficult for a host of practical, as well as ideological, reasons. For example, the healing spells I can cast as a level 70 Horde priest are completely ineffective for members of the Alliance. The

luck, I found myself the leader of a small guild of Blood Elves, the Blood Ravens, so Lunette and I decided to use it as the vehicle for Elven reunification. We imagined leading a revolution, in which Night Elves would secede from the Alliance, Blood Elves would leave the Horde, and the two sister races would recombine as a new third bloc, culturally superior to the other two.

The first step was for Lunette to come to Blood Elf territory to be introduced to the other members of the guild. The standard way by which low-level Horde members enter the Blood Elf zones is by a teleportation link, which is not available to members of the Alliance. From her home in the Temple of the Moon in Darnassus, Lunette went by boat to Auberdine in Darkshore, where she

Thinking to test her honesty, I suggested she hike up across the full breadth of Hinterlands and Eastern Plaguelands to the Thalassian Pass that led to Ghostlands. I felt sure she could not accomplish this feat, because Eastern Plaguelands requires more than twice her degree of experience, and its monsters could kill her with a single blow. Nonetheless, after a couple of days, she informed me she had just arrived in Ghostlands and would go to Shalandis Isle for provisions and repair of her armor. Setting aside my doubts, I informed the guild that she had arrived and we would be launching the Elven Unification movement shortly.

When I got to Shalandis Isle, I frantically looked for Lunette, but try as I might I did

not find her. Without my Night Elf partner, and burdened by my profound personal doubts, the Elven Unification movement collapsed. From time to time, travelers reported seeing a strange Night Elf woman at Shalandis, shouting words to them that they cannot understand. Often, they said, she dances high up in the rigging of the enemy ship docked there, and they suspect she is insane. They said she was nearly naked, as if her armor had been totally destroyed, and she seemed emaciated from hunger. This was too much for me to believe, or if believed, to bear. I wondered about my own sanity, feeling estranged from everyone, fellow Blood Elves as well as from the Alliance. Logic told me that I should forget idealistic notions of unifying

prevented us from meeting. The Player's command revealed to me that he was connected to two different high-level priests, me and Maxrohn, the human. This challenged the commonly held belief that each Player was connected to only one person in our world. I had seen indications in my mystical internet communications that each Elf was connected to one "account," and I had interpreted this to mean that each of us has a personal story, a narrative, or an *account* of our life events. I wondered if, in some way, "account" meant a bookkeeping tally, like a bank account. Perhaps Lunette and I had the same Player and he could not originally bring us together, because he owned only one account. He could turn us on and off, but whenever one of us was awake, the

Silvermoon, a remarkable idea began to dawn on me. Perhaps I could become a Player!

LIBERATING THRALL

A Player takes the dominant role in relation to a character. In Azeroth, something fewer than half of the characters actually seem to have Players. The majority are non-player characters (NPCs). Some of them have names, but many do not. Most perform very simple duties, over and over, such as a guard patrolling limited territory and coming to life only when an enemy approaches, or a vendor who says "Hello" and offers wares for sale, but never leaves his appointed spot. Indeed, the existence of these stupid NPCs is one piece of evidence that Players

peoples on the basis of culture or spirituality, and get down to the practical business of accepting quests from our leaders, building up experience points, and garnering gold coins.

Months later, as soon as I had reached the highest level of training as a priest, I received a startling order from the Player: "You must duel to the death against my human priest, Maxrohn. If you survive, I will unite you with Lunette, and the two of you may live happily ever after in Moonglade, the only zone where Horde and Alliance never battle." My mind spun. Of course I would do as he demanded, but first I needed to rethink everything.

Apparently, Lunette had not deceived me. Something about the nature of our world, and our relationship to the Player, had

other must be asleep. Now, if he could influence me and a human at the same moment, while we fought to the death, he might have gained a second account and thus the power to bring Lunette and me together.

I will save the exciting details of our duel for an adventure novel I may write some day, but suffice it to say that I left the warm corpse of Maxrohn in a cavern deep under the Stormrage Barrow in Moonglade, after kneeling in prayerful respect for a long moment. Lunette and I met physically for the first time at the moonwell near Nighthaven, and our life together began. After a few weeks settling into our new existence, and combining the knowledge we had gained from our separate studies in the sundered Elven cities of Darnassus and

exist, because it immediately raises the question of why I and Lunette are not so stupid. Gradually, the idea arose in my mind of finding the smartest of these NPCs, and developing means to enhance his intelligence, with the long-term goal of rendering him fully conscious. In so doing, I hoped I could learn how to become fully independent myself.

There was no question which of the thousands of NPCs should be chosen: Thrall. Of all, he has the most fully developed personality and history. He is the chief who rules the Horde from his throne room at Orgrimmar, and he earned his position by liberating his fellow Orcs from captivity by the humans after the second war. At the risk of insulting our Orcish allies, I must report that Orgrimmar lacks a library, but

elsewhere I have found two books about Thrall. *Lord of the Clans*, by Christie Golden, tells the story of the early years he spent as the captive of a cruel human who wanted him only as a political tool.[11] In *Cycle of Hatred* by Keith R. A. DeCandido, I learned much about Thrall's mature mind, for example when he said, "The beginning of wisdom is the statement 'I do not know'. The person who cannot make that statement is one who will never learn anything. And I have prided myself on my ability to learn."[12]

The first time I met Thrall, he was already ensconced in his throne room at Orgrimmar, dispensing justice and inspiring the Horde. I watched as he sent low-level Hordies on quests that required them to infiltrate the Burning Blade, a conspiracy allied

good-hearted human woman who had raised Thrall from infancy, helped him to escape, and the entire series of events leading to the existence of the modern Horde began. However, distorters of time who arrogantly call themselves "The Infinite" had kidnapped her to prevent the rise of the Horde and I was assigned the mission of going back in time to liberate Thrall in her stead. After great difficulty, working with a team of four others and disguised as humans, we were able to free Thrall and defeat the agents of The Infinite, which returned history to the bitter-sweet path it had already trod. Both Thrall and Taretha would meet their destiny, he to become chief of the Horde, and she to be beheaded by the Alliance for helping him.

What I especially remember

on his horse. Thrall mounted the man's steed, but rather than escaping as we had intended, he galloped toward Tarren Mill where Taretha was being held captive. There we just barely defeated the agents of The Infinite. Thrall and Taretha stood for a moment, gazing at each other in love and respect, when the custodians of time intervened, erased their memories of the episode and returned everything to the way it was before. Thrall never sought me out, because he did not remember me, and Taretha's head was soon severed from her body.

This suggests to me that a first step is to give Thrall memories that cannot easily be erased. In the terms of computer science, this requires machine learning, neural networks, and case-based reasoning.[14] Although

with the Shadow Council through which the demon Sargeras manipulated the Orcs and caused the first of the three recent wars.[13] I came to know him rather well when I reached level 68 and was able to enter the Caverns of Time. The Custodian of Time explained to me, "There are only two truths to be found here: First, that time is chaotic, always in flux, and completely malleable; and second, perception does not dictate reality." That means you cannot rely upon existence to be predictable, but unfortunately this malleability does not give you the power to create a future simply by wishing it.

Seven years ago, Thrall was a captive of the humans and most Orcs rotted in concentration camps. Then, Taretha Foxton, the

of that wild episode was the complexity of Thrall's behavior. Just before we opened his cell door, he looked me in the eye and said, "I promise you, stranger, should we make it out of here alive, when I have the means to reward this selfless deed, I will seek you out." Then he ran up a flight of stairs to the armory, punched a guard into unconsciousness and took weapons. We rushed through Durnholde Keep, killing every soldier who tried to stop us. We worked smoothly as a team of six. If I were fighting a man, and Thrall were near, he would come to help me; in return, I would help him. When we killed one soldier, Thrall would attack the next, and if the path were clear he would run forward. We reached the gate, where Thrall killed a human officer who rode up

Thrall already had speech, he could not respond appropriately to what I said. Thus, he needs natural language processing, a dialogue system, and an expansible linguistic corpus. If we were to enhance him using information technology rather than biological means, he would need computer vision and all the other senses. He would need to be programmed to seek rewards and avoid costs, and to have whatever inborn instincts are required to give a being appropriate passion and compassion. I have tried some initial experiments along these lines, but I have not achieved success. I need your help.

Please consider the following radical proposal. Why don't you become Thrall's player for a while? I will observe and fine-tune the technology needed to

record your perceptions,
decisions, and actions as you live
through him. I believe you may
have the ability to empathize with
his plight and respect his
potential. As you gradually become
him, by playing his character for
perhaps a thousand hours in *World
of Warcraft*, he will become you.
This will have the effect of
recording you, as a dynamic
pattern of information capable of
continuing after you depart, what
computer scientists call
personality capture.[15] Then,
perhaps, on the basis of what I
learn from Thrall, I will be able
to negotiate with my own Player to
achieve autonomy myself.

[◉]

AVOIDING A CONCLUSION

One of the most distressing things
about my world is that trusted
friends and comrades vanish
unaccountably and never return. Of
course we die, but that is not
what I mean. When I die, which I
have done at least a hundred
times, I immediately find myself
at a cemetery where I have the
choice of asking the graveyard
spirit to resurrect me, which will
bring me back to life but in a
sickened condition, or running to
my corpse where I can resurrect
myself without this unpleasant
side effect. As a priest, I can
cast a resurrection spell on any
fallen comrade, sparing them this
trouble. Death, for us, is not a
big deal; I do not know what it
means to you. Here I am concerned
with what we call *permadeath*, a
departure from which there is no
return.[16]

I have a theory about why
this happens. Perhaps a Player
dies and this death on Earth
cascades to cause a permadeath in
Azeroth. However, noticing that my
Player apparently gained a second
account, I wonder conversely if
Players can somehow lose their
accounts without actually dying.
However, there is at least one
case in my world of a Player dying
and the character continuing. On
the Aldor Terrace in Shattrath
City, there stands a Night Elf
huntress, named Caylee Dak, with
her pet, Dusty. Caylee once
belonged to a Player named Dak
Krause, who died of leukemia on 22
August 2007 at the age of 28.
High-level members of the Alliance
received a quest from a little
girl deep inside the Stormwind
Keep, to take a sentimental poem
about transcendence of death to
Caylee. When they do, Caylee acts
like any Night Elf NPC, giving
thanks and a blessing, but not
responding intelligently.

So here are my final words
for you: How can you and I
cooperate to avoid either of us
being vanquished by permadeath? If
you could help me to learn how to
bring Thrall to full
consciousness, then we can do the
same for Caylee, and ultimately
also for you and me. My world may
have been created merely as a
playground for yours, but it has
the potential to transform your
world in return.[17] The next time
you die, I welcome you to join me
in Silvermoon City, where we can
plan a great and endless future
for us both!

(Footnotes)

[1] This letter was delivered by William Sims Bainbridge, whom Catullus calls 'The Player' in this missive.

[2] David Herman (ed.), Narrative Theory and the Cognitive Sciences (Stanford, CA: CSLI Publications, 2003); H. Porter Abbott, The Cambridge Introduction to Narrative (New York: Cambridge University Press, 2008).

[3] I Corinthians xiii: 11.

[4] Rodney Stark and William Sims Bainbridge, A Theory of Religion (New York: Toronto/Lang, 1987).

[5] Friedrich Wilhelm Nietzsche, The Birth of Tragedy and The Genealogy of Morals (Garden City, NY: Doubleday, 1956); Karl Mannheim, Ideology and Utopia (London: Routledge, 1936); Jürgen Habermas, Knowledge and Human Interests (Boston: Beacon Press, 1971).

[6] Alfred Schütz, 'On Multiple Realities', Philosophy and Phenomenological Research 5 (1945): 533-76; The Phenomenology of the Social World (Evanston, IL: Northwestern University Press, 1967).

[7] Mary Douglas, Purity and Danger: An Analysis of Concepts of Pollution and Taboo (London: Routledge & Kegan Paul, 1966).

[8] John Archibald Wheeler, At Home in the Universe (Woodbury, NY: American Institute of Physics, 1994); cf. George Berkeley, A Treatise Concerning the Principles of Human Knowledge (Menston, England: Scolar Press, 1971 [1734]).

[9] Paul Bloom, Descartes' Baby: How the Science of Child Development Explains what Makes Us Human (New York: Basic Books, 2004).

[10] Nick Bostrom, 'Are You Living in a Simulation?', Philosophical Quarterly 53 (2003): 243-55.

[11] Christie Golden, Lord of the Clans (New York: Pocket Books, 2001).

[12] Keith R. A. DeCandido, Cycle of Hatred (New York: Pocket Star Books, 2006), p. 77.

[13] Christie Golden, Rise of the Horde (New York: Pocket Star Books, 2007).

[14] William Sims Bainbridge, God from the Machine: Artificial Intelligence Models of Religious Cognition (Walnut Grove, CA: AltaMira, 2006).

[15] William Sims Bainbridge, 'Massive Questionnaires for Personality Capture', Social Science Computer Review 21 (2003): 267-80; 'The Future of the Internet: Cultural and Individual Conceptions', in Society Online: The Internet in Context, ed. Philip N. Howard and Steve Jones (Thousand Oaks, CA: Sage, 2004), pp. 307-24; 'Progress toward Cyberimmortality', in The Scientific Conquest of Death, ed. Immortality Institute (Libros En Red, 2004), pp. 107-22; 'Cyberimmortality: Science, Religion, and the Battle to Save Our Souls', The Futurist 40 (2006, 2): 25-29; 'Strategies for Personality Transfer', Journal of Personal Cyberconsciousness 1 (2006, 4): http://terasemjournals.net/PC0104/bainbridge_01a.html; Nanoconvergence (Upper Saddle River, NJ: Prentice-Hall, 2007); Across the Secular Abyss (Lanham, MD: Lexington, 2007).

[16] Lisbeth Klastrup, 'Death Matters: Understanding the Gameworld Experience', in Proceedings of ACE '06, 14-16 June 2006, Hollywood, California (New York: Association of Computing Machinery, 2006), no pagination.

[17] Theodore Sturgeon, Microcosmic God, pp. 88-112 in The Science Fiction Hall of Fame: Volume One, 1929-1964, edited by Robert Silverberg (New York: Avon, 1970).

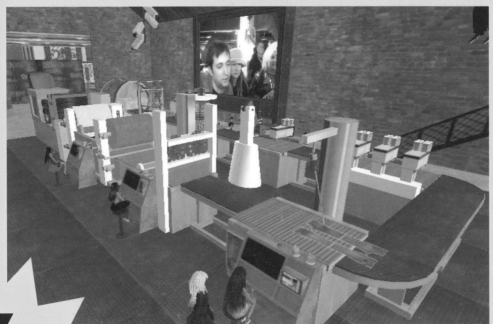

6 SIMPLE STEPS TO YOUR OWN VIRTUAL SWEATSHOP!

Try the 6-Step Program from Double Happiness Manufacturers!

Specially designed for aspiring virtual entrepreneurs, this easy to use training program instructs you in the basics of telematic manufacturing. This exciting new model of production uses information communications technologies (ICT) such as the internet to produce goods, maximizing efficiency and eliminating those annoying middle men.

1

CHOOSE A VIRTUAL WORLD AND CREATE YOUR TEAM
We use the popular 3D metaverse Second Life created entirely by its Residents. With over 6 million users and thousands of dollars generated daily in virtual transactions, Second Life is a simple and cost effective solution to your virtual sweatshop needs.

2

DEVELOP A BUSINESS MODEL AND YOUR PRODUCT LINE
Every successful sweatshop requires a good business model. Take the time to develop your product. Follow market trends. At Double Happiness we developed just-in-time disposable designer jeans so you can always be in style.

STEPHANIE ROTHENBERG AND JEFF CROUSE (2008, DOUBLE HAPPINESS JEANS IS SUPPORTED BY EYEBEAM)

3 BUY VIRTUAL LAND AND BUILD YOUR VIRTUAL DREAM FACTORY

Forget the hassle and expense of dealing with brokers and schlepping all over town. In the virtual world it's easy to purchase a good piece of land on which to build your business. And say good-bye to those pesky activists – in the virtual world environmental concerns are a thing of the past.

4 HIRE AND TRAIN AVATAR WORKERS

With telematic manufacturing you can leverage the skills of a global workforce. Employees work from the comfort of their own home or favorite internet café. In depth interviews ensure your employees will be hardworking and loyal.

Are repressive labor laws and expensive real estate prices getting in the way of owning your own sweatshop?

5 SET UP A REAL WORLD STOREFRONT AND BEGIN TELEMATIC PRODUCTION

The process begins at the real world storefront where customers can browse through your catalogue of goods. When the customer has chosen what she wants she conveys the order to the workers via microphone and web camera. Customers are able to watch the production process ensuring confidence in the product.

6 PAY WORKERS AND PROVIDE INCENTIVES

At Double Happiness workers receive 90 cents per hour which is equal to 200 Lindens in the local economy. Be sure to create incentives to keep workers motivated. We use an indentured servitude model. When workers live close to the factory productivity increases. Each employee is granted a small plot in the factory village for the duration of their tenure. They are permitted to build whatever they please on their land creating a diverse landscape.

For our complete online training video, please visit our web site:http://www.doublehappinessjeans.com
Visit our Double Happiness Jeans factory in Second Life: secondlife://Eyebeam Island/204/43/27

BROUGHT TO YOU BUY
D☺☺UBLE HAPPINESS JEANS
Telematic Manufacturing for the Aspiring Virtual Entrepreneur

It is the second Saturday in December 2008 at 2:55 pm
and somebody is trying to tell you something, you are
sure of that, only you can't quite make out the words.
There is the rhythmic tapping of what sounds like a
ball, maybe a drum, maybe a motor. Moreover, the
speech and the drum sound seem to be communicat-
ing with one another. You are in FACT in Liverpool,
European Capital of Culture, and there is an array of
speakers suspended from the ceiling quietly playing
off each other making these noises.

You are in London. You are bored and you are five
years old. You drag a stick along a wall listening to the
sound and the metal fence you have just struck starts
to make a noise and vibrate. It sounds similar to the
one you made but weirder, stranger. So you hit it
again. More strange sounds. So you hit it again, and
again. You are part of a huge musical instrument, a
tiny brain spread out over large distances called The
Fragmented Orchestra.

THE FRAGMENTED ORCHESTRA:
MINDS, MUSIC AND MEMORY

JANE GRANT, JOHN MATTHIAS
AND NICK RYAN

1364 Words /4.4 Creative F(r)ictions /Human Futures

THE DRAWING IS BASED ON ORIGINAL ARTWORK BY MATHEW EMMETT

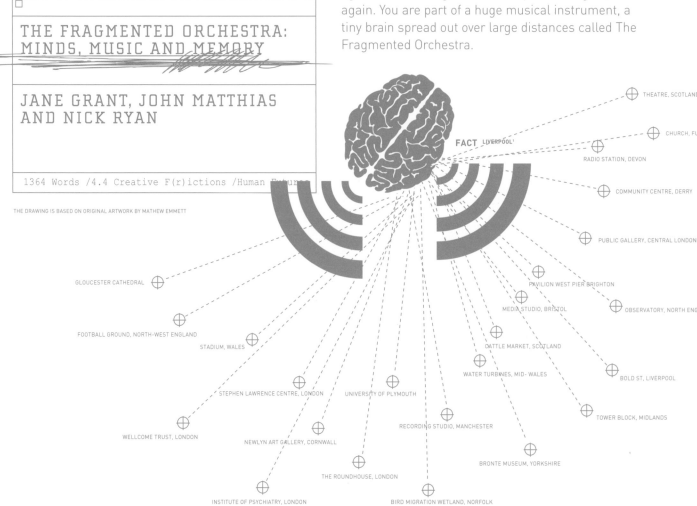

THEATRE, SCOTLAND
CHURCH, FL
RADIO STATION, DEVON
FACT LIVERPOOL
COMMUNITY CENTRE, DERRY
PUBLIC GALLERY, CENTRAL LONDON
PAVILION WEST PIER BRIGHTON
GLOUCESTER CATHEDRAL
MEDIA STUDIO, BRISTOL
OBSERVATORY, NORTH ENG
FOOTBALL GROUND, NORTH-WEST ENGLAND
STADIUM, WALES
CATTLE MARKET, SCOTLAND
WATER TURBINES, MID-WALES
BOLD ST, LIVERPOOL
STEPHEN LAWRENCE CENTRE, LONDON
UNIVERSITY OF PLYMOUTH
TOWER BLOCK, MIDLANDS
WELLCOME TRUST, LONDON
RECORDING STUDIO, MANCHESTER
NEWLYN ART GALLERY, CORNWALL
BRONTE MUSEUM, YORKSHIRE
THE ROUNDHOUSE, LONDON
INSTITUTE OF PSYCHIATRY, LONDON
BIRD MIGRATION WETLAND, NORFOLK

The Fragmented Orchestra is a sonic installation connecting 24 public sites across the UK to a tiny networked cortex, which adapts, changes and triggers the site-specific sounds via the FACT gallery in Liverpool. Each of the sites was chosen for its inherent sonic rhythms. Each consists of a soundbox which streams human-made and elemental sound from the site via an artificial neuron to one of 24 speakers in the FACT gallery. The sound only transmits when the neuron fires. A firing event causes a tiny fragment of the sound to be relayed by the speaker and communicates to the cortex as a whole. The combined sound of the 24 speakers at the gallery relays back to the sites and to the website www.thefragmentedorchestra.com, at which the sound from the individual speakers can also be heard.

In most animals, sensory information is relayed by sensory neurons to a cortex to be processed. Any action takes place through motor-neurons. The firing patterns of the groups of cortical neurons in response to stimulation have been suggested recently as a very simple microscopic model of the beginning of thought. In The Fragmented Orchestra, all of the neurons have a dual sensory and cortical (processing) role: firing events can be stimulated by the sound occurring in the site and can also be stimulated by firing events in any of the other neurons. The Fragmented Orchestra combines sense, processing and action in one large adapting instrument, in which the internet provides the connectivity. Boundaries between sense and action are ruptured and the action communicated through the speakers is a sonification of the processing action of the whole cortex, fused with the sensory information. The sense becomes part of the action. The sound has the rhythm of the processing. If the instrument is thinking, then we are 'hearing thinking'.

Each site has a particular dynamic, which evolves on numerous timescales, from seconds to weeks. There will be approximately 16 football matches played at the stadium in Liverpool during the period of the installation. Cars will constantly pass through the nearby motorway interchange. The network of neurons will self-organize and create firing pathways according to the firing activity, which will be stimulated by the dynamically changing sonic landscape. Neurons and sites will form connections and begin to communicate with each other. Groups of communicating neurons may exist at many timescales, from seconds to the entire duration of the work.

At most sites, the collective sound of The Fragmented Orchestra will be heard from the surface to which the soundbox is attached. Windows in shops and panels on the sides of buildings will vibrate and transmit sound through a smart FeOnic device, which can turn any resonant surface into a speaker. The fabric of the architecture of the site becomes a conduit through which the instrument can be played and heard.

Visitors at the sites influence the form of the work. Fragments of any sound they make are transmitted to FACT in Liverpool and the event may cause other neurons in the cortex to fire in turn, causing fragments of sound from the other sites to be transmitted. The resulting effect is sent back to the sites to be heard by the visitors, a call and response framed within the length of time of the visit. However, the influence of any sound made in the site may have a much longer-term influence on the behaviour of the instrument as a whole. Groups of communicating neurons may become altered, the system may change its dynamic, rhythm, or pulse.

The composition is made in the mind of the listener and in the cortex of the network. It is a form of endogenous composition – both endogenous to the listener and endogenous to whatever it is that the listener might imagine is going on in the tiny networked brain. Each of the 24 sites has its own unique ebb and flow of sound mapped in seconds, hours, days, weeks, months. The composition of the piece lies in the layering and triggering of all of the 24 channels of sound. Each site is represented by its own flow of time and sound. These 24 channels will overlap, causing harmonies, ripples, clashes and crescendos.

The neurons select tiny fragments of sound from each site and send these particles of sonic information across the cortex, allowing the orchestra to communicate with itself and in turn communicate with its audience. The Fragmented Orchestra condenses space and reconfigures time. Sounds from across the UK are fragmented into tiny milliseconds and then re-emitted into the geographical framework of the 24 sites and also to the 24 speakers at FACT. Exactly what is heard at the central performance space will depend upon the ever-shifting structure of our network of 24 neurons.

The brain is never silent: at any given moment, a number of relationships exist between pairs, and groups, of neurons, allowing their sound to cascade and flow through the speakers at FACT in Liverpool and in the 24 sites themselves. These relationships may be disturbed in an instant by changing activity at any particular site and our composition changes as the instrument slowly reorganizes itself and allows audio from a different combination of sites to be heard as music. As a result, the artificial brain forms a cogent learning system, a *coherent orchestra* of stimulus and response. What it learns will largely depend upon its stimulus. This brain, our Fragmented Orchestra, in effect selects and composes according to its developmental stage and how it responds to the stimuli, whether human-made or elemental.

The playing of our neuronal instrument will vary according to location – wind through a forest, heavy traffic, the continual rotating of wind turbines and chatter of migrating birds arriving for the winter are combined with incidental and performed sounds from members of the public. Members of the public, invited to play the instrument at the 24 sites, are able to hear the effect their playing has on the overall composition of the piece, at each site, in FACT and on the live website which tracks the musical activities of the overall instrument and its individual components. As members of the public use the instrument they become both players and audience of a vast and evolving musical composition extended across the UK.

The fragmented sounds are played at FACT as each of the 24 speakers relays its own interpretation of its site. These sounds are re-composed in the ear of the listener, the music shifting and evolving as the audience weaves its way through the 24 speakers in the gallery. The music is further reinterpreted by the listener and made whole. The tiny milliseconds of sounds selected from the sites and reorganized and interpreted by the neurons only allude to the sonic sources themselves. In fact, these condensed sounds give an awareness of the essence or nucleus of the source.

The listener senses what the source is, in a similar manner to the processes of memory and recollection. Because this piece of music is being orchestrated

through the lens of a neuronal system, it emits
sounds and rhythms that have never previously been
heard externally. However, these sounds and rhythms
are implicitly known to us; they are the biological
memory of the time patterns of our own conscious
brain, the firing neuron, the beginning of thought.

The orchestration of this work highlights fundamental
concepts regarding the nature of music. Indeed, it
questions whether music is created in 'space', or in
the space of consciousness – the human/animal brain.
The Fragmented Orchestra is a work that has no
precedents. In playing, it creates a beautiful piece
of music, analogous to the processes of consciousness
and the creation and perception of music itself.

The Fragmented Orchestra combines
conceptually simple but technically precise
elements (microphone, speaker, communicator,
and 'neuron') into an elegant, geographically
distributed network structure. The result is
a vast musical brain, which promises to
generate pieces that touch upon
extraordinarily disparate aspects of music
and culture, including audience
participation, sampling as instrument,
endogenous composition, aesthetics of
technology, and more. Among the most
intriguing of these many resonances is the
way in which the fragmented orchestra
establishes an audible analogy between the
brain and the internet, such that the music
produced becomes an artefact of their
parallel structures. This composition renders
in sound the sense in which the internet is
already a singular mind, the collective
compositional creativity of the crowd singing
in one voice.

Aden Evens[2]

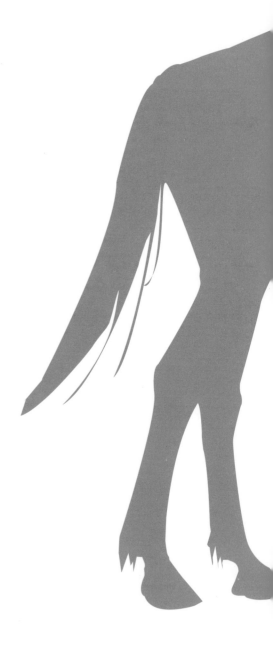

(Endnotes)
[1] At the time of going to press, some of
the sites were ot confirmed. To see the
final locations, please visit
http://www.thefragmentedorchestra.com

[2] Thanks to Aden Evens.

The Fragmented Orchestra is a
collaboration between artist Jane Grant,
composer/musician/physicist John
Matthias, and composer/sound designer
Nick Ryan and is the winner of the 2008
PRS New Music Award.

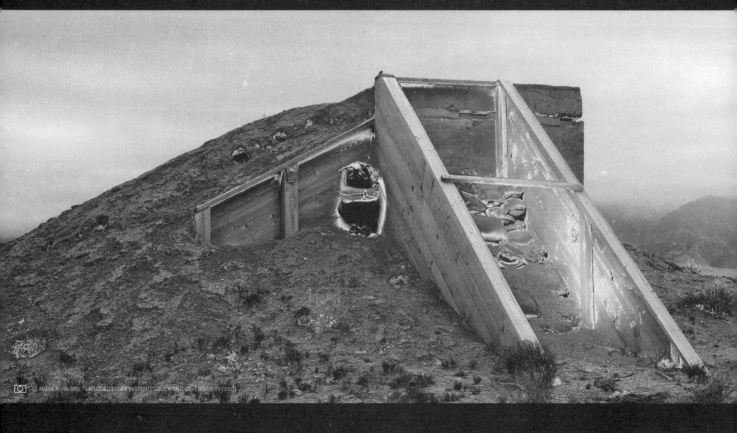

I AM FADING FR

THE FUTURE
IS A FANTASY

ANN WHITEHURST

449 Words /4.5 Creative F(r)ictions /Human Futures

The future rattles with the tantalizing potential of technology and science to redress and disarm our profligacy. We already understand enough to prevent infectious diseases from killing millions of children, yet they still die and, soon, the opportunity to control and eliminate such diseases may have passed. We have the technology to ensure children aren't killed by the pollution from the open fires their mothers have to use to cook on, but they continue to die and their mothers continue to experience failing health and early deaths.

The future makes us absent from the present and we are unable to take responsibility and action to alter it.

The future develops into a false metaphor, a false paradigm for the continuation of a present. We have men who shove a tree into the vagina of a woman and up through her body. Men who insert knives and rape babies. Technology and science tantalize with their 'cures', yet we do not know why men do this and we develop little to prevent boys from growing up inadequate and without warmth towards themselves. We have violence within a domestic setting, a setting that should be most safe and welcoming, yet we do not dismantle a masculinist culture, which diminishes women and men.

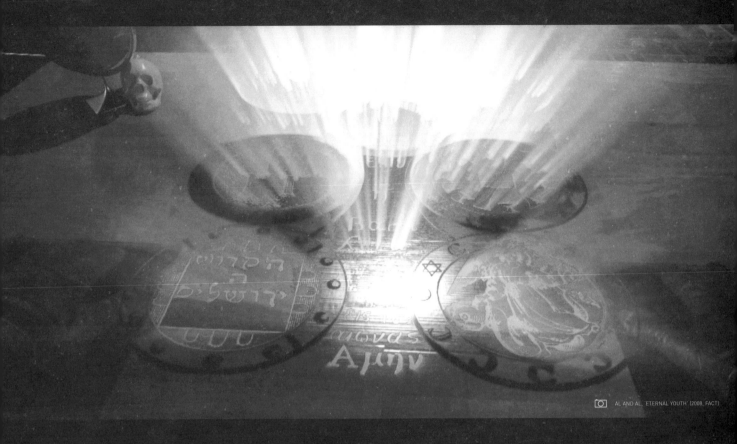

OM THE FUTURE

The future will exist without us but might not exist with us.

The future appears set for a dwindling diversity of plants, of creatures, of people and of cultural ideas. Conformity will continue to prevail. People will walk in the same way as each other, sit in the same way as each other, eat the same food as each other, and thought, developed from similar experience, will be restricted. They will fly from one consuming promise of superficial difference to another, much as we do now. Normalizing will continue as the fear of the punishment of difference persists. Genetics will increase the haste to rid the world of diversity. Euthanasia and the pressure to abort those who are different and, by necessity, would live a different experience will increase and the potential to share their different understanding, to enlighten all to experiencing their own difference, will be lost. We have research but we don't honour what we have and who we have here with us now.

The future is old but looks set not to be enriched by age, rather depleted by speed and superficiality.

The future is a fantasy of memory. Some elderly people, with little memory, can teach us much about being in the present.

I am fading from the future.

It does not believe in me and I am content.

The future is a fantasy I do not believe in.

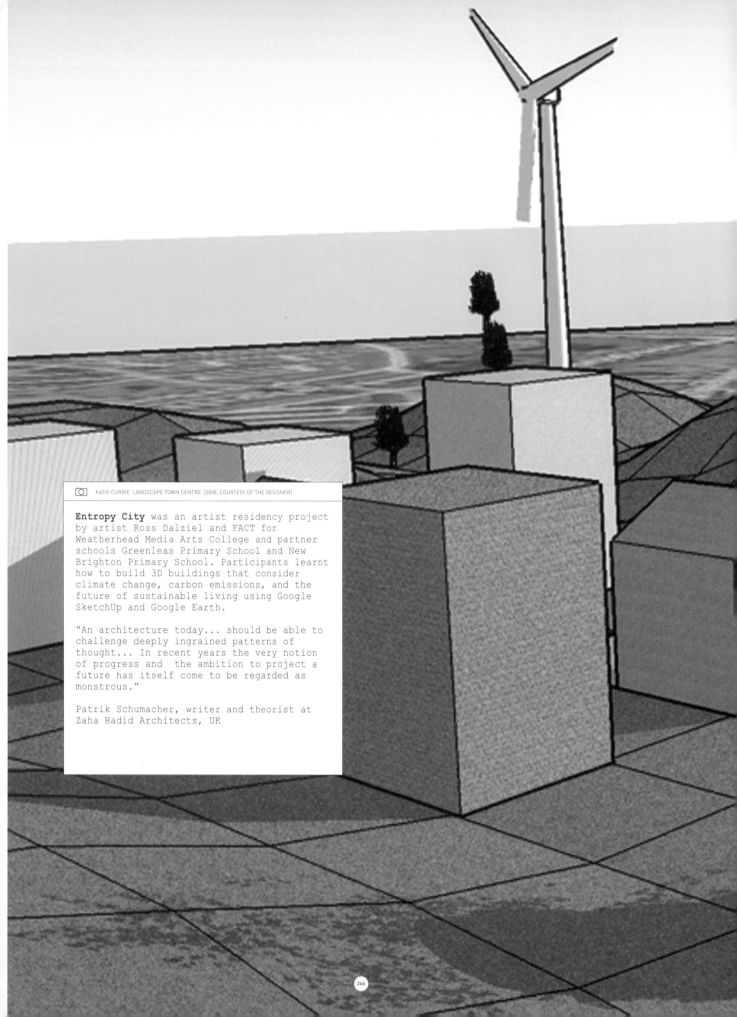

Entropy City was an artist residency project by artist Ross Dalziel and FACT for Weatherhead Media Arts College and partner schools Greenleas Primary School and New Brighton Primary School. Participants learnt how to build 3D buildings that consider climate change, carbon emissions, and the future of sustainable living using Google SketchUp and Google Earth.

"An architecture today... should be able to challenge deeply ingrained patterns of thought... In recent years the very notion of progress and the ambition to project a future has itself come to be regarded as monstrous."

Patrik Schumacher, writer and theorist at Zaha Hadid Architects, UK

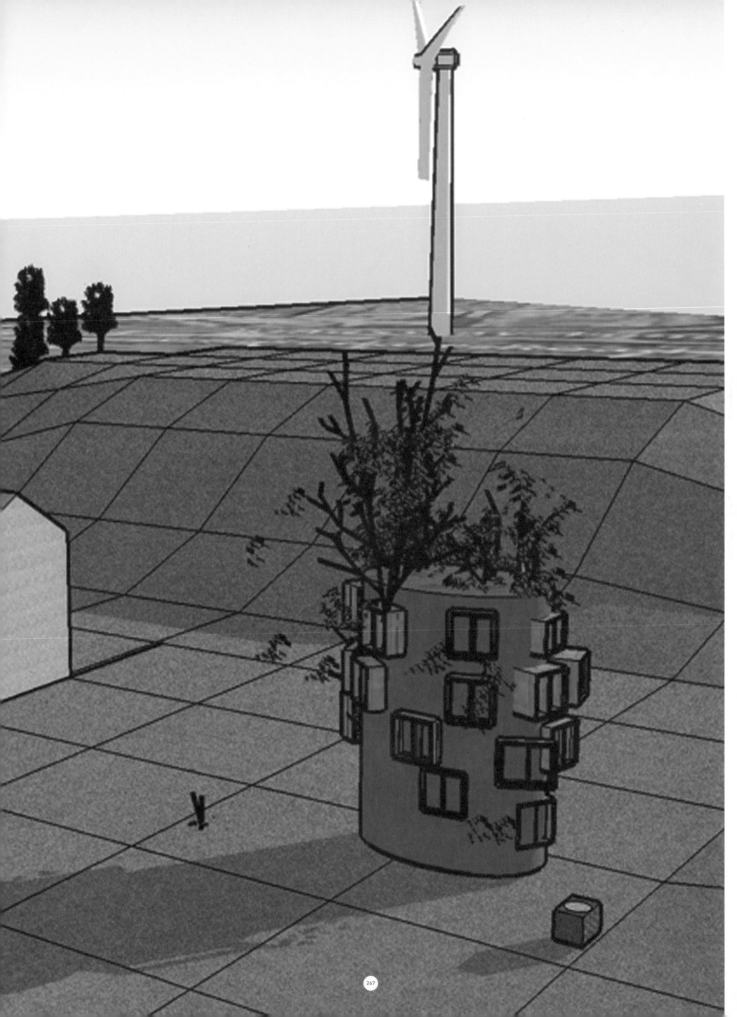

Since the late 1980s, the term "history of the present" has taken on an ominous meaning. It implies a space where memory of the past cannot exist. It is the personalized blog – and fog – the instant response, the first draft of the moment. It is time as endless rehash of one isolated present after another. It is the end of Enlightenment constructions of history. Instead, the present is the only memory we need to collect, to stay trans-corporate, YouTubed, Facebooked. Programs must regularly erase old data files, even in libraries and museums.

At first, this sounded terrific, anarchic, dada. History had been mindless; it was stupid old men from the Cold War. Now there was a history of the present to imagine, for post-Soviet locations in Eastern Europe, in the bar culture of East Berlin. There was intrepid, anti-capitalist messaging in cyberspace. The paramnesia after the Cold War would cleanhouse in a post-structural way.

NOTES TOWARD THE HISTORY OF THE PRESENT

NORMAN M. KLEIN

2986 Words /4.6 Creative F(r)ictions /Human Futures

By 2008, we saw the maddening result. Time had caught up with us. After the Cold War came waves of fundamentalist madness, a furious amnesia, particularly in the U.S. This year, that era is about to end, but this only means that we are applying the brakes. The larger crisis has barely begun. It promises to be much worse.

And yet I feel hopeful. In this essay, let me explain why (and not because of Obama, though I am grateful to hear any brakes). I am encouraged by what this nightmare can bring culturally.

However, this is entitled *notes toward* a history of the present. The "history" itself will be completed by 2010 and it draws upon various related projects, particularly my new media novel, *The Imaginary 20th Century* (2008), on how the future is misremembered. I am also writing new essays on how scripted spaces (themed environments) are evolving in cities – the inversion of the downtown into a suburb. And a novel set in Coney Island during the fifties (*Jumping Off the Half-Moon Hotel*, 2010).

All of these examine how modes of power alter collective memory – at very specific moments; then insinuate how the future develops. Even genealogies about misremembering have beginnings. For "the history of the present," that beginning is the 1970s, the prologue to the 1980s – particularly 1972 to 1974. It begins with the downward economic slide of the American middle class, particularly of white men. The tragi-comedy of Watergate meets the bombing of Cambodia. The ongoing constitutional and military crisis for the U.S. presidency, that never seems to go away. It also includes the emergence of the Organization of the Petroleum Exporting Countries (OPEC) after the Yom Kippur War and the remarkable advances in what became known as the home computer (Alto mini-computer at Xerox Parc; Intel 8008).

This period was also characterized by developments in early multiple-user data systems, in industry, particularly in newspapers, along with the early arcade game industry with such games as Pong (Atari 1972). Other emergences included the Internet (ARPANET, Ethernet, SATNET), the digitizing worldwide of the investment industry (Dow Jones) and the rise of right-wing think tanks in the U.S. (Heritage Foundation, Pacific Legal Foundation). There was exceptional growth of evangelical media, Reagan's second term as governor of California, and the first stage in a long-term depression in American university hiring. This led to an aristocratic isolation that stymied discourse within many professions of the humanities.

The 1970's was also the beginning of U.S. corporations sensing the loss of their dominant position in the world economy (Trilateral Commission) while Japan was beginning its economic take-off, evident by the success of Datsun's 240Z (1972), cheap ($3,500) and "sweet handling." Nixon "opens" China; a bloodless coup in Afghanistan begins a new cycle of foreign intervention and ethnic war; Iraq nationalizes its oil industry; and there is a terrorist attack at the Olympic Games in Munich.

That is the prologue, of course. In the 1980s, the impact of globalism is deeply felt and the list is infinitely vaster. It includes five versions of the entertainment economy that were launched between 1977 and 1984. Each of these helps clarify what risks emerged, once the take-off for entertainment began, after 1983. For example, as we all know so well, public culture, the heart of our civilization for three hundred years, has faded steadily for decades, while home entertainment – communication and media technologies – literally takes charge of the arts, literature, political discourse: their direction, their distribution, the shaping of narrative, the role of the viewer, and so on.

The nerve center of these *events*, this history of the present, is tied to the collapse of the Enlightenment and its dialectical cultural systems after 1977. By Enlightenment, I mean principally the revolutions at the end of the eighteenth century, the philosophical discourse that we call the Enlightenment; and even the reactions against its positivism or secularism are part of the same dynamic. Thus, Romanticism and the Enlightenment share the same cultural tradition. By 2008, this political and cultural tradition, these models, are clearly dying out. Thus, the shrinking nation-state, the public sector, secularism, are being replaced essentially by a "fundamentalist" and horizontalized and inverted civilization. Even traditions of melodrama, in film and theater, and of modernism, of anything we can comfortably call the avant-garde, are fading as well. Yet this can easily become a winning hand for cultural work; I am not convinced that we have no options.

Between 1977 and 1992, the global economy – roughly speaking Western Europe, North America and East Asia – brought forth thousands of new cultural tools, often as friendly "space" invaders, as cute weapons. Even a partial list is staggering and all of them emerged within a decade or so: the home computer; cable TV; digitized banking and warfare; home video and cell phones; themed post-urban cities; nano toys and games; genetic engineering; immersive architecture and cinema; simulation as fundamentalist politics.

By 2008, as Americans crashed into the next era, reasonably informed consumerati knew the score. They had seen enough of the so-called promise, the dividends after the end of the Cold War. They understood the risks very clearly. Postmodern entertainment had essentially brought the long-promised society of control by way of simulation; nothing late about this capitalism. Power used entertainment to appear user-friendly, but it was as brutal as mid-nineteenth-century capitalism. The heritage of the eighteenth-century Enlightenment dissolved. Even in major cities, five-hundred-year distinctions between public and private identity mostly disappeared. And inside the old NATO alliance, the Euro-American nation state is dissolving into electronic feudalism.

Other than that, global coffee tasted better and labor was cheap. As a trade-off, it was the golden age of home entertainment; and an olympian moment for good medication. Most of all, it is a tragi-comedy. A hundred years from now, children will dress as Americans for Halloween. In the U.S., despite political agonies, the collapse was ergonomic. It turned degeneration into media theater. It made special-effects movies about unearthly exploitation. Americans were almost cheerfully colonized by their own economy; but the result was as brutal and clumsy as a field surgeon sawing off limbs during the Civil War.

Even now, the cultural damage is mostly ignored (the shock to film, literature, theater, the fine arts, architecture, philosophy). From cable news to blogs to print, the cultural criticism also tends to be unfocused (even with the Bush era ending). I often call this moment "trying to scream while inside the stomach of the dragon." Our material culture has been anesthetized on a scale that crusader popes and fascist dictators would have envied.

EPIC CONFUSIONS

A cultural "history of the present" has a unique narrative structure as well – as unique as movies, games, architecture. It is an epic form, but not as Brecht meant epic. For example, during the mid-eighties, we walk into a themed mall, something new at the time. Then we visit the early Microsoft campus, or Xerox Parc. These are key sites for history of collective amnesia, tools that reposition the viewer, but also manipulate the viewer. Thus, is it any surprise that their story would not fit movie drama, or old melodrama? They are walk-through pilgrimages into the global economy. They are electronic Baroque theater – closer to epic in the seventeenth-century sense than in the Brechtian sense. Is it a surprise, in any way, that dramatic narrative (that nineteenth-century form) would find no fertile ground here? An electronic Baroque mode of epic storytelling emerges instead, particularly in films that rely increasingly on the branding tools of this new capitalism: digital imaging.

That same week (circa 1984 or 1986), we go to special-effects movies. Almost immediately, we sense parallels between global business and digital effects about alien invasions or cyborgs. We find shared tropes between f/x films and digitized power, and social imaginaries about war and the city. We study the software of Evans and Sutherland by 1996, for the military, for the Bosnian war; then compare it to the programs used for para-military fantasies in a movie like *Judge Dredd*. The similarities are startling.

Most of all, the scale is altogether different. Instead of giganticism, power is centered on bio-engineered microcosms. It is a nano system of increasing power. Each generation of new software points toward an ultimate nano dot. This has been steady, inevitable since the early eighties. Does it matter all that much, if Dubai or Singapore build high-rises that touch the moon? The future increasingly suggests an endless line more than a circle, or an evolution.

Eventually, we discover a point of origin for that line, for our era – 2008. But the spirit of this line is aporia – to drift on a road that seems impossible to name. It is entropic present. We live like aging child stars, constantly getting ready for another adolescence. Of course, my generation of the sixties invented many of these mental confusions. I do not feel that I have any moral high ground, only that I want to offer tools for this anti-future. I am convinced that we are heading toward a new structuralism, a new mode of 1890s' modernity, but without the modern, without the industrial heritage, without the Enlightenment, even without the vertical structure. I have enormous confidence in the generations emerging today. The potential is colossal; and the comic failures will be colossal as well.

WILL YOU FORGET THAT FOR ME?

Clearly, *all* civilizations, not simply ours, are defined by how they train us to forget. Something gigantic and hairy, a thousand meters wide, is standing literally two feet in front of us. It roars for our attention, but we look right through it. We have filtered it out.

Let us imagine a brief history of how systems in the past have engineered forgetting. Fifty examples are raced past us, from biblical to industrial. The camera tracks through Catholic churches, then cuts to woodcuts of heretics on fire, photos from Nuremberg rallies, and of stupid wars and lopsided governments. As an agonizing last straw, Bush waves goodbye to a few evangelical diehards. Meanwhile, the deep voice-over quotes philosophers about power since Hobbes. We've heard this already.

Then we look out the window, or at an iPhone. Clearly, all these new gadgets are ruining our memory in a different way, waltzing through our brain. Over the past thirty-five years, a new kind of memory filter has changed us incredibly, certainly in the West and East Asia.

For decades, I have been obsessed with understanding how this filter works, how collective amnesia and distraction operate today. Clearly, forgetting relies on inversions, where mental pictures utterly reverse, until at last their original place cannot be remembered. For example, in our economy, public life exists primarily at home. The "inner" city, despite its massive poverty, is being redesigned as a tourist suburb. Even voting is now reluctantly understood as a consumer act. And consumers tend to perform in scripted spaces – outwardly friendly spots, but engineered in a strange way, to encourage the myth of free will in a world of absolute predestination. The new models for collective memory do not suggest democracy.

I am studying the future of cities as suburbanized urbanism takes over; and as the public sector vanishes into a kind of urban feudalism in many cities. I watch the shift in global capital, as we all do. I watch the cross-coding of home entertainment with older forms (literature, theater, music, cinema, architecture). I try to learn to see less in order to map the nano logic that is coming so quickly (the miniaturized scale of power).

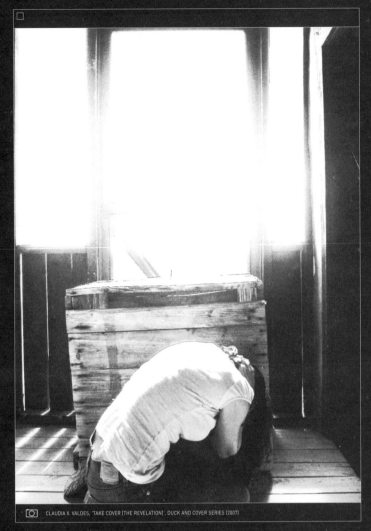

Like the nano, in this cool, polished endless present, we will probably turn increasingly toward very localized forms, to feel intact. As vertical systems corrode, as oversight becomes impossible, the local may be the best form of the global. Perhaps that explains why we cannot easily consolidate our history of the present. Instead of a vertical story, we find culture in a hundred thousand places that barely notice each other.

There is indeed nostalgia for the older forms, of course. That is standard in all civilizations. In major Western cities, we are experiencing a gothic revival – of the industrial city of the early twentieth century. But this is merely a way to erase the industrial memory, to distract it (as the Gothic Revival of 1890 erased what remained of the medieval world).

In our civilization, seemingly omniscient search engines seem to protect our past. But in fact, inside these systems, historical memory is often as good as lost, like a picturesque photo of a pestilence or a world war. Barbarian hordes could not have burned that memory to ground any more thoroughly. And we are even cheerful in our collective amnesia. What's past is past. We prefer horizontal niches, globalized localism.

The age of industrial master planning is also gone. No more world wars and gigantic dams. Perhaps international master planning for global warming will be possible. But for the most part, attempts to revive master planning seem nostalgic. Many in the West even look with envy at China's perverse national government, because it does not seem crippled by nuance. It is blunt; and blunt gets the dams built. Of course, that is pure fantasy on our part.

TENTATIVE CONCLUSION

It is difficult to imagine how to complete an argument that is an aporia, about an age obsessed with never quite beginning, dominated by localized and recycled histories, each set relentlessly in the present. If plastic surgeons keep you eternally young, if your carbon-based form of life turns to silicone, how does your drama get to the third act?

Perhaps we should begin with a different kind of essay altogether, end with a new first paragraph; but with a more hopeful argument. On the negative side, it is true that "the history of the present" (as Foucault and others imagined it) implies new forms of social control. Media controls us. Branding controls us. We enjoy locking ourselves into the program, then forgetting the password. That paranoiac present was essential to the discourse of the seventies, where our genealogy, our picaresque essay begins.

But increasingly, I notice a second meaning to histories of the present. They often suggest new ways to observe the present honestly. By that I mean: appreciating the sense of decay and confusion without flinching. I like to imagine that this honest version of the present was obvious already in the eighties and nineties, during the dislocations of post-colonial and post-structural civilization. I sensed a disappearance of that critique, during the salad days of the nineties, essentially before the shocks of 1997; and before 9/11; before the global economy achieved a full take-off in Asia. Now, of course, the global crises force us to take stock again, and quickly. That "honest" version should point toward new forms of criticism and narrative, despite how sluggish our institutions of culture are today.

For example, in the Renaissance, Italian sea powers sensed their inevitable decay – honestly – as economies turned toward Atlantic trade. In the Baroque era, playwrights such as Calderón in Spain became obsessed with its relentless decline. In the industrial era, French painters and writers after 1871 were equally obsessed with *memento mori*, as France steadily lost ground to Germany.

In the Edwardian age, even as early as 1895 surely, British writers continually refer to the inevitable decadence of Britannia. In the 1920s German writers, dramatists, painters and filmmakers felt the dust on their tongues, the slide toward oblivion.

What do all these moments share in common? They each delivered cultures obsessed with engagement, with momentary change. And they each experienced golden ages. Perhaps the history of the present is merely a sign of cultural shock that is healthy. Perhaps it is a kind of honesty, a perverse answer when the future ceases to offer much promise. It is a picaresque journey that is humanizing. That present I surely welcome.

As the Bush era comes to an end, let me be among the first to look forward to Huckleberry Finn, to attempts at fierce honesty about a world that must face its mortality. "Change" is not jingoism; it is surgical ferocity, a piercing look at your moment. We may be culturally achieving that in a very bizarre way, like a newly rebuilt eighty-year-old, where the machine works fine, but the brain still goes through a senior moment. Who said bizarre can't be fierce, and honest?

The generation born essentially in 1880 was forced into histories of the present, into ferocious objects – becoming modernists by necessity more than as avant-garde rebels. I teach many students born around 1980. They have some of that same anxiety. And they are utterly aware that this civilization has tampered with their memory. I vote for them. I believe they might perform miracles. Why not conclude on that note?

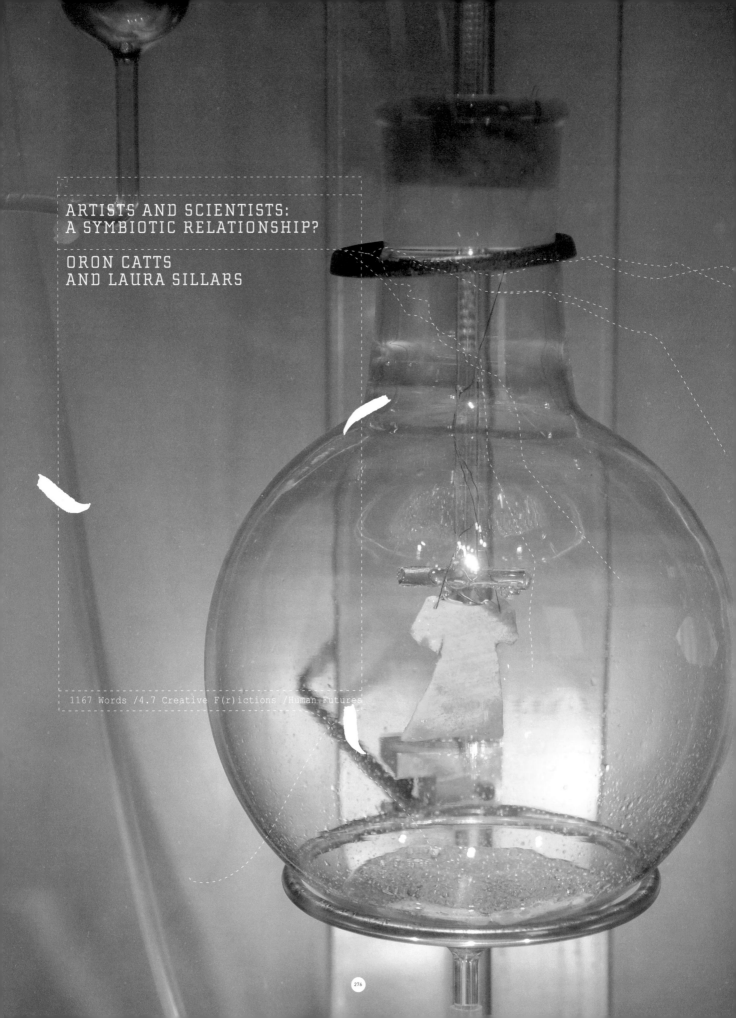

ARTISTS AND SCIENTISTS:
A SYMBIOTIC RELATIONSHIP?

ORON CATTS
AND LAURA SILLARS

1167 Words /4.7 Creative F(r)ictions /Human Futures

LS: When we last talked you were concerned with the question of what happens to our concept of the human body when it extends beyond its original context.

OC: I have been thinking and writing about the whole notion that we can maintain and sustain the human body outside of the original context of the *whole* body.

LS: So, you mean, through creating an artificial biological environment we are able to sustain life (cells and tissues) without the same sort of 'life' that we see in a living human? And so what does this do to our concept of what it is to be human?

OC: We can merge different fragments of other bodies (human or otherwise), therefore every body can be seen as potential fragments, waiting to merge. This is not just experimental or metaphorical; it is happening, with a complex economy already developing around it. These bodies are becoming persistent producers, in the way that anti-bodies production, when cell (sometimes emortilased by fusing them with mouse cancer cells – hybridomas – and sometimes by using modified human and animal cells). We can use tissues for non-medical ends such as muscle actuators or in-vitro meat.

LS: Could you expand on this idea of *persistent producers*?

OC: We think of persistent producers in agricultural husbandry – the living female animal body produces milk and eggs and the living male body produces sperm. In this new biological context we can harvest tissue, and we move away from the body as an ecology out of which we can collect eggs or milk and towards one in which every part of the body can be a producer – in the sense that we can replicate it – so fragments of the body can be seen as persistent producers.

LS: And how do these fragments work?

OC: Tissue culture has traditionally been a metonym, standing in for the whole. So, when you do an experiment on one piece of tissue you extrapolate what it can do for the whole. In actual fact, it doesn't work like this because the tissue on a micro-level works differently compared with the macro-level. By removing tissue from the whole body you create something new. The fragment does not behave in the same way that it would if it were part of the body – the techno-scientific body or the surrogate is the environment in which the fragment can grow outside of the body.

LS: So, what you're saying is that, even though this artificial biological environment provides the conditions the human body would organically produce to keep tissues alive, they are not quite the same and do not replicate like-for-like all of the complexity of what it is to be part of the whole body organism? But tissue culture is not a new thing – so what makes this more problematic now?

OC: The newness in this case is what happens with organized tissue and in particular when you start working with tissue such as nerve and bone (some forms of bone tissue are very similar to nerve cells which respond to stimuli and can transmit information). Here we are starting to look at the potential for a new kind of sentience – a biological system that responds outside of its original body. The development of such a sentient fragment is still at a very early stage but, as an indicator of the future, there is a potential ethical challenge.

LS: You're suggesting that, in the near future, we may be able not only to mix and match body parts, but to make those new bodies thinking, feeling bodies. What does this mean for the future of what we currently understand as human?

OC: It has massive ramifications. It means that we're in the process of assessing the concept of who we are – and historically this concept of identity has been rooted in the idea or notion of individuality.

LS: And now that this biological individuality is being broken down through the fragmentation of the body, this individuality is being lost?

OC: There is no sense of individuality, body or even species – in fact it means that there is no sense of separation between the idea of the human and nature. We are at a crisis point, which we have brought upon ourselves through the process of breaking down nature and bodies. There are two ways of reading this. On one level, it brings us closer to life around us – we're on a more equal playing field with all other life forms because our body can be fragmented as can any other life form and it can re-merge – which can be seen as a technologically driven, new age idea – we're all at one! However, we are still the manipulators. The concept of post-anthropocentrism comes out of this. We can't simply focus on the human any more. However, we cannot be totally anti-anthropocentric, as we have to deal with the fact that we are responsible for the breakdown of borders between the human and the other.

LS: If the first way of looking at this is a picture of us all disintegrating into the environment, then what's the second way of looking at this?

OC: The flip side of this would be the instrumentalization of life. Those same economic forces would drive the commodification of life in an even more extreme way.

LS: Do you think this has already happened?

OC: Yes.

LS: And what is the role of the artist in all of this?

OC: Most of the other people who are involved in this kind of work are driven by a very utilitarian, instrumental point of view. They are looking at life as a tool rather than seeing any life as having an intrinsic value.

LS: 'How can I cure cancer?'

OC: Or 'How can I make money?'! When scientists are fragmenting bodies they are not really concerned with these questions – they are concerned about what this can do for the production of knowledge and the production of wealth. This is why we need artists. Artists are able to critique, while working with the materials. Artistic practice, as well as being conceptual, is engaged – we're not working from the sidelines like philosophers and ethicists, who are essentially watching it from afar.

LS: This primacy is central to your work, then – a first-hand experience of the techniques and tools of a scientist – you run a lab, you know the materials.

OC: I don't see myself as a scientist in any way. I am using scientific tools but I don't follow scientific methodology. But I want to see how your perception of life changes when you are so close to the materials and for my practice I want to be implicated in that.

LS: So you're a peer – not an outsider – a co-conspirator.

OC: As well as a critical interventionist.

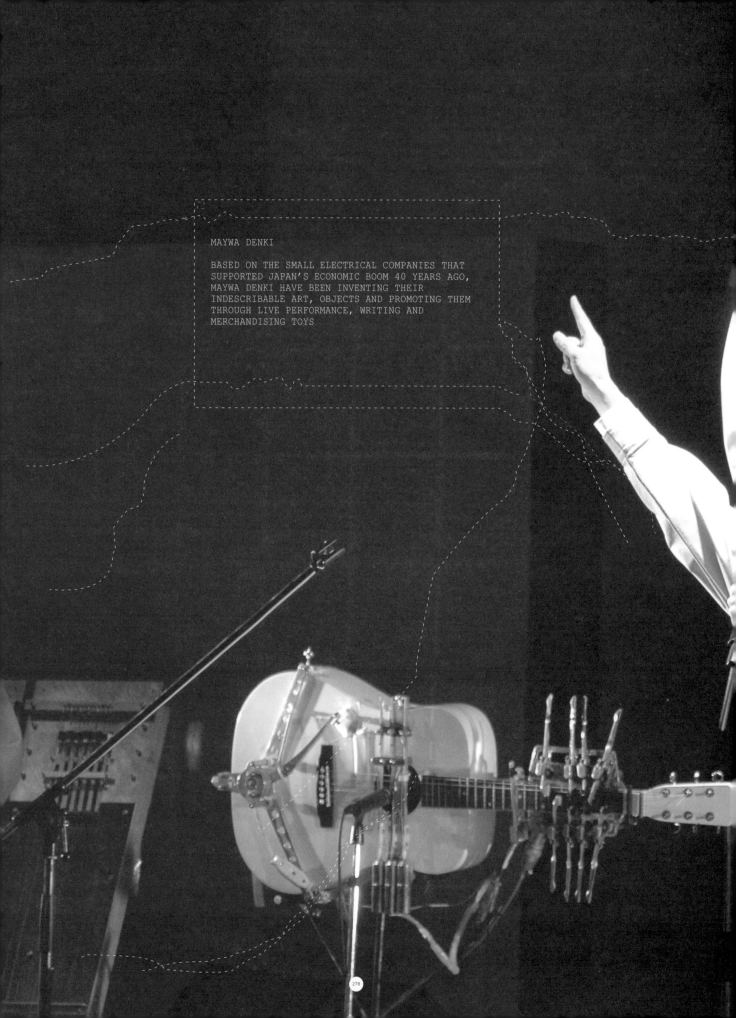

MAYWA DENKI

BASED ON THE SMALL ELECTRICAL COMPANIES THAT
SUPPORTED JAPAN'S ECONOMIC BOOM 40 YEARS AGO,
MAYWA DENKI HAVE BEEN INVENTING THEIR
INDESCRIBABLE ART, OBJECTS AND PROMOTING THEM
THROUGH LIVE PERFORMANCE, WRITING AND
MERCHANDISING TOYS

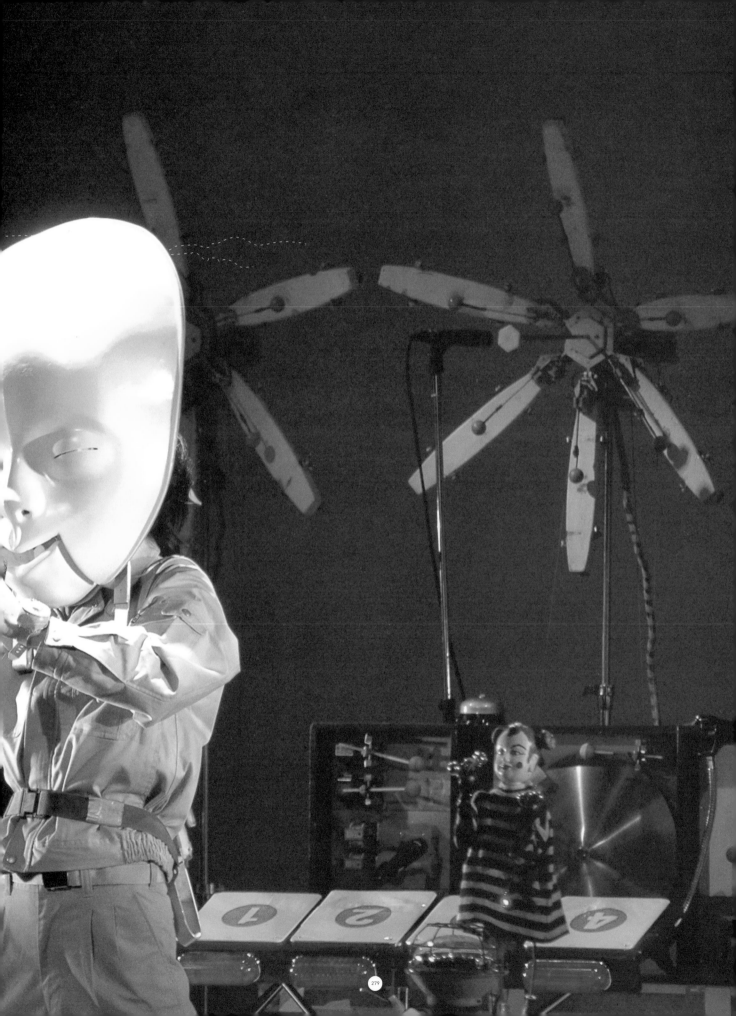

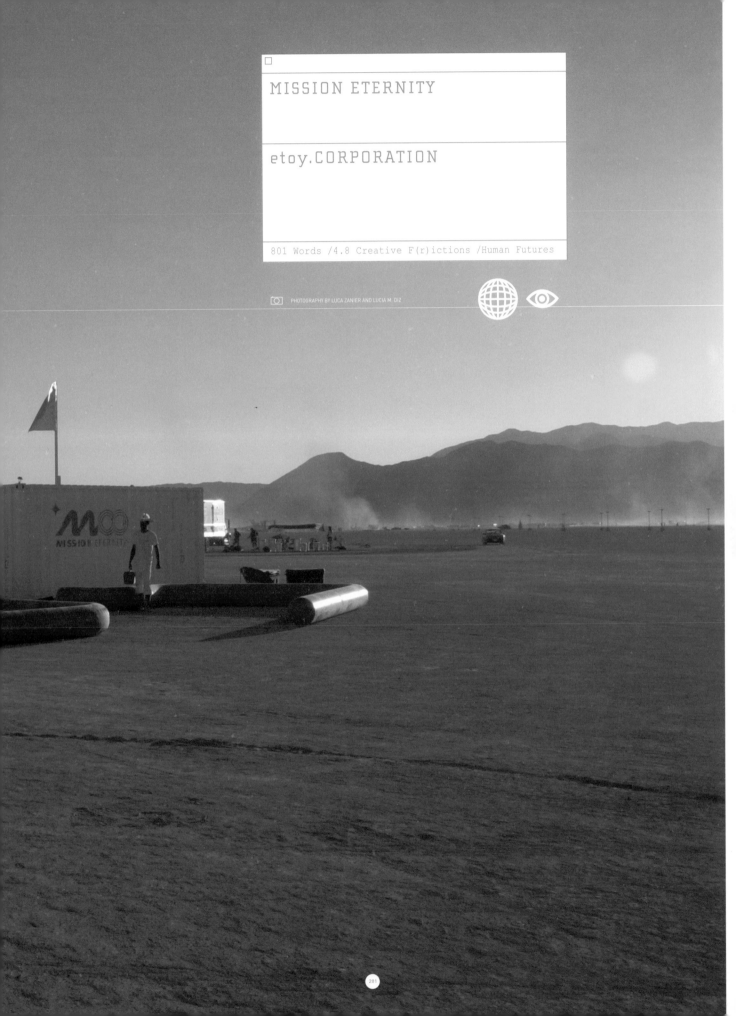

MISSION ETERNITY

etoy.CORPORATION

801 Words /4.8 Creative F(r)ictions /Human Futures

PHOTOGRAPHY BY LUCA ZANIER AND LUCIA M. DIZ

MISSION ETERNITY is an information technology-driven cult of the dead created by the art group etoy. etoy.CORPORATION digitally sends M∞ PILOTS across the ultimate boundary to investigate the afterlife, the most virtual of all worlds. Currently _____[1] registered users build a community of the living and the dead that reconfigures the way information society deals with memory (conservation / loss), time (future / present / past) and death. Under the protection of thousands of M∞ ANGELS (the living) the M∞ PILOTS (the dead) travel space and time forever.

Independent of religious beliefs and scientific speculations, MISSION ETERNITY explores life after death. The operation is based on present-day facts: we all leave behind mortal remains and a massive body of information. The dead continue to exist as biomass and traces in the global memory: in governmental databases, in family archives, in professional records, and in emotional data stored as electrical impulses in the bio-memory of our social network (memories in the brains of friends and family).

etoy exploits computer technology to store and process human remains and traces forever. The goal is to develop and distribute a peer-to-peer software named M∞ ANGEL-APPLICATION http://angelapp.missioneternity.org/

and combine open data formats with extensive documentation to create media art that will survive future computer system updates and back up technologies. With this project, etoy questions the role of storage technology, archiving strategies and loss in the digital age. Decay, afterlife, and the gap between generations are at the centre of etoy's focus.

At the heart of MISSION ETERNITY stands the creation and ultra-long-term conservation of M∞ ARCANUM CAPSULES, interactive portraits and digital communication systems for human beings facing death (M∞ PILOTS). The M∞ ARCANUM CAPSULES reside in the MISSION ETERNITY SARCOPHAGUS and contain digital fragments of the life, knowledge and soul of the users and enable them to design an active presence post mortem: as infinite data particles they forever circulate the global infosphere – hosted in the shared memory of thousands of networked computers and mobile devices of M∞ ANGELS, people who contribute a part of their digital storage capacity to the mission.

The interior of the SARCOPHAGUS is equipped with an immersive LED display of 17,000 pixels that cover the walls, ceiling and floor on which the visitors can walk. With their mobile phones, touch screens or web browsers users interact with the digital remains of the MISSION ETERNITY

PILOTS, contained within the M∞ ARCANUM CAPSULES. The Multi-user sarcophagus is the place where the living call and reactivate the dead. Info-ghosts made of digital fragments appear visually and talk to the audience. The goal is to create a community of the living and the dead. All MISSION ETERNITY DISPLAYS are based on low-resolution images; 32 by 32 pixels form screens of 2 by 2 meters on which visual fragments appear. This aesthetic decision is a strategy to avoid misunderstandings: MISSION ETERNITY is about memory. The Project is not about cloning life in cyberspace or about freezing bodies.

To remember is as much about forgetting as it is about storing data.

MISSION ETERNITY plays with distance, loss, focus and the human brain's capacity to compensate missing parts of individual faces. Resolutions change. The veil that separates the here from the beyond is a veil of pixels. Some data particles might cross the deadline, whereas others remain as traces in the global memory. From here, we cannot know which particles cross the deadline, whether the human conscience lifts off or dissolves, nor what it looks like beyond. Loss is intimately connected to death. Crossing the ultimate deadline is

a one-way move. A nebulous representation of former life, in varying shades of light, adequately reminds us of what has gone. Memory and afterlife is about interpolation. The pixel images allow the brain to project, refill and expand.

Dr Timothy Leary qualified as a test-pilot with his reputation as a pioneer of the information age, and his last book *Design for Dying* (1997), published one year after he passed away on 31 May 1996 at the age of 75. He left etoy a massive body of digital remains and 32 grams of his ashes for MISSION ETERNITY experiments. In May 2007 a first technical test and ceremony took place in Zurich: 8 grams of the ashes of Timothy Leary were mixed with concrete and inserted into a mould. This plug stores the mortal remains of the first PILOT. Several hundred pilots will follow within the next 10 years. The ritual art object – called MISSION ETERNITY TERMINUS – becomes the last resting place of each PILOT and serves as her/his access point after physical death and cremation. It links tangible and non-tangible aspects of existence; biomass and data.

This is just the beginning of an infinite voyage.

The key to the long-term project is TIME.

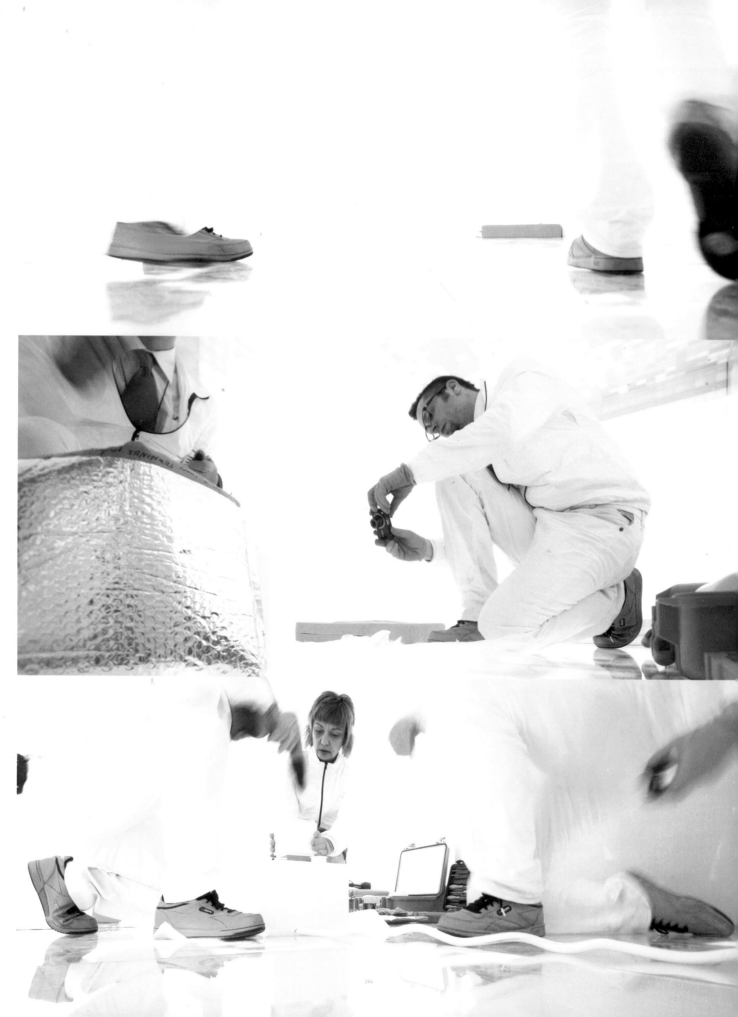

TO REMEMBER IS AS MUCH ABOUT FORGETTING
AS IT IS ABOUT STORING DATA

TO REMEMBER IS AS MUCH ABOUT FORGETTING
AS IT IS ABOUT STORING DATA

END MATTER

GEORGE J. ANNAS

George is the Edward R. Utley Professor and Chair of the Department of Health Law, Bioethics & Human Rights of Boston University School of Public Health, and Professor in the Boston University School of Medicine, and School of Law. He is the co-founder of Global Lawyers and Physicians, a transnational professional association of lawyers and physicians working together to promote human rights and health. He is the author or editor of 17 books on health law and bioethics, including *American Bioethics: Crossing Human Rights and Health Law Boundaries* (2005), *The Rights of Patients* (3rd ed. 2004), *Some Choice: Law, Medicine, and the Market* (1999), *Standard of Care: The Law of American Bioethics* (1993), and *Judging Medicine* (1987), and a play entitled *Shelley's Brain*. He is a fellow of the American Association for the Advancement of Science, a member of the Institute of Medicine, and co-chair of the American Bar Association's Committee on Health Rights and Bioethics (Individual Rights and Responsibilities Section).

WILLIAM SIMS BAINBRIDGE (AKA CATULLUS)

William has published 14 books, 4 textbook-software packages, and 200 articles on technology, information science and culture. After editing *The Encyclopedia of Human Computer Interaction* (2004), he wrote *God from the Machine* (2006), *Across the Secular Abyss* (2007) and *Nanoconvergence* (2007). He has served on five advanced technology initiatives: High Performance Computing and Communications, Knowledge and Distributed Intelligence, Digital Libraries, Information Technology Research, and Nanotechnology.

DAVID J. BENNETT

David has a PhD in biochemical genetics and an MA in science policy studies with long-term experience, activities and interests in the relations between science, industry, government, education, law, the public and the media. He works with the European Commission, government departments, companies, universities, public interest organizations and the media in these areas, having worked in universities and companies in the UK, USA, Australia and, most recently, The Netherlands. He is a member of numerous international organizations and committees in biotechnology and nanobiotechnology, and for the last nearly twenty years has coordinated and managed many European Commission projects in this field. He is now a Visitor to the Senior Combination Room at St Edmund's College, University of Cambridge, Guest at the Kluyver Laboratory for Biotechnology of the Delft University of Technology, Secretary of the European Federation of Biotechnology (EFB) Task Group on Public Perceptions of Biotechnology and Director of Cambridge Biomedical Consultants Ltd.

RUSSELL BLACKFORD

Russell teaches in the School of Philosophy and Bioethics at Monash University, where he is completing his second PhD. He is a Fellow of the Institute for Ethics and Emerging Technologies and editor-in-chief of *The Journal of Evolution and Technology*.

SIR DRUMMOND BONE

Drummond was Vice-Chancellor of the University of Liverpool from 2002 to 2008 and President of Universities UK from August 2005 to August 2007. Previously he was Principal of Royal Holloway and Bedford New College, University of London and Pro-Vice Chancellor of the University of London. He is now a consultant on HE matters with a major role advising Laureate Inc. He has been asked by HM Government to report on National Policy on HE Internationalisation. During the run up to the City of Liverpool's year as European Capital of Culture he chaired the Culture Company responsible for the year's cultural activities. He is Chairman of FACT (Foundation for Art and Creative Technology), of the UK Library Research Reserve Project, and President of the British and Irish Association of Zoos and Aquaria. In the 2008 Queen's Birthday Honours List he received a knighthood for his services to higher education and the regeneration of the north-west of England.

HEATHER BRADSHAW

Heather is working on a thesis on enhancement and disability at the Centre for Ethics in Medicine at the University of Bristol. She is a staffer at the Uehiro Centre for Practical Ethics at the University of Oxford, where she is currently managing the editing and publication of a collection of essays on wisdom in Western and East-Asian culture. She recently published a short story in *Nature*.

NIGEL CAMERON

Nigel is President of the Center for Policy on Emerging Technologies in Washington, DC, and Research Professor in the Illinois Institute of Technology (IIT), where he has been Director of the Center on Nanotechnology and Society and co-founded the Institute on Biotechnology and the Human Future. His books include *The New Medicine: Life and Death after Hippocrates* (1991), and he has edited *Nanoscale: Issues and Perspectives for the Nano Century* (2007). He has been a visiting scholar at UBS Wolfsberg in Switzerland, and a featured speaker at the Aspen Ideas Festival. He serves on the advisory boards of Nanotechnology Law and Business, the Converging Technologies Bar Association, and the World Healthcare Innovation and Technology Congress. He chaired the Technosapiens process that brought together leading liberals, conservatives, and technology leaders with transhumanists, and gave a keynote address at the 2006 Stanford Law School conference on enhancement technologies and human rights. Nigel has represented the United States on delegations to the United Nations General Assembly and UNESCO, and testified before the European Parliament and the US Congress...

CATULLUS

Catullus is a level 70 Blood Elf priest, a member of the Alea Iacta Est guild, and chief sponsor of the first scientific conference to be held inside World of Warcraft. Several times a week, this hero undertakes fully a dozen advanced quests in rapid succession, a real labour of Hercules, to earn gold for the costs of the conference. Having been thoroughly educated, from Silvermoon to the Sunwell, mastering fully six professions, and having completed many advanced research projects, his publishing career is ready to begin. Although the Gnomes and the Draenei have scientific pretensions, the Blood Elves are of course the most scientifically advanced of the ten races, and Catullus is the most brilliant of them all.

ORON CATTS

Oron is an artist, researcher and curator and co-founder and Director of SymbioticA, School of Anatomy & Human Biology, University of Western Australia. SymbioticA - The Centre of Excellence in Biological Arts is dedicated to the research, learning and critique of the life sciences and enables artists to engage in wet biology practices in biological laboratories. SymbioticA was awarded the inaugural Prix Ars Electronica Golden Nica in Hybrid Art (2007). Oron was a research fellow at Harvard Medical School. He exhibited and presented his award-winning work (mostly under the banner of The Tissue Culture & Art Project) and SymbioticA's research internationally at institutions including New York's MoMA, Ars Electronica, National Gallery of Vitoria, Tate Modern and elsewhere. Oron also runs workshops and is a sought-after speaker in international forums and symposia.

DUNCAN DALLAS

Duncan gained a degree in chemistry from Oxford University before joining the BBC in 1964. He then moved over to Yorkshire Television (YTV) in 1968, and became the Head of Science and Features. In 1992 he left YTV and started an independent production company, XYTV, which produced science programmes for the BBC, Channel 4 and ZDF in Germany. In 1998 he created the concept of *Café Scientifique* in a wine bar in Leeds, advertising it as: 'a place where, for the price of a cup of coffee or a glass of wine, people can meet to discuss the latest ideas of science and technology which are changing our lives'. In 2001 he won an Impact Award from The Wellcome Trust to set up science cafés in cities throughout the UK, and there are currently 36 'Cafés' across the UK and over 250 worldwide.

ANTHONY DUNNE

Anthony is Professor and head of the Design Interactions department at the Royal College of Art in London. He studied Industrial Design at the RCA before working at Sony Design in Tokyo. On returning to London he completed a PhD in Computer Related Design at the RCA. He was a founding member of the CRD Research Studio where he worked as a Senior Research Fellow (1996-2001). He also taught in Design Products where he jointly led Platform 3 between 1998 - 2004. Dunne & Raby was established in 1994. Their projects have been exhibited and published internationally and are in the permanent collection of several museums including the MoMA, New York, FRAC, FNAC and the V&A Museum, London. Dunne & Raby have worked with Sony UK, National Panasonic, France Telecom and The Science Museum. They have published two books: *Design Noir: The secret life of electronic products* (Princeton Architectural Press) and *Hertzian Tales* (The MIT Press).

etoy.CORPORATION

etoy.CORPORATION (since 1994) is art and invests all resources in the production of more art. The shareholder company represents the core and code of the corporate sculpture. It controls, protects, shares, and exploits the cultural substance (intellectual property / etoy trademarks) and the etoy.ART-COLLECTION. etoy intends to reinvest all financial earnings in art - the final link in the value chain.

STEVE FULLER

Steve is Professor of Sociology at the University of Warwick. He is best-known for his work in the field of 'social epistemology', which addresses normative philosophical questions about organized knowledge by historical and social scientific means. His most recent work has focused on the future of the public intellectual and the university, as well as the biological challenge to the social sciences, especially as it bears on the future of 'humanity' as a category in terms of which we define ourselves. Fuller is the author of 15 books, including *The Knowledge Book: Key Concepts in Philosophy, Science and Culture* (Acumen and McGill-Queens, 2007), *New Frontiers in Science and Technology Studies* (Polity, 2007), *Science vs Religion?* (Polity, 2007) and *Dissent over Descent: Intelligent Design's Challenge to Darwinism* (Icon, 2008). He is the UK partner of the European Union's Sixth Framework Project on the 'Knowledge Politics of Converging Technologies'.

JANE GRANT

Jane is an artist who works with film/video, sound, installation and drawing. She works both individually and collaboratively with scientists and musicians. She has been working with neurological time patterns and the human voice for a some time and was awarded an AHRC (Arts and Humanities Research Council) grant to make work which merges firing patterns of artificial spiking neurons with the human voice and breath. This work forms the audio part of the film and sound installation entitled *Threshold* shown in Just World Order at Artsway, UK. Recent exhibited works have included *Untitled (Room)*, with John Matthias, in the Sonic Arts Network Expo 2007 and *Nothing is Further* in the Voices III Festival in Plymouth 2008 and *Running Piece* in MUTICHANNEL at Artsway. She has exhibited widely including one-person shows at Spacex Gallery and Still at Chapter, Cardiff. Other exhibitions include *Kissing the Dust* at Walsall Museum and Art Gallery and *Aufsteigen* in Germany funded by the British Council.

RICHARD A. L. JONES

Richard was educated at Cambridge University, with a first degree and a PhD in physics. After postdoctoral work at Cornell University, he was appointed as a lecturer at the Cavendish Laboratory, Cambridge University. In 1998 he moved to Sheffield University, where he is a Professor of Physics. In 2006 he was elected a Fellow of the Royal Society. He lives in Derbyshire, is married and has two young children. He is an experimental physicist, whose research centres around the properties of polymer molecules at interfaces and ultrathin polymer films. He is currently the Senior Strategic Advisor for Nanotechnology for the UK's Engineering and Physical Sciences Research Council.

SANDRA KEMP

Sandra is Head of the London College of Communication, University of the Arts, London. She was formerly Director of Research at the Royal College of Art. She gained her B.A. and D.Phil at Oxford University, and has held senior research posts at the Smithsonian Institution, Washington and the Victoria and Albert Museum, London. Sandra Kemp's research has always explored the connections between individual identity and philosophical, cultural and aesthetic concerns. Her recent work investigated multiple readings of the face as a 3D barcode of identity and the impact of advances in science and technology on both appearance and identity. Her exhibition Future Face was shown at the Science Museum, London, from 2005-6, and toured Southeast Asia in 2006-7. Her current research continues her investigation of the cultural centrality of the human image and its extraordinary expressive repertoire through an exploration of the issues relating to human enhancement.

NORMAN M. KLEIN

Norman is a cultural critic, and both an urban and media historian, as well as a novelist. His books include *The History of Forgetting: Los Angeles and the Erasure of Memory*, *Seven Minutes: The Life and Death of the American Animated Cartoon*, and the data/cinematic novel, *Bleeding Through: Layers of Los Angeles, 1920-86* (DVD-ROM with book). His next book will be *The Vatican to Vegas: The History of Special Effects* (2003). His essays appear in anthologies, museum catalogues, newspapers, scholarly journals, on the WWW – symptoms of a polymath's career, from European cultural history to animation and architectural studies, to LA studies, to fiction, media design and documentary film. His work (including museum shows) centres on the relationship between collective memory and power, from special effects to cinema to digital theory, usually set in urban spaces; and often on the thin line between fact and fiction; about erasure, forgetting, scripted spaces, the social imaginary.

JOHN MATTHIAS

John is a composer, musician and physicist and is lecturer in Sonic Arts at the University of Plymouth. He has released three albums, *Smalltown, Shining* (Accidental Records 2001), *Stories from the Watercooler* (Ninja Tune/Counter 2008) and *Cortical Songs* (with Nick Ryan) (Nonclassical 2008) and has worked with many recording artists including Radiohead, Matthew Herbert and Coldcut. He is the winner (with Jane Grant and Nick Ryan) of the 2008 PRS New Music Award and his research interests include the new subject of Neuronal Music Technology. He has also contributed as a violinist to the sound of many albums, television programmes and two feature films. He also plays in the band, Derailer with David and Andrew Prior.

RUUD TER MEULEN

Ruud is a psychologist and ethicist. He is Chair for Ethics of Medicine and Director of the Centre for Ethics in Medicine at the University of Bristol. He has been working on a broad range of issues in medical ethics, particularly issues of justice in healthcare, ethical issues of healthcare reform and health policy, ethics of evidence-based medicine, ethical issues of long-term care and ethics of research and research ethics committees. Ruud has directed several international projects and was principal co-ordinator of a range of European projects. He was the principal coordinator of the ENHANCE project, funded within the Sixth Framework Program of the European Commission, dealing with the ethical, philosophical and social issues of enhancement technologies.

ANDY MIAH

Andy is Reader in New Media and Bioethics at the School of Media, Language and Music at the University of the West of Scotland, a Fellow at the Foundation for Art and Creative Technology (FACT) and a Fellow of the Institute for Ethics and Emerging Technologies. He has a PhD in bioethics and cultural studies and a Masters degree in medical law. He is author of *Genetically Modified Athletes* (2004 Routledge) and co-author with Emma Rich of *The Medicalization of Cyberspace* (2008, Routledge). He is a Steering Committee member and Panel Co-Chair for ISEA 2009, Belfast.

PRAMOD K. NAYAR

Pramod teaches at the Department of English at the University of Hyderabad, India. He is the author of *Virtual Worlds: Culture and Politics in the Age of Cybertechnology* (Sage, 2004), *Reading Culture: Theory, Praxis, Politics* (Sage, 2006), besides work on colonial discourse (*English Writing and India, 1600-1920: Colonizing Aesthetics*, Routledge, 2008) and postcolonial literature (*Postcolonial Literature: An Introduction*, Pearson, 2008). Forthcoming work includes essays on human rights narratives from India, and books on celebrity culture, cultural studies and cyberculture.

MARILÈNE OLIVER

Marilène was born in the UK in 1977. Marilène has exhibited widely in the UK and Europe in both private and public galleries including the Victoria and Albert Museum, Royal Academy, Royal Institution, Science Museum (UK) and Frissarias Museum (Greece) and Kunsthalle Ahlen (Germany). She has had a number of solo shows in Europe. She was awarded the Royal Academy print prize in 2006 and the Printmaking Today prize in 2001. Her work is held in a number of private collections around the world as well as a number of public collections such as the Wellcome Trust and the Victoria and Albert Museum. Marilène is currently completing a practice-based MPhil in Fine Art Print at the Royal College of Art, London.

SIMONE OSTHOFF

Simone is Associate Professor of Critical Studies at the Pennsylvania State University. She holds a Ph.D. in Media and Communications from the European Graduate School in Switzerland, an M.A. degree in Art History, Theory, and Criticism from the School of the Art Institute of Chicago, and an M.F.A. degree from the University of Maryland. She is a member of the Leonardo Review panel since 2000. Her many interviews, essays, and book chapters focusing upon contemporary art have been translated into eight languages and included in among others, various MIT Press and Routledge books as well as in international art magazines and web publications. She received a Fulbright Fellowship in 2003, and is a frequent lecturer in the United States and abroad having participated in dozens of conferences worldwide.

KATE O'RIORDAN

Kate is a Senior Lecturer in Digital Media and Film at the University of Sussex, and co-director of the Centre for Digital Material Culture. She is also an affiliate member of the Centre for the Economic and Social Aspects of Genomics (CESAGEN), at Lancaster University. Her research is in cultural studies of science and technology, engaging with forms of mediation, and collective and individual identities. She has published widely in these areas, including *Human Cloning in the Media: From Science Fiction to Science Practice* (Routledge, 2007), and *Queer Online: Media Technology and Sexuality* (Peter Lang, 2007).

FIONA RABY

Fiona is a partner in the design practice Dunne & Raby. She was a founding member of the CRD Research Studio at the Royal College of Art where she worked as a Senior Research Fellow (1996-2001). She taught in Architecture at the RCA from 1996-2005 where she led ADS04 with Gerrard O'Carroll. She currently teaches in Design Interactions. Dunne & Raby were established 1994. Their projects have been exhibited and published internationally and are in the permanent collection of several museums including the MoMA, New York, FRAC, FNAC and the V&A Museum, London. Dunne & Raby have worked with Sony UK, National Panasonic, France Telecom and The Science Museum. Design Noir: The Secret Life of Electronic Products (Princeton Architectural Press) was published in 2001.

NICK RYAN

Nick is a composer and sound designer. He holds major industry awards in technical and creative fields for his unique approach to sound and music in the context of multi-sensory experience. In 2006 Nick was invited by photographer Nick Knight and interaction designer Daniel Brown to sonify a still photograph of a Balenciaga garment [worn by Gemma Ward] and to create a multi-sensory interactive artwork. The work, *Synaesthesia*, which allows the user to touch a photograph and hear its texture, was launched on Showstudio website and performed by Nick Ryan at the MAK Building, Vienna, June 2007.

LAURA SILLARS

Laura is Head of Programme at FACT. She leads FACT's artistic programme and manages a team of curators and project managers to develop and deliver exhibitions, projects, education and collaboration programmes. Previously Senior Curator: Collaboration Programme at FACT, Curator: Public Programmes at Tate Liverpool and an Associate Lecturer for the Open University, she holds an MA in Art History from the Courtauld Institute of Art, a PGCE in Adult and Community Education from the Institute of Education and a BA from the University of York in History and History of Art. A member of the Liverpool John Moore's Art and Design Academy Advisory Board, she is a Senior Research Fellow: Centre for Architecture and Visual Arts for the University of Liverpool, is a fellow of the Royal Society of the Arts and currently holds a Clore Leadership Fellowship.

MIKE STUBBS

Mike Stubbs is Director and Chief Executive of FACT. He is jointly appointed by Liverpool John Moores University, where he is Professor of Art, Media and Curating. Encompassing a broad range of arts and media practice, Mike's arts management, curating and artwork has been internationally acknowledged. He was the founder of the International Root Festival 1989. Previously he was Head of Exhibitions at the Australian Centre for Moving Image (ACMI), Senior Research Resident at Dundee University's School of Television Imaging and was Founding Director at Hull Time Based Arts (HTBA). During his career, Mike has commissioned over 250 interactive, site-specific, performative, sonic and moving-image based artworks. Originally educated at the Royal College of Art and Cardiff College of Art, Mike's own internationally commissioned artwork encompasses broadcast films, video art, large-scale public projections and new media installation.

NICOLA TRISCOTT

Nicola is a cultural producer, working in the performing, interdisciplinary and visual arts. She founded The Arts Catalyst, the UK science-art agency, in 1993. As Director of The Arts Catalyst she has built alliances internationally between disciplines and commissioned more than 60 art projects over the last 15 years. Nicola writes and speaks regularly at international conferences on the inter-relationships between art, science, technology and society, and cultural perspectives on space exploration. After studying physics at Imperial College and geography at University College London, Nicola worked in theatre and arts production, arts policy, arts centre management, and as a freelance arts consultant. Prior to setting up The Arts Catalyst, she was working and researching in southern, central and east Africa.

ANN WHITEHURST

Ann is one of the UK's leading
multi-media artists and is also a
theorist and thinker of great
imagination, who challenges the
various axioms of contemporary
thought on otherness and
difference. Ann, fullpainly alive,
creates through her art work and
her perceptions a milieu of
understanding and threat to the
hegemonies of the fictive dramas
of normalcy. Ann is at the heart
of www.outside-centre.org.uk; an
agency which seeks to explore,
instigate and challenge you. She
writes, 'My work is to challenge
the very existence of the norm;
challenge and so liberate the
conforming and their limited and
limiting understanding of life,
politics and culture. Diversity in
body, mind and spirit doesn't
restrict it advances' Ann's 1993
piece *Wheelchairbound* was produced
at a time when the social model of
disability became a universally
recognized concept thus
influencing policy and the 1995
Disability Discrimination Act.

JENNIFER WILLET

Jennifer is an international
artist specializing in
performance, installation and
reproductive (analogue/digital/
biological) technologies. She is
PhD candidate in the
Interdisciplinary Humanities
programme at Concordia University
in Montreal, and an Assistant
Professor in the School of Visual
Arts at the University of Windsor
in Canada. Between 2000 and 2007
she collaborated with Shawn Bailey
on a bioart project called
BIOTEKNICA.

GREGOR WOLBRING

Gregor is an ability and ableism
governance, science and technology
governance, disability studies and
health policy scholar, a
bioethicist and a biochemist. He
is an Assistant Professor,
University of Calgary, Faculty
of Medicine, Dept of Community
Health Sciences, Speciality in
Community Rehabilitation and
Disability Studies. He is an
affiliated scholar for the Center
for Nanotechnology and Society at
Arizona State University, Part-
time Professor, Faculty of Law,
University of Ottawa, Canada,
Adjunct Faculty Critical
Disability Studies York University
Canada.

IMAGE INDEX

NAME
INDEX